THROWING LIKE A GIRL AND OTHER ESSAYS IN FEMINIST PHILOSOPHY AND SOCIAL THEORY

THROWING LIKE A GIRL AND OTHER ESSAYS IN FEMINIST PHILOSOPHY AND SOCIAL THEORY

IRIS MARION YOUNG

INDIANA UNIVERSITY PRESS
Bloomington and Indianapolis

The paper used in this publication meets the minimum requirements of American
National Standard for Information Sciences—Permanence of Paper for Printed
Library Materials, ANSI Z39.48-1984.

♾™

Manufactured in the United States of America

Library of Congress Cataloging-in-Publication Data

Young, Iris Marion.
 Throwing like a girl and other essays in
feminist philosophy and social theory /
Iris Marion Young.
 p. cm.
 Includes bibliographical references.
 ISBN 0-253-36857-X (alk. paper). —
 ISBN 0-253-20597-2 (pbk. : alk. paper)
 1. Feminism—Philosophy. 2. Women and socialism.
3. Body image. I. Title.
HQ1206.Y68 1990
305.42'01—dc20 89-46002
 CIP

CONTENTS

Acknowledgments

All but one of the essays in this volume have been previously published. I gratefully acknowledge the following previous publishers:

Socialist Review, for "Socialist Feminism and the Limits of Dual Systems Theory," no. 50.51 (Summer 1980), pp. 169–88.

Rowman and Littlefield, publishers (formerly Rowman and Allenheld), for "Is Male Gender Identity the Cause of Male Domination?", revised from Joyce Trebilcot, ed., *Mothering: Essays in Feminist Theorizing* (1984), pp. 129–46.

Socialist Politics, for "Women and the Welfare State," no. 3 (April 1985), pp. 20–22.

Valley Women's Voice, for "A Fear and a Hope," vol. 2, no. 10 (December 1980), p. 10.

Pergamon Press, Inc., for "Humanism, Gynocentrism, and Feminist Politics," in *Women's Studies International Forum*, vol. 8, no. 3 (1985), pp. 173–85.

Polity Press, for "Impartiality and the Civic Public: Some Implications of Feminist Critiques of Moral and Political Theory," in Drucilla Cornell and Seyla Benhabib, eds., *Feminism as Critique* (1987), pp. 56–76.

University of Chicago Press, for "Polity and Group Difference: A Critique of the Ideal of Universal Citizenship," in *Ethics*, vol. 99, no. 2 (January 1989), pp. 250–74.

Human Studies, for "Throwing Like a Girl: A Phenomenology of Feminine Body Comportment, Motility, and Spatiality," vol. 3 (1980), pp. 137–56.

Kluwer Academic Publishers, for "Pregnant Embodiment: Subjectivity and Alienation," in *Journal of Medicine and Philosophy*, vol. 9, no. 1 (January 1984), pp. 45–62.

State University of New York Press, for "Women Recovering Our Clothes, Perhaps," revised and expanded from Hugh Silverman and Donn Welton, eds., *Post Modernism and Continental Philosophy* (1988), pp. 144–52.

Portions of "Breasted Experience: The Look and the Feeling," will be published in Drew Leder and Mary Rawlinson, eds., *Medicine and the Lived Body* (D. Reidel, 1990); I thank Kluwer Academic Publishers for permission to print that article here.

Portions of the introduction are based on an article I coauthored with Jana Sawicki, "Issues of Difference in Feminist Philosophy," in the *American Philosophical Association Newsletter on Feminism and Philosophy* (April 1988), pp. 13–16.

Thanks to the Wool Bureau for permission to reprint its advertisement, "See Yourself in Wool," which appeared in *Self* magazine, Fall 1985.

For Morgen

THROWING LIKE A GIRL
AND OTHER ESSAYS IN
FEMINIST
PHILOSOPHY AND
SOCIAL THEORY

Introduction

The original publication of these essays spans the past decade, though two were conceived and largely written before then. The 1980s has been an ambiguous time for feminism. The Reagan–Bush regime confirmed and solidified the power of neoconservatism and slashed away many of the laws and programs that in the '60s and '70s benefited women, people of color, and poor people. Much of the impetuous, fiery feminist activism that changed the lives of millions of women in the 1970s slowed down. At the same time, feminism in the '80s was becoming steadily and determinedly entrenched in the United States and spreading like wildfire over the rest of the world. The *Boston Globe* interviewed the National Women's Health Network about plans that health providers have made to provide abortion services if the Supreme Court throws out the right to abortion. A major Hollywood movie star received an Academy Award for her portrayal of a gang-rape victim in a remarkably woman-centered movie. A socialist-feminist economist headed a major study on comparable worth for the National Academy of Sciences. In this decade feminists have institutionalized our resistance to dominant politics and values to a degree undreamed of when the contemporary women's movement began. At the same time, measured against the goals we had then of radically transforming the institutions of family, church, state, and firm, we have achieved almost nothing, and in the '80s many seem to have lost that radical vision.

One person's writing can hardly represent an entire movement or intellectual field, especially one as invigorating and expansive as contemporary American feminism. I hope that in many ways these papers appear quite idiosyncratic. But I collect them here partly because together they exhibit a wide but connected range of issues in feminist theory and politics and because their sequence shows some of the shifts and pulls that feminist theoretical and political discussions have undergone. In this introduction I probe some of these issues and shifts of the past decade.

I. Socialist Feminism

The socialist feminism that flowered in the 1970s in women's unions and in publications such as *Women: A Journal of Liberation* and many pamphlets and position papers, took on an ambitious theoretical project. We wanted to remain continuous with and retain many of the insights of the most

important tradition of radical social theory, Marxism, but at the same time transform it into a theory in which male domination is at least as important conceptually as class domination. A feminist historical materialist theory should be, like Marxism, comprehensive, but at the same time attentive to historical specificities; it must describe structural relations of domination and explain how they are enacted and reproduced, in terms of the relations of work and production; it must explain changes and variations in those relations; and finally, it should provide some strategic insight for intervention and change. By the mid-'70s a large and rapidly changing discussion developed, making proposals for socialist-feminist theories of domestic labor, reproduction, and sexuality, as well as the public world of work or the state.[1]

The first paper in this volume, "Socialist Feminism and the Limits of Dual Systems Theory," documents much of this discussion. The prevailing method of synthesizing Marxism and feminism at that time, I suggest in it, does not synthesize them enough. Instead of transforming Marxism from within to make gender-conscious categories describing mode and relations of production, the approach that I call dual systems theory conceded to traditional Marxism the primary discourse about capitalist relations, theorizing patriarchal relations as a separate system that interacts with them. In one version of this dual systems theory the patriarchal system refers to the psychic organization of gender and its symbolic meanings. The problem with it, I suggest, is that it does not explain the relations of male power over women—how men gain and keep access to resources that women do not have. The second version I identify claims to be more material, in the sense of theorizing the gendered relations of work. Its inadequacy, however, is that it limits its model of gendered labor to domestic labor.

In criticizing the first of these versions, which I claim limits patriarchal structures to psychology and ideology, I suggest that it wrongly identifies gender differentiation and male domination. In the second paper in this volume, "Is Male Gender Identity the Cause of Male Domination?", I focus on this distinction. The audience for Nancy Chodorow's *The Reproduction of Mothering* was certainly not limited to socialist feminists, but her theory resonated well with the paradigm many socialist feminists had. Chodorow's theory traced the origin of gender differences to the sexual division of labor that allocates the primary care of infants to women. On this base of women's laboring activity, several socialist feminists argued, a feminist historical materialist account of male domination could finally be built. Use of Chodorow's theory to construct a theory of male domination that claimed to be historical materialist was not a dual systems theory. Instead, it tended to reduce both class domination and male domination to the psychology and the symbolic relations of gender, and it is this reductionist tendency that I criticize in the essay.

I argue that a viable social theory should distinguish structural relations of labor and power from symbolic relations of culture and that conceptually, male domination belongs to the former while gender differentiation belongs

to the latter. Thus I argue that a theory accounting for the content of gender differentiation and the greater valuation of masculinity is not sufficient to account for the material operation of male domination. Feminist historical materialist theory, I suggest in these first two essays, must theorize all relations of labor and commodification in thoroughly gendered terms in order to understand the transfer of benefits and burdens that occur in them, and how they produce control over resources and means of production that ensure the power of men and the dependency of women.

Contemporary feminism has been decidedly ambiguous about psychoanalysis. Early second wave feminist classics castigated psychoanalysis, primarily in the person of Freud, for its male centered perspective. Many feminists retain a deep hostility to psychoanalysis, believing that as a framework it is irretrievably male centered, biologistic, and entirely lacking in conceptualization of social relations that can inform an emancipatory politics. Other feminists, however, such as Juliet Mitchell or Gayle Rubin, appropriated psychoanalysis to construct some of the first dual systems theories.

My criticism of uses of Chodorow's theory does not imply a rejection of psychoanalysis as an important tool for feminist social theory. I think psychoanalysis is indispensable to feminist social theory, because this is the only framework that theorizes desire and the unconscious. In contemporary intellectual life psychoanalysis is not one theory, however, but many, and feminists are faced with the question of which to follow. Chodorow appropriated object-relations theory, which explains psychic dynamics more interactively than traditional Freudianism does, avoiding the drive theory that many feminists find too deterministic and biologistic. Mitchell and Rubin, mentioned earlier, along with many other feminists more recently, find a Lacanian approach more productive for feminism. Lacan also breaks with Freud's biologism and insists on the social construction of the subject. I am inclined to favor a Lacanian approach over the object-relations approach. At least as expressed in Chodorow, I find object-relations theory too rationalistic, with too coherent an understanding of the subject. With its notion of the subject as split, I find that a Lacanian approach depicts the unconscious more subtly, better exhibiting the contradictions of subjectivity in capitalist patriarchal society. Some of the papers in this volume make use of psychoanalytic accounts influenced by a Lacanian approach, such as Kristeva's psychoanalytic theory of language, feminist psychoanalytic film theory, and Irigaray's proposal that we express a specific women's desire.

However one appropriates psychoanalysis for a feminist social theory, the problem of avoiding the reductionism of which I accuse the uses of Chodorow remains. Too often psychoanalytic readings of interaction and cultural meanings obliterate economic and power structures. Specific theoretical focus on institutional rules, unintended consequences of the confluence of actions, and issues of access to resources, on the other hand, often obliterate subjects and their meanings.

I have suggested, both in this introduction and in the first two papers of this book, that a feminist social theory should distinguish between two aspects of social life: a psychological and cultural aspect, and a more "material" aspect having to do with access to resources, division of labor, the material consequences of the confluence of aspects, etc. This distinction is a legacy of Marxism that distinguishes between "material base" and "ideological superstructure." In one form or another such a distinction haunts social theory. It appears in Parsons's distinction between social and psychological dynamics of action and in Habermas's distinction between "system" and "lifeworld."[2] Partly under the influence of a deconstructive sensibility that finds suspect any mutually exclusive, apparently comprehensive dichotomy, recent theoretical discussions have called such a distinction into question, especially in Marxism. It does not hold up. Social relations, practices, and institutions are constituted by ideas, symbols, forms of consciousness. Ideas materially affect people's lives because they influence, motivate, and structure people's actions.

In recent years some of the most exciting work of socialist identified social theory has been cultural studies, as represented in journals such as *Cultural Critique* and the *Canadian Journal of Social and Political Thought*. Cultural studies interpret the material effects of cultural forms, the ways in which they enact and reproduce power and serve as the site of struggle. Much of this literature has been influenced by feminism, even when it is not specifically focused on women's oppression. Some of my own recent writing, including several of the papers in this volume, might be called cultural studies.

Yet I believe that something may be lost in following this trend too completely. Feminist theory is less focused on articulating the structural and institutional causes of women's oppression and disadvantage than it was in the heyday of the collective search for a feminist historical materialism. This is partly because we have rightly come to see that the conceptual meaning of social causation is more problematic than some of our sweeping statements about social primacy suggested. Many of us have also stepped back from totalizing theory that risks universalizing particular social perspectives. Like many others, I have been persuaded by deconstructive critiques that the project of totalizing theory is suspect, resulting in reified categories and metaphysical ghosts more than in insights about social life and strategies for change.

Thus I now find the project of constructing a single feminist historical materialist theory overly ambitious and naive. I still think, however, that the promise of socialist feminism to provide specific accounts of the relations of laboring activity that will explain the production and reproduction of male domination remains important and largely unfulfilled. We can still construct "local" theories of economic and power relations in every area of working life—the home, the sex industry, the automated clerical office, the hospital, etc.

There have been some significant developments in theorizing patriarchal relations of work. Carol Brown's thesis that women's mothering work has changed from supporting a private patriarchy in the family to a public patriarchy structured by the state, for example, generates important shifts in the way feminists might ask about access to resources. I include here a short essay on women and the welfare state that reflects on some implications of that thesis. Ann Ferguson has developed this idea of a public patriarchy and has theorized causes of the shift from what she calls husband patriarchy to public patriarchy.[3] Much theoretical work remains, particularly investigating how and why job systems, family relations, law, and state policy continue to materially disadvantage women and to reproduce the power of men.

Politically, socialist feminism has always entailed a commitment to radically transform capitalist patriarchal institutions, to create an economy that no longer runs for profit, that is democratically controlled, in which women's work is equally valued and women do not suffer violence and sexual exploitation. I include here a short piece I wrote for a feminist newspaper that expresses some of the indignation and vision of socialist feminist politics.

I remain committed to the vision that is expressed for me in socialist feminism, but in the years since I wrote that essay I have come to feel that socialism, as a politics for the United States, is terribly abstract. Though every spring brings a bigger and better Socialist Scholars conference in New York City and though several explicitly socialist organizations exist, there is no socialist movement in the United States and none in the offing. Socialism, as a vision of economic life and collective organization, remains a meaningful appeal for many Third World struggles. But in the Northern Hemisphere socialism does not always mean radicalism and democracy, and it does not address many of the issues of oppression and domination that most motivate oppositional activists.

While there is no socialist movement in the United States per se, in my perception there is a huge and expanding amount of radical activism, by which I mean activism seeking significant institutional change in the direction of undermining oppression. Many of these activists affirm the label "socialist," but that fact is somewhat irrelevant to what they do. It is not false, but nevertheless it is too abstract to say that their enemy is capitalism. They struggle against violence and repression, whether public or private; against authoritarian bureaucracy, public or private; against hunger, homelessness, and stultifying work. Feminist analysis shows the connections among violence, authoritarianism, and masculinity. It shows that the passion for order that fuels much of these is linked to the norms and practices of the heterosexual family, which is why gay and lesbian liberation is so threatening and so radical. Radical politics of the '80s and into the '90s has become, for me and many others, more plural and contextualized than the simple label "socialist-feminist" can convey.

II. The Politics of Difference

The dominant feminist impulse has been to deny any significant difference between women and men, and with good reason. For centuries philosophers, theologians, and politicians justified excluding women from important human activities on the grounds that women's essential natures are different from men's. The political necessity of confronting patriarchal constructs of women's nature led feminist theory in the early second wave to theorize women's liberation as the attainment of "androgyny," a social situation transcending gender. Politically, feminism asserted that women can do anything men can do and thus that all discriminations, exclusions, and differential treatment should be eliminated. In the past ten years this rejection of difference has come seriously into question, both theoretically and politically, generating new feminist controversy about the meaning of equality and liberation. My paper "Humanism, Gynocentrism, and Feminist Politics" theorizes some of the conceptual shifts that moved us from clarity to complexity.

Humanist feminism tends to regard femininity, along with the social status and gender-specific situation of women, as primarily liabilities and restraints on the freedom and development of women. Its model of liberation is significantly individualistic, for it assumes that group identity is constraining and that freedom means allowing the creative possibilities of individuals to flower without being channeled into roles and statuses. Existentialism thus supports this ideal of liberation, and in this paper I focus on the strongest expression of humanist feminism in the writing of Simone de Beauvoir.

I call this version of feminism "humanist" because it is committed to an ideal of universal humanity as such, in which gender differences are merely accidental, and because it believes in gender neutral, universal standards of excellence and achievement. I invoke the term "humanism" in order to side with postmodern critics of Enlightenment humanism such as Foucault and Lyotard, who regard commitment to humanist ideals of man, the people, the universal human community, as contributing to modern structures of domination.[4]

What I call "gynocentric" feminism challenges this humanist ideal of gender neutral equality. Much recent feminism questions this model of neutrality and equality as sameness because it entails a devaluation of traditional women's experience and covertly slips masculinist standards into the definition of neutral humanity. Increasingly, feminists have rediscovered and created value and virtue in feminine experience, social status, and expression. Consequently, gynocentric feminism's model of liberation affirms specifically female experience and resistance to its exclusion, denigration, and exploitation by male dominated society. Chodorow's theory of gender psychology was an important turning point in the development of this feminist paradigm, because she provided a theoretical basis for a

positive valuation of feminine gender identity. The vast feminist literature that elevates feminine relatedness, as opposed to masculine separateness, falls within this gynocentric paradigm.

A practical shift also accounts for the emergence of gynocentrism. As the years have passed, many of us have abandoned the heady confidence we often expressed in the late 1960s and early 1970s that conventional gender differences in clothes and body comportment, division of labor, ways of thinking and relating to others, etc., could be easily shed. Many feminist women also discovered that we were attached to our genderedness, that in spite of our feminist commitment to equality, we loved things about ourselves and each other derived from our female socialization and status. In short, many of us have come to believe that gender differentiation is harder to eliminate than we thought and that we may not want to eliminate it. Our program then becomes equality in difference rather than neutrality.

"Humanism, Gynocentrism, and Feminist Politics" straddles the two feminist paradigms, exhibiting strengths and weaknesses in each. Since its writing, I have climbed off the fence to the gynocentric side. Reflection on and revaluation of female gendered experience is uniquely empowering and provides important critical leverage. Gynocentrism seizes the meaning of sexual difference and femininity for women and by women, instead of acceding to patriarchal culture's definition of women as lacking and deficient in relation to a humanist norm. A gynocentric approach also exposes how epistemologies, standards, and accounts of experience that claim neutrality and universality themselves express specifically masculine experience.

As it appears in this volume, the paper suggests that even though gynocentric feminism has a more radical and comprehensive critique of patriarchal society than humanist feminism does, it nevertheless may be objectively less political because it does not focus on transformation of specific institutions of male power. I no longer believe this. Gynocentric insights are relevant to some of the most important policy issues about gender and women debated in the United States today.

A principle of gender blindness in policy presumes something patently untrue: that women's lives are no different from men's. Whatever the goals of feminism, it is undeniable that in contemporary society the socialization of women does often produce in us skills, expectations, and temperaments that are different from men's. More important, whatever else happens in their lives, women who are mothers still bear the children and carry the major burden of child care, and women generally carry greater reponsibility for the care of other family members than men do.

Just as feminist theory attending to gender differences has exposed the masculinism of Western scientific and normative reason that claims impartiality and objectivity, feminist attention to gender difference in policy issues has exposed the masculinism that structures most public institutions in our society. Corporate and bureaucratic institutions presume a male

model of behavior and life cycle of their employees—that professionalism requires detachment and impersonality, that "success" requires old boy networking, impression management, and the willingness to devote many continuous years of more-than-eight-hour days to the job.

The issue of same vs. different treatment in law and policy has received its most volatile treatment in discussion of pregnancy and maternity rights. Recently, feminists have been quite divided over whether such rights should fall under gender neutral disability rights or should be explicitly linked to childbearing. Attention to the situational and social differences of women from men also has specific implications for our interpretation of the meaning of affirmative action, the form and justification of comparable worth policies, and debates about single sex programs and institutions. I discuss these and other issues in my paper "Polity and Group Difference: A Critique of the Ideal of Universal Citizenship."

A second major area of feminist discussion about difference in the women's movement has focused on differences among women. Within the past decade a series of challenges to the false universalism of white, middle-class feminists' claims to represent all women have emerged. Women of color, poor women, old women, lesbians, and disabled women have exposed the particularity and exclusivity of dominant feminists' invocations of concepts such as "sisterhood," "women's experience," and "women's position." Rejecting the view that differences and divisions within a movement inevitably threaten solidarity, these women have suggested that the greatest threat to a unified and powerful women's movement is its refusal to recognize, examine, and rename differences among women.[5]

In response to this internal criticism, some feminists began to explore methods of uncovering and understanding the diverse experiences and situations of women. The early stages of this effort involved a return to consciousness-raising. Unlike much of the consciousness-raising in the early '70s, the aim this time is not to build a sense of "shared experience," but to highlight the specificity of women's experiences and the relations of privilege and oppression among women, and to examine the implications of these for specific institutional issues such as employment policy, reproductive rights, sexual violence, international relations, etc.

Discussions of what it means to acknowledge and affirm group differences among women while retaining a progressive feminist politics serve, I believe, as a model of a general politics of inclusion. The injunction to attend to differences of race, class, nationality, sexuality, or age among women has led my thinking increasingly away from theory and politics focused primarily on women and feminism to reflection on other group oppressions in their own right, not simply as they intersect with women's oppression. In "Impartiality and the Civic Public" and "Polity and Group Difference," I theorize a politics of difference as envisioning a heterogeneous public in which all oppressed or disadvantaged social groups can be explicitly represented.

The call for feminists to take seriously differences among women in our

theory and politics appears to conflict with the gynocentric feminism that focuses on women's specificity. Gynocentrism risks reasserting an essentialism that can bias the definition of feminine gender toward the lives of only some women. Much of the feminist theorizing that elevates the value of traditional women's activity, for example, takes mothering as defining women's values.

I think that a conflict between these two discussions, however, is more apparent than real. Both are motivated by interest in how an assumption of neutrality often masks a privileged position for particular dominant groups and, thus, how attention to differences exposes privilege and oppression. The meaning of group difference, and what differences are important for each discussion, must be understood contextually rather than absolutely, in terms of audience and political strategy.

Feminist discussion of the importance of understanding differences between men and women has been directed toward strategizing within male dominated society, while discussion of the importance of attending to differences among women has been largely internal to the women's movement. The question what is feminism if we must attend to differences among women also can be understood contextually. For whatever else feminism is, it consists of advocating women's interests in male dominated discussions of policy in both state and private institutions. Discussion of the importance of attending to differences among women helps bring it about that such advocacy will not implicitly promote only the interests of white professional women. But in the context of policy discussion, feminists often still focus on differences between women and men. Any discussion of the Black underclass in the United States and how policy might mitigate the oppression of this group, for example, must insist that the situations and motivations of poor Black men and those of poor Black women often are vastly different.

A third discussion of difference that has occupied American feminists in the past ten years concerns the relation, if any, that feminist theory might have to postmodernist theory. Derrida, Foucault, Lyotard, and other writers engage in a critique of what Derrida calls the "phallogocentrism" of the Western logic of identity and difference. They suggest that the construction of any unity or totality (e.g., humanity, the subject, the social system, history) involves the suppression of difference—that is, the reduction of different elements to sameness and the expulsion of some elements to the margins, the outside, otherness. This logic of identity turns difference, understood as relational specificity, into rigid hierarchical, exclusive opposition. Some feminists have expressed skepticism about the relevance of postmodernist critiques of Western discourse to feminism, and I do not endorse everything said by any of the thinkers referred by this label.[6]

I nevertheless have found postmodernist critiques of Western reason's urge to totalization helpful for theorizing all the group exclusions and devaluations typical of modern societies, whether of women, people of color, homosexuals, or Jews. "Impartiality and the Civic Public" combines femi-

nist critiques of the male bias of moral and political theory's idea of reason with postmodern critiques of a logic of identity. It finds that the republican ideal of a civic public that transcends particularities itself operates to exclude groups defined as different, and argues for an ideal of a heterogeneous public in which people are affirmed and recognized in their particularity.

I derive some of my models of a heterogeneous public from feminist organizations. By a "public," I mean a collective body with some defining ends, a polity, with collective decision-making procedures for accomplishing those ends. The National Women's Studies Association, for example, is a polity insofar as its members, through discussion and representation structures, make collective decisions about the business of the association. The complex decision-making and governance structures of NWSA exemplify a heterogeneous public. Delegates to the governing body represent not only regions of the United States, but also specific group constituencies, including lesbians, older women, disabled women, and women of color. The governance of many college and university women's studies programs is similarly group differentiated. Programs often have executive committees whose representatives include students, faculty and staff members, women of color, lesbians, and, depending on the program, commuting or older students. In theorizing a heterogeneous public with group representation, I ask what it might mean to generalize such existing governance forms into political principles guiding any emancipatory politics.

As Bernice Reagon has suggested, for feminists to make good on the promise to accept differences among women means to understand feminist politics—indeed, all progressive politics—as coalition politics.[7] The desire for a unified community among women is a dangerous illusion.[8] In this multidimensional, contradictory society no person is a unity, but a confluence of several group affinities that do not necessarily cohere. Gender is an important and irreducible dimension of social life and personal identity, but race, class, sexuality, age, and so on are just as fundamental.

My most recent political theory work moves beyond the specific problem of women's organizing and feminist politics to a coalition politics in which oppressed groups besides women are just as important.[9] Such a theoretical move reflects both the necessity and maturity of radical politics in the '80s. Social movements of group solidarity—feminists, gay liberationists, radical Black activists, etc.—tended to remain separate in the '70s because each rightly believed that the others did not understand or take seriously their oppressions and because each needed a separate organization in order to develop a positive group identity and social perspective. Recent years have produced more coalescing, I believe, because each movement has come to understand more profoundly the significance of the others, and each has developed confidence that its own perspective need not be swallowed by a larger body.

Thus several major national protest mobilizations during the '80s included the visible presence of such rainbow constituencies as gays and lesbians, Blacks, Latinos, feminists, and others. At the Solidarity Day rally

of 500,000 in the fall of 1981, for example, hundreds of Black labor activists carried "ERA Now" signs. After the Women's Pentagon Actions brought feminists and lesbians to embrace antinuclear politics, to take another example, the largest protest rally in American history, organized around the nuclear freeze in June 1982, contained several separate constituencies, including a beautiful lesbian presence. The mayoral candidacies of Mel King in Boston and Harold Washington in Chicago and the presidential candidacies of Jesse Jackson, especially the second, involved a genuine Rainbow Coalition of groups, explicitly differentiated. It is with deep disappointment that I note that the promise of a sustained Rainbow Coalition organization that includes the political perspectives and oppressed groups that define radical politics in the United States today is not being fulfilled.

III. Female Body Experience

Oppression typically involves the marking or control of the bodies of the oppressed. The worker toils and tires, adapting her movements to the relentless rhythm of the assembly line or the lines on the green screen. People of color are marked in their bodies; they find that others often exhibit nervousness around them or simply avoid them them and that media images often stereotype their bodies. Old people, disabled people, gay men, and lesbians are reduced to bodies understood as being deviant or unhealthy.

Women's oppression is most complexly tied to our bodies, because patriarchal culture gives women's bodies such variable meanings and submits them to so many controls. From the dawn of the West's distinction between reason and body, women have been identified with the body and both feared and devalued as a result of that identification. But we are also desired bodies whose sexual and mothering capacities are the subject of magnificent scientific and technical manipulation. Our being is largely reduced to our bodies, the media of male pleasure and procreation, and we find our ability to live and move freely restricted by that definition. I am writing this in spring 1989, shortly after hundreds of thousands of women have taken to the streets of Washington to tell the Supreme Court that we will not stand for a definition of our bodies as containers for someone else's ends; the justices have not listened. Not only are we imprisoned by patriarchal institutions that physically inhibit us, but also, the masculinist imagination manipulates images of women's bodies in orgies of visual and verbal display.

Central to feminist theory, then, is criticism of masculinist control over and symbolization of female bodies. We now have mountains of feminist writings about women's bodily oppression, much of it very important. Feminist literary, art, and film critics theorize the overdetermined symbolizations of women's bodies as objects of desire. Social critics expose the indifference and hostility to which women's bodies are subject in medical and reproductive technology. Little feminist theory, however, exhibits the

sort of project of describing women's embodied experience that I take up in the last four papers of this volume. These papers resonate with descriptive work about women's embodied oppression by such writers as Nancy Henley, Sandra Bartky, Susan Bordo, and Emily Martin.[10] In these essays I reflect on four aspects of women's bodily experience in capitalist patriarchal society—movement, pregnancy, clothes, and breasts—in a method I loosely refer to as phenomenological.

But what do I mean by "experience"? Both in philosophy and in ordinary language, "experience" often refers to an origin or foundation of knowledge. In everyday talk we often distinguish between a person's speaking from his or her own experience and speaking secondhand, from talking to people, reading, watching television. In this sense, "experience" often means knowledge that is more immediate and trustworthy than secondhand knowledge. Everyday talk also values people's expression of their experiences; people say they know and understand one another when they hear about their experiences. Here, "experience" means an authentic representation of self.

Both of these meanings, which privilege experience as being authentic, truthful, real, are suspect. The discourse we use when we describe our experience is no more direct and unmediated than any other discourse; it is only discourse in a different mode. The narrative form through which even young children learn to relate their experiences, for example, has rules, conventions, and many spaces for the introduction of social assumptions and stereotypes. Often people seem to assume that if we express our authentic experience, we will be free of ideology and the false impressions of society that lead to conflict and irrationality. But this is clearly not so: ideology operates, or interpolates, as Althusser says, at the most immediate level of naive experience. We must listen to others, reflect, and theorize in order to achieve some distance from such ideological influence.

Traditional modes of privileging experience in philosophy are perhaps even more suspect. Whether in the empiricist or idealist traditions, many philosophers since Descartes have assumed a notion of consciousness whose contents are transparent to itself. Philosophers find out what knowledge is—its genesis or its structure, as the case may be—by bracketing the reality claims of the ideas of consciousness and simply examining them as ideas. The assumption of a consciousness immediately present to itself, which can know itself and its contents with an apodictic certainty unlike any knowledge of other things, is illusory. It exhibits what Derrida calls the metaphysics of presence, the idea of consciousness as self-originating, a metaphysics that is possible only by taking speech, or voice, as the model of thought, wherein one can deceive oneself that speaking and hearing oneself are simultaneous and unmediated. There is, however, no originary position of the subject with respect to language or the world; the absent always comes along with the present as a plural relation of difference and context at every instance of discourse.

While both ordinary and philosophical uses of the term "experience"

carry these connotations of origin, immediacy, authenticity, and truth, I join a postmodern critique in finding such connotations suspect. Nevertheless, I retain the term "experience" because it captures some distinctions I can find in no other term. No experience or reality is unmediated by language and symbols; nevertheless, there are aspects of perception, action, and response that are not linguistically constituted. By the term "experience" I also wish to evoke a pragmatic context of meaning. Meaning subsists not only in signs and symbols, but also in the movement and consequences of action; experience carries the connotation of context and action.

Perhaps more important, with the term "experience" I wish to distinguish a certain mode of talk, a language-game. The experiential language-game is specifically first-personal, or subjective. Talk about experience expresses subjectivity, describes the feelings, motives, and reactions of subjects as they affect and are affected by the context in which they are situated. We should be careful, however, not to make the subject any more originary than experience. Much contemporary philosophy and social theory, including my own, argues that the subject is constituted, a product of language and structures always already there that position the subject within cultural and social constraints.

But in its zeal to expose the myth of the subject as authentic origin, some postmodern thought completely eclipses the subject. The question of whether and how to save the subject has been much debated.[11] Subjectivity is constituted in language and interaction, a contradictory and shifting product of social processes in which a person always discovers herself already positioned. But however much we are constituted, we also have purposes and projects that we initiate; the concept of the subject retains this aspect of agency as creative, as the life activity that takes up the given and acts upon it.

Many feminists are inclined to defend the subject. How ironic, feminists such as Nancy Hartsock have said, that Euro-American male intellectuals should declare the death of the subject at just the time when women and people of color all over the world are beginning to find a historical voice and to assert their subjectivity against the Western tradition's objectification and silencing.[12] This feminist defense of the subject sometimes comes with too complete a rejection of postmodernist ideas, as though we are compelled either to accept or to reject everything in the texts of Derrida, Foucault, Lyotard, or Kristeva. Without such total rejection of postmodernism, I share the intuition that emancipatory politics needs the notion of the subject in order to name an awareness of oppression and a starting point of resistance.

My approach to experience and subjectivity, then, is conditioned by a pragmatic concern with emancipation. Description of experience, as the expression of a subject's doing and undergoing from the point of view of the subject, has a dual political function. First, it names forms and meanings of oppression. Describing the processes of social life from the point of view

of the subject brings to language the hurts and harms of oppressive structures, and only such experiential description can do so. Second, it holds open the possibility of resistance. Experience names a moment of creative agency in social processes, which cannot be finally totalized or categorized by the dominant oppressive structures. Describing kinds of oppression, the experience of oppression, and the creative agency of the oppressed can help form resistance and envision alternatives.

These four papers describe female body experience. Dualism so structures our thinking that the appearance of the term "body" seems typically to distinguish itself from mind, consciousness, imagination, etc. The body is a person's "physical" aspect, the biological, the material complex chemical and mechanical processes, the subject of medical and physiological science. The body is meaningless and deterministic.

I mean something else by "body" in these essays. While "Throwing Like a Girl" and "Pregnant Embodiment" most directly use the framework of existential phenomenology, particularly the thought of Maurice Merleau-Ponty, all of the essays are in the spirit of existential phenomenology in their assumptions about embodiment. Merleau-Ponty attacked dualism by locating consciousness in the body. This does not make him materialist or reductionist, however, because he specifically distinguishes the lived body, body as experience, from the objectified body of science.[13] Consciousness has a foundation in perception, the lived body's feeling and moving among things, with an active purposive orientation. Unlike a Cartesian materialist body, the lived body has culture and meaning inscribed in its habits, in its specific forms of perception and comportment. Description of this embodied existence is important because, while laden with culture and significance, the meaning embodied in habit, feeling, and perceptual orientation is usually nondiscursive.

Contemporary cultural studies often include reflection on bodies, the meaning of body images in advertising, for example, or the multiple and contradictory constructions of sexuality. Such analyses, often revealing and witty, usually concentrate on the body as imaged in texts and discourses, whether oral, written, or visual, often showing substantive ways that the subjects addressed by such images are seduced into complicity with racist, imperialist, sexist, or classist stereotypes. More rarely does contemporary theorizing of the body concern what Susan Bordo calls the "practical body," or what Merleau-Ponty called the lived body—the tactile, motile, weighted, painful, and pleasurable experience of an embodied subject; how this subject reaches out with and through this body; and how this subject feels about its embodiment.[14]

Once philosophy climbs down from its universalist rationalism to muck about in the ambiguities of the lived body, it would appear natural to describe the specificities of a sexed body. Existential phenomenology, however, continued the humanism of modern philosophy in treating the subject as neutral. On inspection it has become clear that the neutrally human subject in Merleau-Ponty, as well as Sartre and even Beauvoir, carries male

experience as the norm. While I adapt some frameworks from existential phenomenology, these papers are also critical of that tradition's inattention to embodied experience as specifically sexed and gendered.

Feminists frequently describe women's social oppression in terms of constraint and confinement, but this language is usually metaphorical. In "Throwing Like a Girl" I chose to understand women's confinement quite literally as our feeling physically restricted in our bodies. The ideas for the paper arose from my experience of learning to play tennis when I was in my mid-twenties. I found myself with a set of body habits that greatly impeded my progress. I failed to stretch out toward the ball with the full extent of my trunk and arms. I tended to stay planted in one area instead of moving as though the entire court were my space.

The socialization of girls today produces body habits that are less self-confining than those of my experience, perhaps. Most girls wear pants most of the time, a momentous change from my childhood, with enormous implications for a feeling of free movement. In many ways girls' access to sport has improved. Observation of my eleven-year-old daughter and her friends, however, convinces me that many girls and women still live a confined and inhibited experience of space and movement, which both expresses and reinforces a continuing confined and inhibited right to assert themselves in the social world.

Though it was written more than ten years ago, I continue to believe what I said in that paper. At the same time, I now find it one-sided. In that paper I follow Beauvoir's analysis of femininity as the doubled experience of being an objectified subject. The analysis in the paper thus assumes the humanist feminist framework that I later criticized. It constructs femininity only as a liability, expresses female experience only as victimization, and implicitly assumes masculine styles of comportment and movement as a norm.

The other three papers in this section have a more gynocentric cast. In each I describe not only the physical and emotional harms women suffer in masculinist institutions, but also some positive experiences of embodiment. One reason to retain a category of the subject and to describe and reflect on the experience of the subject, I said earlier, is to locate some basis for resistance against oppression and for formulating alternative visions of liberated subjectivity. Precisely because women's lives and experiences are often ignored by dominant institutions and values, women can create gynocentric culture within male-dominated societies, and there is reason to think we often have. In "Women Recovering Our Clothes" I have sought one aspect of such women's culture: a noncommodity relation to things. The paper exhibits a gynocentric strategy of revaluation. The official word in male dominated society is that concern with clothes is frivolous and trivial. Yet clothes are important in many women's lives. I have tried to construct positive values in those experiences of clothes, values expressed in women's culture about clothes.

In the other two papers, on pregnancy and breasts, I have taken not

only gender culture as my subject, but also sexual difference. If the assumptions of existential phenomenology have some validity, body morphology and sex-specific body experience structure subjectivity and identity. In her injunction to "write the body," Cixous suggests that the specificity of women's body experience can generate a specifically feminine aesthetic. While I find this idea interesting, the project of "l'écriture féminine" often seems rather abstract and metaphorical. My own thinking is closer to that of Irigaray, who suggests that women's bodies express some specifically female pleasure. In writing about the specifically female experiences of breasts or pregnancy I seek to express some of those pleasures; in a less erotic mode, moreover, I also describe some structures of movement and habitual bodily being as modulated by these sexed body experiences. Such description should not reduce women to meaningless objective flesh and container, as does much patriarchal discourse. On the contrary, I hope that it elevates the female body to personhood in the spirit of that classic feminist text, *Our Bodies, Our Selves.*

The project of these four papers is to describe some general structures of movement, habitual bodily being, and sense of identity. But there is a paradox embedded in this project. What does it mean to describe general structures of experience? If the description of experience is to remain on the side of the subject, it would seem that it must be individual and personal. Diaries, however, cannot serve the theoretical and political functions of these descriptions because they do not exhibit structures of experience that arise from male domination, or from sex and gender more generally.

I offer these writings as claiming some general, though not universal, validity as description of femininely gendered or female sexed experience and not just reports of my own case. I retain the subjective mode by trying to express something of the meaning of the experiences. Even though each paper depends on reading and talking about the experiences of other women, my claim to generality is not inductive; I have not accumulated "data" from which I can draw generalizations. The only way I can express what I hope to be the relation of general and particular in these essays is aesthetically. I think of the description of experiences as being like musical notation; it is the "same" for each instance of its performance. But the music exists only in the particulars, and the particular performances vary in innumerable ways—in tempo, timbre, rhythm, phrasing, dynamics. One can even vary the key, the instrumentation, or the arrangement and still call it the "same" composition.

In each of the four papers on female body experience I start from my own experience, but not in the mode of direct personal narrative. I look in my experience for what is female or feminine about it and not simply idiosyncratic. I claim for them generality in the hope that they touch some chords in other women. This generality is only a claim, which can be confirmed or denied only by discussion. I have no doubt that my descriptions are partial. In some ways they may express only my experience; in others they probably express experiences specific to white Anglo hetero-

sexual middle-class women like myself. Yet I refuse to circumscribe these descriptions within this string of identities. I believe that these descriptions can resonate, at least in some aspects, with the experiences of differently identifying women, but I cannot know without their saying so. Feminists should affirm and attend to differences among women, but it would be wrong to construct these differences themselves as being exclusive categories. These descriptions do not claim to be universally and categorically "true," but to express types, modalities, styles of existence around which the particular experiences of particular women vary. We can discover as much about our experience by saying "It is not like that for me" in response to another woman's expression as by saying "Yes, I feel that too." I offer these papers as beginnings for such reflection.

Is there a connection between feminist social theory and reflection on female body experience? The essays in this volume provide such a connection only very indirectly. Despite the obvious fact that social actors are embodied, most social theory provides little space for conceptualizng the socialized body and the lived experience of culture in daily bodily habits and movement.[15] Showing how broad social and symbolic structures are expressed in the lived body is a crucial continued task for feminist theory, one in which psychoanalysis is an indispensable tool.[16] Feminist appropriations of Foucault's analyses of the disciplinary body also open important new ways of thinking about women's oppression and resistance. I hope that together, the essays in this volume stretch the thought and the imagination of its readers to further this project of embodied feminist social theorizing.

NOTES

1. Alison Jaggar's *Feminist Politics and Human Nature* (Totowa, N.J.: Rowman and Allenheld, 1983) contains a comprehensive summary and analysis of many of these theories; see especially chapters 6 and 10.

2. Talcott Parsons, *The Social System* (New York: The Free Press, 1954); Jurgen Habermas, *The Theory of Communicative Action,* especially vol. II, *Lifeworld and System: A Critique of Functionalist Reason* (Boston: Beacon Press, 1987); Anthony Giddens identifies the structure subject dichotomy as the major methodological problem in social theory and proposes a theory of structuration to solve it; see *Central Problems in Social Theory* (Berkeley: University of California Press, 1976).

3. Carol Brown, "Mothers, Fathers and Children: From Private to Public Patriarchy," in Lydia Sargent, ed., *Women and Revolution* (Boston: South End Press, 1981), pp. 239–68. Ann Ferguson, "On Conceiving Motherhood and Sexuality: A Feminist Materialist Approach," in Joyce Trebilcot, ed., *Mothering: Essays in Feminist Theory* (Totowa, N.J.: Rowman and Allenheld, 1984), pp. 153–84; Ann Ferguson, *Blood at the Root* (London: Pandora Press, 1989), chapter 5.

4. Michel Foucault, *The Order of Things* (New York: Vintage Books, 1970), chapters 9 and 10; Jean François Lyotard, *The Postmodern Condition* (Minneapolis: University of Minnesota Press, 1984) pp. 31–41.

5. Elizabeth Spelman has analyzed the difficulties of taking differences among women seriously in her book *The Inessential Woman* (Boston: Beacon Press, 1989).

6. Michelle Barrett, "The Concept of 'Difference,' " *Feminist Review*, no. 26 (1987), pp. 28–41; Linda Alcoff, "Cultural Feminism v. Post-Structuralism: The Identity Crisis in Feminist Theory," *Signs*, vol. 13 (1988), pp. 405–36.

7. Bernice Reagon, "Coalition Politics: Turning the Century," in Barbara Smith, ed., *Home Girls* (New York: Kitchen Table, Women of Color Press, 1983), pp. 356–69.

8. See my essay "The Ideal of Community and the Politics of Difference" in Linda Nicholson, *Feminism/Postmodernism* (New York: Routledge, Chapman, and Hall, 1990).

9. See my book *Justice and the Politics of Difference* (Princeton: Princeton University Press, 1990).

10. Sandra Bartky, *Femininity and Domination: Studies in the Phenomenology of Oppression* (New York: Routledge, Chapman and Hall, 1990); Susan Bordo, "Anorexia Nervosa: Psychopathology as the Crystallization of Culture," *The Philosophical Forum*, vol. 17 (1985/86), pp. 73–104; Nancy Henley, *Body Politics* (New York: Prentice-Hall, 1977); Emily Martin, *The Woman in the Body* (Boston: Beacon Press, 1986).

11. Fred Dallmayer, *Twilight of Subjectivity* (Amherst: University of Massachusetts Press, 1981); Paul Smith, *Discerning the Subject* (Minneapolis: University of Minnesota Press, 1988).

12. Nancy Hartsock, "Epistemology and Politics: Minority vs. Majority Theories," *Cultural Critique*, no. 7 (Fall 1987).

13. Maurice Merleau-Ponty, *The Phenomenology of Perception* (New York: Humanities Press, 1962).

14. Susan Bordo, "Material Girl: Postmodern Culture, Gender and the Body," manuscript, Le Moyne College, May 1989.

15. Bryan S. Turner, *The Body and Society* (Oxford: Basil Blackwell, 1984).

16. Chapter 6 of my book *Justice and the Politics of Difference* theorizes body avoidances in everyday life, using in part a psychoanalytic framework.

Part One

Socialist Feminism

ONE

Socialist Feminism and the Limits of Dual Systems Theory

Socialist feminist theory is perhaps the most vital and profound development in contemporary Marxist theory and is also central to advances in feminist social theory.* This growing body of theoretical and analytical literature locates itself in the tradition of Marxism, but agrees with the radical feminist claim that traditional Marxian theory cannot adequately comprehend the bases, structure, dynamic, and detail of women's oppression. It thus seeks to supplement the Marxian theory of class society with at least elements of the radical feminist analysis of sexist society.

The predominant manner of accomplishing this synthesis of Marxism and radical feminism has been through what I call the "dual systems theory." Stated briefly, for I will define it at more length in what follows, the dual systems theory says that women's oppression arises from two distinct and relatively autonomous systems. The system of male domination, most often called "patriarchy," produces the specific gender oppression of women; the system of the mode of production and class relations produces the class oppression and work alienation of most women. Patriarchy "interacts" with the system of the mode of production—in our case, capitalism—to produce the concrete phenomena of women's oppression in society.

As one committed to the project of incorporating many radical feminist insights into a theory of women's situation within the tradition of Marxism, I used to accept the dual systems theory. Recently, however, it has begun to seem inadequate. In this paper I express some of my discomfort with the dual systems theory by raising some theoretical and practical questions about it.

My primary motive in raising these critical questions in political: I wish to see the political principles of socialist feminism furthered. By socialist feminist politics I mean the following: a socialist movement must pay attention to women's issues and support the autonomous organization of women in order to succeed, and all socialist organizing should be conducted

*I say feminist social theory, not all feminist theory, for I think that current works of radical feminism, like Daly's *Gyn/Ecology* (Boston: Beacon Press, 1978), make profound and in some cases unparalleled contributions to theory and analysis of cultural symbols and patriarchal mythology.

with a feminist consciousness; and feminist struggle and organizing should be anticapitalist in its thrust and should make explicit connections between the oppression of women and other forms of oppression. The dual systems theory is a better basis for these principles than any other existing theory of women's situation under capitalism, but I have begun to think that it does not serve well enough and that it even fosters analyses and practices contrary to those principles.

The Origins of Dual Systems Theory

The feminist break with the new left and the resulting contemporary women's movement stand as perhaps the most revolutionary and lasting effect of the movements of the 1960s. Quickly these new-wave feminists, who called themselves radical feminists, began developing questions, categories, and analyses that broke wholly new ground and irrevocably altered the perceptions of most progressive people. For the first time we had systematic accounts of such unspeakable phenomena as rape and heterosexism. Those identifying themselves as radical feminists continue to develop their analyses with extraordinary insight.

Like the feminist politics and movement that began by distinguishing itself from the radical left, many of the early theoretical works of radical feminism, such as Firestone's *Dialectic of Sex* and Millett's *Sexual Politics*, began from a confrontation with Marxism. We do not need to summarize the details of the arguments they developed. They concluded that Marxism failed as a theory of history and a theory of oppression because it did not account for the origins, structure, and dynamic of male domination and failed to recognize sex oppression as the most fundamental oppression. Radical feminism thus rejected Marxian theory as a basis for understanding women's oppression and rejected the socialist movement as a viable means of organizing to alter the social structure.

Some feminist women, however, acknowledged the radical feminist criticisms of the socialist movement but did not wish to separate from that movement entirely. Believing that eliminating capitalist economic institutions would not itself liberate women, these emerging socialist feminists nevertheless found this a necessary condition for that liberation. The socialist feminists agreed with the radical feminist claim that traditional Marxian theory cannot articulate the origins and structure of sex oppression in a way that accounts for the presence of this oppression as a pervasive and fundamental element of most societies. But they did not wish thereby to reject entirely the Marxist theory of history or critique of capitalism.

Accepting and rejecting elements of both radical feminism and Marxist socialism, the socialist feminists found themselves with a political and a theoretical problem. The political problem was how to participate in a movement for socialism without sacrificing feminist autonomy and without forfeiting feminist criticism of socialists. Socialist feminist politics has also had to grapple with how to orient feminist organizing and self-help projects

in such a way that they recognize the particular oppressions of race and poverty, and promote critique of capitalist institutions.

The theoretical problem socialist feminists face is how to synthesize Marxian theory and radical feminist theory into a viable theory of social reality in general and of women's oppression in particular. The solution to this problem emerged as the dual systems theory. One of the earliest statements of the dual systems theory is Linda Phelps's "Patriarchy and Capitalism." In discussing women's situation in contemporary society, she claims that we must talk of two distinct systems of social relations: patriarchy and capitalism.

> If sexism is a social relationship in which males have authority over females, *patriarchy* is a term which describes the whole system of interaction which arises from that basic relationship, just as capitalism is a system built on the relationship between capitalist and worker. Patriarchal and capitalist social relationships are two markedly different ways that human beings have interacted with each other and have built social, political and economic institutions.[1]

According to Phelps, patriarchy and capitalism constitute distinct systems of oppression because the principles of authority differ and because they have distinct histories. Capitalism and patriarchy, moreover, contradict as well as reinforce each other as they interact in contemporary society.

More recently, Zillah Eisenstein has attempted to articulate in a more complex fashion this relation between the dual systems of capitalism and patriarchy. In her formulation, a mode of production (e.g., capitalism) and patriarchy are distinct systems in their structures but nevertheless support each other.

> This statement of the mutual dependence of patriarchy and capitalism not only assumes the malleability of patriarchy to the needs of capital, but assumes the malleability of capital to the needs of patriarchy. When one states that capitalism needs patriarchy in order to operate efficiently one is really noting that male supremacy, as a system of sexual hierarchy, supplies capitalism (and systems previous to it) with the necessary order and control. . . . To the extent that the concern with profit and the concern with societal control are inextricably connected (but cannot be reduced to each other), patriarchy and capitalism become an integral process; specific elements of each system are necessitated by the other.[2]

Other dual systems theorists claim a less harmonious relationship between capitalism and patriarchy. Heidi Hartmann, for example, claims that at times during the history of modern society the interests of the system of patriarchy have struggled against the interests of the system of capitalism and that the patriarchal interests have won out.[3]

I have been referring to "the" dual systems theory not in order to designate one unified body of theory, but to refer to a general *type* of theoretical approach. Those who subscribe to a dual systems approach to understand-

ing women's oppression differ significantly in the categories they use and in their particular formulations of the dual systems account. The two systems are not always called "patriarchy" and "capitalism." The terms "mode of production" and "mode of reproduction" frequently designate the two types of system.[4] Gayle Rubin criticizes both "patriarchy" and "reproduction" as terms to designate the system of male domination. She prefers the term "sex/gender system" as a neutral category that can stand as the analogue in the realm of sex power to the system of production in the realm of class power.[5] Among the other categories that have been proposed to designate the system underlying male domination, as distinct from the mode of production, are "sex/affective production"[6] and the "relations of procreation."[7]

Development of the dual systems approach has fostered major theoretical, analytical, and practical advances over traditional Marxist treatments of "the women question" and has contributed to a revitalization of Marxist method. Socialist feminist analyses springing from the dual systems approach have examined in detail the relationship of women's specific oppression to capitalist institutions in a way that otherwise might not have occurred. The dual systems theory has directed the attention of socialists to phenomena in capitalist society that lie beyond the production process, but nevertheless are central for understanding the contemporary economy and ideology—such as family relations, advertising and sexual objectification, consumer culture, and so on.

As the first attempt to synthesize Marxism and radical feminisn, the dual systems theory has been a crucial theoretical development, and I do not wish to belittle its contribution. I suspect, however, that it may now be holding socialist feminists back from developing further theoretical insights and practical strategies. In what follows I shall argue that the dual systems theory has not succeeded in confronting and revising traditional Marxist theory enough, because it allows Marxism to retain in basically unchanged form its theory of economic and social relations, on to which it merely grafts a theory of gender relations.

Ideological and Psychological Approaches

There are numerous variations in dual-systems accounts. Some develop more important insights than others. In this essay I do not wish to review the work of all the major dual systems theorists. In criticizing the dual systems approach I will be reconstructing what I see as the basic form of those accounts. Where I refer to specific works, I am using them as examples of a general approach.

All dual systems accounts begin from the premise that the system of male domination is structurally independent of the relations of production described by Marxian theory. Given this assumption, the dual systems theorists must specify the independent origins and structure of the system(s) of gender relations and articulate their relation to the system(s) of

production relations. In my reading I have seen two general approaches to articulating the nature of the system of gender relations. The first understands the system of patriarchy as an ideological and psychological structure independent of specific social, economic, and historical relations. This version of the dual systems theory then attempts to give an account of the interaction of the ideological and psychological structures of patriarchy with the social and economic structures of class society. The second version of the dual systems theory considers patriarchy itself to be a particular system of social relations of production (or "reproduction") relatively independent of the relations of production that Marxists traditionally analyze. Some dual systems theorists, such as Rubin, combine both versions of the dual systems theory, but most writers tend toward one or the other.

Juliet Mitchell's approach in *Psychoanalysis and Feminism* is an example of the first, ideological-psychological version, as indeed are most theories that rely on Freudian theory as the basis of a theory of male domination.[8] Mitchell clearly states the autonomy of the systems of patriarchy and capitalism, one being ideological and the other material.

> Though, of course, ideology and the given mode of production are interdependent, one cannot be reduced to the other nor can the same laws be found to govern the other. To put the matter schematically, in analyzing contemporary Western society we are (as elsewhere) dealing with two autonomous areas: the economic mode of capitalism and the ideological mode of patriarchy.[9]

Mitchell understands patriarchy as a universal and formal structure of kinship patterning and psychic development that interacts with the particular structure of a mode of production.

> Men enter into the class-dominated structures of history while women (as women, whatever their work in actual production) remain defined by the kinship pattern of organization. Differences of class, historical epoch, specific social situation alter the expression of femininity; but in relation to the law of the father, women's position across the board is a comparable one.[10]

In this account, the patriarchal structures that Freudian theory articulates exist as a pre- or nonhistorical ideological backdrop to transformations in social and economic relations of the mode of production. This ideological and psychological structure lying outside economic relations persists in the same form throughout them. Mitchell does not wish to deny, of course, that the concrete situation of women differs in varying social circumstances. She accounts for this variation in women's situation by the way in which particular structures of a given mode of production intersect with the universal structures of patriarchy.

This version of the dual systems theory inappropriately dehistoricizes and universalizes women's oppression. It may be true that in all male-

dominated societies there are common elements to the situation of women and the social relations in which they stand. Relations having to do with children are not least of these. Such elements, however, by no means exhaust the distinctiveness of women's situation. It is absurd to suggest, as does Mitchell, that women as women stand outside history. Women participate in the social relations of production, as well as most other social relations, in *gender-specific* ways that vary enormously in form and content from one society or epoch to another. Describing such differences in the specific characteristics of sexist oppression as merely "expressions" of one and the same universal system of male domination trivializes the depth and complexity of women's oppression.

There are certain practical dangers, moreover, in representing male domination as universal in form. On the one hand, it tends to create a false optimism regarding the possibility of a common consciousness among women. This can lead to serious cultural, ethnic, racial, and class biases in the account of the allegedly common structures of patriarchy.[11] On the other hand, the notion of a single system of patriarchy that persists in basically unchanged form through different epochs paralyzes feminist action because it represents the beast we are struggling against as so ancient and monolithic.

The main problem with this version of the dual systems theory, however, is that it does not in fact succeed in giving the alleged system of patriarchy equal weight with and independence from the system of production. It conceives of all concrete social relations as belonging to the economic system of production. Thus it gives no material weight to the system of patriarchy, which it defines in its basic structure as independent of the mode and relations of production, the social relations that proceed from them, and the processes of historical change. Thus this version of the dual systems theory ends by ceding to the traditional theory of production relations the primary role in giving an account of women's concrete situation. The theory of patriarchy supplies the *form* of women's oppression, but traditional Marxist theory supplies its content, specificity, and motors of change. Thus this version of the dual systems theory fails to challenge traditional Marxism because it cedes to that Marxism theoretical hegemony over historically material social relations.[12]

This version of the dual systems theory tends to identify gender differentiation with male domination. Gender is a culturally produced psychological structure that also expresses itself in images, symbols, and ideologies. Thus far the feminist appropriation of psychoanalysis in the work of such thinkers as Mitchell, Rubin, Chodorow, and Dinnerstein[13] represents the best theory of the origins and structure of gender that we have. Without doubt any account of the situation and oppression of women must contain such a gender theory as an element. But gender theory in itself cannot explain how men in a particular society occupy an *institutionalized* position of superiority and privilege. For men can occupy and main-

tain such an institutionalized position of superiority only if the organization of social and economic relations gives them a level of control over and access to resources that women do not have. However important an ideological-psychological account of gender identity and symbolization may be for a theory of women's oppression, it is not sufficient. A feminist theory must account for male domination as structured in a set of specific, though variable, social and economic relations, with specific material effects on the relations of men and women.[14] Feminism cannot allow gender-blind traditional Marxism to have the last word on the structure and movement of social relations of labor and other social relations.

Patriarchy as a Social Structure

A number of dual systems theorists have recognized these weaknesses in the first version of the dual systems theory and thus have sought to develop an account of patriarchy as a system distinct from capitalism, yet based in a set of specific social relations. Heidi Hartmann, for example, maintains that patriarchy is a set of social relations with a material base that lies in men's control over women's labor and in women's exclusion from access to essential productive resources.[15] She clearly subscribes to the dual systems approach: patriarchy should be understood as a system of domination distinct from capitalism, with its own "laws of motion." It is not clear, however, how one can maintain both these positions. In order to succeed in separating capitalism and patriarchy, this social-structural version of the dual systems theory requires articulating a structure by which we can isolate the social relations of production belonging to patriarchy from those belonging to capitalism. Hartmann's account does not develop such a structure of social relations, however, and she even admits that it is difficult to isolate structures specific to patriarchy.[16]

Dual systems theorists commonly tackle this problem of isolating the material relations specific to patriarchy by positing what Rosalind Petchesky has called the "model of separate spheres."[17] In this model women and men historically have had their primary places in separate spheres of production, from which arise distinct relations of production. Almost invariably this model poses the family as the locus of the women's productive sphere and social relations outside the family as the locus of men's. The model of separate spheres seems to provide us with the distinct structures and histories that the dual systems theory requires. The history of patriarchy will be constituted in the history of relations in the "domestic" sphere, while the history of class society will be constituted in the "public" sphere, on which traditional Marxism focuses.

Ann Ferguson, for example, argues that women are the exploited workers in the distinct sphere of production that she calls sex/affective production, a type of production distinct from the production of material goods. This type of production, like the production of material goods, goes through different historical states, or modes of production. In contempo-

rary society the mode of sex/affective production is the nuclear family. Inside the family women produce sex/affective goods that their husbands appropriate, and hence women in contemporary society constitute an exploited class in the strict Marxian sense.[18] Those socialist feminists who regard the family under capitalism as a vestige of the feudal mode of production also hold that women's situation is structured by the interaction of two modes of production,[19] as do those who wish to distinguish a "mode of reproduction" from mode of production.[20]

The model of separate spheres appears to hypostasize a separation peculiar to capitalism—that between family and work—into a universal form. In all precapitalist societies, the family is the primary unit of production, and kinship relations are a powerful determinant of economic relations. Separation of productive activity from the household and kinship relations, and the creation of two spheres of social life, is one of the defining characteristics of capitalist society itself, as a number of writers have pointed out.[21] Projecting this separation onto the structure of all societies—or at least all male-dominated class societies—cannot but obscure crucial differences between precapitalist and capitalist societies with respect to the situation of women.

Precisely because the separation of domestic from economic life is peculiar to capitalism, use of that separation as the basis for the analysis of women's situation in contemporary society may be playing right into the hands of bourgeois ideology. Bourgeois ideology itself promoted and continues to promote the identification of women with the home, domesticity, affective relations, and "nonproductive" activity, and defines these as structurally distinct from the "public" world of "real" economic life. For this reason socialist feminists should be suspicious of this identification of women's situation with a distinct sphere of private domestic relations, and above all should be wary of utilizing such an identification as a basis of their own analytic framework.

We should also ask whether the separation itself does not obscure a more basic integration. A number of analyses have emphasized the degree to which the alleged separation of the domestic and affective sphere from the economic sphere is ultimately illusory. Weinbaum and Bridges, for example, argue quite persuasively that contemporary capitalism not only has rationalized and socialized production operations in accordance with its domination and profit needs, but has rationalized and socialized the allegedly private work of consumption as well.[22] Other theorists, such as Marcuse, suggest that contemporary capitalism has actually entered into and rationalized sexual and affective relations for its own ends.[23]

The main problem with the model of separate spheres, however, is that because it assumes the family as the primary sphere of patriarchal relations, it fails to bring into focus the character of women's specific oppression as women outside the family. For example, it is difficult to view the use of women as sexual symbols to promote consumption as a function of some

separate sphere distinct from the economic requirements of monopoly capitalism. When more than half of women over sixteen are working outside as well as inside the home, the model of separate spheres, and the focus on domestic life that it encourages, may divert attention from a capitalism that increasingly exploits women in gender-specific paid work.

The character of women's oppression in the contemporary workplace has specifically sexist forms that cannot be encompassed by traditional accounts of relations of production. For example, sexual harassment is a routine way that superiors discipline women workers. More broadly, in contemporary society not only images of "sexy" women foster capitalist accumulation, but also real live women are employed for their "sexual" labor—for being sexy on their jobs, suggesting sexiness to customers, and performing many jobs whose main function is being sexy in one way or another. The dual systems theory does not seem to have the theoretical equipment to comprehend these diverse kinds of sexist oppression outside the family and personal sphere.

The only means the dual systems theory has for doing so is to view gender-structured phenomena of the capitalist economy and workplace as modeled on or effects of relations in the family, and this in fact is the strategy for explanation adopted by many dual systems theorists. Admitting and trying to explain the pervasiveness of gender structuration in all spheres of contemporary society, however, seriously weakens the model of separate spheres on which the explanation of that gender structuration is based in the dual systems theory. It would be much more direct to construct a theory of capitalist patriarchy as a unified system entailing specific forms of gender structuring in its production relations and ideology.

Viewing gender phenomena of the contemporary capitalist workplace as modeled on or effects of family relations, moreover, still tends to play down the specific oppression of women outside family life and to give inordinate emphasis to the family. It also misses the specific character of the sexist oppression of the workplace and other realms outside the family. Patriarchal oppression outside family life in contemporary society depends on impersonal, routinized, and generalized behavior as opposed to the personal relations of oppression that characterize the patriarchal family.

My criticisms of the dual systems approach to socialist feminist theorizing ultimately issue in the claim that dual systems theory does not go far enough. The dual systems approach accepts the traditional Marxian theory of production relations, historical change, and analysis of the structure of capitalism in basically unchanged form. It rightly criticizes that theory for being essentially gender-blind, and hence seeks to supplement Marxist theory of capitalism with feminist theory of a system of male domination. Taking this route, however, tacitly endorses the traditional Marxian position that "the woman question" is auxiliary to the central questions of a Marxian theory of society.

The dual systems theory, that is, declines from confronting Marxism

directly in its failure to take account of the situation and oppression of women. Our nascent historical research coupled with our feminist intuition tells us that the labor of women occupies a central place in any system of production, that gender division is a basic axis of social structuration in all hitherto existing social formations, and that gender hierarchy serves as a pivotal element in most systems of social domination. If traditional Marxism has no theoretical place for such hypotheses, it is not merely an inadequate theory of women's oppression, but also an inadequate theory of social relations, relations of production, and domination. *We need not merely a synthesis of feminism with traditional Marxism, but also a thoroughly feminist historical materialism, which regards the social relations of a particular historical social formation as one system in which gender differentiation is a core attribute.*

Dual Systems Theory and Politics

Socialist feminists insist that no political program or political activity is truly socialist unless it attends to the unique situation and oppression of women. Likewise, socialist feminists insist that feminist analyses and political activity should always look for ways of exposing the class- and race-differentiated character of patriarchal oppression, as well as its internal connection with the dynamic of profit. For example, in the sphere of reproductive rights, socialist feminists have emphasized the racist character of sterilization abuse and recent attacks on abortion rights. They have also taken pains to expose the interests of the medical establishment and drug companies in keeping women ignorant of our bodies and dependent on expensive and often dangerous means of birth control, birthing, and "curing" menopause.

Precisely what distinguishes the politics of socialist feminism is this commitment to the practical unity of the struggle against capitalism and the struggle for women's liberation. The dual systems theory, however, can tend to sever this practical unity, which socialist feminism has been trying to achieve since its inception. Thus the politics of socialist feminism would be better served by a theory of capitalist society that explicitly incorporated gender differentiation into its structural analysis, and hence took the oppression of women as a core aspect of the system.

Some socialist feminists might fear that such a "one system" theory would undermine arguments for the necessity of an autonomous women's movement, for a cornerstone of socialist feminist politics has been its conviction that women should be organized autonomously in groups in which they alone have decision-making power. Women must have the space to develop positive relations with each other, apart from men, and we can best learn to develop our own organizing, decision-making, speaking, and writing skills in an environment free of male dominance or paternalism. Only by being separately organized can feminist women confront the sexism of socialist men. And only in an autonomous women's movement can socialist women unify with women who see the need for struggle against

male domination but do not see that struggle as integrated with an anti-capitalist struggle.

The dual systems theory arose at least in part from this socialist feminist recognition of the strategic necessity of a women's movement allied with but autonomous from the mixed socialist movement. If capitalism and patriarchy are each distinct systems, mutually influencing but nevertheless ultimately separate and irreducible, it follows most plausibly that the struggle against patriarchy should be organizationally distinct from the struggle against capitalism.

I am convinced of the necessity of separately organizing women around issues relating to our own situation. Without such an autonomous women's movement the socialist movement itself cannot survive and grow. One can argue for the strategic necessity of such an autonomous women's movement, however, without postulating male domination and capitalist domination as distinct social systems. One only need appeal to the indisputable practical realities that capitalist patriarchal society structures the lives of women in special ways and that these capitalist patriarchal structures give to most men relative privilege and power. From this analysis it does not follow that there are two distinct systems of social relations. The dual systems theory can have the damaging effect of justifying a segregation of feminist concerns to the women's movement. This segregation means that socialists outside the women's movement need not take feminism seriously, and those who work in that movement must justify how their political work relates to socialism.

Because it does not confront traditional Marxian theory directly enough as a theory of social relations and oppression, the dual systems theory allows many socialists not to take feminism as seriously as they should. It can tend to justify the dismissal of feminist organizing by socialists not persuaded of the centrality of women's oppression to contemporary capitalism, and it can tend to justify their not bringing issues of women's oppression to the fore in their own practice. To be sure, the failure of many socialists to take feminist concerns seriously as socialist concerns reflects a political tension that no theory will alone heal. Nevertheless, confinement of feminist concerns to the periphery of socialist organizing would be more difficult for nonfeminist socialists to justify if socialist feminists confronted them with a theory of capitalist society that showed that society to be patriarchal in its essence and internal structure.

The necessity for all socialist work to have a feminist dimension and for socialists in the mixed left to take seriously issues surrounding women's oppression becomes most pressing under contemporary conditions. The new right does not appear to separate capitalism and patriarchy into distinct systems. Those attacking women's and gay rights ally unambiguously with those attacking unions or those promoting increased armaments. The new right has a total platform, the main plank of which is defense of the sanctity of the monogamous heterosexual many-children family. With a theory of capitalist patriarchy that showed its relations of labor and hierarchy as one

gender-structured system in which the oppression of women is a core element, socialist feminists would be in a better position to argue and enact this practical necessity.

Because the mixed left does not take feminism as seriously as it should, many socialists who choose to concentrate all their energy on women's issues feel called upon, and often enough are called upon, implicitly or explicitly, to justify the socialist character of their work. On the other hand, not all socialists with strong feminist commitments wish to devote their political energies to specifically women's issues, nor should they. They then often are called upon to demonstrate the feminist meaning of their work. As a result of these tensions, many socialist feminists feel as though they ought to do twice as much work—socialist work on the one hand, and feminist work on the other. As long as we define patriarchy as a system ultimately distinct from capitalism, this practical tension appears necessary.

This "double shift" syndrome, of course, cannot be overcome by theory alone. Socialist women who choose to devote all their energies to separately organizing women around women's issues, however, should have the full active support and recognition of a socialist movement that perceives such work as in itself vital political work. Within the mixed left, moreover, feminist consciousness should be so incorporated that one could justifiably understand oneself as engaging in feminist work on issues not immediately concerning women's situation. We are a long way from that situation today. A major reason for this, I claim, is lack of a theory of capitalist society that would foster analyses revealing the patriarchal meaning of nearly every aspect of society.

I have been concentrating most of my argument here on the claim that all socialist political work should be feminist in its thrust and that socialists should recognize feminist concerns as internal to their own. Likewise, socialist feminists take as a basic principle that feminist work should be anticapitalist in its thrust and should link women's situation with the phenomena of racism and imperialism. Once again, this political principle would best be served by a social theory that regards these phenomena as aspects of a single system of social relations. With such a theory we would be in a better position to argue to other feminists that they must attend to issues of class and race in their analysis and organizing.

Toward a Unified Theory

I am not prepared here to offer even the outlines of such a theory. In concluding I will merely offer some of the general elements I believe such a theory should contain and some of the basic issues it should address.

A feminist historical materialism must be a total social theory, not merely a theory of the situation and oppression of women. That theory will take gender differentiation as its basic starting point, in the sense that it will seek always to keep the fact of gender difference in the center of its accounts and will reject any account that obscures gender-differentiated phenomena.

It will take gender statuses, gender hierarchy and domination, changes in gender relations, gender ideologies, etc., as central aspects of any social formation. These must be analyzed in any account of a social formation, and other aspects of the social formation must be linked to them.

Following the lead of the early radical feminists, a feminist historical materialism must explore the hypothesis that class domination arises from and/or is intimately tied to patriarchal domination. We cannot simply assume that sex domination causes class society, as most radical feminists have done. But we must take seriously the question of whether there is a causal relation here, to what extent there is, and precisely how the causal relations operate if and when they exist.

A feminist historical materialism must be a truly *materialist* theory. This does not mean that it must "reduce" all social phenomena to economic phenomena, narrowly understood as processes of the production and distribution of material goods. Following Delphy and Williams, among others, I understand a materialist account as one that considers phenomena of "consciousness"—e.g., intellectual production, broad social attitudes and beliefs, cultural myths, symbols, images, etc.—as rooted in real social relationships.[24] This should not imply "reducing" such phenomena of consciousness to social structures and social relationships, nor does it even mean that the phenomena of consciousness cannot be treated as having a logic of their own. Nor should it mean that phenomena like attitudes and cultural definitions cannot enter as elements into the explanation of a particular structure of social relationships, though I would claim they can never be the sole explanation. This requirement mainly calls for a methodological priority to concrete social institutions and practices, along with the material conditions in which they take place.

The concrete social relations of gender and the relations in which these stand to other types of interaction and domination must appear at the core of the theory. In another paper I have suggested that a feminist historical materialism might utilize gender division of labor as a central category. This category would refer to all structured gender differentiation of laboring activity in a particular society, where "labor" includes any task or activity that the society defines as necessary.[25] Whether or not this is the correct approach, a feminist historical materialism should remain Marxist in the sense that it takes the structure of laboring activity and the relations arising from laboring activity, broadly defined, as a crucial determinant of social phenomena. Accepting that Marxist premise, it must also find a way of analyzing social relations arising from laboring activity in gender-differentiated terms.

Finally, a feminist historical materialism must be thoroughly *historical*. It must eschew any explanations that claim to apply to societies across epochs. In practice this means that a feminist historical materialism must be suspicious of any claims to universality regarding any aspect of women's situation. If there exist any circumstances common to the situation of all women, these must be discovered empirically, not presupposed. We must

develop a theory that can articulate and appreciate the vast differences in the situation, structure, and experience of gender relations in different times and places. At the same time, however, we want a single theory that can be utilized to analyze vastly different social structures. This means we need a set of basic categories that can be applied to differing social circumstances in such a way that their specificity remains and yet comparison is possible. In addition to such a set of categories we need a theoretical method that will guide us in our explanation of the particular phenomena in a particular society.

The remarks in this section have been very abstract. I intend only to outline some general directions for moving toward a feminist social theory in which the basic insights of Marxism can be absorbed and developed. Whether the above criteria for a socialist-feminist theory are correct can be decided only by embarking on the theoretical task in light of our practical needs.

NOTES

I am grateful to Heidi Hartmann, Nancy Hartsock, Ruth Milkman, Sandra Bartky, and Alison Jaggar for their comments and criticisms on earlier versions of this paper.

1. Linda Phelps, "Patriarchy and Capitalism," *Quest*, vol. 2 no. 2 (Fall 1975), p. 39.

2. Zillah Eisenstein, "Developing a Theory of Capitalist Patriarchy," in Eisenstein, ed., *Capitalist Patriarchy and the Case for Socialist Feminisn* (New York: Monthly Review Press, 1979), p. 27.

3. See Heidi Hartmann, "The Unhappy Marriage of Marxism and Feminism: Toward a More Progressive Union," in Lydia Sargent, ed., *Women and Revolution* (Boston: South End Press, 1980); this paper, which was originally coauthored with Amy Bridges, has received wide distribution among socialist feminists over the past several years. On similar points see also Hartmann's paper "Capitalism, Patriarchy, and Job Segregation by Sex," in Eisenstein, ed., *Capitalist Patriarchy*.

4. See, for example, Jane Flax, "Do Feminists Need Marxism?", *Quest*, vol. 3, no. 1 (Summer 1976), p. 55.

5. Gayle Rubin, "The Traffic in Women: Notes on the Political Economy of Sex," in Rayna Reiter, ed., *Toward an Anthropology of Women* (New York: Monthly Review Press, 1976), p. 167.

6. Ann Ferguson, "Women as a New Revolutionary Class," in Pat Walker, ed., *Between Labor and Capital* (Boston: South End Press, 1979), pp. 279–312.

7. Alison Jaggar develops this term in *Feminist Politics and Human Nature* (Totowa, N.J.: Rowman and Allenheld, 1983).

8. Compare Flax's approach in her "Do Feminists Need Marxism?"

9. Juliet Mitchell, *Psychoanalysis and Feminism* (New York: Vintage Books, 1974), p. 409.

10. Mitchell, p. 409.

11. See Mina Davis Caulfield, "Universal Sex Oppression?—A Critique from Marxist Anthropology," *Catalyst*, nos. 10–11 (Summer 1977), pp. 60–77. She points to some consequences of cultural bias that result from the assumption of a universal

and common sex oppression, specifically with respect to the way we regard Third World women. I have articulated in another place some contrary attributes of sexism as experienced by black women and white women in America; see "Proposals for Socialist Feminist Theory," in *Women Organizing*, publication of the Socialist Feminist Commission of the New American Movement, no. 2 (June 1978). Eisenstein, in "Developing a Theory," does a good job of laying out the variables that differently structure the lives of different groups of women in such a way that it is not possible to speak of a common situation.

12. Compare McDonough and Harrison's criticism of Mitchell in "Patriarchy and Relations of Production," in Kuhn and Wolpe, eds., *Feminism and Materialism* (London: Routledge and Kegan Paul, 1978), pp. 12–25.

13. In addition to Mitchell and Rubin, already cited, see Nancy Chodorow, *The Reproduction of Mothering* (Berkeley: University of California Press, 1978), and Dorothy Dinnerstein, *The Mermaid and the Minotaur* (New York: Harper and Row, 1976).

14. This is similar to a point that Christine Delphy makes in her paper "For a Feminist Materialism," in *Close to Home: A Materialist Analysis of Women's Oppression* (Amherst: University of Massachusetts Press, 1984), pp. 211–19. She takes a strong stand against all psychological reductionism that would explain social structures and social relations in psychological terms.

15. Hartmann, "Unhappy Marriage."

16. Hartmann, 1978 manuscript, pp. 38–39.

17. Rosalind Petchesky, "Dissolving the Hyphen: A Report on Marxist-Feminist Groups 1–5," in Eisenstein, *Capitalist Patriarchy*, pp. 373–90.

18. Ferguson, pp. 279–312.

19. This is basically Mitchell's position in *Women's Estate* (New York: Vintage Books, 1973); see also Sheila Rowbotham, *Women's Consciousness, Man's World* (Middlesex: Penguin Books, 1973), pp. 61–63.

20. Flax, "Do Feminists Need Marxism?"

21. See Eli Zaretsky, *Capitalism, the Family, and Personal Life* (New York: Harper and Row, 1976); Ann Oakley, *Woman's Work: The Housewife, Past and Present* (New York: Vintage Books, 1974); and Roberta Hamilton, *The Liberation of Women: A Study of Patriarchy and Capitalism* (London: George Allen and Unwin, 1978).

22. Batya Weinbaum and Amy Bridges, "The Other Side of the Paycheck: Monopoly Capital and the Structure of Consumption," in Eisenstein, ed., *Capitalist Patriarchy*, pp. 190–205.

23. See Herbert Marcuse, *One Dimensional Man* (Boston: Beacon Press, 1964), chapter 3.

24. Delphy, "For a Feminist Materialism"; Raymond William, *Marxism and Literature* (New York: Oxford University Press, 1977), part 2.

25. Iris Young, "Beyond the Unhappy Marriage: A Critique of the Dual Systems Theory," in Sargent, ed., *Women and Revolution*.

TWO

Is Male Gender Identity the Cause of Male Domination?

In this essay I assess the place of Nancy Chodorow's theory of the development of gender personality with respect to the overall project of a feminist social theory. Without doubt Chodorow's theory has made a vital contribution to a feminist understanding of the meaning and production of gender identity. Chodorow herself and a number of other writers, however, have suggested that this gender theory can ground a theory of male domination as a whole, as well as other relations of domination. I argue that such a use of Chodorow's theory is illegitimate.

I examine passages in Chodorow's writing that suggest that she takes her theory as a theory of male domination. I examine as well the accounts of Nancy Hartsock and Sandra Harding, who use Chodorow's theory to account for male domination more explicitly than Chodorow does and who also go farther to claim that male personality is a foundation for all domination relations. All three writers tend to claim that the social relations of women's mothering and the gender personalities they produce are a crucial foundation for male domination. I should emphasize that this is only a tendency in their work, and in focusing on this tendency I shall to a certain extent not be doing justice to the subtlety of their arguments. The precise status of the explanatory power they claim for the theory of gender is ambiguous, I argue, because they fail to distinguish adequately the categories of gender differentiation and male domination. Once these categories are distinguished and their reference formulated, it becomes clear that a theory of gender personality at best can provide only a small part of the description and explanation of institutions of male domination. By failing to distinguish explicitly these categories and focusing primarily on phenomena relating to gender, these accounts divert the attention of feminist theory from questions of the material and structural bases of power.

I

In *The Reproduction of Mothering*, Nancy Chodorow begins from the observations that in contemporary society women more often than men actively desire to have children and that women are generally more comfortable around small children than men are.[1] Mothering, that is, comes more easily

to many women than it does to most men. Many women who have shed other aspects of the traditional feminine role, who have pursued careers or disdain housework, even many lesbians, have retained a desire to raise children and put a great deal of emotional energy into relations with children. Chodorow develops a theory to explain why women more than men often appear to have a deep-seated need to mother.

While her account begins from certain contemporary facts such as these, Chodorow's focus on mothering also has a broad theoretical purpose. For nearly two centuries at least, the most powerful justifications of women's exclusion from full participation in public life and our standing in a dependent relation to men have appealed to women's unique role as mothers. The requirements of mothering, moreover, have often operated as a real constraint on the possibilities for individual women to work outside the home, acquire education, and engage in leisure activities and countless other possibilities for self-development that many men take for granted. Women's connection with mothering thus has operated and continues to operate as an important ideological and material source of our inequality. Chodorow's theory claims to explain how this connection between women and mothering is reproduced in women themselves from generation to generation.

Chodorow derives the conceptual framework for her argument from a school of psychoanalytic thought that has had little current in the United States, referred to as object-relations theory. Unlike traditional Freudian theory, of which Chodorow is critical, object-relations theory does not rely on concepts of drives and instincts to explain developmental processes. Instead, at least as Chodorow interprets it, object-relations theory proposes a thoroughly social conceptualization of unconscious processes. The psychological stages that produce stable identity and personality characteristics are conditioned by the social context of interaction in which they take place. The psychic drama of anxieties, repressions, attachments, and symbolic substitutions takes place within the individual unconscious always with reference to the internalized persona of the most important objects of the child's affections, hence the name object-relations theory.

In society where mothers often have nearly exclusive relations with infants and young children, the mother is the primary object of all affective life in the child, whether that life is love, rage, or fear. For infants, mother is the one who relieves frustrations, feeds, comforts, and herself produces frustration when she is not immediately available. Chodorow's theory starts with the fact that the primary person in the lives of both men and women is the mother. In her theory, the significant stages of psychological development that lead to the formation of a separate sense of identity, personality characteristics, gender identity, and sexual orientation play out for both boys and girls in the context of their relations to their mothers. She explains how this exclusive female parenting produces gender identities and personality characteristics that predispose women to be nurturant and cuts off these dispositions in men.

The developing person must acquire a sense of identity distinct from other people. In a society characterized by exclusive female parenting of young children, both sexes develop identities by separating from their mothers. In a strongly gender-differentiated society, moreover, this issue of separation is intertwined with the acquisition of gender identity. Both boys and girls, that is, undergo the process of separating their identities from mother within the context of acquiring an identity as masculine or feminine and of learning that the mother belongs to the same or the other gender. The process of developing a separate identity is therefore very different for boys and girls, and in Chodorow's theory this difference accounts for differences in the characteristics and personalities each acquires.

Because of her own gender identity, the mother identifies with her girl more than with her boy. In relating to her daughter she unconsciously replays many of the ambiguities and identifications she experiences with her own mother. Thus, the mother often tends to relate to her daughter more as an extension of herself than as a separate person.[2] The infant girl also experiences herself as identified with her mother, as does the infant boy. At the same time that the girl begins to develop a separate sense of self, she also learns that her mother is of the same gender as herself. The discovery encourages a continued sense of identification with her mother. The mutually reinforcing identification of mother and daughter results in the girl's acquiring a sense of separate identity later than boys do and never acquiring a sense of separation from others as strong as a boy's. Feminine personality, Chodorow argues, entails the development of relatively permeable "ego boundaries." The normal woman does develop a sense of identity distinct from other people, an ego. But she tends more than a man does to fashion her identity through references to her relations to other people and to emphathize more easily with other people.

For the boy, the story is rather different. Due again to her gender identity, which usually entails a heterosexual identity, the mother of the boy does not identify with him as much as with a girl. She often tends unconsciously to sexualize her relation to him, thus pushing him into a relation of opposition with her. Unlike the girl, then, the boy is encouraged in his effort to separate his identity from his mother. When the boy begins to acquire an understanding of gender, his project of separating from the mother becomes one of defining himself not merely as a different person, but also as a different *kind* of person. In separating from the mother and developing a distinct identity, then, the boy sets himself in opposition to the mother and all that is feminine. Chodorow concludes that from this process the masculine personality typically develops rigid ego boundaries. A man's sense of separate identity, that is, entails cutting off a sense of continuity and empathy with others.

This account of the difference in the strength of ego boundaries in masculine and feminine personalities depends on the assumption that the father or other male figure is not involved in intense, ongoing interaction with the child. In Chodorow's account, the relative absence of the father

in the young child's life accounts for two additional components of masculine and feminine personality, respectively.

The gender identity that the girl acquires has a secure and concrete model in the mother she identifies with. The girl does not have to puzzle about what it means to be a woman, because she usually spends all day in the presence of womanly activity. Neither girls nor boys, however, have a concrete sense of what it means to be a man because they do not have ongoing, intense interactions with men engaged in manly activity. In boys this leads to a greater anxiety about maintaining their gender. Boys define masculinity negatively, as what is not feminine, since they most continuously experience the feminine. Boys have an abstract and idealized sense of masculinity because they have to imagine what men do away from home. This difference between girls and boys in the security and concreteness of their gender identity, according to Chodorow, accounts for a particularistic personality in women and a more universalistic personality in men. Feminine personality, that is, entails an orientation toward concrete relations with others, while masculine personality is oriented toward more generalized relations, such as abstract relations of economic exchange. The insecurity and the abstractness of their gender identity resulting form the absense of male models, moreover, accounts in large part for an achievement orientation in masculine personality.

In Chodorow's account the father who leaves the home to participate in the world's activities provides an abstract ideal for the girl as well as the boy. He provides for her the possibility of liberation from the binding mutual identification of daughter and mother that threatens her separate identity. In search of freedom, the girl turns her active affection for her mother to her father. In Chodorow's theory this accounts for why most women grow up heterosexual.[3] The girl never completely sheds her original attachment to her mother, however. While she may develop an erotic attachment to her father, she retains a strong emotional attachment to her mother. The girl's original intimate attachments form a triangle in which both mother and father stand as objects of intense involvement. In adult heterosexual relationships, according to Chodorow, women unconsciously seek to reproduce these childhood affective attachments. In a relationship with a man the girl is not likely to replicate her attachment to her mother. Her gender identity prevents her from identifying with any man in the way she identifies with her mother, and the man's own gender personality tends to limit his capacity for emotional nurturance. The adult woman thus often desires to nurture children in order to complete the triangle of her affective life. This accounts for the reproduction of motivation to mother in women from one generation to another.[4]

Chodorow's theory, whose complexities and subleties I have not attempted to reproduce in this summary, have evoked much discussion among feminists in recent years. Though this discussion has sometimes been very critical, there is little doubt that her theory, along with similar work by Jane Flax[5] and the related but rather different work of Dorothy

Dinnerstein,[6] has opened a territory of theorizing previously only slightly explored by feminist thinkers, namely theory of gender.

In this feminist psychoanalytic theory we have an approach to conceptualizing typical differences in the behavior and experience of men and women that avoids the disadvantages of the only two alternatives we have had until recently for understanding these differences: a biological account or a role-learning account. Chodorow's theory shows the gender characteristics that are stubbornly typical among men and women in our society as being determined by social factors. Unlike a biological account, then, feminist psychoanalytic theory of gender reveals this structure as changeable. But Chodorow's theory also accounts for why gender identity is so deep-seated as to be virtually impossible to unlearn and for why so much anxiety surrounds gender issues, even for adults. Socialization theory of gender, which conceptualizes gender characteristics as being no different in principle from any other learned-role norms, cannot account for the uniquely central place of gender in self-identity.

While there are many aspects of Chodorow's accounts about which questions can be asked and refinements should be made, this essay does not subject her theory to internal examination. I assume that in its basic framework Chodorow has offered us an enormously persuasive theory rich enough to generate explanations for a diversity of phenomena. In what follows I wish to ask, however, just what the theory is about and what the limits to its explanatory power are. In particular, I will argue that this theory cannot serve as the basis of a total theory of male domination, as some believe, but only for a small portion of such a theory.

II

Chodorow is ambiguous about the scope and applicability of her theory. In some passages she seems to restrict the theory's scope to advanced industrial, particularly capitalist, society. Under the conditions of this society, which dates no earlier than 1800, most productive activity is separated from the home, and all people in the nuclearized family have a heavy emotional investment in mothering because it remains one of the only truly personalized relations in society. Men are absent from the home the greater part of the time, and in their working lives they have decreasing autonomy and authority. These passages suggest that Chodorow's theory focuses on the mothering relations peculiar to the modern nuclear family.[7]

Chodorow is also ambiguous about the explanatory status of her theory. On one reading, her theory accounts for no more than how people accommodate to gender divided and male dominated social relations in our society. Her theory explains only how the gender division of labor in the modern nuclear family, which gives exclusive responsibility for early child care to the mother, produces gender differentiated people with desires and capacities that particularly suit them for continuing that gender division of labor.[8] On this reading, the structures of male domination in our society

are presupposed. A separate explanation is required to account for the origin and maintenance of these structures themselves, such as the relations of authority, dependence, and coercion that define this or any other male-dominated society, or the differential access to important resources that underlies gender equality.

By far the dominant strain in Chodorow's book, however, suggests that she thinks that at least the basic form of her theory applies to an explanation of male domination in all societies that have existed. Immediately after spending two pages developing an exposition of the historically specific conditions of women's mothering in our society, Chodorow asserts that gender inequality is a tenacious, almost transhistorical, fact, which, she suggests, despite some variations has basically the same form in all societies. In all societies, she claims, women are the primary caretakers of young children. She asserts that her theory of the consequences of women's mothering is a contribution to explaining "how sexual asymmetry and inequality are constituted, reproduced and changed."[9]

Alongside passages suggesting that this theory of gender accounts for the motivation of individuals to act in accordance with the institutions of male domination, that is, are passages that appear to claim that the theory accounts for male domination itself. I shall quote one of these, in order to make clear the strength of the claims it makes.

> We can define and articulate certain broad universal sexual asymmetries in the social organizations of gender *generated* by women's mothering. Women's mothering *determines* women's primary location in the domestic sphere and creates a *basis* for the structural differentiation of domestic and public spheres. But these spheres operate hierarchically. Kinship rules organize claims of men on domestic units, and men dominate kinship. Culturally and politically, the public sphere dominates the domestic, and *hence* men dominate women.[10]

As I read this and similar passages, Chodorow claims that her theory explains the basic causes of male domination in all societies. Following Rosaldo and Lamphere,[11] she assumes that the subordination of women is a function of a universal public–domestic division. This public–domestic division, she says, originates in and is reproduced by the social relations of women's mothering that produce distinctive gender personalities. While a direct argument for this set of claims does not appear in Chodorow's writing, one can be reconstructed from what she does say.

As already noted, Chodorow argues that in developing a masculine self-identity boys must develop a sense of being a different kind of self. Since the mother provides him with his first model of what it is to be a person, the boy defines masculinity negatively, as what the mother is not. To have a positive sense of masculinity, therefore, boys must denigrate and dissociate themselves from the female. Boys develop a dread of women and a desire to have power over them through this process, because mother poses a threat to their separate masculine identities.[12]

To secure his masculine identity, the boy rejects the mother and joins with other boys and men in a positive exclusive sphere without the attributes of nurturance and dependence associated with the feminine. This masculine realm takes on a more highly valued character than the domestic, because men must affirm their masculinity by denying and denigrating the female. This would appear to be the argument for Chodorow's above-quoted claim that women's mothering "creates a basis for the structural differentiation of domestic and public spheres" and sets up a hierarchial relation between them.

Women's mothering, this argument would continue, also creates gender personalities that particularly suit women and men for the domestic and public realms, respectively. The relative stability of her identification with the mother gives to the girl's gender identity a personality oriented toward affective relations with others. This suits girls for the particularistic relations of the domestic realm. Women's mothering creates in boys, on the other hand, a more bounded, instrumentally oriented, and abstract personality. This suits them particularly for the formal and instrumental character of relations in the public realm. This presumably is the argument for Chodorow's above quoted claim that "women's mothering determines women's primary location in the domestic sphere."

Assuming that this is an accurate reconstruction of Chodorow's argument, we should notice that it is flawed by circularity. The argument purports to show how the public–domestic division is grounded in the gender personalities created by women's mothering. The account of the development of gender personalities that Chodorow gives, however, presupposes the existence of a public–domestic division. Her account of why boys must initially define masculinity negatively and why their sense of masculinity is abstract assumes that men are absent from the sphere in which little boys dwell, that is, that the men are in a separate public sphere.

The argument is not saved, moreover, by asserting that Chodorow is not concerned with the original causes of male domination, but only with the sustaining causes. Gender personalities can perhaps partly explain how individual men and women conform to structures and practices that distinguish public and private spheres, allocate women to the private sphere and men to the public, and devalue the private sphere. Such an account of motivations must be supplemented, however, by a concrete account of the nature of public institutions, the degree of their separation from private ones, and the interest and structural causes within the public institutions themselves that contribute to their reproduction. None of this touches on explaining the male domination of women, moreover. Gender personality cannot explain how the institutions of the public sphere give men the power to dominate women. I will develop this claim in greater detail in the following sections.

In a paper entitled "The Feminist Standpoint: Developing the Ground of a Specifically Feminist Historical Materialism,"[13] Nancy Hartsock uses Chodorow's theory of the development of gender personalities as a central

element in her account of the "abstract masculinity" that she claims underlies Western culture. Abstract masculinity is a mode of conceptualization that emphasizes mutually exclusive dualities. These dualities—such as some–other, identity–difference, negation–affirmation, life–death, body–mind—have a crucial ground in the structure of the masculine personality, which creates in men an oppositional attitude in human relations, a polarity of self and other.

Hartsock uses the notion of abstract masculinity primarily to account for the logic of much of Western metaphysical and political thought. More relevant for the issues of this paper, she also appeals to abstract masculinity to account for the nature of institutions. Abstract masculinity, she claims, accounts for hierarchical dualism in the institutions of society, which underlies relations of class domination and gender domination. She argues that "male rather than female experience and activity replicates itself in both the hierarchical and dualist institutions of class society and the frameworks of thought generated by that experience."[14] A primary determinant of this experience is the self–other dichotomy produced in the masculine personality by women's mothering.

It is difficult to tell just what sort of casual relations Hartsock asserts, or how strongly. As I read her claims, she asserts that masculine personality causes institutions of domination in the following way: Being mothered by women produces in men a propensity to approach relations with others in an oppositional and competitive way; thus men produce institutions defined by opposition, hierarchy, and competition. The masculine personality generated by women's mothering also produces the oppression of women because men tend to denigrate and repress activities associated with the body, and women are most linked to such activities.

Before evaluating Hartsock's argument for the grounding of institutions of domination in the gender differentiated experience of self produced by women's mothering, it will be helpful to look at Sandra Harding's similar account. Harding asserts an even more explicit and stronger relationship between women's mothering and institutions of domination. In a paper entitled "What Is the Real Material Base of Patriarchy and Capital?" she answers that the social relations of women's mothering are the most fundamental material base of all forms of oppression—not only gender oppression, but class, race, lesbian, and gay oppression as well. The theory of the production of gendered personalities, she claims, explains "why it is that *men* control and thus have material interests in maintaining both patriarchy and capital."[15] The social relations of women's mothering "create patterns of dominating social relations which are more general than class oppression and gender oppression."[16]

A later paper by Harding specifies more precisely the nature of her causal claim. The social relations of women's mothering determine the form or structure common to male personalities, institutions of domination, and the ideas associated with them.[17] The social relations of women's mothering constitute the material base of classism, racism, heterosexism, and sexism

insofar as they are all structured by a dualistic hierarchy of dominance and subordination.

Like Chodorow and Hartsock, Harding does not clearly and explicitly lay out the argument for this claim. Once again reconstructing somewhat, her argument appears to be the following: Like Hartsock, Harding theorizes that women's mothering produces a self–other dichotomy in the masculine personality. Because boys have particular separation problems, their search for a separate identity leads them to form rigid ego boundaries and to tend to regard other people, especially women, as in antagonistic opposition to themselves. This self–other dichotomy is not merely an opposition, but also a hierarchy in which self is of greater value. Men thus have a psychic interest in dominating, in setting themselves up as master in relation to other men, nature, and, of course, women. Since men design and control all of society's institutions, according to Harding, these institutions reflect this psychology of self–other domination. Thus class oppression, racial oppression, gender oppression, and homosexual oppression have a common formal cause in "the sterotypically masculine modes of structuring social relations between self and other which originate *in individuals*, in the psycho/physical labor required to become masculinely gendered social persons."[18]

Interpreted as an account of the causes of institutions of male domination, the arguments of Hartsock and Harding suffer from a circularity similar to Chodorow's. For in their accounts, social institutions and idea systems reflect the hierarchical dualism characteristic of the masculine personality only if men are in a position to define those institutions and idea systems either exclusively or to a much greater degree than women. Their accounts presuppose male domination. Thus they cannot have an account that shows male domination to be based on the social relations of women's mothering, though it appears that they claim to.

But perhaps this is too strong a reading of the claims of Hartsock and Harding. Like Chodorow, and in similar fashion, they are ambiguous about just what explanatory force they attribute to gender theory. On a weaker reading, they merely articulate how the institutional structures of male domination produce the psychic dispositions and cultural categorizations that accommodate people to those institutions. This reading, however, reduces the gender personalities created by women's mothering to, at best, one of many causes of the reproduction of institutions of male domination. All three writers, however, appear to attribute an explanatory power to gender theory stronger than this interpretation would allow.

In either the strong or the weak interpretation, gender theory leaves unanswered the most important questions of the causes, exercise, and reproduction of male power. If a public–domestic division exists, and if men dwell in the public sphere, why does that give men the means to dominate women? What are the natures of these public institutions such that they entail this power? How do men have the means and resources

to enforce their power? Precisely how do they exercise it? If our institutions and cultural categories do reflect the masculine psyche because men design and control them, as Hartsock and Harding suggest, how does it happen that men have that power?

III

Nancy Chodorow appears to identify gender differentiation with male domination, and thus tends to argue that her theory of development of gender personalities is a theory of male domination. Hartsock and Harding also tend to argue that her theory of the development of gender personalities is a theory of male domination. In addition, Hartsock and Harding tend to collapse the categories of gender differentiation and male domination, at least insofar as they appear to make inferences about male domination directly from claims about gender differentiation. In contrast, I perceive and defend a distinction between these two categories. While gender differentiation is a phenomenon of individual psychology and experience, as well as of cultural categorization, male domination refers to structural relations of genders and institutional forms that determine those structures. Any complete account of male-dominated society requires an account of gender, but also requires an account of the causes and reproduction of structures not originating from gender psychology. For these reasons a theory of gender cannot, as the three writers here treated think, be used as the basis for a theory of male domination. The failure to distinguish the category of gender differentiation from male domination is not uncommon among feminist theorists, especially those who rely on psychoanalytic theory.[19] Thus the significance of the theoretical remarks in this section exists beyond the three thinkers I focus on to the whole project of feminist social theory.

Gender differentiation refers primarily to phenomena of individual psychology and experience. Chodorow shows how the unconscious inner life of men and women is differently structured because they have different infant relations to their mothers, and Harding follows Chodorow on this. Hartsock defines the phenomena of gender less in terms of personality structure and more in terms of the different experiences men and women have of the world because they are mothered by women and because the sexual division of labor allocates to them different sorts of activities.[20] Whether interpreted primarily in terms of personality structure or mode of experiencing the world, gender differentiation also includes men's and women's propensities and dispositions to behave in certain typical ways. For such dispositions to be actualized, however, practices and institutional structures must encourage the disposing behavior, and gender differentiation alone cannot explain the existence or nature of these structures. All three of the writers under discussion here appear to think that psychological dispositions associated with gender can themselves explain social structural

phenomena, such as a distinction between public and private spheres or relations of hierarchy in institutions, and I shall argue that such reasoning is inappropriate.

Gender is not merely a phenomenon of individual psychology and experience, however. In most cultures it is a basic metaphysical category by which the whole universe is organized. Most languages, for example, are elaboratedly gendered, with gender-differentiated modes of address, verbal and noun forms, and so on. In most cultures, moreover, all the significant elements of the social, natural, and spiritual world are differentiated by gender. This usually means more than merely designating animals, weather phenomena, abstract concepts, and so on as masculine or feminine; it also means that the categorized entities carry a rich set of genderized attributes and relationships. The integrating mythologies of most cultures rely heavily on gender symbols, as do most legitimating ideologies.[21]

There is direct interaction, of course, between gender as a phenomenon of individual personality and way of experiencing the world and gender as a symbolic framework for giving meaning to the phenomena experienced. The particular gender images that appear in a culture's religion or political ideology condition the individual's interpretation of his or her gender and of the gender attributes of other persons. In turn, the particular determinations of gender psychology, which vary with family organization as well as with other institutional structures, condition the symbolic and ideological uses of gender.

As a category, then, gender differentiation is primarily a phenomenon of symbolic life, in the individual consciousness and in the general metaphysical framework and ideologies of a culture. Psychoanalytic theory of gender is the most adequate because more than any other type of theory, it can make the connections between individual affectivity, motivation, and desire, on the one hand, and the symbolic and categories of culture, on the other. A psychoanalytic account of gender can explain why gender meanings are so deep-seated in individual identity and cultural categorization and why discussion of alteration in gender meanings or gender relationships causes most people great anxiety. As a theory of symbolism and the unconscious mechanism for symbol substitution and transference, moreover, psychoanalysis can provide a framework for understanding the pervasiveness of gender meanings throughout a culture's categorical and symbolic systems. The feminist theories of gender developed by Chodorow, Flax, Dinnerstein, and others no doubt need more elaboration and refinement, particularly with regard to question of cross-cultural and historical variation. There is little doubt, however, that they have already contributed significantly to the development of feminist social theory.

Regarding male domination as identical with or derivable from gender differentiation, however, over-psychologizes the social phenomena of male domination.[22] As a category, male domination refers primarily not to psychological and cultural phenomena, but to a different aspect of social reality, namely institutional structures.[23] This structural aspect of social reality

includes at least the following: (1) what the major institutions in a given society are, how differentiated they are from one another, and how they reinforce or conflict with one another; (2) how material resources are produced and distributed within and among these institutions, and how these patterns of production and distribution provide different capacities and satisfactions for different individuals and groups of people; and (3) the rules according to which the institutions are organized and the means of their enforcement, especially as these define relations of authority and subordination.

Male domination refers to the organization of a particular institution or the pattern of institutional organization in a whole society, in which men have some degree of unreciprocated authority or control over women and/or men have greater control than women over the operations of the institution or set of institutions. Male domination exists within an institution or a whole society when one or more of the following conditions exist: (1) men have the power to control aspects of women's lives and actions and the means to enforce their will, and women do not have complementary control over men's lives; (2) men occupy institutionalized positions of social decision-making from which women are excluded, and women do not have their own spheres with comparable privilege or control over men's lives; and (3) men benefit from the labor and other activity of women to a greater degree than women benefit from that of men.[24]

It is possible to conceive of a gender-differentiated society, I suggest, in which none of these conditions of male domination exists. It may be true that all societies have been male dominated as well as gender differentiated, though this is a matter of some dispute. Even if it were true that male domination has always existed along with gender differentiation, that would not mean that they are identical or that the former derives from the latter. Unless we make clear distinction between these two categories and develop clear criteria for what counts as male domination, we will not be able to discover how culturally and historically widespread male domination is or how it varies in degree and kind. Only by keeping the distinction clear can we ascertain whether there is any regular relation between phenomena of gender differentiation and phenomena of male domination.

Gender is a necessary, but not sufficient, condition of male domination. Any system of male domination presupposes that persons understand themselves as gendered and attach much significance to masculine and feminine symbols. An account of the acquisition of gender personality, however, cannot locate the institutional sources of male power. Gender theory helps account for the maintenance and reproduction of institutions of male domination, because gender personality usually motivates adherence to norms of male dominated institutions, and gender symbols usually legitimate those structures. A full account of a particular male dominated society, however, requires in addition explanation of the grounds of male power and privilege in social structural terms that do not reduce to individual psychology or behavior. Most accounts of male domination, for ex-

ample, must examine the structural relation between the institutions of family and state.[25]

Before continuing the examination of the theories of Chodorow, Harding, and Hartsock, it might be useful to illustrate the categorical distinctions I have been making with some examples of phenomena of male domination that cannot be explained by appealing to gender theory.

Ruby Rohrlich-Levitt has done a very interesting comparative study of ancient Crete and Sumer. Those societies were similar in many respects. Both had differentiated political realms, both were fairly well urbanized, with well developed exchange institutions, and so on. In Minoan society on Crete, however, women occupied very high status in political and religious institutions, as well as within the family. Sumerian society, on the other hand, was extremely male dominated. She accounts for this difference by noting the differing structures and roles of military activity in each society and the differing relations of military institutions to other institutions in each case.[26] A specific structural explanation is required.

More generally, a theory of the universal reproduction of women's mothering and its differential effects on the personalities and aptitudes that men and women tend to have cannot account for why in some ancient societies, such as the Minoan or the early Aztec, mothers appear to have high status and public roles.[27] Nor can it account for the changes such societies underwent that gave men greater status and more direct control over women.

Let us take another example from modern structures of male domination. Evelyn Fox Keller presents a very interesting account of the origins of the style of modern scientific inquiry in the masculine personality that women's mothering generates. She argues that the rigid notion of scientific objectivity that excludes all affectivity, value, and human meaning derives from the rigid character of masculine ego boundaries. Moreover, she argues that the metaphors of Bacon and other founders of modern science depicting the scientist as conquering and mastering a female nature arise from a masculine self–other opposition that identifies the other as female.[28] Her account reveals much about the cognitive styles of modern and contemporary science and about the degree to which we can understand these as being bound to the identities of the men who founded and dominated that science.

It does not itself account for why since the early modern period men have dominated scientific activity, however, as Keller suggests it does. Nor does it show how male domination of scientific or technological activity has had crucial implications for the specific forms of women's oppression in the modern world. Explaining why men dominate science and how that fact enables them to dominate women entails reference to more structural aspects of social life and their changes.

Important among these structural aspects is specific change in the gender division of labor that accompanied the rise of science. During the time that Bacon defined science as the domination of nature, men were appro-

priating from women many of the practical arts whose union with traditional intellectual science Bacon saw as the key to the new method. For example, feminists have most researched the male appropriation of the healing arts, which before that time were dominated by women. An account like Keller's can explain why once men dominated medicine and defined it as science, the conceptualization of the body by medicine became more objectified, the use of instruments increased, and so on. The gender theory cannot explain, however, how men were able to take over the formerly female-dominated professions, or even why they wanted to.[29]

IV

I have argued that accounts that attempt to develop a general theory of women's oppression from gender theory fail to distinguish clearly between gender differentiation and male domination. As a result, I will show in this section that this use of gender theory tends to divert the attention of feminist social theory from questions of the bases, conditions, and exercise of power.

Chodorow's theory of the development of gender personalities itself exhibits a curious lack of reference to male power. This becomes most apparent when one reads her account alongside earlier efforts, such as those of Firestone, Rubin, and Mitchell,[30] to reinterpret psychoanalysis along feminist lines. These earlier accounts begin with the assumption that male power, symbolized in the phallus, is the primary fact about the relations within which gender acquisition takes place. They interpret the development of masculine and feminine gender identities as differential reactions to male power.

These accounts follow classical Freudian theory more closely than does Chodorow. In the pre-oedipal period both boys and girls have an erotic attachment to the mother. The father, however, has exclusive rights to the mother. The boy fears castration—that is, loss of powerful phallic status—by the father in punishment for his desire for his mother. Thus he gives up his attachment to his mother in exchange for the promise that one day he can accede to the power of the father. Thus when the boy despises the mother and gives up identification with her, he does so not simply because he is uncertain about who he is, but also because he despises her powerlessness. For the girl, on the other hand, discovery that she lacks the phallus, like her mother, is discovery that she belongs to the class of the powerless. Penis envy is her desire to belong to the class of the powerful. The girl drops her desire for her mother and turns her affection to the father as her only avenue to power.

From a technical point of view, Chodorow's approach to a theory of gender personality makes several advances over these earlier accounts. Her critique of the Freudian model and her reliance on object-relations theory gives more weight than they do to relations of interaction. Chodorow also points out that traditional psychoanalytic accounts have concentrated on

the oedipal period, when in fact the processes more relevant to the formation of gender personality occur in the pre-oedipal period. In this period, she argues, the child's relations with the mother are much more significant than his or her relation with the father. This emphasis on the relations of mothering in Chodorow's gender theory, however, seems to divert feminist questioning from power. She conceptualizes men primarily as an absence, not as a power.

The absence of power in Chodorow's theory carries over into the uses made of it for a general feminist social theory. All three of the thinkers summarized here, of course, claim to be concerned with explaining the sources of male power and the oppression of women. The most they explain, however, is a masculine *desire* for power. The social relations of infant care, they argue, produce men with a greater propensity than women have to instrumentalize relations with others. Men also emerge from the mothering process with a hierarchical self–other dichotomy that allows them to view all persons as potential subordinates. They account for a specific male desire to dominate women, moreover, by appealing to an unconscious dread of women resulting from male insecurity of self as being different from the other.

Unless a psychological propensity to wield power itself makes men powerful, however, this account does not touch on the question of the sources of male power. Chodorow, Hartsock, and Harding, however, do not see that their theories ignore concrete relations of domination, and as I have already pointed out, they tend to draw conclusions about the latter from arguments about the former. Other elements of gender theory also contribute to a tendency to deemphasize concrete relations of power. In particular, uses of gender theory to found a theory of male domination tend to (a) ignore historical and cultural specificity, (b) focus on ideational forms, and (c) assume an incorrect social ontology.

(a) All three of the theorists under discussion here abstract from the cultural and historical specificity of concrete social structures. They pose their claims in terms of what is common to all societies or common to all male dominated societies. As a consequence of this universalizing tendency, they make controversial claims about the universality of certain social phenomena. Chodorow and Harding both assume, for example, that in all societies women have exclusive responsibility for primary infant care and that in all societies women have been devalued.[31] Both assumptions, however, would be disputed by many anthropologists. Chodorow appears to assume that all societies have a public–private split, which allocates men to the public and women to the private.[32] Finally, many anthropologists and historians would dispute the assumption made by all three writers that in all societies women are oppressed or at least have a lesser status than men.

From a methodological point of view, there are several problems with this universalizing tendency. As a number of writers have pointed out, transhistorical or transcultural claims too often carry over assumptions

based in the historically specific structures of modern European society to ways of looking at other societies and periods.[33] We can avoid such cultural bias only by looking for differences and suspending judgment about commonalities until we have carefully studied societies in their concrete detail.

The second problem with the transcultural generality of these theories is that their claims are often made without empirical warrant. As I have already pointed out, many of the transhistorical claims made by the theorists under discussion here are controversial. On most questions about what is common to all societies, the data simply are not in. Data are subject to differing interpretations, moreover, depending on the theoretical framework within which one operates. Feminist theories are not entitled to claim that devaluation of women is universal or that male domination is universal, and so on, unless we clearly delineate our categories and develop precise, agreed-upon criteria for deciding when and how observable phenomena fit into the categories. Feminist social theory does not currently have such a precise framework, and it is among the aims of this paper to call attention to that fact and to take some direction toward correcting it.

The tendency to make universalistic claims about male domination, finally, requires taking a very abstract approach to social reality, for concrete observation shows that there is extraordinary variability in the causes and degree of male domination in different societies and even among different subgroups in one society. Since the concrete social relations of gender vary enormously in content and structure, then, gender theory can make transhistorical or transcultural assertions only by abstracting from these concrete relations. For Chodorow to regard the public–private distinction as a cultural universal always connected with women's mothering and women's status in the same way, for example, she must conceive it as an abstract and purely formal distinction empty of specific content. Harding says explicitly that gender theory is concerned not with the content of social phenomena, but rather with the formal similarity that she claims exists among masculine personality, patriarchal social institutions, and the belief systems that arise within those institutions.[34] These all have in common, she suggests, the formal structure of hierarchical dualism.[35]

The motive for making universalistic claims in feminist theory has generally been to identify causes. We have assumed that if we can identify one or a few things common to all societies with respect to women's situation, we will be able to locate the key factors that determine the oppression of women. Certainly the theory of gender personalities created by women's mothering is intended to serve as such a key in the accounts of the three writers discussed here. If the distinction between gender differentiation and male domination developed in the previous section is appropriate, however, much more than such a theory of personality and experience is needed to explain how men have control over particular institutions in a particular society, how they have access to resources by which they can enforce authority over women, and so on. The mistake in the universalizing tendency of gender theory, moreover, is not that it has identified the basic

cause of male domination incorrectly, but that it assumes that there is a single basic cause. An account of the origins, maintenance, and reproduction of structures and relations of male domination within a given society must necessarily refer to a multitude of causes, showing how they reinforce or conflict with one another.

Accounts of the structures and processes determining male domination, moreover, will vary with different systems. Even if we should come to the conclusion that all societies have been male dominated, there is no question that women's situation has been better or worse off in ways that vary enormously. The important question is what are the variables that determine change in women's situation for the better or worse, or simply to a different situation. Chodorow's gender theory can contribute to analysis of such variables, and in a few passages both she and Harding interpret this theory as articulating a set of variables.

(b) Relations of power and domination drop out of consideration in the accounts we are examining here, precisely because of the level of abstraction at which they operate. The bases, structure, and operation of power and domination are necessarily concrete and extraordinarily variable in both form and degree.[36] The inability of this formalism to deal with power becomes apparent in the way that Hartsock and Harding conceptualize domination itself. They do not refer to concrete material conditions to describe the enactment of power and domination, but only to the relations among categories. For both, social relations of domination appear to be defined as nothing more than a hierarchical dualism of self and other.

Hartsock, for example, appears to define class society as a social structure in which there is a hierarchical dualism, a ruling group standing in opposition to a ruled group.[37] This merely defines the abstract categorical relations of class society and excludes reference to the social structures and material relations that ought also to define class society. Class society is indeed hierarchical, but more specifically it involves relations of power and dependence in which one sector of society enforces the appropriation of the products of the labor of other segments of society.[38]

Despite the fact that the gender theorists claim to be materialist in their account of the bases of male domination, their accounts are idealist in the strict sense. They claim that the nature of an institution is determined by a relation among ideas. To be sure, they attempt to ground the self–other dichotomy that they attribute to the masculine personality in the material relations of infant care. They do not argue, however, that material relations determine the institutional structure. They argue, rather, that a certain logical or metaphysical structure determines the structure of social institutions, namely a conceptualization of experience in terms of a rigid self–other dichotomy.

If I have offered a correct analysis of the categories of gender differentiation and male domination, phenomena related to gender differentiation cannot explain structures of male domination by themselves, because the former category refers to ideas, symbols, and forms of consciousness,

and the latter refers to the appropriation of benefits from women by men in a concrete material way. Gender theory can plausibly be used to argue that certain forms of conceptualization that appear in Western theories and ideologies have a root in the masculine personality generated by women's mothering.[39] For here the account grounds one set of forms of consciousness in another.

Gender theory surely can contribute part of the explanation of the nature and relation of social institutions, moreover. But the explanation of any institutional form, especially one relating to power and domination, requires in addition reference to the relations of institutions to one another and an account of the material means of access, control, enforcement, and autonomy that agents have within those institutions. In not recognizing the categorical difference between gender differentiation and male domination, gender theory ignores these explanatory requirements.

Let me give an example of this sort of confusion. Chodorow's arguments, as well as Harding's, focus on the devaluation of women rather than directly on the question of male domination. In explaining devaluation of women, they appear to think that they have thereby explained male domination, when in fact no such inference is warranted.

As summarized earlier, Chodorow explains the source of the devaluation of women by men as a dread of women and anxiety about their masculinity caused by the social relations of mothering. Inasmuch as it argues that one form of consciousness—masculine personality—grounds another—masculine attitude toward women—this is a plausible argument. One cannot pass from such an argument directly to a conclusion about the causes of male domination, however. Even if we find that devaluation of women and male domination always occur together, we cannot conclude that the explanation of one is also the explanation of the other. Description and explanation of male domination still requires reference to material relations of dependence and autonomy, access to resources, and material means of coercion, as well as to the structural relations among institutions that reinforce or change these.

It seems conceivable, moreover, that cultural devaluation of women might exist without male domination. Susan Carol Rogers has argued, for example, that in a peasant village of contemporary France there exists a "myth" of male dominance, through which women are devalued and men elevated, but that in a concrete material way women have as much power as men within the narrow spheres of the family and local community, if indeed not more. In these villages the sources of economic independence and security lie in the family, and the domestic sphere is also the major realm in which the community is tied together. Because women dominate decision-making in the domestic sphere, Rogers argues, they have significant power in the community. The myth that men are more important operates in the interest of women as well as men, she argues, because it keeps men from wanting to participate in the domestic realm and hence preserves the autonomy and power of women.[40]

One would not argue that in the situation that Rogers describes, men and women are fully equal. A myth of male dominance gives men a certain advantage over women and a means of benefiting from women's activity. The point of introducing this example is to support the claim that cultural devaluation of women does not necessarily imply the material domination of women.[41]

(c) A final element of the accounts of Hartsock and Harding contributes to their lack of specific attention to the concrete causes and operation of power. They both assume that the institutions of male-dominated society reflect masculine personality and only masculine personality. Harding most explicitly argues that the nature of institutions of domination is determined by the self–other dichotomy of masculine personality because men design and control all institutions in patriarchal societies and make them in their own image.[42]

This argument falsely assumes that the nature of institutions in patriarchal societies is solely or primarily a product of male action. Even in the most male-dominated societies, many spheres of social life exist in which women's action and temperament have a significant influence. The problem of male domination is not that women are prevented from acting upon and within institutions, but that the benefits of their contribution are systematically transferred to men.

More important, this argument that institutions of domination reflect the structure of masculine personality rests on a questionable assumption about the relation of individuals and social structures. It assumes that the nature of institutions is determined by the nature of the individuals whose actions produce and maintain them. There are several problems, however, with this assumption.

While acting people are indeed the only concrete human entities that exist in the social world, it does not follow that the nature of institutions is isomorphic with the nature of individuals. The assumption mistakes the fundamental unit of institutions, which is not individuals but *interactions* among individuals.[43] Most institutions relevant to a theory of male domination are products of interactions between men and women, not merely among men. The characteristics of personality, the motives they influence, and the interpretations of events they color are surely important elements in these interactions. But the structure of the institutions cannot be read off from the structures of individual personalities.

Actions and interactions, moreover, are not the only determinants of institutional structures and practices. Individuals always act situated within and oriented toward natural and geographical givens, the possibilities and limits of available technologies and artifacts, and the cultural traditions to which they are heir. Perhaps even more important, the actions and interactions of social life almost always generate unintended consequences. One cannot foresee or control the interpretation others will give to one's actions or how they will respond to them, nor how others will respond to the

response, and so on. Social events are often the result of the cumulative effect of a great many individual actions and interactions, moreover, bringing results neither intended nor predicted by any of the actors. Economic events such as depressions, for example, often have this character.[44]

The argument that the nature of institutions of domination is determined by the self–other dichotomy of the masculine personality created by women's mothering, then, erases the hugely complex material and social structural factors involved in the causes, maintenance, and operation of relations of power and domination. These arguments fail to distinguish male domination from gender differentiation insofar as they tend to reduce social structural phenomena to psychological causes. Thus they fail to give adequate focus to those structures of male domination in a particular context that cannot be reduced to individual psychologies.

In sum, gender theory diverts feminist thinking from specific focus on power because it tends to be universalistic, hence to couch its claims in terms of abstract relations of categories and to reduce social structures to products of individual personality.[45] What does it mean, then, for feminist theory to pay attention to issues of power and domination?

I have suggested in the previous section that it entails a structural analysis of relations, authority, and dependence, and a description of the transfer and appropriation of benefits of labor. To describe and explain male domination as concrete relations of power, feminist theory must ask questions such as the following: Which gender has access to what social resources as a result of performing its gender-differentiated activity, and what do the resources give members of the gender the capacity to do? How much, and by what means, are members of each gender organized in networks of solidarity?[46] How do the structural relations among various institutions—state and family, for example—affect the concrete relations of dependence and autonomy in which women stand?[47]

Gender theory can surely be useful in any particular account of the causes, maintenance, and exercise of male domination in explaining processes of motivation, complicity and ideological legitimation, and relations of power. It can provide a link between material possibilities and institutional forms, on the one hand, and individual action and understanding of those institutions, on the other. Relations of power and domination between the genders themselves, however, must be comprehended as determinate material structures of capacity and effect.

V

Chodorow's theory, as well as Dinnerstein's, has received much discussion and has been absorbed quickly into feminist theorizing at least partly because it seemed to offer a concrete and workable strategy for transforming gender relations. The theories suggest that exclusive parenting of infants by women is a key cause of male domination and the oppression of women.

Thus if the social relations of infant care were to change such that men would participate as much as women, it seems to follow that whole edifice erected on the base of exclusive female parenting would topple.

Parenting shared by men and women is the key step in eliminating the oppression of women. When that strategy was first put forward, it sounded simple and straightforward. It has not taken feminists long, however, to see that the matter is not so simple. Many wonder whether men with their present masculine personalities, complete with their insecurities and hatred of women, should be anywhere near children. Others have pointed out that in contemporary society mothering is one of the only activities in which most women have some autonomy and from which they derive a measure of self-respect. If men are encouraged to participate in that sphere as well, under present conditions, it could mean a loss of status for women.

It quickly became apparent, moreover, that really changing the social relations of infant care would entail monumental changes in all institutions of society.[48]

The practice of parenting as shared between women and men could not be instituted on a significant scale without altering most other institutions first. For shared parenting to be possible, the whole structure of work outside the home would have to change to make it more flexible. To encourage men to be child care workers, outside the home as well as in it, the value of child care would have to be significantly increased. Without alteration in other elements of male domination, moreover, shared parenting, even if it happened, would not be likely to change greatly the patterns of socialization and the resulting masculine and feminine personalities. If men were to continue to occupy positions of authority, for example, and the idea of authority continued to be associated with masculinity, children raised by both women and men would be likely to maintain that association. If media images continued to sentimentalize and sexualize women while presenting men as tough and emotionally distant, children and adults of both sexes would be likely to internalize and reproduce those images.

When we ask about feminist strategy, the errors of collapsing the categories of male domination and gender differentiation and of attributing the key cause of male domination to women's mothering become apparent. Gender division in parenting is one of many institutional structures that produce and maintain the oppression of women. If the above arguments are sound, moreover, women's mothering may be less fundamental than other institutions of male domination, since it appears that relations of parenting cannot be changed without first changing other structures.

If it does not offer us a very full strategy for feminist revolution, what can gender theory offer that will aid in undermining the oppression of women? Gender theory can provide us with an important understanding of the power of symbols and the bases of motivation and desire. It can help sensitize both women and men to the deep sources of some of the ways of experiencing particular to each gender. It can also help us under-

stand, as Flax has argued, how in the women's movement itself we may tend to reproduce our relations to our mothers with each other. Perhaps more important, gender theory can be an enormous aid in consciousness-raising about contemporary masculinist ideologies by showing some of the sources of their misogyny. All this needs to be supplemented with a concrete analysis of the social structure, however, which cannot be provided by gender theory. To fight against male domination, we need to understand how the institutions work in such a way as to promote women's working for men, how the current arrangements are enforced, and who controls the resources that produce and maintain them.

NOTES

I began research for this paper while participating in a National Endowment for the Humanities Summer Seminar Fellowship on "Themes in Cross-cultural Analysis of Women and Society," directed by Eleanor Leacock, City University of New York, summer 1980. An earlier version of this paper was presented at the Caucus for a New Political Science, American Political Sciences Association meetings, New York City, September 1981; and at a meeting of the Society for Women in Philosophy, Western Division, Fort Wayne, Indiana, October 1981. I am grateful to women at those meetings for their response and suggestions. I am also grateful to Nancy Hartsock, Muriel Dimen, Linda Nicholson, Sandra Bartky, Roger Gottlieb, and David Alexander for their helpful suggestions.

1. Nancy Chodorow, *The Reproduction of Mothering* (Berkeley: University of California Press, 1978).

2. Psychoanalytic accounts typically depict the mother as the object of love and ambivalence upon which the child's desires and fears are projected, and rarely show the mother as herself being an active participant in the child's development, playing out her own desires and fears in interaction with the child. A great virtue of Chodorow's account is that she views the mother as an actor, as a person with reference to whom the child acts.

3. Suzanne Relyea has argued that Chodorow's theory, as well as the use of psychoanalytic theory by some French feminists, contains a heterosexual bias because it assumes that there are two genders in polar opposition, thus obscuring the particular situation of lesbians. See Relyea's "None of the Above: Gender Theory and Heterosexual Hegemony in Recent French and American Thought," unpublished paper. Adrienne Rich also criticizes Chodorow's attention to lesbian identity in "Compulsory Heterosexuality and Lesbian Existence," in Snitow, Stansell, and Thompson, *Powers of Desire* (New York: Monthly Review Press, 1981).

4. Chodorow does not mention strongly enough that her account can also explain the place of friendship among women, that women often seek emotional support and nurturance from other women rather than from men, even when they are heterosexual. Her claim that women retain a strong affective attachment to their mothers also makes the claimed heterosexuality of most women more problematical than she makes explicit. Chodorow does not ask, for example, whether female heterosexuality perhaps entails an aspect of coercion. In a heterosexist society, acquiring gender identity also entails learning that desire should be for one of the "opposite" sex. See Rich, op. cit.

5. Jane Flax, "The Conflict Between Nurturance and Autonomy in Mother–Daughter Relationships and Within Feminism," *Feminist Studies*, vol. 4, no. 2 (1978).

6. Dorothy Dinnerstein, *The Mermaid and the Minotaur: Sexual Arrangements and Human Malaise* (New York: Harper and Row, 1976).

7. See *Reproduction of Mothering*, pp. 4–6, pp. 185–90, pp. 211–13. See also Chodorow's article "Family Structure and Feminine Personality," in Rosaldo and Lamphere, ed., *Women, Culture and Society* (Stanford, Calif.: Stanford University Press, 1974). There Chodorow suggests that the nuclearized, father-absent family, where the mother is the sole focus of emotional attachment, creates the particular masculine and feminine personality traits we experience.

One good reason to regard Chodorow's theory as limited in its historical applicability is that mothering was not understood as a distant vocation, to which women were supposed to give exclusive physical and emotional attention, until the late eighteenth and early nineteenth centuries. By this time most production had been removed from the home, and the development of the ideology of the home as the refuge for sentiment had taken hold.

8. *Reproduction of Mothering*, p. 85; pp. 208–9.

9. *Reproduction*, p. 7.

10. *Reproduction*, pp. 9–10, italics mine.

11. Rosaldo and Lamphere, introduction to *Woman, Culture and Society*, pp. 1–16.

12. Chodorow talks most explicitly about dread of women as an element of masculine personality in her paper "Being and Doing: A Cross-Cultural Examination of the Socialization of Males and Females," in Gornick and Moran, eds., *Woman in a Sexist Society* (New York: Basic Books, 1971); see also *Reproduction of Mothering*, pp. 181–83.

13. In Harding and Hintikka, eds., *Discovering Reality: Feminist Perspectives on Epistemology, Metaphysics, Methodology and the Philosophy of Science* (Dordrecht, the Netherlands: Reidel Publishing Co., 1981).

14. Nancy Hartsock, *Discovering Reality*, p. 296.

15. Sandra Harding, "What Is the Real Material Base of Patriarchy and Capital?", in Sargent, ed., *Women and Revolution* (Boston: South End Press, 1981), p. 139.

16. Harding, "What Is the Real Material Base of Patriarchy and Capital?", p. 139.

17. Harding, "Gender Politics of Infancy," *Quest*, vol. 5, no. 3 (1981), p. 63.

18. Harding, "Gender Politics of Infancy," p. 62.

19. For example, Juliet Mitchell, in her book *Psychoanalysis and Feminism* (New York: Vintage Books, 1975), clearly identifies patriarchy with the psychodynamics of gender. See my critique of her failure to make this distinction in Young, "Socialist Feminism and the Limits of Dual Systems Theory," *Socialist Review*, 50/51 (Summer 1980).

20. Hartsock, in a personal communication, has pointed out this difference in emphasis between her account and the others. This distinction raises the question, which I do not intend to answer here, of what the relationship is between the concepts of "personality" and "experience."

21. For an incisive definition of gender in these terms, see David Alexander, "Gendered Job Traits and Women's Occupations," Ph.D. dissertation, University of Massachusetts, 1987.

22. Susan Bourque and Kay Barbara Warren make this point in *Women of the Andes: Patriarchy and Social Change in Two Peruvian Towns* (Ann Arbor: University of Michigan Press, 1981), chapter 3, p. 58 and p. 83. They do not give very thorough reasons for their claim that an understanding of patriarchy requires analysis of the institutional context of sex roles independent of psychology.

23. For an account of the logic of social analysis that distinguishes between psychological and structural aspects without falling into the polarization typical of

other sociological frameworks, see Anthony Giddens, *Central Problems in Social Theory* (Berkeley: University of California Press, 1979), chapters 2–5.

24. There are very few discussions among feminist theorists about how to define criteria of male domination. Peggy Reeves Sanday has a useful discussion of the way certain anthropologists have defined the concept and offers an alternative articulation of her own, one somewhat more narrow than the one I have articulated. See *Female Power and Male Dominance* (New York: Cambridge University Press, 1981), especially pp. 163–79.

Naomi Rosenthal has developed a useful notion of the measures of male domination and female autonomy on the ability to mobilize resources, including political and ideological resources, which she applies to five Amazonian societies. In "Women in Amazonia," unpublished manuscript, SUNY at Old Westbury, 1981.

Lisa Leghorn and Kathrine Parker, in *Women's Worth* (New York: Routledge and Kegan Paul, 1981), develop criteria for distinguishing kinds of male-dominated societies: those in which women have token power, and those in which women have negotiating power. They measure women's power within the framework of three areas: (a) valuation of women's fertility and physical integrity; (b) women's access to and control over crucial resources, including property, paid and collective labor, training, and education; and (c) women's networks (p. 22).

25. Several recent historical studies by feminists have demonstrated the central importance of this particular structural relation in explaining particular patterns of male domination. See Sherry Ortner, "The Virgin and the State," *Feminist Studies,* vol. 4, no. 34 (October 1978), pp. 19–36; Marilyn Arthur, " 'Liberated' Women in the Classical Era," in Bridenthal and Koonz, ed., *Becoming Visible* (New York: Houghton Mifflin, 1977), pp. 60–89; and Natalie Davis, "Women at the Top," in *Society and Culture in Early Modern France* (Stanford, Calif.: Stanford University Press, 1975). Linda Nicholson has developed some of the theoretical significance of studies such as these in *Gender and History* (New York: Columbia University Press, 1986), especially chapter 4.

26. Ruby Rohrlich-Levitt, "Women in Transition: Crete and Sumer," in Bridenthal and Koonz, op. cit.

27. June Nash, "The Aztecs and the Ideology of Male Dominance," *Signs,* vol. 4, no. 2 (1978), pp. 349–62. Ruby Rohrlich and June Nash, "Patriarchal Puzzle: State Formation in Mesopotamia and Mesoamerica," *Heresies,* no. 13 (1981).

28. Evelyn Fox Keller, "Gender and Science" and "Baconian Science: A Hermaphroditic Birth," in *Reflections on Gender and Science* (New Haven, Conn.: Yale University Press, 1985).

29. To my knowledge Alice Clark's book *The Working Life of Women in the Seventeenth Century,* published in 1919, is still the best single source on this process of change in women's economic status.

30. Shulamith Firestone, *The Dialectic of Sex* (New York: William Morrow & Co., 1970), chapter 3; Gayle Rubin, "The Traffic in Women: Notes on the 'Political Economy' of Sex," in Rayna Reiter, ed., *Toward an Anthropology of Women* (New York: Monthly Review Press, 1975), pp. 157–210; Mitchell, op. cit.

31. Sanday, op. cit.; Leacock, "Women in Egalitarian Society," in Bridenthal and Koonz.

32. In an article published shortly before she died, Michelle Rosaldo argued against her earlier position that discussion of a universal public–domestic split tends to rely on cultural assumptions based on the particular form of the public–private split, which dates from the nineteenth century in Western Europe. See Rosaldo, "The Use and Abuse of Anthropology: Reflections on Feminism and Cross-Cultural Understanding," *Signs,* vol. 5, no. 3 (1980), pp. 389–417. Linda Nicholson suggests that feminist theory should conceptualize public–domestic divisions in historically specific ways; op. cit., part three.

33. Mina Davis Caufield, "Universal Sex Oppression? A Critique from Marxist Anthropology," *Catalyst*, no. 10/11 (Summer 1977), pp. 60–77.

34. Harding, "Gender Politics of Infancy," p. 63.

35. In "Family Structure and Feminine Personality," Chodorow does put some of her claims in terms of the way the character and degree of women's subordination varies with the different meaning of motherhood and differing social status of women. She argues that the relational orientation characteristic of the feminine personality produced by women's mothering provides the ground for a positive self-image among women in societies where women's labor is important and respected, but that same relational orientation can produce low self-esteem in women where these social circumstances are absent. These claims about the variability of the character and degree of women's subordination occur within the context of an article that stresses that women's mothering and devaluation of women are invariant facts in all societies.

This ambiguity occurs even more strongly in Harding. In the same article in which she says that gender theory is concerned to focus on "two constants which appear to be virtually universal" ("Gender Politics of Infancy," p. 60) to all societies, namely women's mothering and devaluation of women, she also says that "Chodorow's and Dinnerstein's work does not rest on universalistic claims about the devaluation of women or about child-raising practices" (p. 66). She goes on to say that gender theory "directs our attention to the probable importance of cultural variation in the labor and the value of women for the personalities of the social individuals produced through psycho/social/physical interaction with them" (p. 66). I think this last statement is true of gender theory and ought to be the primary way in which it guides concrete accounts of women's situation. Understanding gender theory as providing a means of accounting for variations in gender personalities that result from variations in the status and position of women, however, is quite a different project from accounting for women's secondary status, claimed to exist in all societies, as arising from the same basic masculine personality produced by women's mothering. As I have tried to show, this rather static, more universalistic approach is more typical in gender theory.

36. Rosaldo, op. cit.

37. Hartsock, "The Feminist Standpoint."

38. It is indicative that in her account of the social relations of class society as grounded in a self–other dichotomy, Hartsock appeals to Hegel's master–slave account. This provides some support for my claim that her conceptualization of the basis of social relations is essentially idealistic.

39. Hartsock and Keller have arguments to this effect in the papers already cited. See also the papers by Jane Flax and Naomi Schemen in the previously cited volume *Discovering Reality*.

40. Susan Carol Rogers, "Female Forms of Power and the Myth of Male Dominance: A Model of Female/Male Interaction in Peasant Society," *American Ethnologist*, vol. 2 (1975), pp. 727–56.

41. Sanday, op. cit., develops three categories of sexual relations in order to take account of cases such as these. She distinguishes among (1) societies in which the sexes are *equal*; (2) those in which there are strong ideological devaluation of women and male aggression toward women, but where women have a high degree of political and economic power; and (3) those in which there are a devaluation of women and male aggression toward women, and where women lack political and economic power.

42. Harding, "What is the Real Material Base of Patriarchy and Capitalism?", p. 139. Here Harding asserts quite strongly that *all* institutions in society are controlled by men; on p. 150 Harding makes the argument that institutions reflect male psyche because men design and control them.

43. Cf. Rosaldo, "Use and Abuse."

44. Cf. Giddens, op. cit., pp. 73–95. Sartre conceptualizes the notion of social structure as the result of individual actions that nevertheless do not have attributes that can be assigned to individuals in his concepts of *totalization* and *counter-finality*. In *Critique of Dialectical Reason* (London: New Left Books, 1976).

45. Harding specifically disclaims that her theory is psychological-reductionist on the grounds that it says that the psychic structures that cause institutional forms are themselves caused by the social relations of mothering. "What is the Real Material Base" p. 149. This does not answer my point, however, since I am claiming that she reduces the attributes of institutions to attributes of individuals.

46. Rosenthal, op. cit., takes gender solidarity as a major factor in accounting for male domination or the lack of it. In examining Amazonian societies, she concludes that collective solidarity among men, where such collective solidarity is lacking among women, accounts for the only significant inequality between the genders in those societies.

47. Feminist theories have begun to look at the connection between developments in state institutions and increased restrictions on women's sexuality. See Ortner, op. cit.

48. Harding, "Gender Politics of Infancy," p. 68; cf. Chodorow, *Reproduction of Mothering*, pp. 218–19.

Women and the Welfare State

In the early and mid-1970s, socialist feminist theory in the United States, like most other feminist theorizing, implicitly or explicitly understood the family to be the primary institution enacting and reproducing the oppression of women. Beginning with Margaret Benston's pathbreaking article on women's domestic labor,[1] Marxist feminists debated the precise relationship of housework to capitalist production, never doubting that housework was the main source of women's sex-specific exploitation.[2] Socialist feminist theorists such as Ann Ferguson and Heidi Hartmann began developing theoretical frameworks for conceptualizing patriarchy in historical materialist terms as women working for men in the home—not only doing housework, but also caring for children and providing emotional and sexual services for men.[3]

In one of the first articles to break with this received wisdom of socialist feminism, Barbara Easton explained this focus by feminists on the family. The second wave of feminism, she argued, like the first, has focused its attack on the weakest link in male domination. In the nineteenth century women's exclusion from full citizenship rights was the least legitimized aspect of male dominance, so it was the easiest to struggle against. In the twentieth century the material power and legitimacy of the traditional patriarchal family have receded, and thus feminists have found this a successful target.[4]

Whatever one might have thought of Easton's account of contemporary feminism, it quickly became difficult to deny that the male dominated family was losing its force at the primary oppressor of women. With married women entering the labor force in large numbers, women's economic dependence on men was being reduced, and husbands had to compete with bosses for authority over women. Barbara Ehrenreich pointed out that husbands have often been happy to abandon women to those authorities and the women's own devices; for the past thirty years more and more of them have rejected the patriarchal family and seem quite able to survive without the domestic and sexual service of a live-in wife.[5]

Public Patriarchy

From these kinds of insights socialist-feminist analyses in the past several years have tended to shift away from focus on the family to what Carol

Brown calls the "public patriarchy."[6] Consistant with Ehrenreich, Brown suggests that contemporary social control by men over women and children in the family is not the primary form of male domination. On the contrary, she argues, since children have become an economic and social liability rather than a benefit, men gain by shifting the financial and labor burden onto women in the family. Neither the patriarchal system as a whole nor individual men suffers from permitting the widespread existence of female-headed families. The private family has lost some of its value to patriarchy because the family no longer produces goods or the economic skills needed to produce goods. Husbands no longer need to enforce control over women's reproductive labor and the appropriation of women's service labor for men, because this enforcement is now exercised by institutions outside the family.

Brown argues that what she calls "public patriarchy" now constitutes the primary form of male domination. Public patriarchy refers to male control over the primary nonfamilial institutions: corporations, the state, religious institutions, and so on. Men collectively control these institutions and use this control to uphold the rights and privileges of the male sex as well as individual men. Public patriarchy, Brown suggests, has always played a role in patriarchal society. In contemporary society, however, public institutions have taken more direct control of women's productive and reproductive labor than in any previous society and have taken over primary control of children as well.

Instead of being economically dependent on husbands, Brown argues, women are more likely to depend on corporations or the state for their survival. Maintenance and reproductive labor, moreover, have increasingly come under the control of male dominated hospitals, schools, restaurants, stores, mental-health agencies, and so on, where women work for pay. Even women's unpaid labor in the home increasingly falls subject to corporate and state manipulation and control.[7]

Increased attention by feminists to the feminization of poverty, coupled with awareness of the vulnerability of women in particular to the social-service cutbacks perpetrated by the Reagan administration, have made an analysis such as Brown's practically urgent. Increasingly, feminists seeking to understand and struggle against the oppression of women in capitalist society have focused on the state, and particularly the welfare state, as a primary site of the oppression of women.[8] Women, furthermore, are more economically dependent on the services of the state than on individual male breadwinners. State institutions, moreover, control or potentially control many aspects of women's lives, from the availability of abortion and sterilization to their relationships with their children.

Piven's Dissent

In a recent article Frances Fox Piven has challenged what she perceives as the new received wisdom of socialist feminism. This public patriarchy

analysis, which claims that the welfare state is a primary structure of patriarchal power over women, is wrong. On the contrary, she claims, "income supports, services and government employment have compensated somewhat for the deteriorating position of women in the family and economy, and have even given them some measure of protection and hence power in these institutions. Therefore the state is turning out to be the main recourse of women."[9]

Piven asserts her strong dissent from the public-patriarchy analysis in part because she finds it paralyzing. From the public-patriarchy analysis, she claims, it follows that women have few prospects for improvement and cannot exert any power on the state. If we understand that women derive their main sustenance and protection from the institutions of the welfare state, on the other hand, we can see that these institutions are the main sources of the empowerment of women in contemporary society. Piven gives two reasons for this claim. First, the much touted "gender gap" in voting patterns signals an increased assertion by women of traditionally female values of caring and nurturance as values that ought to be promoted in public institutions. In Piven's view, this new women's politics "draws both ideological and political resources from the existence of the welfare state."[10]

Second, Piven thinks that welfare-state institutions bring women together in networks of solidarity in the welfare office and neighborhoods, bringing them power to organize. She thinks, moreover, that the fact that in welfare agencies and offices women predominate as service providers creates the possibility for women to organize across class around the values of caring and nurturance. Organizing women around welfare issues and pressing government for the maintenance and expansion of welfare services, then, in Piven's view, offers a possible and desirable means of empowering women in contemporary society.

Piven is wrong, I think, to draw pessimistic practical conclusions from the public patriarchy analysis she rejects. From the claim that the institutions of the welfare state are a primary area of control over women, it certainly does not follow that the welfare state is not an arena of struggle in which women can make some relative gains. That would be like claiming that workers have no possibility of struggling over the length of the working day or the nature of the work process, since the work process is the primary area of the exploitation of workers. On the contrary, the intention of Brown and the others who have put forward the public-patriarchy analysis has been in part to focus the direction of feminist struggle. If the welfare state is one of the primary areas of control over and oppression of women, it is there, rather than in relations with men in the family, that socialist feminists ought to focus their activist energy.

Women's Organizing and the State

Upon the importance of organizing having to do with women's relationship to the state, Piven and those whom she criticizes agree more than she

allows. Still, she has proposed two quite contrary positions about the meaning of that relationship, and the quandry for socialist feminists consists of the fact that they are both right. We must support the welfare state and struggle for its expansion, and must reject the welfare state and look for other institutions to meet women's needs.

In an economy where jobs for women are not expanding quickly enough, where women's wages continue to be half those of men, and where costs of child care, when available, are usually very high, the welfare state is the main recourse of many women. The services provided by state institutions in the way of health care, education, direct payments and subsidies, loans, etc., unquestionably help the women who are the vast majority of adults served by those institutions. These services sometimes free women from abject dependence on individual men.

The welfare state frees some women from some misery and dependency, but this is far from saying that it makes women free. As Nancy Fraser points out, when state administration socializes services it also subjects the clients of those services, usually women, to formalized and massified administrative procedures that are at best frustrating and demeaning, and at worst fail to meet their real needs while defining their needs in welfare administrative terms. The welfare state provides services, but usually at the cost of the autonomy of its clients and their ability to define their own situations and needs.[11] State agencies define what counts as quality child care or a decent lunch, and the mothers must accept this definition or do without. The state will define whether your family needs a two bedroom apartment and says that laundry soap does not count as "food" to be paid for by food stamps.

Expansion of the services of the welfare state, moreover, has sometimes meant a collective reduction in women's autonomy. In response to the vast need for rape crisis and battered women's services that the sweat of feminist activism demonstrated, for example, state agencies in many regions of the United States have begun to fund and/or provide such services. Almost invariably, however, the autonomy of the service, and the women provided for and their providers, have suffered in the process. Executive directors are introduced; collective process disappears, as does the education of clients; meticulous forms and records must be kept. In the era of cutbacks, moreover, many of these post-feminist additions to the welfare state have been the first excised. Having lost their base in independent feminist organizing, then, these services, struggled for and developed over fifteen years, disappear.

Even so, as Piven contends, the welfare state is largely the result of progressive struggle to alter the economy from a free market capitalist economy to one that will meet human needs. That struggle, which began in the Depression years, has succeeded in some extent in shifting hegemonic values in the United States. The right of the unemployed, the elderly, and the indigent to state support is widely accepted today.[12] But these rights are under vicious attack and will not be maintained without the

vigorous struggle of progressive people. Piven is right, moreover, to see the potential power of women's organizing, voting, and holding office as being of key importance in such a struggle.

But it is an illusion to think that such organizing around the maintenance of the welfare state can reward women except insofar as any organizing can give people a sense of confidence. As long as women and feminist values do not control the welfare state, decisions will be made about women's lives that do not respect their needs and that treat women and children as problems and "cases." The logic of state administration as it exists in our society is profoundly antidemocratic and bureaucratic, and when the very services themselves are under attack, socialist feminists are not in a position to call for revolutionizing their manner of provision. So progressive people are compelled to press for maintaining and expanding the existing oppressive welfare state.

Simultaneously, progressive people should look for methods of self-help and service provision that are outside or at the margins of state services. Women and their children are likely to get better and lower cost housing, for example, if they explore cooperative ownership, credit unions, and other forms of autonomous economic development than if they call upon the state to open public housing units. Only such pockets of autonomy can in a small way nurture a vision of democratic welfare institutions, while we struggle just to maintain undemocratic ones.

NOTES

1. Margaret Benston, "The Political Economy of Women's Liberation," *Monthly Review*, vol. 21 (September 1969), pp. 13–17.

2. For a useful summary and evaluation of the "domestic labor" debate, see Lise Vogel, "Marxism and Socialist-Feminist Theory: A Decade of Debate," *Current Perspectives in Social Theory*, vol. 2 (1980), pp. 209–31.

3. Ann Ferguson, "Women as a Revolutionary Class," in Pat Walker, ed., *Between Labor and Capital* (Boston: South End Press, 1979), pp. 170–312; Heidi Hartmann, "The Unhappy Marriage of Marxism and Feminism: Towards a More Progressive Union," in Lydia Sargent, ed., *Women and Revolution* (Boston: South End Press, 1981), pp. 1–42.

4. Barbara Easton, "Feminism and the Contemporary Family," *Socialist Review*, no. 39 (May–June 1978), pp. 11–36.

5. Barbara Ehrenreich, *The Hearts of Men* (New York: Doubleday, 1982).

6. Carol Brown, "Mothers, Fathers and Children: From Private to Public Patriarchy," in Sargent, op. cit., pp. 239–69.

7. Cf. Ann Ferguson, "Reconceiving Motherhood: A Feminist Historical Materialist Account," in Joyce Trebilcot, ed., *Mothering: Essays in Feminist Theorizing* (Totowa, N.J.: Rowman and Allenheld, 1983), pp. 153–84.

8. See Michelle Barrett, *Women's Oppression Today* (London: Verson Editions, New Left Books, 1980), chapter 7.

9. Frances Fox Piven, "Women and the State: Ideology, Power and the Welfare State," *Socialist Review* vol. 14, no. 2 (March–April 1984), pp. 13–22.

10. Piven, p. 16.

11. Nancy Fraser, "Women, Welfare, and the Politics of Need Interpretation," *Hypatia: A Journal of Feminist Philosophy*, vol. 2, no. 1 (Winter 1987), pp. 103–22.

12. See Frances Fox Piven and Richard Cloward, *The New Class War* (New York: Pantheon Books, 1982).

A Fear and a Hope

For more than two years, between 1980 and 1982, when I lived in North-ampton, Massachusetts, I was a member of the editorial collective of a local feminist newspaper, *The Valley Women's Voice.* I cherish that experience, the most intense involvement I have had in a feminist group either before or since. I discovered that I liked being a reporter, finding out about a local nurses' strike or the strike of university clerical workers, or writing up the lecture of a feminist woman from Brazil. Putting out a whole newspaper once a month was an arduous task—developing story ideas; going out and getting the stories; soliciting or writing them; getting photos, drawings, and above all ads; editing; laying the paper out and pasting it up. We always felt in crisis but also fired up, and we celebrated every month when the issue hit the stands. My friends in the Pioneer Valley tell me that the paper is still publishing.

As a feminist collective, we had intense and reflective relationships with one another, involving both love and anger. Besides getting out the news-paper, we spent countless hours talking about our structure and process, our lesbian–straight tensions, our just plain competitiveness and jealousy, our ways of giving and accepting criticism, why we didn't have women of color or older women in our collective. We spent at least as many hours laughing, going to potlucks, and having women's dances to benefit the paper.

I wrote the following piece after hearing Tatyana Mamonova, exiled Russian feminist, speak at Amherst College in November 1980. She had recently arrived in the United States, where she was touring with Robin Morgan to tell Americans about her part in publishing an underground feminist magazine and about the situation of women in the Soviet Union. I was grateful to hear a first-person account of women's lives and struggles there, but I also worried about the ambiguous political context that any discussion of the Soviet Union has in the United States, especially then, before *glasnost* and *perestroika.*

We all sat together in a stuffy glaring room, Americans facing you, meeting in a modest womanly way across the gulf and terror of superpower politics. I listened, Tatyana, to your measured report of the oppression of women in your country, so like our own.

I thought, you, we, here in this room, may be sisters, but some in my country may use you and misunderstand you, and they may not know it and you may not know it. To the American press a Soviet dissident is a Soviet dissident. There are no distinctions, there are only those who have rushed to the arms of the Free World. Will they remember that you were pushed?

Your picture has been in the *Boston Globe*, *The New York Times*, and many more papers to come. Feted here, interviewed there, you have fast become a small celebrity. How much of this, I wonder, is for your feminism? And how much is the self-congratulatory chauvinism of a nation nearly united in its anticommunism?

Your pain has been great, Tatyana, and your repression mighty. But I think of our feminist sisters, living and dead, under the lawless rulers of nations of unfathomable horror—in Chile, El Salvador, Brazil, Thailand, Indonesia, and so many others to which my country sends guns and money. If these women escaped to tell their stories, would they be received by Amherst College and the Women's Congressional Caucus?

As a young girl you learned of your revolution as the dawn of world socialism, just a I learned of my country's revolution as the birth of democracy. You and I walked separate dusty roads of disillusionment, those ideals of socialism and democracy lying along them like dead branches. Now our paths meet here in our feminism.

I have a cloudy vision of our democratic socialist society, barely visible, but it is necessary to hope. In this society work and beauty are not divorced, and I have a real voice in the rules I must follow and the plans my work enacts. No men are the authoritative experts, because we have excised the authority of expertism. In our government there are positions of great responsibility that pay no more than a wage for a comfortable life, and in these positions a person will be immediately recalled if she does not promote the policies her electors have sent with her.

In this democratic socialist feminist society we design only useful things, for their beauty and durability, and in such a way that neither their production nor their consumption poisons us. All who can work do; hence none of us has to work so much. Children are not segregated from us in pens of forty apiece. They learn to read, write, and reason, and they too work at useful tasks. The children are present everywhere, lending their imaginations to our plans and our games, and we women do not have the sole responsibility of seeing to their welfare.

There is no rape.

We eat well, but cooking is no longer the unpaid work of women. In our society all work is recognized and rewarded, including the labor of birthing itself. We have comfortable rooms to live in and common spaces where we talk, plan festivals, and make movies together.

In our democratic socialist feminist society the streets are not stuffed

with cars spewing smelly sulfuric soot. We have clean-running speedy buses and trains going everywhere that one cannot go with a bicycle.

In place of many black asphalt slabs we have grassy lanes where women stroll with arms around each other.

We may be dreamers, Tatyana, but the best things are done by dreamers.

Part Two

The Politics of Difference

FIVE

Humanism, Gynocentrism, and Feminist Politics

December 1978. At a mostly male conference I hug, chat, eat, drink, listen with my sisters in philosophy. My body avalanches from its recent maternal swellings to the plateaus of a folded uterus, milkless breasts. I left my baby daughter in Chicago, who used to suckle for ninety minutes at a time while I read *The Women's Room.* For the first time in fifteen months that warm red flow moves through my clitoral canals. No quiet transition, but a body revolution throbbing my back and neck. Clouded in this private woman-state, I glide around the chandeliered ballroom finding one woman's face and another and another. Fervently we converse about the day's papers and one another's questions. We catch up on the news about one another's lovers or children or jobs.

That night in my restless sleep, I dream. A ballroom filled with women, hundreds under the chandeliers, a reception after business at the Society for Women in Philosophy. I flit from one group of women to another in smiling comfort. As I turn to find another friend I see her tall figure across the room, as though overlooking the sisterly crowd: Simone de Beauvoir. Then, just before I wake, a single object, shimmering: a glass of milk.

No other woman can so occupy our dreams as the mother of feminist philosophy (who in her time, in her view, could be a writing mother only by leaving her body out of mothering, and I think she was right). Yet most feminists in the United States today find irredeemable flaws in Beauvoir's story of women's oppression and her hope for liberation. What has happened between the childhood and puberty of our feminist revolution?

In this essay I explore the shift in feminist thinking from a Beauvoirian sort of position, which I define as humanist feminism, to an analysis that I call gynocentric feminism. Humanist feminism defines women's oppression as the inhibition and distortion of women's potential by a society that allows the self-development of men. Most feminists of the nineteenth and twentieth centuries, including feminists of the early second wave, have been humanist feminists. In recent years a different account of women's oppression has gained influence, however, partly growing from a critique of humanist feminism. Gynocentric feminism defines women's oppression as the devaluation and repression of women's experience by a masculinist culture that exalts violence and individualism. It argues for the superiority

of the values embodied in traditionally female experience and rejects the values it finds in traditionally male dominated institutions. Gynocentric feminism, I suggest, contains a more radical critique of male dominated society than does humanist feminism. But at the same time, especially within the social context of antifeminist backlash, however, its effect can be quieting and accommodating to official powers.

I

Humanist feminism consists of a revolt against femininity. Patriarchal culture has ascribed to women a distinct feminine nature by which it has justified the exclusion of women from most of the important and creative activity of society—science, politics, invention, industry, commerce, the arts. By defining women as sexual objects, decorative charmers, and mothers, the patriarchal culture enforces behavior in women that benefits men by providing them with domestic and sexual servants. Women's confinement to femininity stunts the development of their full potential and makes women passive, dependent, and weak. Humanist feminism defines femininity as the primary vehicle of women's oppression and calls upon male dominated institutions to allow women the opportunity to participate fully in the public world-making activities of industry, politics, art, and science.

Women's liberation, in this view, consists of freeing women from the confines of traditional femininity and making it possible for women to pursue the projects that have hitherto been dominated by men. Any assumptions that women are not capable of achieving the excellence that men have attained must be suspended until women are allowed to develop their full potential. When gender differences are transcended in this manner, people will be able to choose whatever activities they wish to pursue, will be able to develop their full potential as individuals. Women's liberation consists of eliminating a separate women's sphere and giving women the opportunity to do what men have done. This implies that men will have to do more of the work traditionally assigned to women.

I call this position humanist feminist because it defines gender difference as accidental to humanity. The goal of liberation is for all persons to pursue self-development in those creative and intellectual activities that distinguish human beings from the rest of nature. Women's liberation means sexual equality. Sexual equality means bringing women and men under a common measure, judged by the same standards. We should judge all by the standards according to which men have judged one another: courage, rationality, strength, cunning, quick-wittedness.

Humanist feminism, in one version or another, has dominated feminist accounts for most of the nineteenth and twentieth centuries. The feminist classics of Wollstonecraft, Mill, and Taylor, as well as the views of many of the suffragettes in nineteenth-century England and the United States, exhibit the main outlines of humanist feminism. Until recently humanist feminism was also the dominant strain in contemporary feminism. Simone

de Beauvoir's description of the oppression of women and her vision of liberation in *The Second Sex* stands as one of the most theoretically grounded and thorough articulations of humanist feminism.[1]

Beauvoir's account of women's oppression depends on the distinction between transcendence and immanence. Transcendence designates the free subjectivity that defines its own nature and makes projects that bring new entities into the world. The free subject moves out into the world, takes initiative, faces the world boldly, creates his own individualized life. According to Beauvoir, patriarchal society allows only men such transcendence. Masculinity entails no particular attributes but in patriarchal society is identified with transcendence, free activity that fashions artifacts and history. A man is confined to no particular nature but has all manner of projects open to him—he can be a soldier or an artist, a politician or a chef, a scientist or a gambler. To be sure, Beauvoir understands the class and race oppression that puts more limits on the possibilities of some men than on those of others. Gender does not restrict oppressed men, however. The possibility of action is still open to oppressed men, in the form of wily sabotage or open rebellion. Masculinity entails individual existence, where the person defines his own individual projects and creates his own nature.

Patriarchal culture confines women, on the other hand, to immanence. Immanence designates being an object, a thing with an already defined nature lined up within a general category of things with the same nature. Femininity is an essence, a set of general attributes that define a class, that restricts women to immanence and to being defined as the Other. Whereas a man exists as a transcending subject who defines his own individual projects, patriarchal institutions require a woman to be the object for the gaze and touch of a subject, to be the pliant responder to his commands.

Beauvoir discusses several respects in which femininity confines women's existence to immanence and the repetition of the species rather than individual existence. She finds female biology itself in part responsible for rooting women in immanence; women's reproductive processes limit their individual capacities for the sake of the needs of the species. But gender determines women's oppression more significantly than does biology. Whatever might be her position in the world and whatever her individual accomplishments, a women is appraised first *as a woman*, and only afterward for her position or accomplishments. Others will evaluate her beauty or lack of it; ascertain whether her clothes are tasteful and becoming; determine whether her smiles, gestures, and manner of speech exhibit charm. Whether a woman conforms to the requirements of feminine attractiveness, is indifferent to them, or rebels against them, both her and other people's attitudes toward her will be determined by this definition. Women have been barred from the important business of government and commerce, or from fashioning products that achieve recognition, and instead have been expected to expend most of their energy keeping a home for husband and children. From early childhood women learn that the world of individual achievement is closed to them and that their primary vocation is to

please and serve men. Thus women learn to be deferential, accommodating, and attentive to the desires of others.

The expectations of femininity that circumscribe the lives of women inhibit the development of their possibilities. Beauvoir describes how in their childhood, girls learn early that the world of action and daring is closed to them, learn not to move freely and openly and do not develop an ability to fight.[2] Women's sexual being is clouded with masochism, a desire to love the strong actor but not to be actors themselves.[3] Women often become timid and lacking in confidence, or fear that success will conflict with their femininity.

More than merely inhibiting possibilities, in Beauvoir's account femininity often produces mutilated or deformed persons. In my view this is the most ingenious aspect of Beauvoir's account. She explains characteristics that many have found undesirable about women as the effects of imprisonment in femininity. Despite the culture's denial, women are subjects, full of creative energy, intelligence, and the desire to make their mark on the world. Patriarchal institutions, however, restrict their recognized activity to caring for their appearance, for a household, and for children. Women thus channel their creativity into these activities. They try to make a project out of turning themselves into mannequins; keeping a house clean, orderly, and pleasing; and rearing children. These activities, however, belong to immanence, to objectification and mere life maintenance. Trying to make them the freely chosen projects of a transcending subject only produces a monstrous caricature of expressiveness and individuality: the haughty vanity of a woman preoccupied with her image in the mirror; the shrewish woman who will not allow living action to occur in her house, for fear that it will soil the rug or knock over a plant; the clutching mother who tries to mold her child's life according to her own plan.

To summarize, Beauvoir defines women's oppression as the confinement and mutilation of women's potentialities by patriarchal requirements that she be a pleasing and deferential object for men. Unlike femininity, masculinity does not entail confinement to an essence or nature, but the freedom to make oneself and assert oneself in the world. Women's liberation consists of freeing women from the confines of traditional femininity and making it possible for women to pursue the projects that have hitherto been dominated by men.

While Beauvoir's book remains one of the most sensitive, thorough, and theoretically grounded descriptions of women's oppression under patriarchy, most feminists today find it deeply marred by at least two related factors: Beauvoir does not call into question the definition of being human that traditional Western society holds, and she devalues traditionally female activity in the same way as does patriarchal culture.

Beauvoir fiercely rails at the male privilege that restricts such transcendence to men, but she does not question the value of the activities through which men compete with one another and achieve recognition. Power, achievement, individual expression, rationality, mastery of natural pro-

cesses are for her, as for the patriarchal culture she criticizes, the most human values. She is a socialist, of course, and therefore asserts that the achievement of full humanity by both men and women requires the elimination of capitalist domination. She calls for participation of women in these public world-making achievements but does not question the prominence that male-dominated society gives to achievement itself and to public activities of politics, competition, and individual creativity.

Beauvoir's humanism identifies the human with men. She points out in several places that whereas women experience a contradiction between being human and being feminine, men do not experience such a contradiction. The other side of her impressive and often sympathetic account of how patriarchy has victimized women is her description of the free subjectivity that she claims it gives to men. Boys roam, climb, play rough, and, very important for Beauvoir, learn to fight.

> Violence is the authentic proof of each one's loyalty to himself, to his passions, to his own will; radically to deny this will is to deny oneself any objective truth, it is to wall oneself up in an abstract subjectivity; anger or revolt that does not get into the muscles remains a figment of the imagination. It is a profound frustration not to be able to register one's feelings upon the face of the world. (p. 371)

Men are allowed, encouraged to be daring, to reach out and accomplish a project. Men are supposed to be rational, inventive, and creative. Thus, the great achievements of humanity have been accomplished almost entirely by men: exploring the world, charting and mapping it, formulating theories of the universe, writing great plays, developing constitutions and ruling cities and states. Even less-renowned or -accomplished men have a privilege not accorded to women, the privilege of being in public; they can achieve some public recognition in the workplace, among comrades or cronies at the bar. Men's situation allows or encourages them to be free subjects, transcending the given to bold new futures, confronting other subjects as equals.

The distinction between transcendence and immanence ensnares Beauvoir in the very definition of woman as a nonhuman Other, which her brilliant analysis reveals as patriarchal. Defining humanity as transcendence requires setting a human being in opposition to nonhuman objects and in particular nature. Fully human, free subjectivity transcends mere life, the processes of nature that repeat in an eternal cycle without individuality or history. Thus, risking life and being willing to kill are cardinal marks of humanity for Beauvoir as for Hegel. Taking control of one's needs and fashioning objects to satisfy them, confronting and mastering the forces of nature that threaten one's life or comfort—these are the aims of human projects.[4] Humanity achieves its greatest freedom, however, in the creation of moral ideals and works of art, for these express a wholly new and unnatural way of being in the world. Beauvoir's ontology reproduces

the Western tradition's oppositions of nature and culture, freedom and mere life, spirit and body.

With those distinctions Beauvoir brilliantly shows that patriarchal culture has projected onto women all those aspects of human existence that participate in mere life. She does not, however (as Dinnerstein, rereading her later, does), call upon a transformation of culture in the direction of a greater acceptance of life, the body, and mortality.[5] Instead, she herself devalues women's lives insofar as she finds them closer to nature and the body than men's.

Beauvoir mirrors patriarchal culture in her exposition of the experiences of the female body. The young girl finds her puny clitoris less glorious than the boy's more apparent penis. At puberty girls react to menstruation with shame and disgust, though Beauvoir asserts this is due to the social status of femininity rather than to any natural reaction. Female sexuality is passive and masochistic:

> Feminine sex desire is the soft throbbing of a mollusk. Whereas a man is impetuous, woman is only impatient; her expectation can become ardent without ceasing to be passive; man dives upon his prey like the eagle and the hawk; woman lies in wait like the carnivorous plant, the bog, in which insects and children are swallowed up. She is absorption, suction, humus, pitch and glue, a passive influx vaguely feels herself to be. (p. 431)[6]

Pregnancy is an "ordeal" (p. 559) in which the woman submits to the species and must suffer limitations on her capacity to individualize herself. Beauvoir expresses with understanding and sympathy how many women take pleasure in pregnancy and nursing. But clearly she regards such pleasures as examples of women's resignation to their condition of immanence, one among many ways women agree to relinquish their freedom.[7] That pregnancy itself can be a human project is impossible in her ontological framework.[8]

Beauvoir also devalues traditionally feminine activity, such as housework and mothering. The woman is imprisoned in her home, and since she is deprived there of activity, she loses herself in things and becomes dependent on them. Though she recognizes that housework and mothering are arduous and important tasks, in her account they have no truly human value. Housework has a negative basis: one gets rid of dirt, eliminates disorder, and in performing it the woman is condemned to endless repetition that results in no product, no work. Beauvoir finds cooking to be something of an exception here and explains that women thus rightly take pride in culinary achievements; but even these are only to be consumed, not to stand as lasting artifacts.

As a wife, the woman is abjectly dependent, not in control of her life. This makes her dangerous for rearing children, since she tends to be smotheringly possessive or brutally resentful. Even the best of mothers, in Beauvoir's account, do not attain transcendence—that is, fully humanity—by

caring for and loving their children; they only make it possible for their children to do so. Beauvoir thus devalues women's reproductive labor.[9]

Beauvoir's concrete descriptions of women's lives are full of insights, sympathy, and an understanding of the variations in each individual existence. (She does not, however, systematically examine variations in women's situation due to structural considerations such as class and race.) The overall picture she offers, however, portrays woman only as victim— maimed, mutilated, dependent, confined to a life of immanence, and forced to be an object. She rarely describes the strength that women have had and the earthly value of their work: ways women have formed networks and societies among themselves, the lasting beauty of the caring social values women often exhibit. While she expresses outrage at the selfishness, blindness, and ruthlessness of the men who benefit from the mutilation of the personhood of half the human race, she finds little to criticize in the modern humanist conception of individuality and freedom.

II

Gynocentric feminism defines the oppression of women very differently from humanist feminism. Women's oppression consists not of being prevented from participating in full humanity, but of the denial and devaluation of specifically feminine virtues and activities by an overly instrumentalized and authoritarian masculinist culture. Unlike humanist feminism, gynocentric feminism does not focus its analysis on the impediments to women's self-development and the exclusion of women from spheres of power, prestige, and creativity. Instead, gynocentric feminism focuses its critique on the values expressed in the dominant social spheres themselves. The male-dominated activities with the greatest prestige in our society—politics, science, technology, warfare, business—threaten the survival of the planet and the human race. That our society accords these activities the highest value only indicates the deep perversity of patriarchal culture. Masculine values exalt death, violence, competition, selfishness, a repression of the body, sexuality, and affectivity.

Gynocentric feminism finds in women's bodies and traditionally feminine activity the source of more positive values. Women's reproductive processes keep us linked with nature and the promotion of life to a greater degree than men's. Female eroticism is more fluid, diffuse, and loving than violence-prone male sexuality. Our feminine socialization and traditional roles as mothers give to us a capacity to nurture and a sense of social cooperation that may be the only salvation of the planet. Gynocentric feminism thus defines the oppression of women quite differently from the way humanistic feminism defines it. Femininity is not the problem, not the source of women's oppression, but indeed within traditional femininity lie the values that we should promote for a better society. Women's oppression consists of the devaluation and repression of women's nature and female activity by the patriarchal culture.

In distinguishing between humanist feminism and gynocentric feminism I intend to mark out two tendencies or poles of feminism, which are held in various forms and degrees by different feminists. Feminism of the nineteenth century in the United States was marked by an oscillation between humanist and gynocentric feminism. For most of the period of the suffrage movement the humanist position prevailed, but the movements of moral motherhood and social housekeeping had a more gynocentric cast. In contemporary feminism both tendencies have been present, often in uneasy union. Nevertheless I think it is appropriate to distinguish periods of contemporary feminism when one of these tendencies has been stronger. Until the late 1970s feminism in the United States was predominantly humanist feminism, but in the mid- and late 1970s feminism has shifted more in the direction of gynocentrism.

The distinction between humanist feminism and gynocentric feminism cannot be mapped onto the more commonly held way of classifying feminism as liberal, radical, or socialist. The set of positions often referred to as liberal feminism is indeed a species of humanist feminism, and to the degree that these positions are still held by many feminists, humanist feminism is still a strong tendency among feminists. Many of those who called themselves radical feminists in the early and mid-'70s, however, asserted something similar to the humanist feminist position I have identified as Beauvoir's. They found women's oppression located primarily in confinement to femininity, which they claimed made women dependent on men and inhibited women's self-development, and they often called upon women to develop skills and attributes traditionally associated with men—physical strength, mechanical ability, assertiveness, etc. Similarly, until recently most feminists who called themselves socialist feminists held humanist-feminist positions like that of Beauvoir. They took socialism as a necessary but not sufficient condition of the self-development of all human beings, and took the goal of feminism to be the elimination of gender differences and the requirements of femininity that inhibit the full development of women's capacities.

Starting about the mid- to late '70s, many of those called radical feminists and those called socialist feminists increasingly moved toward a more gynocentric feminism, and several of the writers treated in this section are self-identified socialist feminists. Those calling themselves radical feminists moved toward gynocentric analysis first, but by the late '70s this mode of feminism had become increasingly influential even among those who might in other ways be called liberal feminists. In the herstory of the contemporary women's movement I find at least three factors that have produced this shift from humanistic to gynocentric feminism: antifeminist reaction to feminism, the emergence of black feminism, and the development of women's history and feminist anthropology.

Antifeminists have identified feminism solely with humanist feminism. In their perception feminists eschew femininity, devalue traditional wom-

anhood, and want to be equal to—that is, like, in identity with—men. Antifeminists women have sneered at such a naïve claim to eliminate difference and have argued without difficulty that treating men and women equally will often lead to injustice for women.[10] Early during the second wave of the women's movement, moreover, antifeminists protested what they regarded as feminist denigration of women. Many women take pride in the homes they decorate and bring warmth to and regard their caring for children as a noble vocation, they claimed. They dress well and do their hair to please themselves, not because men require it of them. How dare you feminists claim that these activities lack value, entail imprisonment?, they exclaimed. Furthermore, they asserted, we don't want to be like men —competitive, unfeeling, getting high blood pressure and ulcers at the office or cancer in the factory. Antifeminists still screech this line, even though contemporary feminism has changed considerably in response to such protests of antifeminist women.

One of the first jobs of black feminists was to attack the victim/dependent image of women's situation that held sway in the women's movement in the early '70s. Our women, they said, have rarely had the luxury to be housewives, kept relatively comfortably by men, having their capacity to act smothered by diapers, corsets, and girdles. On the contrary, to survive black women typically learned to be tough, physically strong, clever, but usually also warm, sexy, and nurturant. Black women have suffered endless injustice and humiliation, but it has not maimed their spirits, for they have acted with brilliance, courage, and righteousness.[11] Through such discussion the women's movement learned that the typical account of femininity as entailing weakness and dependence had a class and race bias.

The work of feminist historians also promoted awareness of the differences in women's situations and the historical specificity of bourgeois femininity, as well as a sense of women as active participants in history. We discovered the mother rulers of Mycenae and the wisdom of the witches. We found that in most cultures women's work contributes as much as or more than men's work does to the subsistence of the family and village, and we recovered the contributions women have made to agricultural development, diplomacy, healing, art, literature, music, philosophy. We reconstructed the lives of peasant and proletariat women and saw them as providing crucial strength and foci of resistance for dominated classes. From the protests of some feminists against the humanist image of women as forced to be inactive and less than human, and from these concrete studies of women's lives and action, a new focus on the positivity of women's culture was born.

Gynocentric feminism has received a number of expressions in the United States women's movement in recent years. Artists and poets have been among the leaders in developing images of celebration of this more positive understanding of women's history and contemporary self-understanding. Judy Chicago's *The Dinner Party*, for example, laboriously and

beautifully recovers whole aspects of women's history and locates them within images of female genitalia and objects that rely on traditionally female arts.

Within the sphere of political activism, gynocentric feminism perhaps is best represented in the feminist antimilitarist and ecology movements of the past five years. In the Women's Pentagon Action or the action at the Seneca Army Depot, for example, a major aspect of the political protest has been the use of symbols and actions that invoke traditional labor, such as weaving, spinning, birthing, mothering. Feminist antimilitarist and ecological analysis has argued that the dangers to the planet that have been produced by the nuclear arms race and industrial technology are essentially tied to masculinist values.[12] The burgeoning movement of feminist spirituality entails a similar analysis and promotes values associated with traditional femininity.

A number of prominent recent theories of contemporary feminism express a gynocentric feminism. I see Susan Griffin's *Woman and Nature*[13] as one of the first written statements of gynocentric feminism in the second wave. It shows that one of the first steps of gynocentrism is to deny the nature/culture dichotomy held by humanists such as Beauvoir and to affirmatively assert the connection of women and nature. Daly's *Gyn/Ecology*[14] I see as a transition work. In it Daly asserts an analysis of the victimization of women by femininity that outdoes Beauvoir, but she also proposes a new gynocentric language.

Carol Gilligan's critique of male theories of moral development has had a strong influence on the formation of gynocentric analysis.[15] She questions dominant assumptions about moral valuation and affirms forms of moral reasoning associated with traditional femininity. Following Chodorow, she argues that gender socialization creates in women a relational communal orientation toward others, while it creates in men a more oppositional and competitive mode of relating to others. These gender differences produce two different forms of moral rationality: a masculine ethic of rights and justice, and a feminine ethic of responsibility and care. Traditional moral theory has ignored and repressed the particularistic ethic of care as being pre-moral. Women's moral oppression consists of being measured against male standards, according to Gilligan, in the silencing of women's different voice. The dominance of those male centered values of abstract reasoning, instrumentality, and individualism, moreover, produce a cold, uncaring, competitive world. Both the liberation of women and the restructuring of social relations require tempering these values with the communally oriented values derived from women's ethic of care.[16] While Gilligan herself would reject the label of gynocentric feminist, her work has exerted an enormous influence on feminists in fields as diverse as mathematics and philosophy, providing the foundation for a revaluation of attributes associated with femininity.

Mary O'Brien[17] articulates a gynocentric critique of traditional political

theory starting from the biological fact that the reproductive process gives women a living continuity with their offspring that it does not give men. Women thus have a temporal consciousness that is continuous, whereas male temporal consciousness is discontinuous. Arising from the alienation from the child they experience in the reproductive process, masculine thought emphasizes dualism and separation. Men establish a public realm in which they give spiritual birth to a second nature, transcending the private realm of mere physicality and reproduction to which they confine women. Patriarchy develops an ideology of the male potency principle, which installs the father as ruler of the family and men as rulers of society, and substitutes an intellectual notion of creativity for the female principle of life generation. The contemporary women's movement has the potential to overturn such a conception of politics that is separated from life continuity because out of female reproductive consciousness can come a politics based on women's experience of life processes and species continuity.

Nancy Hartsock's theory of the feminist standpoint from which she analyzes patriarchal culture is a more sweeping version of gynocentric feminism. She argues that the sexual division of labor provides men and women with differing experiences that structure different standpoints upon nature and social relations. Based on Chodorow's theory of the development of gender personalities, Hartsock argues that men experience the relation of self and other as one of hostility and struggle. The sexual division of labor also removes men from the needs of the body, from the vulnerability and basic demands of children and the aged, and provides men with an instrumentally calculative relation to nature. This division of labor, she argues, produces a way of thinking about the world that Hartsock calls abstract masculinity, which organizes experience and social relations into binary oppositions in which one term carries greater value than the other. This standpoint of abstract masculinity has determined the primary structure of Western social relations and culture. This male dominated culture's values are both partial and perverse. It embodies sexuality where desire for fusion with the other takes the form of domination of the other. Masculine consciousness denies and fears the body and associates birth with death. The only sense of community generated by abstract masculinity, moreover, is the community of warriors in preparation for combat.

From women's experience, Hartsock claims, we can both criticize masculinist values and conceptualization and develop a better vision of social relations. The gender personalities women develop in relation to their mothers give them a propensity to feel more connected with others than men do. The experiences of menstruation, coitus, pregnancy, and lactation, which challenge body boundaries, give women a greater experience of continuity with nature. Women's labor in caring for men and children and producing basic values in the home, finally, gives them a greated rootedness in nature than men's work gives them, a more basic understanding of life processes. These attributes of women's experience can ground, Hartsock

argues, a form of conceptualization that does not depend on dichotomous thinking and that values connections among persons more than their separation, as does abstract masculinity.[18]

While Sara Ruddick is careful to claim that any recovery and revaluation of traditionally feminine attributes must be infused with a feminist politics, her notion of maternal thinking provides another example of a gynocentric feminist analysis. She argues that the specific daily practices of mothering generate specific modes of thinking motivated by the interests in preservation, growth, and the acceptability of the child to the society. Maternal practice is not restricted to mothers, but exists wherever such nurturing and preservation interests prevail. She suggests that maternal thinking provides antimilitarist values that feminists can use in promoting a politics of peace.[19]

Writing within a very different intellectual current from American feminists, using rather different assumptions and style, several women in France in recent years have developed distinctive versions of gynocentric feminism. I shall mention only Luce Irigaray and Julia Kristeva. Like a number of other contemporary French thinkers, Irigaray describes phallocentric culture as preoccupied by a metaphysics of identity dominated by visual metaphors. Male thinking begins by positing the One, the same, the essence, that generates binary oppositions in which the second term is defined by the first as what it is not, thus reducing it to its identity. Phallogocentric discourse defines the opposition male/female in just this way—woman is only not a man, a lack, a deficiency. Preoccupied with the straight, the true, the proper, men establish relations of property and exchange in which accounts are balanced. Women in the phallocentric system have been silenced and separated, exchanged as goods among men. Irigaray proposes that women must find and speak the specificity of female desire, which has completely different values from those of phallic thinking. Women's eroticism is neither one nor two but plural, as women's bodies themselves experience arousal and pleasure in a multiplicity of places that cannot all be identified. Touch, not sight, predominates, the autoeroticism of vaginal lips touching clitoris, of intimate bodies touching. A genuinely feminine language moves and twists, starts over again from different perspectives, does not go straight to the point. Such a language can displace the sterility and oppressiveness of phallogocentric categorization.[20]

Kristeva also focuses on language and the repression of specifically female experience. Language has two moments: the symbolic, the capacity of language to represent and define, to be literal; and the semiotic, those elements of language that slip and play in ambiguities and nuance. Certain linguistic practices, such as poetry, make most explicit use of the semiotic, but for the most part the playful, the musical in language is repressed in Western culture and the symbolic, rational, legalistic discourse rules. For Kristeva this repression concerns the repression of the body and the installation of order, hierarchy, and authority. Repression of the body and

the semiotic entails repression of the pre-oedipal experience of the maternal body before the subject emerges with a self-identical ego, as well as denial by the culture of the specificity and difference that the female body exhibits. Challenge to the dominant oppressions, to capitalism, racism, sexism, must come not only from specific demands within the political arena, but also from changing the speaking subject.

Kristeva finds in the repressed feminine the potential for such change, where feminine means at least two things: first, women's specific experience as female bodies, the daughters of mothers, and often mothers themselves, an experience of a decentered subject; second, the aspects of language and behavior Western culture has devalued and repressed: the poetic, rhythmic, musical, nurturant, and soothing, but also contradictory and shifting ways of being, that fickleness that women have been accused of. This revolution of the feminine Kristeva finds in a number of male avant-garde writers. The women's movement, however, also carries the possibility of displacing the rigidity of a subject that loves authority, provided that women do not fall into that humanist feminism by which they simply demand to get in on the masculinist power game.[21]

To summarize, humanist feminism defines femininity as the source of women's oppression and calls upon male-dominated institutions to allow women the opportunity to participate fully in public world-making activities of industry, politics, art, and science. In contrast, gynocentric feminism questions the values of these traditional public activities that have been dominated by men. Women's oppression consists not of being prevented from participating in full humanity, but of the denial and devaluation of specifically feminine virtues and activities by an overly instrumentalized and authoritarian masculinist culture. Femininity is not the problem for gynocentric feminism, and indeed in the source of a conception of society and the subject that can not only liberate women, but also all persons.

III

The polarity between humanist and gynocentric feminism might be considered part of the logic of feminism itself. Feminism consists of calling attention to and eradicating gender-based oppression. Humanism and gynocentrism are the two most obvious positions to take in that struggle. Either feminism means that we seek for women the same opportunities and privileges the society gives to men, or feminism means that we assert the distinctive value of womanhood against patriarchal denigration. While these positions need not be mutually exclusive, there is a strong tendency for both feminists and nonfeminists to make them so: Either we want to be like men or we don't.

I think that contemporary gynocentric feminism has a number of aspects that make it a better analysis than humanist feminism. At the same time, I think the swing toward gynocentrism has left behind some important

elements of feminist politics that humanist feminism has emphasized. We need to rethink our analysis, not to form a synthesis of the two, but to cook up a better mixture out of some of the old ingredients.

Since it was first uttered in the eighteenth century, humanist feminism has assumed the liberation of women as an extension of the values of liberalism. The ideal of universal humanity—that all persons have equal rights whatever their station or class—should be extended to women. To be sure, many humanist feminists, such as Beauvoir, have been socialists and have called for radical transformation of economic and political institutions. The argument for such socialism, however, is that only publicly controlled and democratic economic and political institutions will make it possible to realize the ideal of equality and self-development promised by liberalism. Even socialist versions of humanist feminism, then, stand in continuity with the modern humanist tradition insofar as it seeks to realize the values articulated by that tradition for all persons, including and especially women.[22]

Gynocentric feminism confronts humanist feminism on one of its core assumptions, namely, that the ideal for feminists is a universal humanity in which all persons equally realize their potential for self-development. Nearly every term in this sentence can be put to gynocentric feminist critique, but I will restrict myself to the notion of universal humanity. In the humanist feminist view uttered by Beauvoir, differences between men and women are socially enforced oppressions. In their humanity there is no essential difference between men and women, and we look forward to a society in which sex difference will make no difference.

Gynocentric feminism can reveal this ideal of universal humanity as both unrealistic and oppressive. This ideal proposes to measure all persons according to the formal standards of rationality and rights. But the material differences among persons determined by history, region, or bodies continue to operate, so some will measure differently. Only an explicit affirmation of difference and social plurality, gynocentric feminism suggests, offers the hope of overcoming sexism, racism, ethnic oppression. Such affirmation of difference is difficult and threatening, however, because it challenges modes of individual and community self-identification.

As I already pointed out in discussing Beauvoir, humanist feminism focuses its investigation primarily on women's situation and criticizes patriarchy because of its specifically destructive effect on women's lives, without questioning the dominant culture's basic assumptions about the good human life. Gynocentric feminism, on the other hand, takes a much broader look at our society. It seeks to uncover and throw into question some of the most basic assumptions of the Western tradition of thought of which modern humanism is a part—the distinction between nature and culture, spirit and body, the universal and particular. Gynocentric feminism links masuclinist culture's equation of humanity with rationality, on the one hand, and to the repression of life spontaneity and the development of an oppressive web of social controls and organizational hierarchy, on

the other. In these ways it is similar to and stands in the same category with critiques of Western culture uttered by Nietzsche, Adorno and Horkheimer, Foucault and Derrida.

As a result of its greater comprehensiveness, gynocentric feminism broadens its critique of our society beyond focus on specifically sexist institutions and practices and specific damage to women. Because it brings feminist critique to basic assumptions of the society as a whole, gynocentric feminism offers for the first time distinctively feminist analyses of social structures and forms of symbolization not tied to women in particular—such as racism, classism, the military, or the state. This has produced a broadened politics in which feminists participate as feminists in ecological, antimilitarist, antiracist struggles. Unlike humanist feminism, that is, gynocentric feminism has developed a perspective from which to criticize any institution or practice in our society, even if it does not distinguish women's specific oppression.

While gynocentric feminism is deeply radical in these ways, it also harbors some dangers to radical politics. Turning to femininity as the source of values by which to criticize patriarchal culture and form the image of a better society seems to lead to a disturbing essentialism. By "essentialism" I mean an account that theorizes women as a category with a set of essential attributes. O'Brien states that she describes the structure of womanhood in her articulation of the female mode of reproductive consciousness. Hartsock acknowledges historical and situational differences among women, but claims that feminist theory requires identifying common attributes of women's experience. Gynocentric feminists find these attributes in the same place as has patriarchy—in women's reproductive biology and the activity of mothering. Feminists antimilitarist and ecological analysis finds women more in touch with nature than men are because of the cycles and changes of our bodies, and more peace-loving because our nurturing impulses foster in us a love of life.

French theorists explicitly criticize feminist tendencies toward essentialism. On this account many of them reject the label "feminist." They fear replacing humanism, where universal humanity is projected as an ideal, with universal womanhood. "Woman" is a fiction, a metaphysical attempt to bring multiplicity into unity. The French theorists I have referred to nevertheless share some of the essentialist tendencies of gynocentric feminism in the United States. They rely on an opposition between the masculine and the feminine, even where, as in Kristeva, they do not necessarily associate these with men and women. Though these theories explicitly question Western dichotomous thinking, their use of the opposition of masculinity and femininity retains its traditional dichotomous terms, in revaluated form: the masucline is power, discursive rationality, calculation, abstraction, while the feminine is desire, sensuality, poetic language, immediacy of contact with nature. Like their counterparts across the ocean, these French theorists tend to reduce women's specificity to reproductive biology and the function of mothering,[23] though in some of her writing

Irigaray reaches toward a woman-to-woman relation beyond the mother–daughter cycle.

Gynocentrism's most important contribution is its affirmation of difference against humanism's claim of a universal humanity. Gynocentric feminism, however, still tends to see gender difference as a relation of inside and outside. We need a conception of difference that is less like the icing bordering the layers of cake, however, and more like a marble cake, in which the flavors remain recognizably different but thoroughly insinuated in one another.

Gynocentric feminism has rightly restored dignity to the character of women, shown how within our confined roles and despite often severe domination by men, we have made new things, contributed to historical events, struggled actively against our oppression, and formed networks of solidarity. It has been especially necessary to topple the stance of women as victims, weak, passive, and only partial human beings.

In its effort to recover self-respect, agency, and authentic subjectivity of women by finding greater value in traditional women's culture than in the dominant masculinist culture, however, gynocentric feminism tends to swing too far away from understanding women as confined or enslaved. It rejects too completely the Beauvorian claim that femininity inhibits, distorts, and mutilates women's lives. Gilligan's accent on women's traditional sovereignty in the private realm, where she cares for each person in her particularity, for example, fails to note how this ethic of care often leads women to a sacrificing stance that can make us easily hurt.

The gynocentric revaluation of traditional femininity can weaken the claim that women are oppressed. If women's labor has been as creative or more so than men's labor is, if women's networks and relations with children have been the source of values more life-giving than the public activities of men are, if female desire is more playful, less rigid than male desire is, what warrants the claim that women need liberating? To be sure, all gynocentric feminists find that men rule society and in so doing devalue and repress this feminine sphere. Such a way of conceptualizing male domination, however, mutes the outrage against injustice that humanist feminism exhibits because it claims that women are not simply devalued, but also damaged, by male domination.

Gynocentric feminism, moreover, tends to reject too categorically the value of the activities and ambitions traditionally associated with masculinity. Men have traditionally reserved for themselves the public activities of political position, recognized artist, inventor, or scientist, and have recognized only other men worthy to compete for the accolades that reward excellence. If the activities that men have dominated really are less valuable than those in which women have traditionally engaged, as gynocentric feminism suggests, of what does male privilege consist? The other side of gynocentrism's denial of the damaging consequences of femininity is its denial of the growth-promoting aspects of traditional masculinity. If we claim that masculinity distorts men more than it contributes to their self-

development and capacities, again, the claim that women are the victims of injustice loses considerable force.

Within the context of antifeminist backlash, the effect of gynocentric feminism may be accommodating to the existing structure. Gynocentric feminism relies on and reinforces gender stereotypes at just the time when the dominant culture has put new emphasis on marks of gender difference. It does so, moreover, by relying on many of those aspects of women's traditional sphere that traditional patriarchal ideology has most exploited and that humanist feminists such as Beauvoir found most oppressive— reproductive biology, motherhood, domestic concerns. Even though its intentions are subversive, such renewed attention to traditional femininity can have a reactionary effect on both ourselves and our listeners because it may echo the dominant claim that women belong in a separate sphere.

Humanist feminism calls upon patriarchal society to open places for women within those spheres of human activity that have been considered the most creative, powerful, and prestigious. Gynocentric feminism replies that wanting such things for women implies a recognition that such activities are the most humanly valuable. It argues that in fact, militarism, bureaucratic hierarchy, competition for recognition, and the instrumentalization of nature and people entailed by these activities are basic disvalues.[24]

Yet in contemporary society, men still have most institutionalized power, and gynocentric feminism shows why they do not use it well. If feminism turns its back on the centers of power, privilege, and individual achievement that men have monopolized, those men will continue to monopolize them, and nothing significant will change. Feminists cannot undermine masculinist values without entering some of the centers of power that foster them, but the attainment of such power itself requires at least appearing to foster those values. Still, without being willing to risk such co-optation, feminism can be only a moral position of critique rather than a force for institutional change.

Despite its intention, I fear that gynocentric feminism may have the same consequence as the stance of moral motherhood that grew out of nineteenth century feminism: a resegregation of women to a specifically women's sphere, outside the sites of power, privilege, and recognition. For me the symptom here is what the dominant culture finds more threatening. Within the dominant culture a middle-aged assertive woman's claim to co-anchor the news alongside a man appears considerably more threatening than women's claim to have a different voice that exposes masculinist values as body-denying and selfish. The claim of women to have a right to the positions and benefits that have hitherto been reserved for men, and that male dominated institutions should serve women's needs, is a direct threat to male privilege. While the claim that these positions of power themselves should be eliminated and the institutions eliminated or restructured is indeed more radical, when asserted from the gynocentric feminist position it can be an objective retreat.

Gynocentrism's focus on values and language as the primary target of its critique contributes to this blunting of its political force. Without doubt, social change requires changing the subject, which in turn means developing new ways of speaking, writing, and imagining. Equally indubitable is the gynocentric feminist claim that masculinist values in Western culture deny the body, sensuality, and rootedness in nature and that such denial nurtures fascism, pollution, and nuclear games. Given these facts, however, what shall we do? To this gynocentrism has little concrete answer. Because its criticism of existing society is so global and abstract, gynocentric critique of the values, language, and culture of masculinism can remove feminist theory from analysis of specific institutions and practices, and how they might be concretely structurally changed in directions more consonant with our visions.

NOTES

1. Simond de Beauvoir, *The Second Sex*, H. M. Parshley, trans. (New York: Random House, 1952); page citations from the 1974 Vintage paperback edition appear in the text.

2. See my paper "Throwing Like a Girl," in this volume, on the issue of assertiveness of the female body.

3. On femininity and masochism, compare Sandra Bartky, "Feminine Masochism and the Politics of Personal Transformation," *Women's Studies International Forum*, vol. 7, no. 5 (1984), pp. 323–34.

4. Nancy Hartsock, *Money, Sex and Power: Toward a Feminist Historical Materialism* (New York: Longman, 1983), appendix 2.

5. Dorothy Dinnerstein, *The Mermaid and the Minotaur* (New York: Harper and Row, 1976).

6. On Beauvoir's views of female sexuality, see Jo-Ann Pilardi, "Female Eroticism in the Works of Simone de Beauvoir," in Allen and Young, ed., *The Thinking Muse: Feminism and Modern French Philosophy* (Bloomington: Indiana University Press, 1989), pp. 18–34.

7. See Mary O'Brien, *The Politics of Reproduction* (Boston: Routledge and Kegan Paul, 1981), pp. 67–76.

8. For an understanding of pregnancy as a woman's project, see my paper "Pregnant Embodiment," in this volume.

9. Alison Jaggar and William McBride argue for this claim in their essay " 'Reproduction' As Male Ideology," *Women's Studies International Forum*, vol. 8, no. 3 (1985), pp. 185–96.

10. See, for example, Elizabeth G. Wolgast, *Equality and the Rights of Women* (Ithaca, N.Y.: Cornell University Press, 1978).

11. For two excellent examples of accounts of the strength of black women, see Carol B. Stack, *All Our Kin: Strategies for Survival in a Black Community* (New York: Harper and Row, 1975); and Angela Davis, *Women, Race and Class* (New York: Random House, 1981).

12. Lyn Blumenthal, et al., ed., *Heresies: A Feminist Publication of Art and Politics*, vol. 4, no. 1 (1981); this entire issue is devoted to articles and art works about feminism, environmentalism, and militarism; see also I. M. Young, "Review Essay: Feminism and Ecology," *Environmental Ethics*, vol. 5, no. 2 (1983), pp. 174–79.

13. Susan Griffin, *Woman and Nature: The Roaring Inside Her* (New York: Harper and Row, 1978).

14. Mary Daly, *Gyn/Ecology* (Boston: Beacon Press, 1978).

15. Carol Gilligan, *In a Different Voice* (Cambridge, Mass.: Harvard University Press, 1981).

16. See Carol Gould, "Private Rights and Public Virtues: Women, the Family and Democracy," in Carol Gould, ed., *Beyond Domination: New Perspectives on Women and Philosophy* (Totowa, N.J.: Rowman and Allenheld, 1983).

17. O'Brien, op. cit.

18. Hartsock, op. cit., especially chapter 10.

19. Sara Ruddick, "Maternal Thinking," *Feminist Studies*, vol. 6, no. 2 (1980), pp. 342–67; and "Preservative Love and Military Destruction," in Joyce Trebilcot, ed., *Mothering: Essays in Feminist Theory* (Totowa, N.J.: Rowman and Allenheld, 1984), pp. 231–62.

20. Irigaray's best text, in my opinion, is *Speculum of the Other Woman* (Ithaca, N.Y.: Cornell University Press, 1985), but the above remarks are also based on the important essays in *This Sex Which Is Not One* (Ithaca, N.Y.: Cornell University Press, 1985). For useful responses to Irigaray, see Jane Gallop, *The Daughter's Seduction* (Ithaca, N.Y.: Cornell University Press, 1981); Elizabeth L. Berg, "The Third Woman," *Diacritics*, vol. 12, no. 2 (1982), pp. 11–20; and Eleanor Kuykendall, "Toward an Ethic of Nurturance: Luce Irigaray on Mothering and Power," in Trebilcot, op. cit., pp. 263–74.

21. For this account of Kristeva I am relying on the following texts primarily: "The Ethics of Linguistics," "From One Identity to an Other," "The Novel as Polylogue," and "Motherhood According to Giovanni Bellini," all in *Desire in Language*, Leon S. Roudiez, ed. (New York: Columbia University Press, 1980); "Woman Can Never Be Defined," in Marks and de Courtivron, ed., *New French Feminism* (New York: Schocken Books, 1981); and "Women's Time," *Signs*, vol. 7, no. 1 (1981), pp. 5–12.

22. See Zillah Eisenstein, *The Radical Future of Liberal Feminism* (New York: Longman, 1980).

23. For a critical look at the use of mother as metaphor by French theorists, see Donma Stanton, "Difference on Trial: A Critique of the Maternal Metaphor in Cixous, Irigaray, and Kristeva," in Allen and Young, ed., op. cit, pp. 156–79.

24. Kathy E. Ferguson, "Feminism and Bureaucratic Discourse," *New Political Science*, vol. 11 (1983), pp. 53–73.

Impartiality and the Civic Public

Some Implications of Feminist Critiques of Moral and Political Theory

Many writers seeking emancipatory frameworks for challenging both liberal individualist political theory and the continuing encroachment of bureaucracy on everyday life claim to find a starting point in unrealized ideals of modern political theory. John Keane, for example, suggests that recent political movements of women, oppressed sexual and ethnic minorities, environmentalists, and so on return to the contract tradition of legitimacy against the legalistic authority of contemporary state and private bureaucracies. Like many others, Keane looks specifically to Rousseau's unrealized ideals of freedom and cooperative politics.

> According to Rousseau, individualism could no longer be seen as consisting in emancipation through mere competitive opposition to others; its authentic and legitimate form could be constituted only through the communicative intersubjective enrichment of each bodily individual's qualities and achievements to the point of uniqueness and incomparability. Only through political life could the individual become this specific, irreplaceable individual "called" or destined to realize its own incomparable capacities.[1]

There are plausible reasons for claiming that emancipatory politics should define itself as realizing the potential of modern political ideals that have been suppressed by capitalism and bureaucratic institutions. No contemporary emancipatory politics wishes to reject the rule of law as opposed to whim or custom, or fails to embrace a commitment to preserving and deepening civil liberties. A commitment to a democratic society, moreover, can plausibly look upon modern political theory and practice as beginning the democratization of political institutions, which we can deepen and extend to economic and other nonlegislative and nongovernmental institutions.

Nevertheless, in this chapter I urge proponents of contemporary emancipatory politics to break with modernism rather than recover suppressed possibilities of modern political ideals. Whether we consider ourselves continuous or discontinuous with modern political theory and practice, of

course, can only be a choice, more or less reasonable given certain presumptions and interests. Since political theory and practice from the eighteenth to the twentieth centuries are hardly unified, making even the phrase "modern political theory" problematic, contemporary political theory and practice both continue and break with aspects of the political past of the West. From the point of view of a feminist interest, nevertheless, emancipatory politics entails a rejection of modern traditions of moral and political life.

Feminists did not always think this, of course. Since Mary Wollstonecraft, generations of women and some men wove painstaking arguments to demonstrate that excluding women from modern public and political life contradicts the liberal democratic promise of universal emancipation and equality. They identified the liberation of women with expanding civil and political rights to include women on the same terms as men, and with the entrance of women into the public life dominated by men on an equal basis with them.

After two centuries of faith that the ideal of equality and fraternity included women have still not brought emancipation for women, contemporary feminists have begun to question the faith itself.[2] Recent feminist analyses of modern political theory and practice increasingly argue that ideals of liberalism and contract theory, such as formal equality and universal rationality, are deeply marred by masculine biases about what it means to be human and the nature of society.[3] If modern culture in the West has been thoroughly male dominated, these analysis suggest, there is little hope of laundering some of its ideals to make it possible to include women.

Women are by no means the only group, moreover, that has been excluded from the promise of modern liberalism and republicanism. Many nonwhite people of the world wonder at the hubris of a handful of Western nations to have claimed liberation for humanity at the very same time that they enslaved or subjugated most of the rest of the world. Just as feminists see in male domination no mere aberration in modern politics, so many others have come to regard racism as endemic to modernity as well.[4]

In this chapter I draw out the consequences of two strands of recent feminist responses to modern moral and political theory and weave them together. Part 1 is inspired by Gilligan's critique of the assumption that a Kantian-like "ethic of rights" describes the highest stage of moral development, for women as well as men.[5] Gilligan's work suggests that the deontological tradition of moral theory excludes and devalues women's specific, more particularist and affective experience of moral life. In her classification, however, Gilligan retains an opposition between universal and particular, justice and care, reason and affectivity, which I think her insights clearly challenge.

Thus in part 1, I argue that an emancipatory ethics must develop a conception of normative reason that does not oppose reason to desire and affectivity. I pose this issue by questioning the deontological tradition's

assumption of normative reason as impartial and universal. I argue that the ideal of impartiality expresses what Theodor Adorno calls a logic of identity that denies and represses difference. The will to unity expressed by this ideal of impartial and universal reason generates an oppressive opposition between reason and desire or affectivity.

In part 2, I seek to connect this critique of the way modern normative reason generates opposition with feminist critiques of modern political theory, particularly as exhibited in Rousseau and Hegel. Their theories make the public realm of the state express the impartial and universal point of view of normative reason. Their expressions of this ideal of the civic public of citizenship rely on an opposition between public and private dimensions of human life, which corresponds to an opposition between reason, on the one hand, and to the body, affectivity, and desire on the other.

Feminists have shown that the theoretical and practical exclusion of women from the universalist public is no mere accident or aberration. The ideal of the civic public exhibits a will to unity and necessitates the exclusion of aspects of human existence that threaten to disperse the brotherly unity of straight and upright forms, especially the exclusion of women. Since man as citizen expresses the universal and impartial point of view of reason, moreover, someone has to care for his particular desires and feelings. The analysis in part 2 suggests that an emancipatory conception of public life can best ensure the inclusion of all persons and groups not by claiming a unified universality, but by explicitly promoting heterogeneity in public.

In part 3, I suggest that Habermas's theory of communicative action offers the best direction for developing a conception of normative reason that does not seek the unity of a transcendent impartiality and thereby does not oppose reason to desire and affectivity. I argue, however, that despite the potential of his communicative ethics, Habermas remains too committed to the ideals of impartiality and universality. In his conception of communication, moreover, he reproduces the opposition between reason and affectivity that characterizes modern deontological reason.

Finally, in part 4, I sketch some directions for an alternative conception of public life. The feminist slogan "the personal is political" suggests that no persons, actions, or attributes of persons should be excluded from public discussion and decision-making, although the self-determination of privacy must nevertheless remain. From new ideals of contemporary radical political movements in the United States, I derive the image of a heterogeneous public with aesthetic and affective, as well as discursive, dimensions.

I. The Opposition Between Reason and Affectivity

Modern ethics defines impartiality as the hallmark of moral reason. As a characteristic of reason, impartiality means something different from the pragmatic attitude of being fair, considering other people's needs and desires as well as one's own. Impartiality names a point of view of reason

that stands apart from any interests and desires. Not to be partial means being able to see the whole, how all the particular perspectives and interests in a given moral situation relate to one another in a way that, because of its partiality, each perspective cannot see itself. The impartial moral reasoner thus stands outside and above the situation about which he or she reasons, with no stake in it, or is supposed to adopt an attitude toward a situation as though he or she were outside and above it. For contemporary philosophy, calling into question the ideal of impartiality amounts to questioning the possibility of moral theory itself. I will argue, however, that the ideal of normative reason as standing at a point transcending all perspectives is both illusory and oppressive.

Both the utilitarian and deontological traditions of modern ethical theory stress the definition of moral reason as impartial.[6] Here I restrict my discussion to deontological reason for two reasons. Utilitarianism, unlike deontology, does not assume that there is a specifically normative reason. Utilitarianism defines reason in ethics in the same way as in any other activity: determining the most efficient means for achieving an end (in the case of ethics, the happiness of the greatest number). I am interested here in modern efforts to define a specifically normative reason. Second, I am interested in examining the way a commitment to impartiality results in an opposition between reason and desire, and this opposition is most apparent in deontological reason.

The ideal of an impartial normative reason continues to be asserted by philosophers as "the moral point of view." From the ideal observer to the original position to a spaceship on another planet,[7] moral and political philosophers begin reasoning from a point of view that they claim is impartial. This point of view is usually a counterfactual construct, a situation of reasoning that removes people from their actual contexts of living moral decisions to a situation in which they could not exist. As Michael Sandel argues, the ideal of impartiality requires constructing the ideal of a self abstracted from the context of any real persons: the deontological self is not committed to any particular ends, has no particular history, is a member of no communities, has no body.[8]

Why should normative rationality require the construction of a fictional self in a fictional situation of reasoning? Because this reason, like the scientific reason from which deontology claims to distinguish itself, is impelled by what Adorno calls the logic of identity.[9] In this logic of identity reason does not merely mean having reasons or an account, or intelligently reflecting on and considering a situation. For the logic of identity reason is *ratio*, the principled reduction of the objects of thought to a common measure, to universal laws.

The logic of identity consists of an unrelenting urge to think things together, in a unity, to formulate a representation of the whole, a totality. This desire itself is a least as old as Parmenides, and the logic of identity begins with the ancient philosophical notion of universals. Through the notion of an essence, thought brings concrete particulars into unity. As

long as qualitative difference defines essence, however, the pure program of identifying thought remains incomplete. Concrete particulars are brought into unity under the universal form, but the forms themselves cannot be reduced to unity.

The Cartesian ego founding modern philosophy realizes the totalizing project. This *cogito* itself expresses the idea of pure identity as the reflective self-presence of consciousness to itself. Launched from this point of transcendental subjectivity, thought now more boldly than ever seeks to comprehend all entities in unity with itself and in a unified system with one another.

But any conceptualization brings the impressions and flux of experience into an order that unifies and compares. It is not the unifying force of concepts per se that Adorno finds dangerous. The logic of identity goes beyond such an attempt to order and describe the particulars of experience. It constructs total systems that seek to engulf the alterity of things in the unity of thought. The problem with the logic of identity is that through it thought seeks to have everything under control, to eliminate all uncertainty and unpredictability, to idealize the bodily fact of sensuous immersion in a world that outruns the subject, to eliminate otherness. Deontological reason expresses this logic of identity by eliminating otherness in at least two ways: the irreducible specificity of situations and the difference among moral subjects.

Normative reason's requirement of impartiality entails a requirement of universality. The impartial reasoner treats all situations according to the same rules, and the more rules can be reduced to the unity of one rule or principle, the more this impartiality and universality will be guaranteed. For Kantian morality, to test the rightness of a judgment the impartial reasoner need not look outside thought, but only seek the consistency and universalizability of a maxim. If reason knows the moral rules that apply universally to action and choice, there will be no reason for one's feelings, interests, or inclinations to enter into the making of moral judgments. This deontological reason cannot eliminate the specificity and variability of concrete situations to which the rules must be applied; by insisting on the impartiality and universality of moral reason, however, it renders itself unable rationally to understand and evaluate particular moral contexts in their particularity.[10]

The ideal of an impartial moral reason also seeks to eliminate otherness in the form of differentiated moral subject. Impartial reason must judge from a point of view outside the particular perspectives of persons involved in interaction, able to totalize these perspectives into a whole, or general will. This is the point of view of a solitary transcendent God.[11] The impartial subject need acknowledge no other subjects whose perspectives should be taken into account and with whom discussion might occur.[12] Thus the claim to be impartial often results in authoritarianism. By asserting oneself as impartial, one claims authority to decide an issue, in place of those whose interests and desires are manifest. From this impartial point of view

one need not consult with any other, because the impartial point of view already takes into account all possible perspectives.[13]

In modern moral discourse, being impartial means especially being dispassionate: being entirely unaffected by feelings in one's judgment. The idea of impartiality thus seeks to eliminate alterity in a different sense, in the sense of the sensuous, desiring, and emotional experiences that tie me to the concreteness of things, which I apprehend in their particular relation to me. Why does the idea of impartiality require the separation of moral reason from desire, affectivity, and a bodily sensuous relation with things, people, and situations? Because only by expelling desire, affectivity, and the body from reason can impartiality achieve its unity.

The logic of identity typically generates dichotomy instead of unity. The move to bring particulars under a universal category creates a distinction between inside and outside. Since each particular entity or situation has both similarities with and differences from other particular entities and situations, and since they are neither completely identical nor absolutely other, the urge to bring them into unity under a category or principle necessarily entails expelling some of the properties of the entities or situations. Because the totalizing movement always leaves a remainder, the project of reducing particulars to a unity must fail. Not satisfied then to admit defeat in the face of difference, the logic of identity shoves difference into dichotomous normative oppositions: essence–accident, good–bad, normal–deviant. The dichotomies are not symmetrical, however, but stand in a hierarchy. The first term designates the positive unity on the inside; the second, less-valued term designates the leftover outside.[14]

For deontological reason, the movement of expulsion that generates dichotomy happens this way. As I have already discussed, the construct of an impartial point of view is arrived at by abstracting from the concrete particularity of the person in situation. This requires abstracting from the particularity of bodily being, its needs and inclinations, and from the feelings that attach to the experienced particularity of things and events. Normative reason is defined as impartial, and reason defines the unity of the moral subject, both in the sense of knowing the universal principles of morality and in the sense of what all moral subjects have in common in the same way. This reason thus stands opposed to desire and affectivity as what differentiates and particularizes persons. In the next section I will discuss a similar movement of the expulsion of persons from the civic public in order to maintain its unity.

Several problems follow from the expulsion of desire and feeling from moral reason. Because all feeling, inclinations, needs, desires become thereby equally irrational, they are all equally inferior.[15] By contrast, premodern moral philosophy sought standards for distinguishing among good and bad interests, noble and base sentiments. The point of ethics in Aristotle, for example, was precisely to distinguish good desires from bad and to cultivate good desires. Contemporary moral intuitions, moreover, still distinguish good and bad feelings, rational and irrational desires. As

Lawrence Blum argues, deontological reason's opposition of moral duty to feeling fails to recognize the role of sentiments of sympathy, compassion, and concern in providing reasons for and motivating moral action.[16] Our experience of moral life teaches us, moreover, that without the impulse of deprivation or anger, for example, many moral choices would not be made.

Thus as a consequence of the opposition between reason and desire, moral decisions grounded in considerations of sympathy, caring, and an assessment of differentiated need are defined as not rational, not "objective," merely sentimental. To the degree that women exemplify or are identified with such styles of moral decision-making, then, women are excluded from moral rationality.[17] The moral rationality of any other groups whose experience or stereotypes associate them with desire, need, and affectivity, moreover, is suspect.

By simply expelling desire, affectivity, and need, deontological reason finally represses them and sets morality in opposition to happiness. The function of duty is to master inner nature, not to form it in the best directions. Since all desiring is equally suspect, we have no way of distinguishing which desires are good and which bad, which will expand the person's capacities and relations with others, and which stunt the person and foster violence. In being excluded from understanding, all desiring, feeling, and needs become unconscious, but certainly do not thereby cease to motivate action and behavior. Reason's task thereby is to control and censure desire.

II. The Unity of the Civic Public

The dichotomy between reason and desire appears in modern political theory in the distinction between the universal, public realm of sovereignty and the state, on the one hand, and the particular private realm of needs and desires, on the other. Modern normative political theory and political practice aim to embody impartiality in the public realm of the state. Like the impartiality of moral reason, this public realm of the state attains its generality by the exclusion of particularity, desire, feeling, and those aspects of life associated with the body. In modern political theory and practice, this public achieves a unity in particular by the exclusion of women and others associated with nature and the body.

As Richard Sennett and others have written, the developing urban centers of the eighteenth century engendered a unique public life.[18] As commerce increased and more people came into the city, the space of the city itself was changed to make for more openness, vast boulevards where people from different classes mingled in the same spaces.[19] As Habermas has argued, one of the functions of this public life of the mid-nineteenth century was to provide a critical space where people discussed and criticized the affairs of the state in a multiplicity of newspapers, coffeehouses, and other forums.[20] While dominated by bourgeois men, public discussion in the coffeehouses admitted men of any class on equal terms.[21] Through

the institution of the salons, moreover, as well as by attending the theater and being members of reading societies, aristocratic and bourgeois women participated, and sometimes took the lead in such public discussion.[22]

Public life in this period appears to have been wild, playful, and sexy. The theater was a social center, a forum where wit and satire criticized the state and predominant mores. This wild public to some degree mixed sexes and classes, mixed serious discourse with play, and mixed the aesthetic with the political. It did not survive republican philosophy. The idea of the universalist state that expresses an impartial point of view transcending any particular interest is in part a reaction to this differentiated public. The republicans grounded this universalist state in the idea of the civic public, which political theory and practice institutionalized by the end of the eighteenth century in Europe and the United States to suppress the popular and linguistic heterogeneity of the urban public. This institutionalization reordered social life on a strict division of public and private.

Rousseau's political philosophy is the paradigm of this ideal of the civic public. He develops his conception of politics precisely in reaction to his experience of the urban public of the eighteenth century,[23] as well as in reaction to the premises and conclusions of the atomistic and individualist theory of the state expressed by Hobbes. The civic public expresses the universal and impartial point of view of reason, standing opposed to and expelling desire, sentiment, and the particularity of needs and interests. From the premises of individual desire and want we cannot arrive at a strong enough normative conception of social relations. The difference between atomistic egoism and civil society does not consist simply of the fact that the infinity of individual appetite has been curbed by laws enforced by threat of punishment. Rather, reason brings people together to recognize common interests and a general will.

The sovereign people embody the universal point of view of the collective interest and equal citizenship. In the pursuit of their individual interests people have a particularist orientation. Normative reason reveals an impartial point of view, however, that all rational persons can adopt, which expresses a general will not reducible to an aggregate of particular interests. Participation in the general will as a citizen is an expression of human nobility and genuine freedom. Such rational commitment to collectivity is not compatible with personal satisfaction, however, and for Rousseau this is the tragedy of the human condition.[24]

Rousseau conceived that this public realm ought to be unified and homogeneous, and indeed suggested methods of fostering among citizens commitment to such unity through civic celebrations. While the purity, unity, and generality of this public realm require transcending and repressing the partiality and differentiation of need, desire, and affectivity, Rousseau hardly believed that human life can or should be without emotion and the satisfaction of need and desire. Man's particular nature as a feeling, needful being is enacted in the private realm of domestic life, over which women are the proper moral guardians.

Hegel's political philosophy developed this conception of the public realm of the state as expressing impartiality and universality as against the partiality and substance of desire. For Hegel the liberal account of social relations, as based on the liberty of self-defining individuals to pursue their own ends, properly describes only one aspect of social life: the sphere of civil society. As a member of civil society, the person pursues private ends for himself and his family. These ends may conflict with those of others, but exchange transactions produce much harmony and satisfaction. Conceived as a member of the state, on the other hand, the person is not a locus of particular desire but the bearer of universally articulated rights and responsibilities. The point of view of the state and law transcends all particular interests to express the universal and rational spirit of humanity. State laws and action express the general will, the interests of the whole society. Since maintaining this universal point of view while engaged in the pursuit of one's own particular interests is difficult, if not impossible, a class of persons is necessary whose sole job is to maintain the public good and the universal point of view of the state. For Hegel, these government officials are the universal class.[25]

Marx, of course, was the first to deny the state's claim to impartiality and universality. The split between the public realm of citizenship and the private realm of individual desire and greed leaves the competition and inequality of that private realm untouched. In capitalist society application of a principle of impartiality reproduces the position of the ruling class, because the interests of the substantially more powerful are considered in the same manner as those without power.[26] Despite this critique, as powerful as it ever was, Marx stops short of questioning the ideal of a public that expresses an impartial and universal normative perspective; he merely asserts that such a public is not realizable within capitalist society.

I think that recent feminist analyses of the dichotomy of public and private in modern political theory imply that the ideal of the civic public as impartial and universal is itself suspect. Modern political theorists and politicians proclaimed the impartiality and generality of the public and at the same time quite consciously found it fitting that some persons—namely women, nonwhites, and sometimes those without property—be excluded from participation in that public. If this was not just a mistake, it suggests that the ideal of the civic public as expressing the general interest, the impartial point of view of reason, itself results in exclusion. By assuming that reason stands opposed to desire, affectivity, and the body, the civic public must exclude bodily and affective aspects of human existence. In practice this assumption forces a homogeneity of citizens upon the civic public. It excludes from the public those individuals and groups that do not fit the model of the rational citizen who can transcend body and sentiment. This exclusion is based on two tendencies that feminists stress: the opposition between reason and desire, and the association of these traits with kinds of persons.

In the social scheme expressed by Rousseau and Hegel, women must

be excluded from the public realm of citizenship because they are the care-takers of affectivity, desire, and the body. Allowing appeals to desires and bodily needs to move public debates would undermine public deliberation by fragmenting its unity. Even within the domestic realm, moreover, women must be dominated. Their dangerous, heterogeneous sexuality must be kept chaste and confined to marriage. Enforcing chastity on women will keep each family a separated unity, preventing the chaos and blood-mingling that would be produced by illegitimate children. These chaste, enclosed women can then be the proper caretakers of men's desire by tempering its potentially disruptive impulses through moral education. Men's desire for women itself threatens to shatter and disperse the universal rational realm of the public, as well as to disrupt the neat distinction between the public and private. As guardians of the private realm of need, desire, and affectivity, women must ensure that men's impulses do not remove them from the universality of reason. The moral neatness of the female-tended hearth, moreover, will temper the possessively individualistic impulses of the particularistic realm of business and commerce, which, like sexuality, constantly threatens to explode the unity of society under the umbrella of universal reason.[27]

The bourgeois world instituted a moral division of labor between reason and sentiment, identifying masculinity with reason and femininity with sentiment and desire.[28] As Linda Nicholson has argued, the modern sphere of family and personal life is as much a modern creation as is the modern realm of state and law, and is part of the same process.[29] The impartiality and rationality of the state depend on containing need and desire in the private realm of the family.[30] While the realm of personal life and sentiment has been thoroughly devalued because it has been excluded from rationality, it has nevertheless been the focus of increasingly expanded commitment. Modernity developed a concept of "inner nature" that needs nurturance and within which is to be found the authenticity and individuality of the self, rather than in the conformity, regularity, and universality of the public. The civic public excludes sentiment and desire, then, partly in order to protect its "natural" character.

Not only in Europe, but in the early decades of the United States as well, the white male bourgeoisie conceived republican virtue as rational, restrained, and chaste, not yielding to passion or desire for luxury. The designers of the American Constitution specifically restricted the access of the laboring class to this rational public because they feared disruption of commitment to the general interests. Some, like Jefferson, even feared developing an urban proletariat. These early American republicans were also quite explicit about the need for the homogeneity of citizens, which from the earliest days in the republic involved the relationship of the white republicans to the Black and American Indian people. These republican fathers, such as Jefferson, identified the Red and Black people in their territories with wild nature and passion, just as they feared that women outside the domestic realm were wanton and avaricious. They defined

moral, civilized republican life in opposition to this backward-looking un-cultivated desire, which they identified with women and nonwhites.[31]

To summarize, the ideal of normative reason, moral sense, stands op-posed to desire and affectivity. Impartial civilized reason characterizes the virtue of the republican man who rises above passion and desire. Instead of cutting bourgeois man entirely off from the body and affectivity, how-ever, this culture of the rational public confines them to the domestic sphere, which also confines women's passions and provides emotional solace to men and children. Indeed, within this domestic realm sentiments can flower, and each individual can recognize and affirm his particularity. Because virtues of impartiality and universality define the public realm, it precisely ought not to attend to our particularity. Modern normative reason and its political expression in the idea of the civic public, then, have unity and coherence by their expulsion and confinement of everything that would threaten to invade the polity with differentiation: the specificity of women's bodies and desire, the difference of race and culture, the variability of heterogeneity of the needs, the goals and desires of each individual, the ambiguity and changeability of feeling.

III. Habermas As Opposing Reason and Affectivity

I have argued that the modern conception of normative reason derived from the deontological tradition of moral and political theory aims for a unity that expels particularity and desire and sets feeling in opposition to reason. To express that impartiality and universality, a point of view of reasoning must be constructed that transcends all situations, contexts, and perspectives. The identification of such a point of view with reason, how-ever, devalues and represses the concrete needs, feelings, and interests that people have in their practical moral lives and thus imposes an impos-sible burden on reason itself. Deontological reason generates an opposition between normative reason, on the one hand, and desire and affectivity, on the other. These latter cannot be entirely suppressed and reduced to the unity of impartial and universal reason, however. They sprout out again, menacing because they have been expelled from reason.

Because the ideal of impartiality is illusory, and because claims to assert normative reason as impartial and universal issue practically in the political exclusion of persons associated with affectivity and the body, we need a conception of normative reason that does not hold this ideal and does not oppose reason to affectivity and desire. I think that Habermas's idea of a communicative ethics provides the most promising starting point for such an alternative conception of normative reason. Much about the way he formulates his theory of communicative action, however, retains several problems that characterize deontological reason.

In his theory of communicative action Habermas seeks to develop a conception of rationality with a pragmatic starting point in the experience of discussion that aims to reach an understanding. Reason in such a model

does not mean universal principles dominating particulars, but more concretely means giving reasons, the practical stance of being reasonable, willing to talk and listen. Truth and rightness are not something known by intuition or through tests of consistency, but achieved only from a process of discussion. This communicative ethics eliminates the authoritarian monologism of deontological reason. The dialogic model of reason supplants the transcendental ego sitting at a height from which it can comprehend everything by reducing it to synthetic unity.

In the theory of communicative action Habermas also seeks directly to confront the tendency in modern philosophy to reduce reason to instrumental reason, a tendency that follows from its assumption of a solitary reasoning consciousness. He insists that normative, aesthetic, and expressive utterances can be just as rational as factual or strategic ones, but differ from the latter in the manner of evaluating their rationality. For all these reasons Habermas's theory of communicative action has much more to offer a feminist ethics than do modern ethical and political theories. Habermas's communicative ethics remains inadequate, however, from the point of view of the critique of deontological reason I have made, for he retains a commitment to impartiality and reproduces in his theory of communication an opposition between reason and desire.

A dialogic conception of normative reason promises a critique and abandonment of the assumption that normative reason is impartial and universal. Precisely because there is no impartial point of view in which a subject stands detached and dispassionate to assess all perspectives, to arrive at an objective and complete understanding of an issue or experience, all perspectives and participants must contribute to its discussion. Thus dialogic reason ought to imply reason as contextualized, where answers are the outcome of a plurality of perspectives that cannot be reduced to unity. In discussion speakers need not abandon their particular perspective or bracket their motives and feelings. As long as the dialogue allows all perspectives to speak freely and be heard and taken into account, the expression of need, motive, and feelings will not have merely private significance, and will not bias or distort the conclusions because they will interact with other needs, motives, and feelings.

Habermas reneges on this promise to define normative reason contextually and perspectivally, however, because he retains a commitment to the ideal of normative reason as expressing an impartial point of view. Rather than arbitrarily presuppose a transcendental ego as the impartial reasoner, as does the deontological tradition, he claims that an impartial point of view is actually presupposed by a normative discussion that seeks to reach agreement. A faith in the possibility of consensus is a condition of beginning dialogue, and the possibility of such consensus presupposes that people engage in discussion "under conditions that neutralize all motives except that of cooperatively seeking truth."[32] Habermas claims here theoretically to reconstruct a presumption of impartiality implicitly carried by any discussion of norms that aims to reach consensus. I take this to be

a transcendental argument, inasmuch as he poses this abstraction from motives and desires as a condition of the possibility of consensus. Through this argument Habermas reproduces the opposition between universal and particular, reason and desire characteristic of deontological reason. A more thoroughly pragmatic interpretation of dialogic reason would not have to suppose that participants must abstract from all motives in aiming to reach agreement.[33]

Communicative ethics also promises to break down the opposition between normative reason and desire that deontological reason generates. Individual needs, desires, and feelings can be rationally articulated and understood, no less than can facts about the world or norms.[34] A possible interpretation of communicative ethics then can be that normative claims are the outcome of the expression of needs, feelings, and desires which individuals claim to have met and recognized by others under conditions where all have an equal voice in the expression of their needs and desires. Habermas stops short of interpreting normative reason as the dialogue about meeting needs and recognizing feelings, however. As Seyla Benhabib argues, because Habermas retains a universalistic understanding of normative reason, he finds that norms must express shared interests.[35] In his scheme discussion about individual need and feeling is separate from discussion about norms.

I suggest that Habermas implicitly reproduces an opposition between reason and desire and feeling in his conception of communication itself, moreover, because he devalues and ignores the expressive and bodily aspects of communication. The model of linguistic activity Habermas takes for his conception of communicative action is discourse, or argumentation. In argumentation we find the implicit rules underlying all linguistic action, whether teleological, normative, or dramaturgical. In discourse people make their shared activity the subject of discussion in order to come to agreement about it. People make assertions for which they claim validity, give reasons for their assertions, and require reasons of others. In the ideal model of discourse, no force compels agreement against that of the better argument. This model of the communication situation, which any attempts to reach understanding presuppose, defines the meaning of utterances: the meaning of an utterance consists of the reasons that can be offered for it. To understand the meaning of an utterance is to know the conditions of its validity.[36]

In Habermas's model of communication, understanding consists of participants in discussion understanding the same meaning by an utterance, which means that they agree that the utterance refers to something in the objective, social, or subjective world. The actors

> seek consensus and measure it against truth, rightness and sincerity, that is, against the "fit" or "misfit" between the speech act, on the one hand, and the three worlds to which the actor takes up relations with his utterances, on the other.[37]

The term "reaching understanding" means, at the minimum, that at least two speaking and acting subjects understand a linguistic expression in the same way . . . In communicative action a speaker selects a comprehensible linguistic expression only in order to come to an understanding *with* a hearer *about* something and thereby to make *himself* understandable.[38]

Behind this apparently innocent way of talking about discourse lies the presumption of several unities: the unity of the speaking subject, who knows himself or herself and seeks faithfully to represent his or her feelings; the unity of subjects with one another, which makes it possible for them to have the same meaning; and the unity, in the sense of fit or correspondence, between an utterance and the aspects of one or more of the "worlds" to which it refers. By this manner of theorizing language Habermas exhibits the logic of identity I discussed in part 1, or also what Derrida calls the metaphysics of presence.[39] This model of communication presumes implicitly that speakers can be present to themselves and to one another and that signification consists in the representation by a sign of objects. To be sure, Habermas denies a realist interpretation of the function of utterances; it is not as though there are worlds of things apart from situated human and social linguistic life. Nevertheless he presumes that utterances can have a single meaning understood in the same way by speakers because they affirm that it expresses the same relation to a world. As writers such as Michael Ryan and Dominick LaCapra have argued, such a conception of meaning ignores the manner in which meaning arises from the unique relationship of utterances to one another, and thereby ignores the multiple meaning that any movement of signification expresses.[40]

I suggest, moreover, that this model of communication reproduces the opposition between reason and desire because, like modern normative reason, it expels and devalues difference: the concreteness of the body, the affective aspects of speech, the musical and figurative aspects of all utterances, which all contribute to the formation and understanding of their meaning. John Keane argues that Habermas's model of discourse abstracts from the specifically bodily aspects of speech—gesture, facial expression, tone of voice, rhythm. One can add to this that it abstracts from the material aspects of written language, such as punctuation, sentence construction, and so on. This model of communication also abstracts from the rhetorical dimensions of communication, that is, the evocative terms, metaphors, dramatic elements of the speaking, by which a speaker addresses himself or herself to this particular audience.[41] When people converse in concrete speaking situations, when they give and receive reasons from one another with the aim of reaching understanding, gesture, facial expression, tone of voice (or, in writing, punctuation, sentence structure, etc.), as well as evocative metaphors and dramatic emphasis, are crucial aspects of their communication.

In the model of ideal discourse that Habermas holds, moreover, there appears to be no role for metaphor, jokes, irony, and other forms of com-

munication that use surprise and duplicity. The model of communication Habermas operates with holds an implicit distinction between "literal" and "figurative" meaning and between a meaning and its manner of expression. Implicitly this model of communication supposes a purity of the meaning of utterances by separating them from their expressive and metaphorical aspects.

He considers irony, paradox, allusion, metaphor, and so on as derivative, even deceptive, modes of linguistic practice, thus assuming the rational literal meaning in opposition to these more playful, multiple, and affective modes of speaking.[42] In the practical context of communication, however, such ambiguous and playful forms of expression usually weave in and out of assertive modes, together providing the communicative act.

Julia Kristeva's conception of speech provides a more embodied alternative to that proposed by Habermas, which might better open a conception of communicative ethics. Any utterance has a dual movement, in her conception, which she refers to as the "symbolic" and "semiotic" moments. The symbolic names the referential function of the utterance, the way it situates the speaker in relation to a reality outside him or her. The semiotic names the unconscious, bodily aspects of the utterance, such as rhythm, tone of voice, metaphor, word play, and gesture.[43] Different kinds of utterances have differing relations of the symbolic and the semiotic. Scientific language, for example, seeks to suppress the semiotic elements, while poetic language emphasizes them. No utterance is without the duality of a relation of the symbolic and semiotic, however, and it is through their relationship that meaning is generated.

This understanding of language bursts open the unity of the subject that Habermas presupposes, as the sender and receiver and negotiator of meaning. The subject is in process, positioned by the slipping and moving levels of signification, which is always in excess of what is grasped or understood discursively. The heterogeneous semiotic aspects of utterances influence both speakers and hearers in unconscious, bodily, and affective ways that support and move the expressing and understanding of referential meaning. Kristeva is quite clear in rejecting an irrationalist conception that would hold that all utterances are equally sensible and simply reduce any speech to play. The point is not to reverse the privileging of reason over emotion and body that it excludes, but to expose the process of the generation of referential meaning from the supporting valences of semiotic relations.

> Though absolutely necessary, the thetic [i.e., proposition or judgment] is not exclusive: the semiotic, which also precedes it, constantly tears it open, and this transgression brings about all the various transformations of the signifying practice that are called "creation." Whether in the realm of metalanguage (mathematics, for example) or literature, what remodels the symbolic order is always the influx of the semiotic.[44]

What difference does such a theory of language make for a conception of normative reason grounded in a theory of communicative action? As I understand the implications of Kristeva's approach to language, it entails that communication is not only motivated by the aim to reach consensus, a shared understanding of the world, but also and even more basically by a desire to love and be loved. Modulations of eros operate in the semiotic elements of communication, putting the subject's identity in question in relation to itself, to its own past and imagination, and to others in the heterogeneity of their identity. People do not merely hear, take in, and argue about the validity of utterances. Rather we are affected, in an immediate and felt fashion, by the other's expression and its manner of being addressed to us.

Habermas has a place in his model of communication for making feelings the subject of discourse. Such feeling discourse, however, is carefully marked off in his theory from factual or normative discourse. There is no place in his conception of linguistic interaction for the feeling that accompanies and motivates all utterances. In actual situations of discussion, tone of voice, facial expression, gesture, the use of irony, understatement, or hyperbole all serve to carry with the propositional message of the utterance another level of expression relating the participants in terms of attraction or withdrawal, confrontation or affirmation. Speakers not only say what they mean, but also say it excitedly, angrily, in a hurt or offended fashion, and so on, and such emotional qualities of communication contexts should not be thought of as non- or prelinguistic. Recognizing such an aspect of utterances, however, involves acknowledging the irreducible multiplicity and ambiguity of meaning. I am suggesting that only a conception of normative reason that includes these affective and bodily dimensions of meaning can be adequate for a feminist ethics.

IV. Toward a Heterogeneous Public Life

I have argued that the distinction between public and private as it appears in modern political theory expresses a will for homogeneity that necessitates the exclusion of many persons and groups, particularly women and racialized groups culturally identified with the body, wildness, and irrationality. In conformity with the modern idea of normative reason, the idea of the public in modern political theory and practice designates a sphere of human existence in which citizens express their rationality and universality, abstracted from their particular situations and needs and opposed to feeling. This feminist critique of the exclusionary public does not imply, as Jean Elshtain suggests, a collapse of the distinction between public and private.[45] Indeed, I agree with those writers, including Elshtain, Habermas, Wolin, and many others, who claim that contemporary social life itself has collapsed the public and that emancipatory politics requires generating a renewed sense of public life. Examination of the exclusionary and homo-

geneous ideal of the public in modern political theory, however, shows that we cannot envision such renewal of public life as a recovery of Enlightenment ideals. Instead, we need to transform the distinction between public and private that does not correlate with an opposition between reason and affectivity and desire, or universal and particular.

The primary meaning of public is what is open and accessible. For democratic politics this means two things: there must be public spaces and public expression. A public space is any indoor or outdoor space to which anyone has access. Expression is public when third parties may witness it within institutions that give these others opportunity to respond to the expression and enter a discussion, and through media that allow anyone in principle to enter the discussion. Expression and discussion are political when they raise and address issues of the moral value or human desirability of an institution or practice whose decisions affect a large number of people. This concept of a public, which indeed is derived from aspects of modern urban experience, expresses a conception of social relations in principle not exclusionary.

The traditional notion of the private realm, as Hannah Arendt points out, is etymologically related to deprivation. The private, in her conception, is what should be hidden from view or what cannot be brought to view. The private, in this traditional notion, is connected with shame and incompleteness, and, as Arendt points out, implies excluding bodily and personally affective aspects of human life from the public.[46]

Instead of defining privacy as what the public excludes, privacy should be defined, as an aspect of liberal theory does, as that aspect of his or her life and activity that any individual has a right to exclude others from. I mean here to emphasize the direction of agency, as the individual withdrawing rather than being kept out. With the growth of both state and nonstate bureaucracies, defense of privacy in this sense has become not merely a matter of keeping the state out of certain affairs, but also of asking for positive state action to ensure that the activities of nonstate organizations, such as corporations, respect the claims of individuals to privacy.

The feminist slogan "the personal is political" does not deny a distinction between public and private, but it does deny a social division between public and private spheres, with different kinds of institutions, activities, and human attributes. Two principles follow from this slogan: (a) no social institutions or practices should be excluded a priori as being the proper subject for public discussion and expression; and (b) no persons, actions, or aspects of a person's life should be forced into privacy.

1. The contemporary women's movement has made public issues out of many practices claimed to be too trivial or private for public discussion: the meaning of pronouns, domestic violence against women, the practice of men's opening doors for women, the sexual assault on women and children, the sexual division of housework, and so on. Radical politics in contemporary life consists of taking many actions and activities deemed

properly private, such as how individuals and enterprises invest their money, and making public issues out of them.

2. The second principle says that no person or aspects of persons should be forced into privacy. The modern conception of the public, I have argued, creates a conception of citizenship that excludes from public attention most particular aspects of a person. Public life is supposed to be "blind" to sex, race, age, and so on, and all are supposed to enter the public and its discussion on identical terms. Such a conception of a public has resulted in the exclusion of persons and aspects of persons from public life.

Ours is still a society that forces persons or aspects of persons into privacy. Repression of homosexuality is perhaps the most striking example. In the United States today most people seem to hold the liberal view that persons have a right to be gay as long as they remain private about their activities. Calling attention in public to the fact that one is gay, making public displays of gay affection, or even publicly asserting needs and rights for gay people provokes ridicule and fear in many people. Making a public issue out of heterosexuality, moreover, by suggesting that the dominance of heterosexual assumptions is one-dimensional and oppressive can rarely get a public hearing even among feminists and radicals. In general, contemporary politics grants to all persons entrance into the public on condition that they do not claim special rights or needs, or call attention to their particular history or culture, and that they keep their passions private.

The new social movements of the 1960s, 1970s and 1980s in the United States have begun to create an image of a more differentiated public that directly confronts the allegedly impartial and universalist state. Movements of racially oppressed groups, including Black, Chicano and American Indian liberation, tend to reject the assimilationist ideal and assert the right to nurture and celebrate in public their distinctive cultures and forms of life, as well as asserting special claims of justice deriving from suppression or devaluation of their cultures, or compensating for the disadvantage in which the dominant society puts them. The women's movement too has claimed to develop and foster a distinctively women's culture and that both women's specific bodily needs and women's situation in male-dominated society require attending in public to special needs and unique contributions of women. Movements of the disabled, the aged, and gay and lesbian liberation—all have produced an image of public life in which persons stand forth in their differences and make public claims to have specific needs met.

The street demonstrations that in recent years have included most of these groups, as well as traditional labor groups and advocates of environmentalism and nuclear disarmament, sometimes create heterogeneous publics of passion, play, and aesthetic interest. Such demonstrations always focus on issues they seek to promote for public discussion, and these issues are discussed: claims are made and supported. The style of politics of such events, however, has many less discursive elements: gaily decorated ban-

ners with ironic or funny slogans, guerilla theater or costumes serving to make political points, giant puppets standing for people or ideas towering over the crowd, chants, music, song, dancing. Liberating public expression means not only lifting formerly privatized issues into the open of public and rational discussion that considers the good of ends as well as means, but also affirming in the practice of such discussion the proper place of passion and play in public.

As the 1970s progressed, and the particular interests and experience expressed by these differing social movements matured in their confidence, coherence, and understanding of the world from the point of view of these interests, a new kind of public became possible that might persist beyond a single demonstration. This public is expressed in the idea of a "Rainbow Coalition." Realized to some degree only for sporadic months during the 1983 Mel King campaign in Boston and the 1984 Jesse Jackson campaign in certain cities, this is an idea of a political public that goes beyond the ideal of civic friendship in which persons unite for a common purpose on terms of equality and mutual respect.[47] While it includes commitment to equality and mutual respect among participants, the idea of the Rainbow Coalition specifically preserves and institutionalizes in its form of organizational discussion the heterogeneous groups that make it up. In this way it is quite unlike the Enlightenment ideal of the civil public (which might have its practical analogue here in the idea of the "united front"). As a general principle, this heterogeneous public asserts that the only way to ensure that public life will not exclude persons and groups that it has excluded in the past is to give specific recognition to the disadvantage of those groups and bring their specific histories into the public.[48]

I have been suggesting that the Enlightenment ideal of the civic public, where citizens meet in terms of equality and mutual respect, is too rounded and tame an ideal of public. This idea of equal citizenship attains unity because it excludes bodily and affective particularity, as well as the concrete histories of individuals that make groups unable to understand one another. Emancipatory politics should foster a conception of public that in principle excludes no persons, aspects of persons' lives, or topic of discussion and that encourages aesthetic as well as discursive expression. In such a public, consensus and sharing may not always be the goal, but the recognition and appreciation of differences, in the context of confrontation with power.[49]

NOTES

1. John Keane, "Liberalism Under Siege: Power, Legitimation, and the Fate of Modern Contract Theory," in *Public Life in Late Capitalism* (Cambridge, Mass.: Cambridge University Press, 1984), p. 253. Andrew Levine is another writer who finds

in Rousseau an emancipatory alternative to liberalism. See "Beyond Justice: Rousseau Against Rawls," *Journal of Chinese Philosophy*, vol. 4 (1977), pp. 123–42.

2. I develop the contrast between commitment to a feminist humanism, on the one hand, and reaction against belief in women's liberation as the attainment of equality with men in formerly male-dominated institutions, on the other, in my paper "Humanism, Gynocentrism and Feminist Politics," in *Hypatia: A Journal of Feminist Philosophy*, no. 3, special issue of *Women's Studies International Forum*, vol. 8, no. 5 (1985).

3. The literature on these issues has become vast. My own understanding of them is derived from reading, among others, Susan Okin, *Women in Western Political Thought* (Princeton, N.J.: Princeton University Press, 1978); Zillah Eisenstein, *The Radical Future of Liberal Feminism* (New York: Longman, 1979); Lynda Lange and Lorrenne Clark, *The Sexism of Social and Political Theory* (Toronto: University of Toronto Press, 1979); Jean Elshtain, *Public Man, Private Woman* (Princeton, N.J.: Princeton University Press, 1981); Alison Jaggar, *Human Nature and Feminist Politics* (Totowa, N.J.: Rowman and Allenheld, 1983); Carole Pateman, "Feminist Critiques of the Public/Private Dichotomy," in S. I. Benn and G. F. Gaus, ed., *Public and Private in Social Life* (New York: St. Martin's Press, 1983), pp. 281–303; Hannah Pitkin, *Fortune is a Woman* (Berkeley: University of California Press, 1984); Nancy Hartsock, *Money, Sex and Power* (New York: Longman Press, 1983); and Linda Nicholson, *Gender and History* (New York: Columbia University Press, 1986).

4. See Cornel West, *Prophesy Deliverance* (Philadelphia: Westminster Press, 1983); and "The Genealogy of Racism: On the Underside of Discourse," *The Journal*, The Society for the Study of Black Philosophy, vol. 1, no. 1 (Winter–Spring 1984), pp. 42–60.

5. Carol Gilligan, *In a Different Voice* (Cambridge, Mass.: Harvard University Press, 1982).

6. Bentham's utilitarianism, for example, assumes something like an "ideal observer" that sees and calculates each individual's happiness and weighs it in relation to all other individuals' happiness, calculating the overall amount of utility. This stance of an impartial calculator is like that of the warden in the panopticon that Foucault takes as expressive of modern normative reason. The moral observer towers over and is able to see individual persons in relation to one another, while remaining itself outside their observation. See Foucault, *Discipline and Punish* (New York: Vintage, 1977).

7. Bruce Ackerman, *Social Justice in the Liberal State* (New Haven, Conn.: Yale University Press, 1980).

8. Michael Sandel, *Liberalism and the Limits of Justice* (Cambridge, Mass.: Cambridge University Press, 1982); cf. Seyla Benhabib, "The Generalized and the Concrete Other," in Benhabib and Cornell, ed., *Feminism as Critique* (London: Polity Press, 1987), chapter 4; see also Theodore Adorno, *Negative Dialectics* (New York: Continuum Publishing Co., 1973), pp. 238–39.

9. Adorno, introduction.

10. Roberto Unger identifies this problem of applying universals to particulars in modern normative theory. See *Knowledge and Politics* (New York: The Free Press, 1974), pp. 133–44.

11. Thomas A. Spragens, Jr., *The Irony of Liberal Reason* (Chicago: University of Chicago Press, 1981), p. 109.

12. Rawls's original position is intended to overcome his monologism of Kantian deontology. Since by definition in the original position everyone reasons from the same perspective, however, abstracted from all particularities of history, place, and situation, the original position is monological in the same sense as Kantian reason. I have argued this in my article "Toward a Critical Theory of Justice," *Social Theory and Practice*, vol. 7, no. 3 (Fall 1981), pp. 279–301; see also Sandel, op. cit., pp. 59–64, and Benhabib, op. cit.

13. Adorno, op. cit., p. 242, p. 295.

14. I am relying on a reading of Derrida's *Of Grammatology* (Baltimore: Johns Hopkins University Press, 1976), in addition to Adorno's *Negative Dialectics*, for this account. Several writers have noted similarities between Adorno and Derrida in this regard. See Fred Dallmayr, *Twilight of Subjectivity: Contributions to a Post-Structuralist Theory of Politics* (Amherst: University of Massachusetts Press, 1981), pp. 107–14, pp. 127–36; and Michael Ryan, *Marxism and Domination* (Baltimore: Johns Hopkins University Press, 1982), pp. 73–81.

15. Spragens, op. cit., pp. 250–56.

16. Lawrence A. Blum, *Friendship, Altruism and Morality* (London: Routledge and Kegan Paul, 1980).

17. This is one of Gilligan's points in claiming that there is a "different voice" that has been suppressed; see Benhabib, op. cit.; see also Lawrence Blum, "Kant's and Hegel's Moral Rationalism: A Feminist Perspective," *Canadian Journal of Philosophy*, vol. 12 (June 1982), pp. 287–302.

18. Richard Sennett, *The Fall of Public Man* (New York: Random House, 1974).

19. See Marshall Berman, *All That Is Solid Melts Into Air* (New York: Simon and Schuster, 1982).

20. Jurgen Habermas, "The Public Sphere: An Encyclopedia Article," *New German Critique*, vol. 1, no. 3 (Fall 1974), pp. 49–55.

21. Sennett, chapter 4.

22. See Joan Landes, "Women and the Public Sphere: The Challenge of Feminist Discourse," paper presented as part of the Bunting Institute Colloquium, April 1983.

23. Charles Ellison, "Rousseau and the Modern City: The Politics of Speech and Dress," *Political Theory*, vol. 13 (1985), pp. 497–534.

24. Judith Skhlar, *Men and Citizens* (Cambridge, Mass.: Cambridge University Press, 1969).

25. See Z. A. Pleczynski, "The Hegelian Conception of the State," in Pelczynski, ed., *Hegel's Political Philosophy: Problems and Perspectives* (Cambridge, Mass.: Cambridge University Press, 1971), pp. 1–29; and Anthony S. Walton, "Public and Private Interests: Hegel on Civil Society and the State," in S. Benn and G. Gaus, ed., *Public and Private in Social Life* (London: St. Martin's Press, 1983), pp. 249–66.

26. There are many texts in which Marx makes these sorts of claims, including "On the Jewish Question" and "Critique of the Gotha Program." For some discussion of these points, see Shlomo Avineri, *The Social and Political Thought of Karl Marx* (Cambridge, Mass.: Cambridge University Press, 1968), pp. 41–48.

27. For feminists' analyses of Rousseau and Hegel, see op. cit. Okin, Elshatin, Eisenstein, Lange and Clark, footnote 3. See also Joel Schwartz, *The Sexual Politics of Jean-Jacques Rousseau* (Chicago: University of Chicago Press, 1984).

28. See Genevieve Lloyd, *The Man of Reason: "Male" and "Female" in Western Philosophy* (Minneapolis: University of Minnesota Press, 1984); Lynda Glennon, *Women and Dualism* (New York: Longman, 1979).

29. Nicholson, op. cit.

30. Zillah Eisenstein claims that the modern state depends on the patriarchal family. Op. cit.

31. Ronald Takaki, *Iron Cages: Race and Culture in 19*th Century America (New York: Knopf, 1979).

32. Jurgen Habermas, *Reason and the Rationalization of Society* (Boston: Beacon Press, 1983), p. 19. In the footnote to this passage Habermas explicitly connects this presumption with the tradition of moral theory seeking to articulate the impartial "moral point of view."

33. Richard Bernstein suggests that Habermas vacillates between a transcendental and empirical interpretation of his project in many respects. See *Beyond Objec-*

tivism and Relativism (Philadelphia: University of Pennsylvania Press, 1983), pp. 182–96.

34. Habermas, op. cit., pp. 91–93.

35. Benhabib, "Communicative Ethics and Moral Autonomy," presented to the American Philosophical Association, December 1982.

36. Habermas, op. cit., p. 115, pp. 285–300.

37. Habermas, p. 100.

38. Habermas, p. 307.

39. I am thinking here particularly of Derrida's discussion of Rousseau in *Of Grammatology*. I have dealt with these issues in much more detail in my paper "The Ideal of Community and the Politics of Difference," *Social Theory and Practice*, vol. 12, no. 1 (Spring 1986), pp. 1–26.

40. For critiques of Habermas's assumptions about language from a Derridian point of view, which argue that he does not attend the difference and spacing in signification that generates undecidability and ambiguity, see Michael Ryan, *Marxism and Deconstruction* (Baltimore: Johns Hopkins University Press, 1982); Dominick LaCapra, "Habermas and the Grounding of Critical Theory," *History and Theory* (1977), pp. 237–64.

41. Keane, "Elements of a Socialist Theory of Public Life," in op. cit., pp. 169–72.

42. Habermas, op. cit., p. 331.

43. Kristeva, *Revolution in Poetic Language* (New York: Columbia University Press, 1984), pp. 21–37; "From One Identity to an Other," in *Desire in Language* (New York: Columbia University Press, 1980), pp. 124–47.

44. Kristeva, *Revolution in Poetic Language*, p. 291.

45. Jean Elshtain, *Public Man, Private Woman* (Princeton, N.J.: Princeton University Press, 1981), part two.

46. Hannah Arendt, *The Human Condition* (Chicago: University of Chicago Press, 1958).

47. See Drucilla Cornell, "Toward A Modern/Postmodern Reconstruction of Ethics," *University of Pennsylvania Law Review*, vol. 133, no. 2 (1985), pp. 291–380.

48. Thomas Bender promotes a conception of a heterogeneous public as important for an urban political history that would not be dominated by the perspective of the then- and now-privileged; "The History of Culture and the Culture of Cities," paper presented at meeting of the International Association of Philosophy and Literature, New York City, May 1985.

49. I am grateful to David Alexander for all the time and thought he gave to this paper.

Polity and Group Difference

A Critique of the Ideal of Universal Citizenship

An ideal of universal citizenship has driven the emancipatory momentum of modern political life. Ever since the bourgeoisie challenged aristocratic privileges by claiming equal political rights for citizens as such, women, workers, Jews, Blacks, and others have pressed for inclusion in that citizenship status. Modern political theory asserted the equal moral worth of all persons, and social movements of the oppressed took this seriously as implying the inclusion of all persons in full citizenship status under the equal protection of the law.

Citizenship for everyone, and everyone the same qua citizen. Modern political thought generally assumed that the universality of citizenship in the sense of citizenship for all implies a universality of citizenship in the sense that citizenship status transcends particularity and difference. Whatever the social or group differences among citizens, whatever their inequalities of wealth, status, and power in the everyday activities of civil society, citizenship gives everyone the same status as peers in the political public. With equality conceived as sameness, the ideal of universal citizenship carries at least two meanings in addition to the extension of citizenship to everyone: (a) universality defined as general in opposition to particular; what citizens have in common as opposed to how they differ, and (b) universality in the sense of laws and rules that say the same for all and apply to all in the same way; laws and rules that are blind to individual and group differences.

During this angry, sometimes bloody, political struggle in the nineteenth and twentieth centuries, many among the excluded and disadvantaged thought that winning full citizenship status, that is, equal political and civil rights, would lead to their freedom and equality. Now in the late twentieth century, however, when citizenship rights have been formally extended to all groups in liberal capitalist societies, some groups still find themselves treated as second-class citizens. Social movements of oppressed and excluded groups have recently asked why extension of equal citizenship rights has not led to social justice and equality. Part of the answer is straightforwardly Marxist: those social activities that most determine the

status of individuals and groups are anarchic and oligarchic; economic life is not sufficiently under the control of citizens to affect the unequal status and treatment of groups. I think this is an important and correct diagnosis of why equal citizenship has not eliminated oppression, but in this article I reflect on another reason more intrinsic to the meaning of politics and citizenship as expressed in much modern thought.

The assumed link between citizenship for everyone, on the one hand, and the two other senses of citizenship—having a common life with and being treated in the same way as the other citizens—on the other, is itself a problem. Contemporary social movements of the oppressed have weakened the link. They assert a positivity and pride in group specificity against ideals of assimilation. They have also questioned whether justice always means that law and policy should enforce equal treatment for all groups. Embryonic in these challenges lies a concept of *differentiated* citizenship as the best way to realize the inclusion and participation of everyone in full citizenship.

In this article I argue that far from implying one another, the universality of citizenship, in the sense of the inclusion and participation of everyone, stands in tension with the other two meanings of universality embedded in modern political ideas: universality as generality, and universality as equal treatment. First, the ideal that the activities of citizenship express or create a general will that transcends the particular differences of group affiliation, situation, and interest has in practice excluded groups judged not capable of adopting that general point of view; the idea of citizenship as expressing a general will has tended to enforce a homogeneity of citizens. To the degree that contemporary proponents of revitalized citizenship retain that idea of a general will and common life, they implicitly support the same exclusions and homogeneity. Thus I argue that the inclusion and participation of everyone in public discussion and decision-making requires mechanisms for group representation. Second, where differences in capacities, culture, values, and behavioral styles exist among groups but some of these groups are privileged, strict adherence to a principle of equal treatment tends to perpetuate oppression or disadvantage. The inclusion and participation of everyone in social and political institutions, therefore, sometimes requires the articulation of special rights that attend to group differences in order to undermine oppression and disadvantage.

I. Citizenship As Generality

Many contemporary political theorists regard capitalist welfare society as depoliticized. Its interest-group pluralism privatizes policy-making, consigning it to back-room deals and autonomous regulatory agencies and groups. Interest-group pluralism fragments both policy and the interests of the individual, making it difficult to assess issues in relation to one

another and set priorities. The fragmented and privatized nature of the political process, moreover, facilitates the dominance of the more powerful interests.[1]

In response to this privatization of the political process, many writers call for a renewed public life and a renewed commitment to the virtues of citizenship. Democracy requires that citizens of welfare corporate society awake from their privatized consumerist slumbers, challenge the experts who claim the sole right to rule, and collectively take control of their lives and institutions through processes of active discussion that aim at reaching collective decisions.[2] In participatory democratic institutions citizens develop and exercise capacities of reasoning, discussion, and socializing that otherwise lie dormant, and they move out of their private existence to address others and face them with respect and concern for justice. Many who invoke the virtues of citizenship in opposition to the privatization of politics in welfare capitalist society assume as models for contemporary public life the civic humanism of thinkers such as Machiavelli or, more often, Rousseau.[3]

With these social critics I agree that interest-group pluralism, because it is privatized and fragmented, facilitates the domination of corporate, military, and other powerful interests. With them I think that democratic processes require the institutionalization of genuinely public discussion. There are serious problems, however, with uncritically assuming as a model the ideals of the civic public that come to us from the tradition of modern political thought.[4] The ideal of the public realm of citizenship as expressing a general will, a point of view and interest that citizens have in common and that transcends their differences, has operated in fact as a demand for homogeneity among citizens. The exclusion of groups defined as different was explicitly acknowledged before this century. In our time, the excluding consequences of the universalist ideal of a public that embodies a common will are more subtle, but they still obtain.

The tradition of civic republicanism stands in critical tension with the individualist contract theory of Hobbes or Locke. Where liberal individualism regards the state as a necessary instrument to mediate conflict and regulate action so that individuals can have the freedom to pursue their private ends, the republican tradition locates freedom and autonomy in the actual public activities of citizenship. By participating in public discussion and collective decision-making, citizens transcend their particular self-interested lives and the pursuit of private interests to adopt a general point of view from which they agree on the common good. Citizenship is an expression of the universality of human life; it is a realm of rationality and freedom as opposed to the heteronomous realm of particular need, interest, and desire.

Nothing in this understanding of citizenship as universal as opposed to particular, common as opposed to differentiated, implies extending full citizenship status to all groups. Indeed, at least some modern republicans thought just the contrary. While they extolled the virtues of citizenship as

expressing the universality of humanity, they consciously excluded some people from citizenship on the grounds that they could not adopt the general point of view or that their inclusion would disperse and divide the public. The ideal of a common good, a general will, a shared public life leads to pressures for a homogeneous citizenry.

Feminists in particular have analyzed how the discourse that links the civic public with fraternity is not merely metaphorical. Founded by men, the modern state and its public realm of citizenship paraded as universal values and norms that were derived from specifically masculine experience: militarist norms of honor and homoerotic camaraderie, respectful competition and bargaining among independent agents, discourse framed in unemotional tones of dispassionate reason.

Several commentators have argued that in extolling the virtues of citizenship as participation in a universal public realm, modern men expressed a flight from sexual difference, from having to recognize another kind of existence that they could not entirely understand, and from the embodiment, dependency on nature, and morality that women represent.[5] Thus the opposition between the universality of the public realm of citizenship and the particularity of private interest became conflated with oppositions between reason and passion, masculine and feminine.

The bourgeois world instituted a moral division of labor between reason and sentiment, identifying masculinity with reason and femininity with sentiment, desire, and the needs of the body. Extolling a public realm of manly virtue and citizenship as independence, generality, and dispassionate reason entailed creating the private sphere of the family as the place to which emotion, sentiment, and bodily needs must be confined.[6] The generality of the public thus depends on excluding women, who are responsible for tending to that private realm and who lack the dispassionate rationality and independence required of good citizens.

Rousseau's political theory makes apparent the imperative of preserving the unity and universality of the public by excluding women. The particularities of affectivity, desire, and the body should be kept out of public debates because their influence tends to fragment the unity of the public. Women should be the caretakers of these desires and needs, confined to a domestic realm outside the public realm of citizenship. Within that domestic realm, moreover, women's own desires must be harnessed to heterosexual marriage and motherhood. Women must be chaste, dutiful, and obedient if the chaos of illegitimacy and lust is not to disrupt the clear borders of household property. Chaste and dutifully nurturing women will in turn keep men's desires in their proper limits and orient their interests toward the moral sentiments of the common good.[7]

It is important to recall that universality of citizenship conceived as generality operated to exclude not only women, but other groups as well. European and American republicans found little contradiction in promoting a universality of citizenship that excluded some groups, because the idea that citizenship is the same for all translated in practice to the re-

quirement that all citizens be the same. The white male bourgeoisie conceived republican virtue as rational, restrained, and chaste, not yielding to passion or desire for luxury, and thus able to rise above desire and need to a concern for the common good. This implied excluding poor people and wage workers from citizenship on the grounds that they were too motivated by need to adopt a general perspective. The designers of the American Constitution were no more egalitarian than their European brethren in this respect; they specifically intended to restrict the access of the laboring class to the public, because they feared disruption of commitment to the general interests.

These early American republicans were also quite explicit about the need for the homogeneity of citizens, fearing that group differences would tend to undermine commitment to the general interest. This meant that the presence of Blacks and American Indians, and later Mexicans and Chinese, in the territories of the republic posed a threat that only assimilation, extermination, or dehumanization could thwart. Various combinations of these three were used, of course, but recognition of these groups as peers in the public was never an option. Even such republican fathers as Jefferson identified the Red and Black people in their territories with wild nature and passion, just as they feared that women outside the domestic realm were wanton and avaricious. They defined moral, civilized republican life in opposition to this backward-looking, uncultivated desire that they identified with women and nonwhites.[8] A similar logic of exclusion operated in Europe, where Jews were particular targets.[9]

These republican exclusions were not accidental, nor were they inconsistent with the ideal of universal citizenship as understood by these theorists. They were a direct consequence of a dichotomy between public and private that defined the public as a realm of generality in which all particularities are left behind, and defined the private as the particular, the realm of affectivity, affiliation, need, and the body. As long as that dichotomy is in place, the inclusion of the formerly excluded in the definition of citizenship—women, workers, Jews, Blacks, Asians, Indians, Mexicans—imposes a homogeneity that suppresses group differences in the public and in practice forces the formerly excluded groups to be measured according to norms derived from and defined by privileged groups.

Contemporary critics of interest-group liberalism who call for a renewed public life certainly do not intend to exclude any adult persons or groups from citizenship. They are democrats, convinced that only the inclusion and participation of all citizens in political life will make for wise and fair decisions and for a polity that enhances rather than inhibits the capacities of its citizens and their relations with one another. The emphasis by such participatory democrats on generality and commonness, however, still threatens to suppress differences among citizens.

I shall focus on the text of Benjamin Barber, who, in his book *Strong Democracy*, produces a compelling and concrete vision of participatory democratic processes. Barber recognizes the need to safeguard a democratic

public from intended or inadvertent group exclusions, though he offers no proposals for safeguarding the inclusion and participation of everyone. He also argues fiercely against contemporary political theorists who construct a model of political discourse purified of affective dimensions. Thus Barber does not fear the disruption of the generality and rationality of the public by desire and the body in the way that nineteenth-century republican theorists did. He retains, however, a conception of the civic public as defined by generality, as opposed to group affinity and particular need and interest. He makes a clear distinction between the public realm of citizenship and civic activity, on the one hand, and a private realm of particular identities, roles, affiliations, and interests on the other. Citizenship by no means exhausts people's social identities, but it takes moral priority over all social activities in a strong democracy. The pursuit of particular interests, the pressing of the claims of particular groups, all must take place within a framework of community and common vision established by the public realm. Thus Barber's vision of participatory democracy continues to rely on an opposition between the public sphere of general interest and a private sphere of particular interest and affiliation.[10]

While recognizing the need for majority-rule procedures and means of safeguarding minority rights, Barber asserts that "the strong democrat regrets every division and regards the existence of majorities as a sign that mutualism has failed" (p. 207). A community of citizens, he says, "owes the character of its existence to what its constituent members have in common" (p. 232), and this entails transcending the order of individual needs and wants to recognize that "we are a moral body whose existence depends on the common ordering of individual needs and wants into a single vision of the future in which all can share" (p. 224). This common vision is not imposed on individuals from above, however, but is forged by them in talking and working together. Barber's models of such common projects, however, reveal his latent biases: "Like players on a team or soldiers at war, those who practice a common politics may come to feel ties that they never felt before they commenced their common activity. This sort of bonding, which emphasizes common procedures, common work, and a shared sense of what a community needs to succeed, rather than monolithic purposes and ends, serves strong democracy most successfully" (p. 244).

The attempt to realize an ideal of universal citizenship that finds the public embodying generality as opposed to particularity, commonness vs. difference, will tend to exclude or to put at a disadvantage some groups, even when they have formally equal citizenship status. The idea of the public as universal and the concomitant identification of particularity with privacy makes homogeneity a requirement of public participation. In exercising their citizenship, all citizens should assume the same impartial, general point of view transcending all particular interests, perspectives, and experiences.

But such an impartial general perspective is a myth.[11] People necessarily and properly consider public issues in terms influenced by their situated

experience and perception of social relations. Different social groups have different needs, cultures, histories, experiences, and perceptions of social relations, which influence their interpretation of the meaning and consequences of policy proposals and influence the form of their political reasoning. These differences in political interpretation are not merely or even primarily a result of differing or conflicting interests, for groups have differing interpretations even when they seek to promote justice and not merely their own self-regarding ends. In a society where some groups are privileged while others are oppressed, insisting that as citizens, persons should leave behind their particular affiliations and experiences to adopt a general point of view, serves only to reinforce that privilege, for the perspectives and interests of the privileged will tend to dominate this unified public, marginalizing or silencing those of other groups.

Barber asserts that responsible citizenship requires transcending particular affiliations, commitments, and needs, because a public cannot function if its members are concerned only with their private interests. Here he makes an important confusion between plurality and privatization. The interest-group pluralism that he and others criticize indeed institutionalizes and encourages an egoistic, self-regarding view of the political process, one that sees parties entering the political competition for scarce goods and privileges only in order to maximize their own gain, and therefore they need not listen to or respond to the claims of others who have their own points of view. The processes and often the outcomes of interest-group bargaining, moreover, take place largely in private; they are neither revealed nor discussed in a forum that genuinely involves all those potentially affected by decisions.

Privacy in this sense of private bargaining for the sake of private gain is quite different from plurality, in the sense of the differing group experiences, affiliations, and commitments that operate in any large society. It is possible for persons to maintain their group identity and to be influenced by their perceptions of social events derived from their group-specific experience and at the same time to be public spirited, in the sense of being open to listening to the claims of others and not being concerned for their own gain alone. It is possible and necessary for people to take a critical distance from their own immediate desires and gut reactions in order to discuss public proposals. Doing so, however, cannot require that citizens abandon their particular affiliations, experiences, and social location. As I will discuss in the next section, having the voices of particular group perspectives other than one's own explicitly represented in public discussion best fosters the maintenance of such critical distance without the pretense of impartiality.

A repoliticization of public life should not require the creation of a unified public realm in which citizens leave behind their particular group affiliations, histories, and needs to discuss a general interest or common good. Such a desire for unity suppresses but does not eliminate differences and tends to exclude some perspectives from the public.[12] Instead of a

universal citizenship in the sense of this generality, we need a group-differentiated citizenship and a heterogeneous public. In a heterogeneous public, differences are publicly recognized and acknowledged as irreducible, by which I mean that people from one perspective or history can never completely understand and adopt the point of view of those with other group-based perspectives and histories. Yet commitment to the need and desire to decide together the society's policies fosters communication across those differences.

II. Differentiated Citizenship As Group Representation

In her study of the functioning of a New England town meeting government, Jane Mansbridge discusses how women, Blacks, working-class people, and poor people tend to participate less and have their interests represented less than do whites, middle-class professionals, and men. Even though all citizens have the right to participate in the decision-making process, the experience and perspectives of some groups tend to be silenced for many reasons. White middle-class men assume authority more than others do, and they are more practiced at speaking persuasively; mothers and old people often find it more difficult to get to meetings.[13] Amy Gutmann also discusses how participatory democratic structures tend to silence disadvantaged groups. She offers the example of community control of schools, where increased democracy led to increased segregation in many cities because the more privileged and articulate whites were able to promote their perceived interests against Blacks' just demand for equal treatment in an integrated system.[14] Such cases indicate that when participatory democratic structures define citizenship in universalistic and unified terms, they tend to reproduce existing group oppression.

Gutmann argues that such oppressive consequences of democratization imply that social and economic equality must be achieved before political equality can be instituted. I cannot quarrel with the value of social and economic equality, but I think its achievement depends on increasing political equality as much as the achievement of political equality depends on increasing social and economic equality. If we are not to be forced to trace a utopian circle, we need to solve now the "paradox of democracy" by which social power makes some citizens more equal than others, and equality of citizenship makes some people more powerful citizens. That solution lies at least in part in providing institutionalized means for the explicit recognition and representation of oppressed groups. Before discussing principles and practices involved in such a solution, however, it is necessary to say something about what a group is and when a group is oppressed.

The concept of a social group has become politically important because recent emancipatory and leftist social movements have mobilized around group identity rather than exclusively class or economic interests. In many cases such mobilization has consisted of embracing and positively defining

a despised or devalued ethnic or racial identity. In the women's movement, gay-rights movement, or elders' movements, differential social status based on age, sexuality, physical capacity, or the division of labor has been taken up as a positive group identity for political mobilization.

I shall not attempt to define a social group here, but I shall point to several marks that distinguish a social group from other collectivities of people. A social group involves first of all an affinity with other persons by which they identify with one another and by which other people identify them. A person's particular sense of history, understanding of social relations and personal possibilities, her or his mode of reasoning, values, and expressive styles are constituted at least partly by her or his group identity. Many group definitions come from the outside, from other groups that label and stereotype certain people. In such circumstances the despised-group members often find their affinity in their oppression. The concept of social group must be distinguished from two concepts with which it might be confused: aggregate and association.

An aggregate is any classification of persons according to some attribute. Persons can be aggregated according to any number of attributes, all of them equally arbitrary—eye color, the make of car we drive, the street we live on. At times the groups that have emotional and social salience in our society are interpreted as aggregates, as arbitrary classifications of persons according to attributes of skin color, genitals, or years lived. A social group, however, is not defined primarily by a set of shared attributes but by the sense of identity that people have. What defines Black Americans as a social group is not primarily their skin color; this is exemplified by the fact that some persons whose skin color is fairly light, for example, identify as Black. Though sometimes objective attributes are a necessary condition for classifying oneself or others as a member of a certain social group, it is the identification of certain persons with a social status, a common history that social status produces, and a self-identification that defines the group as a group.

Political and social theorists tend more often to elide social groups with associations rather than aggregates. By an association I mean a collectivity of persons who come together voluntarily—such as a club, corporation, political party, church, college, union, lobbying organization, or interest group. An individualist contract model of society applies to associations but not to groups. Individuals constitute associations; they come together as already formed persons and set them up, establishing rules, positions, and offices.

Since one joins an association, even if membership in it fundamentally affects one's life, one does not take that association membership to define one's very identity in the way, for example, that being Navajo might. Group affinity, on the other hand, has the character of what Heidegger calls "thrownness": one finds oneself as a member of a group whose existence and relations one experiences as always already having been, for a person's identity is defined in relation to how others identify him or her, and others

do so in terms of groups that already have specific attributes, stereotypes, and norms associated with them, in reference to which a person's identity will be formed. From the thrownness of group affinity it does not follow that one cannot leave groups and enter new ones. Many women become lesbian after identifying as heterosexual, and anyone who lives long enough becomes old. These cases illustrate thrownness precisely in that such changes in group affinity are experienced as a transformation in one's identity.

A social group should not be understood as an essence or nature with a specific set of common attributes. Instead, group identity should be understood in relational terms. Social processes generate groups by creating relational differentiations, situations of clustering and affective bonding in which people feel affinity for other people. Sometimes groups define themselves by despising or excluding others whom they define as other and whom they dominate and oppress. Although social processes of affinity and separation define groups, they do not give groups a substantive identity. There is no common nature that members of a group have.

As products of social relations, groups are fluid; they come into being and may fade away. Homosexual practices have existed in many societies and historical periods, for example, but gay-male group identification exists only in the West in the twentieth century. Group identity may become salient only under specific circumstances, when in interaction with other groups. Most people in modern societies have multiple group identifications, moreover, and therefore groups themselves are not discrete unities. Every group has group differences cutting across it.

I think that group differentiation is an inevitable and desirable process in modern societies. We need not settle that question, however. I merely assume that ours is now a group-differentiated society and that it will continue to be so for some time to come. Our political problem is that some of our groups are privileged and others are oppressed.

But what is oppression? In another place I give a fuller account of the concept of oppression.[15] Briefly, a group is oppressed when one or more of the following conditions occurs to all or a large portion of its members: (1) The benefits of their work or energy go to others without those others reciprocally benefiting them (exploitation); (2) they are excluded from participation in major social activities, which in our society means primarily a workplace (marginalization); (3) they live and work under the authority of others and have little work autonomy and authority over others themselves (powerlessness); (4) as a group they are stereotyped at the same time that their experience and situation is invisible in the society in general, and they have little opportunity and little audience for the expression of their experience and perspective on social events (cultural imperialism); (5) group members suffer random violence and harassment motivated by group hatred or fear. In the United States today at least the following groups are oppressed in one or more of these ways: women, Blacks, American Indians, Chicanos, Puerto Ricans and other Spanish-speaking Americans,

Asian-Americans, gay men, lesbians, working-class people, poor people, old people, and mentally and physically disabled people.

Perhaps in some utopian future there will be a society without group oppression and disadvantage. We cannot develop political principles by starting with the assumption of a completely just society, however, but must begin from within the general historical and social conditions in which we exist. This means that we must develop participatory democratic theory not on the assumption of an undifferentiated humanity, but rather on the assumption that there are group differences and that some groups are actually or potentially oppressed or disadvantaged.

I assert, then, the following principle: a democratic public, however that is constituted, should provide mechanisms for the effective representation and recognition of the distinct voices and perspectives of those of its constituent groups that are oppressed or disadvantaged within it. Such group representation implies institutional mechanisms and public resources supporting three activities: (1) Self-organization of group members so that they gain a sense of collective empowerment and a reflective understanding of their collective experience and interests in the context of the society; (2) voicing a group's analysis of how social policy proposals affect them and generating policy proposals themselves, in institutionalized contexts where decision-makers are obliged to show that they have taken these perspectives into consideration; (3) having veto power regarding specific policies that affect a group directly—for example, reproductive rights for women or use of reservation lands for American Indians.

The principles call for specific representation only for oppressed or disadvantaged groups, because privileged groups already are represented. Thus the principle would not apply in a society entirely without oppression. I do not regard the principle as being merely provisional or instrumental, however, because I believe that group difference in modern complex societies is both inevitable and desirable and that wherever there is group difference, disadvantage or oppression always looms as a possibility. Thus a society should always be committed to representation for oppressed or disadvantaged groups and ready to implement such representation when oppression appears. These considerations are rather academic in our own context, however, since we live in a society with deep group oppressions, the complete elimination of which is only a remote possibility.

Social and economic privilege means, among other things, that the groups that have it behave as though they have a right to speak and be heard, that others treat them as though they have that right, and that they have the material, personal, and organizational resources that enable them to speak and be heard in public. The privileged are usually not inclined to protect and further the interests of the oppressed, partly because their social position prevents them from understanding those interests and partly because to some degree their privilege depends on the continued oppression of others. So a major reason for explicit representation of oppressed groups

in discussion and decision-making is to undermine oppression. Such group representation also exposes in public the specificity of the assumptions and experience of the privileged, for unless confronted with different perspectives on social relations and events, different values and language, most people tend to assert their own perspective as universal.

Theorists and politicians extol the virtues of citizenship because through public participation people are called on to transcend merely self-centered motivation and to acknowledge their dependence on and responsibility to others. The responsible citizen is concerned not merely with interests but also with justice, with acknowledging that each other person's interest and point of view is as good as his or her own and that the needs and interests of everyone must be voiced and be heard by the others, who must acknowledge, respect, and address those needs and interests. The problem of universality has occurred when this responsibility has been interpreted as transcendence into a general perspective.

I have argued that defining citizenship as generality avoids and obscures this requirement that all experiences, needs, and perspectives on social events have a voice and are respected. A general perspective does not exist that all persons can adopt and from which all experiences and perspectives can be understood and taken into account. The existence of social groups implies different, though not necessarily exclusive, histories, experiences, and perspectives on social life that people have, and it implies that they do not entirely understand the experience of other groups. No one can claim to speak in the general interest, because no one of the groups can speak for another, and certainly no one can speak for them all. Thus the only way to have all group experience and social perspectives voiced, heard, and taken account of is to have them specifically represented in the public.

Group representation is the best means to promote just outcomes to democratic decision-making processes. The argument for this claim relies on Habermas's conception of communicative ethics. In the absence of a philosopher–king who reads transcendent normative verities, the only ground for a claim that a policy or decision is just is that it has been arrived at by a public that has truly promoted free expression of all needs and points of view. In his formulation of a communicative ethic, Habermas retains inappropriately an appeal to a universal or impartial point of view from which claims in a public should be addressed. A communicative ethic that not merely articulates a hypothetical public that would justify decisions, but also proposes actual conditions tending to promote just outcomes of decision-making processes, should promote conditions for the expression of the concrete needs of all individuals in their particularity.[16] The concreteness of individual lives, their needs and interests, and their perception of the needs and interests of others, I have argued, are structured partly through group-based experience and identity. Thus full and free expression of concrete needs and interests under social circumstances where some groups are silenced or marginalized requires that they have a specific voice in deliberation and decision-making.

The introduction of such differentiation and particularity into democratic procedures does not encourage the expression of narrow self-interest; indeed, group representation is the best antidote to self-deceiving self-interest masked as an impartial or general interest. In a democratically structured public where social inequality is mitigated through group representation, individuals or groups cannot simply assert that they want something; they must say that justice requires or allows that they have it. Group representation provides the opportunity for some to express their needs or interests who would not likely be heard without that representation. At the same time, the test of whether a claim on the public is just, or a mere expression of self-interest, is best made when persons making it must confront the opinions of others who have explicitly different, though not necessarily conflicting, experiences, priorities, and needs. As a person of social privilege, I am not likely to go outside myself and have a regard for social justice unless I am forced to listen to the voices of those whom my privilege tends to silence.

Group representation best institutionalizes fairness under circumstances of social oppression and domination. But group representation also maximizes knowledge expressed in discussion and thus promotes practical wisdom. Group differences involve not only different needs, interests, and goals, but also probably more important different social locations and experiences from which social facts and policies are understood. Members of different social groups are likely to know different things about the structure of social relations and the potential and actual effects of social policies. Because of their history, their group-specific values or modes of expression, their relationship to other groups, the kind of work they do, and so on, different groups have different ways of understanding the meaning of social events, which can contribute to the others' understanding if expressed and heard.

Emancipatory social movements in recent years have developed some political practices committed to the idea of a heterogeneous public, and they have at least partly or temporarily instituted such publics. Some political organizations, unions, and feminist groups have formal caucuses for groups (such as Blacks, Latinos, women, gay men and lesbians, and disabled or old people) whose perspectives might be silenced without them. Frequently these organizations have procedures for caucus voice in organization discussion and caucus representation in decision-making, and some organizations also require representation of members of specific groups in leadership bodies. Under the influence of these social movements asserting group difference, during some years even the Democratic Party, at both national and state levels, has instituted delegate rules that include provisions for group representation.

Though its realization is far from assured, the ideal of a "Rainbow Coalition" expresses such a heterogeneous public with forms of group representation. The traditional form of coalition corresponds to the idea of a unified public that transcends particular differences of experience and

concern. In traditional coalitions, diverse groups work together for ends that they agree interest or affect them all in a similar way, and they generally agree that the differences of perspective, interests, or opinion among them will not surface in the public statements and actions of the coalition. In a Rainbow Coalition, by contrast, each of the constituent groups affirms the presence of the others and affirms the specificity of its experience and perspective on social issues.[17] In the rainbow public, Blacks do not simply tolerate the participation of gays, labor activists do not grudgingly work alongside peace-movement veterans, and none of these paternalistically allows feminist participation. Ideally, a rainbow coalition affirms the presence and supports the claims of each of the oppressed groups or political movements constituting it, and it arrives at a political program not by voicing some "principles of unity" that hide differences but rather by allowing each constituency to analyze economic and social issues from the perspective of its experience. This implies that each group maintains autonomy in relating to its constituency and that decision-making bodies and procedures provide for group representation.

To the degree that there are heterogeneous publics operating according to the principles of group representation in contemporary politics, they exist only in organizations and movements resisting the majority politics. Nevertheless, in principle participatory democracy entails commitment to institutions of a heterogeneous public in all spheres of democratic decision-making. Until and unless group oppression or disadvantages are eliminated, political publics, including democratized workplaces and government decision-making bodies, should include the specific representation of those oppressed groups, through which those groups express their specific understanding of the issues before the public and register a group-based vote. Such structures of group representation should not replace structures of regional or party representation but should exist alongside them.

Implementing principles of group representation in national politics in the United States or in restructured democratic publics within particular institutions, such as factories, offices, universities, churches, and social service agencies, would require creative thinking and flexibility. There are no models to follow. European models of consociational democratic institutions, for example, cannot be taken outside the contexts in which they have evolved, and even within them they do not operate in a very democratic fashion. Reports of experiments with publicly institutionalized self-organization among women, indigenous peoples, workers, peasants, and students in contemporary Nicaragua offer an example closer to the conception I am advocating.[18]

The principle of group representation calls for such structures of representation for oppressed or disadvantaged groups. But what groups deserve representation? Clear candidates for group representation in policy-making in the United States are women, Blacks, American Indians, old people, poor people, disabled people, gay men and lesbians, Spanish-

speaking Americans, young people, and nonprofessional workers. But it may not be necessary to ensure specific representation of all these groups in all public contexts and in all policy discussions. Representation should be designated whenever the group's history and social situation provide a particular perspective on the issues, when the interests of its members are specifically affected, and when its perceptions and interests are not likely to receive expression without that representation.

An origin problem emerges in proposing a principle such as this, which no philosophical argument can solve. To implement this principle a public must be constituted to decide which groups deserve specific representation in decision-making procedures. What are the principles guiding the composition of such a "constitutional convention"? Who should decide what groups should receive representation and by what procedures this decision should take place? No program or set of principles can found a politics, because politics is always a process in which we are already engaged; principles can be appealed to in the course of political discussion, and they can be accepted by a public as guiding their action. I propose a principle of group representation as a part of such potential discussion, but it cannot replace that discussion or determine its outcome.

What should be the mechanisms of group representation? Earlier I stated that the self-organization of the group is one of the aspects of a principle of group representation. Members of the group must meet in democratic forums to discuss issues and formulate group positions and proposals. This principle of group representation should be understood as part of a larger program for democratized decision-making processes. Public life and decision-making processes should be transformed so that all citizens have significantly greater opportunities for participation in discussion and decision-making. All citizens should have access to neighborhood or district assemblies where they participate in discussion and decision-making. In such a more participatory democratic scheme, members of oppressed groups would also have group assemblies, which would delegate group representatives.

One might well ask how the idea of a heterogeneous public that encourages self-organization of groups and structures of group representation in decision-making is different from the interest-group pluralism criticism that I endorsed earlier in this article. First, in the heterogeneous public not just any collection of people that chooses to form an association counts as a candidate for group representation. Only those groups that describe the major identities and major status relationships constituting the society or particular institution, and that are oppressed or disadvantaged, deserve specific representation in a heterogeneous public. In the structures of interest-group pluralism, Friends of the Whales, the National Association for the Advancement of Colored People, the National Rifle Association, and the National Freeze Campaign all have the same status, and each influences decision-making to the degree that their resources and ingenuity can win the competition for policymakers' ears. While democratic politics must

maximize freedom of expression of opinion and interest, that is a different issue from ensuring that the perspectives of all groups have a voice.

Second, in the heterogeneous public the groups represented are not defined by some particular interest or goal or by some particular political position. Social groups are comprehensive identities and ways of life. Because of their experiences their members may have some common interests that they seek to press in the public. Their social location, however, tends to give them distinctive understandings of all aspects of the society and unique perspectives on social issues. For example, many American Indians argue that their traditional religion and relation to land gives them a unique and important understanding of environmental problems.

Finally, interest-group pluralism operates precisely to forestall the emergence of public discussion and decision-making. Each interest group promotes only its specific interest as thoroughly and forcefully as it can, and it need not consider the other interests competing in the political marketplace except strategically, as potential allies or adversaries in the pursuit of its own. The rules of interest-group pluralism do not require justifying one's interest as right or as compatible with social justice. A heterogeneous public, however, is a *public*, where participants discuss the issues before them and are supposed to come to a decision that they determine is best or most just.

III. Universal Rights and Special Rights

A second aspect of the universality of citizenship is today in tension with the goal of full inclusion and participation of all groups in political and social institutions: universality in the formulation of law and policies. Modern and contemporary liberalism hold as basic the principle that the rules and policies of the state, and in contemporary liberalism also the rules of private institutions, ought to be blind to race, gender, and other group differences. The public realm of the state and law properly should express its rules in general terms that abstract from the particularities of individual and group histories, needs, and situations to recognize all persons equally and treat all citizens in the same way.

As long as political ideology and practice persisted in defining some groups as unworthy of equal citizenship status because of supposedly natural differences from white male citizens, it was important for emancipatory movements to insist that all people are the same in respect of their moral worth and deserve equal citizenship. In this context, demands for equal rights that are blind to group differences were the only sensible way to combat exclusion and degradation.

Today, however, the social consensus is that all persons are of equal moral worth and deserve equal citizenship. With the near achievement of equal rights for all groups, with the important exception of gay men and lesbians, group inequalities nevertheless remain. Under these circumstances many feminists, Black-liberation activists, and others struggling for the

full inclusion and participation of all groups in this society's institutions and positions of power, reward, and satisfaction, argue that rights and rules that are universally formulated and thus blind to differences of race, culture, gender, age, or disability perpetuate rather than undermine oppression.

Contemporary social movements seeking full inclusion and participation of oppressed and disadvantaged groups now find themselves faced with a dilemma of difference.[19] On the one hand, they must continue to deny that there are any essential differences between men and women, whites and Blacks, able-bodied and disabled people that justify denying women, Blacks, or disabled people the opportunity to do anything that others are free to do or to be included in any institution or position. On the other hand, they have found it necessary to affirm that there are often group-based differences between men and women, whites and Blacks, able-bodied and disabled people that make application of a strict principle of equal treatment, especially in competition for positions, unfair because these differences put those groups at a disadvantage. For example, white middle-class men as a group are socialized into the behavioral styles of a particular kind of articulateness, coolness, and competent authoritativeness that is most rewarded in professional and managerial life. To the degree that there are group differences that disadvantage, fairness seems to call for acknowledging rather than being blind to them.

Though in many respects the law is now blind to group differences, the society is not, and some groups continue to be marked as deviant and as the other. In everyday interactions, images, and decision-making, assumptions continue to be made about women, Blacks, Latinos, gay men, lesbians, old people, and other marked groups, which continue to justify exclusions, avoidances, paternalism, and authoritarian treatment. Continued racist, sexist, homophobic, ageist, and ableist behaviors and institutions create particular circumstances for these groups, usually disadvantaging them in their opportunity to develop their capacities and giving them particular experiences and knowledge. Finally, in part because they have been segregated and excluded from one another, and in part because they have particular histories and traditions, there are cultural differences among social groups—differences in language, style of living, body comportment and gesture, values, and perspectives on society.

Acknowledging group difference in capacities, needs, culture, and cognitive styles poses a problem for those seeking to eliminate oppression only if difference is understood as deviance or deficiency. Such understanding presumes that some capacities, needs, culture, or cognitive styles are normal. I suggested earlier that their privilege allows dominant groups to assert their experience of and perspective on social events as impartial and objective. In a similar fashion, their privilege allows some groups to project their group-based capacities, values, and cognitive and behavioral styles as the norm to which all persons should be expected to conform. Feminists in particular have argued that most contemporary workplaces, especially

the most desirable, presume a life rhythm and behavioral style typical of men and that women are expected to accommodate to the workplace expectations that assume those norms.

Where group differences in capacities, values, and behavioral or cognitive styles exist, equal treatment in the allocation of reward according to rules of merit composition will reinforce and perpetuate disadvantage. Equal treatment requires everyone to be measured according to the same norms, but in fact there are no "neutral" norms of behavior and performance. Where some groups are privileged and others oppressed, the formulation of law, policy, and the rules of private institutions tend to be biased in favor of the privileged groups, because their particular experience implicitly sets the norm. Thus where there are group differences in capacities, socialization, values, and cognitive and cultural styles, only attending to such differences can ensure the inclusion and participation of all groups in political and economic institutions. This implies that instead of always formulating rights and rules in universal terms that are blind to difference, some groups sometimes deserve special rights.[20] In what follows, I shall review several contexts of contemporary policy debate where, I argue, such special rights for oppressed or disadvantaged groups are appropriate.

The issue of a right to pregnancy and maternity leave and the right to special treatment for nursing mothers is highly controversial among feminists today. I do not intend here to wind through the intricacies of what has become a conceptually challenging and interesting debate in legal theory. As Linda Krieger argues, the issue of rights for pregnant and birthing mothers in relation to the workplace has created a paradigm crisis for our understanding of sexual equality, because the application of a principle of equal treatment on this issue has yielded results whose effects on women are at best ambiguous and at worst detrimental.[21]

In my view an equal-treatment approach on this issue is inadequate because it either implies that women do not receive any right to a leave with job security when having babies, or it assimilates such guarantees under a supposedly gender-neutral category of "disability." Such assimilation is unacceptable because pregnancy and childbirth are normal conditions of normal women; they themselves count as socially necessary work, and they have unique and variable characteristics and needs.[22] Assimilating pregnancy into disability gives a negative meaning to these processes as "unhealthy." It suggests, moreover, that the primary or only reasons that a woman has a right to a leave with job security are that she is physically unable to work at her job or that doing so would be more difficult than when she is not pregnant and recovering from childbirth. While these are important reasons, depending on the individual woman, another reason is that she ought to have the time to establish breast-feeding and to develop a relationship and routine with her child, if she chooses.

The pregnancy-leave debate has been heated and extensive because both feminists and nonfeminists tend to think of biological sex difference as the

most fundamental and irradicable difference. When difference slides into deviance, stigma, and disadvantage, this impression can engender the fear that sexual equality is not attainable. I think it is important to emphasize that reproduction is by no means the only context in which issues of same vs. different treatment arise. It is not even the only context where it arises for issues involving bodily difference. The past twenty years have seen significant success in winning special rights for persons with physical and mental disabilities. Here is a clear case where promoting equality in participation and inclusion requires attending to the particular needs of different groups.

Another bodily difference that has not been as widely discussed in law and policy literature, but should be, is age. With increasing numbers of willing and able old people marginalized in our society, the issue of mandatory retirement has been increasingly discussed. This discussion has been muted because serious consideration of working rights for all people able and willing to work implies major restructuring of the allocation of labor in an economy with already socially volatile levels of unemployment. Forcing people out of their workplaces solely on account of their age is arbitrary and unjust. Yet I think it is also unjust to require old people to work on the same terms as younger people. Old people should have different working rights. When they reach a certain age they should be allowed to retire and receive income benefits. If they wish to continue working, they should be allowed more flexible and part-time schedules than most workers currently have.

Each of these cases of special rights in the workplace—pregnancy and birthing, physical disability, and being old—has its own purposes and structures. They all challenge, however, the same paradigm of the "normal, healthy" worker and "typical work situation." In each case the circumstance that calls for different treatment should not be understood as lodged in the differently treated workers, per se, but in their interaction with the structure and norms of the workplace. Even in cases such as these, that is, difference does not have its source in natural, unalterable, biological attributes, but in the relationship of bodies to conventional rules and practices. In each case the political claim for special rights emerges not from a need to compensate for an inferiority, as some would interpret it, but from a positive assertion of specificity in different forms of life.[23]

Issues of difference arise for law and policy not only regarding bodily being, but also, and just as important, for cultural integrity and invisibility. By culture I mean group-specific phenomena of behavior, temperament, or meaning. Cultural differences include phenomena of language, speaking style or dialect, body comportment, gesture, social practices, values, group-specific socialization, and so on. To the degree that groups are culturally different, however, equal treatment in many issues of social policy is unjust because it denies these cultural differences or makes them a liability. There are a vast number of issues where fairness involves attention to cultural differences and their effects, but I shall briefly discuss only three: affir-

mative action; comparable worth; and bilingual, bicultural education and service.

Whether they involve quotas or not, affirmative-action programs violate a principle of equal treatment because they are race- or gender-conscious in setting criteria for school admissions, jobs, or promotions. These policies are usually defended in one of two ways. Giving preference to race or gender is understood either as just compensation for groups that have suffered discrimination in the past or as compensation for the present disadvantage these groups suffer because of that history of discrimination and exclusion.[24] I do not wish to quarrel with either of these justifications for the differential treatment based on race or gender implied by affirmative action policies. I want to suggest that in addition, we can understand affirmative action policies as compensating for the cultural biases of standards and evaluators used by the schools or employers. These standards and evaluators reflect at least to some degree the specific life and cultural experience of dominant groups—whites, Anglos, or men. In a group-differentiated society, moreover, the development of truly neutral standards and evaluations is difficult or impossible, because female, Black, or Latino cultural experience and the dominant cultures are in many respects not reducible to a common measure. Thus affirmative action policies compensate for the dominance of one set of cultural attributes. Such an interpretation of affirmative action locates the "problem" that affirmative action solves partly in the understandable biases of evaluators and their standards, rather than only in specific differences of the disadvantaged group.

Although they are not a matter of different treatment as such, comparable worth policies similarly claim to challenge cultural biases in traditional evaluation in the worth of female-dominated occupations, and in doing so require attending to differences. Schemes of equal pay for work of comparable worth require that predominantly male and predominantly female jobs have similar wage structures if they involve similar degrees of skill, difficulty, stress, and so on. The problem in implementing these policies, of course, lies in designing methods of comparing the jobs, which often are very different. Most schemes of comparison choose to minimize sex differences by using supposedly gender-neutral criteria, such as educational attainment, speed of work, whether it involves manipulation of symbols, decision-making, and so on. Some writers have suggested, however, that standard classifications of job traits may be systematically biased to keep specific kinds of tasks involved in many female-dominated occupations hidden.[25] Many female-dominated occupations involve gender-specific kinds of labor—such as nurturing, smoothing over social relations, or exhibiting sexuality—that most task observation ignores.[26] A fair assessment of the skills and complexity of many female-dominated jobs may therefore involve paying explicit attention to gender differences in kinds of jobs rather than applying gender-blind categories of comparison.

Finally, linguistic and cultural minorities ought to have the right to maintain their language and culture and at the same time be entitled to all

the benefits of citizenship, as well as to valuable education and career opportunities. This right implies a positive obligation on the part of governments and other public bodies to print documents and to provide services in the native languages of recognized linguistic minorities, and to provide bilingual instruction in schools. Cultural assimilation should not be a condition of full social participation, because it requires a person to transform his or her sense of identity, and when it is realized on a group level it means altering or annihilating the group's identity. This principle does not apply to any persons who do not identify with the majority language or culture within a society, but only to sizable linguistic or cultural minorities living in distinct, though not necessarily segregated, communities. In the United States, then, special rights for cultural minorities applies at least to Spanish-speaking Americans and American Indians.

The universalist finds a contradiction in asserting both that formerly segregated groups have a right to inclusion and that these groups have a right to different treatment. There is no contradiction here, however, if attending to difference is necessary in order to make participation and inclusion possible. Groups with different circumstances or forms of life should be able to participate together in public institutions without shedding their distinct identities or suffering disadvantage because of them. The goal is not to give special compensation to the deviant until they achieve normality, but rather to denormalize the way institutions formulate their rules by revealing the plural circumstances and needs that exist, or ought to exist, within them.

Many opponents of oppression and privilege are wary of claims for special rights because they fear a restoration of special classifications that can justify exclusion and stigmatization of the specially marked groups. Such fear has been particularly pronounced among feminists who oppose affirming sexual and gender difference in law and policy. It would be foolish for me to deny that this fear has some significant basis.

Such fear is founded, however, on accession to traditional identification of group difference with deviance, stigma, and inequality. Contemporary movements of oppressed groups, however, assert a positive meaning to group difference, by which a group claims its identity as a group and rejects the stereotypes and labeling by which others mark it as inferior or inhuman. These social movements engage the meaning of difference itself as a terrain of political struggle, rather than leaving difference to be used to justify exclusion and subordination. Supporting policies and rules that attend to group difference in order to undermine oppression and disadvantage is, in my opinion, a part of that struggle.

Fear of claims to special rights points to a connection of the principle of group representation with the principle of attending to difference in policy. The primary means of defense from the use of special rights to oppress or exclude groups is the self-organization and representation of those groups. If oppressed and disadvantaged groups are able to discuss among themselves what procedures and policies they judge will best fur-

ther their social and political equality, and have access to mechanisms to make their judgments known to the larger public, policies that attend to difference are less likely to be used against them than for them. If they have the institutionalized right to veto policy proposals that directly affect them, and them primarily, moreover, such danger is further reduced.

In this article I have distinguished three meanings of universality that have usually been collapsed in discussions of the universality of citizenship and the public realm. Modern politics properly promotes the universality of citizenship in the sense of the inclusion and participation of everyone in public life and democratic processes. The realization of genuinely universal citizenship in this sense today is impeded rather than furthered by the commonly held conviction that when they exercise their citizenship, persons should adopt a universal point of view and leave behind the perceptions they derive from their particular experience an social position. The full inclusion and participation of all in law and public life is also sometimes impeded by formulating laws and rules in universal terms that apply to all citizens in the same way.

In response to these arguments, some people have suggested to me that such challenges to the ideal of universal citizenship threaten to leave no basis for rational normative appeals. Normative reason, it is suggested, entails universality in a Kantian sense: when a person claims that something is good or right, he or she is claiming that everyone in principle could consistently make that claim and that everyone should accept it. This refers to a fourth meaning of universality, more epistemological than political. There may indeed be grounds for questioning a Kantian-based theory of the universality of normative reason, but this is a different issue from the substantive political issues I have addressed here, and the arguments in this paper neither imply nor exclude such a possibility. In any case, I do not believe that challenging the ideal of a unified public or the claim that rules should always be formally universal subverts the possibility of making rational normative claims.

NOTES

1. Theodore Lowi's classic analysis of the privatized operations of interest-group liberalism remains descriptive of American politics; see *The End of Liberalism* (New York: W. W. Norton, 1969). For more recent analyses, see Jurgen Habermas, *Legitimation Crisis* (Boston: Beacon Press, 1973); Claus Offe, *Contradictions of the Welfare State* (Cambridge, Mass.: MIT Press, 1984); John Keane, *Public Life in Late Capitalism* (Cambridge, Mass.: MIT Press, 1984); and Benjamin Barber, *Strong Democracy* (Berkeley: University of California Press, 1984).

2. For an outstanding recent account of the virtues of and conditions for such democracy, see Philip Green, *Retrieving Democracy* (Totowa, N.J.: Rowman and Allenheld, 1985).

3. Barber, op. cit., and Keane, op. cit., both appeal to Rousseau's understanding

of civic activity as a model for contemporary participatory democracy, as does Carole Pateman in her classic work *Participation and Democratic Theory* (Cambridge, Mass.: Cambridge University Press, 1970). (Pateman's position has, of course, changed.) See also James Miller, *Rousseau: Dreamer of Democracy* (New Haven, Conn.: Yale University Press, 1984).

4. Many who extol the virtues of the civic public, of course, appeal also to a model of the ancient polis. For a recent example, see Murray Bookchin, *The Rise of Urbanization and the Decline of Citizenship* (San Francisco: Sierra Club Books, 1987). In this essay, however, I choose to restrict my claims to modern political thought. The idea of the ancient Greek polis often functions in both modern and contemporary discussion as a myth of lost origins, the paradise from which we have fallen and to which we desire to return; in this way appeals to the ancient Greek polis are often contained within appeals to modern ideas of civic humanism.

5. Hannah Pitkin performs a most detailed and sophisticated analysis of the virtues of the civic public as a flight from sexual difference through a reading of the texts of Machiavelli; see *Fortune Is a Woman* (Berkeley: University of California Press, 1984). Carol Pateman has an important analysis of contract theory in this respect, in *The Sexual Contract* (Stanford, Conn.: Stanford University Press, 1988). See also Nancy Hartsock, *Money, Sex and Power* (New York: Longman, 1983), chapters 7 and 8.

6. See Susan Okin, "Women and the Making of the Sentimental Family," *Philosophy and Public Affairs*, vol. 11, no. 1 (Winter 1982), pp. 65–88; see also Linda Nicholson, *Gender and History: The Limits of Social Theory in the Age of the Family* (New York: Columbia University Press, 1986).

7. For analyses of Rousseau's treatment of women, see Susan Okin, *Women in Western Political Thought* (Princeton, N.J.: Princeton University Press, 1978); Lynda Lange, "Rousseau: Women and the General Will," in Lorenne M. G. Clark and Lynda Lange, ed., *The Sexism of Social and Political Theory* (Toronto: University of Toronto Press, 1979); Jean Bethke Elshtain, *Public Man, Private Woman* (Princeton, N.J.: Princeton University Press, 1981), chapter 4. Mary Dietz develops an astute critique of Elshtain's "maternalist" perspective on political theory; in so doing, however, she also seems to appeal to a universalist ideal of the civic public in which women will transcend their particular concerns and become general; see "Citizenship with a Feminist Face: The Problem with Maternal Thinking," *Political Theory*, vol. 13, no. 1 (February 1985), pp. 19–37. On Rousseau on women, see also Joel Schwartz, *The Sexual Politics of Jean-Jacques Rousseau* (Chicago: University of Chicago Press, 1984).

8. See Ronald Takaki, *Iron Cages: Race and Culture in 19th Century America* (New York: Knopf, 1979). Don Herzog discusses the exclusionary prejudices of some other early American republicans; see "Some Questions for Republicans," *Political Theory*, vol. 14, no. 3 (August 1985), pp. 473–93.

9. George Mosse, *Nationalism and Sexuality* (New York: Howard Fertig, 1985).

10. Barber, op. cit., chapters 8 and 9.

11. I have developed this account more thoroughly in my paper "Impartiality and the Civic Public: Some Implications of Feminist Critiques of Moral and Political Theory," *Praxis International*, vol. 5., no. 4 (January 1986), pp. 381–401.

12. See Pateman, op. cit., "Feminism and Participatory Democracy."

13. Jane Mansbridge, *Beyond Adversary Democracy* (New York: Basic Books, 1980).

14. Amy Gutmann, *Liberal Equality* (Cambridge, Mass.: Cambridge University Press, 1980), pp. 191–202.

15. I have developed a fuller account of oppression in "Five Faces of Oppression," *The Philosophical Forum*, vol. XIX, no. 4 (Summer 1988), pp. 270–90.

16. Jurgen Habermas, *Reason and the Rationalization of Society* (Boston: Beacon Press, 1983), part III. For criticism of Habermas as retaining too universalist a conception of communicative action, see Seyla Benhabib, *Critique, Norm and Utopia*

(New York: Columbia University Press, 1986); and my "Impartiality and the Civic Public," cited in note 11.

17. The Mel King for Mayor campaign organization exhibited the promise of such group representation in practice, which there was only partially and haltingly realized; see special double issue of *Radical America*, vol. 17, no. 6 (1984) and vol. 18, no. 1 (1984). Sheila Collins discusses how the idea of a Rainbow Coalition challenges traditional American political assumptions of a "melting pot" and how lack of coordination between the national-level rainbow departments and the grass-roots campaign committees prevented the Jackson campaign from realizing the promise of group representation; see *The Rainbow Challenge: The Jackson Campaign and the Future of U.S. Politics* (New York: Monthly Review Press, 1986).

18. See Gary Ruchwarger, *People in Power: Forging a Grassroots Democracy in Nicaragua* (S. Hadley, Mass.: Bergin and Garvey, 1985).

19. Martha Minow, "Learning to Live with the Dilemma of Difference: Bilingual and Special Education," *Law and Contemporary Problems*, no. 48 (Spring 1985).

20. I use the term "special rights" in much the same way as Elizabeth Wolgast does in *Equality and the Rights of Women* (Ithaca, N.Y.: Cornell University Press, 1980). Like Wolgast, I wish to distinguish a class of rights that all people should have, general rights, and a class of rights that categories of people should have by virtue of particular circumstances. That is, the distinction should refer only to different levels of generality, where "special" means only "specific." Unfortunately, "special rights" tends to carry a connotation of *exceptional*, that is, specially marked and deviating from the norm. As I assert below, however, the goal is not to compensate for deficiencies in order to help people be "normal," but to denormalize, so that in certain contexts and at certain levels of abstraction everyone has "special" rights.

21. Linda J. Krieger, "Through a Glass Darkly: Paradigms of Equality and the Search for a Women's Jurisprudence," in *Hypatia: A Journal of Feminist Philosophy*, vol. 2, no. 1 (Winter 1987), pp. 45–62. Deborah Rhode provides an excellent synopsis of the dilemmas involved in this pregnancy debate in feminist legal theory in *Justice and Gender* (Cambridge, Mass.: Harvard University Press, 1989), chapter 9.

22. See Ann Scales, "Towards a Feminist Jurisprudence," *Indiana Law Journal*, vol. 56 (1983). Christine Littleton provides a very good analysis of the feminist debate about equal vs. different treatment regarding pregnancy and childbirth, among other legal issues for women, in "Reconstructing Sexual Equality," *California Law Review*, vol. 75, no. 4 (July 1987), pp. 1279–337. Littleton suggests, as I have stated above, that only the dominant male conception of work keeps pregnancy and birthing from being conceived of as work.

23. Littleton, op. cit., suggests that difference should be understood not as a characteristic of particular sort of people, but of the interaction of particular sorts of people with specific institutional structures. Minow, op. cit., expresses a similar point by saying that difference should be understood as a function of the relationship among groups, rather than located in attributes of a particular group.

24. For one among many discussions of such "backward-looking" and "forward-looking" arguments, see Bernard Boxill, *Blacks and Social Justice* (Totowa, N.J.: Rowman and Allenheld, 1984), chapter 7.

25. See R. W. Beatty and J. R. Beatty, "Some Problems with Contemporary Job Evaluation Systems," and Ronnie Steinberg, "A Want of Harmony: Perspectives on Wage Discrimination and Comparable Worth," both in Helen Remick, ed., *Comparable Worth and Wage Discrimination: Technical Possibilities and Political Realities* (Philadelphia: Temple University Press, 1981); D. J. Treiman and H. I. Hartmann, ed., *Women, Work and Wages* (Washington D.C.: National Academy Press, 1981), p. 81.

26. David Alexander, *Gendered Job Traits and Women's Occupations*, Ph.D. dissertation, economics, University of Massachusetts, 1987.

Part Three

Female Body Experience

EIGHT

Throwing Like a Girl

*A Phenomenology of Feminine Body Comportment,
Motility, and Spatiality*

In discussing the fundamental significance of lateral space, which is one of the unique spatial dimensions generated by the human upright posture, Erwin Straus pauses at "the remarkable difference in the manner of throwing of the two sexes"[1] (p. 157). Citing a study and photographs of young boys and girls, he describes the difference as follows:

> The girl of five does not make any use of lateral space. She does not stretch her arm sideward; she does not twist her trunk; she does not move her legs, which remain side by side. All she does in preparation for throwing is to lift her right arm forward to the horizontal and to bend the forearm backward in a pronate position. . . . The ball is released without force, speed, or accurate aim. . . . A boy of the same age, when preparing to throw, stretches his right arm sideward and backward; supinates the forearm; twists, turns and bends his trunk; and moves his right foot backward. From this stance, he can support his throwing almost with the full strength of his total motorium. . . . The ball leaves the hand with considerable acceleration; it moves toward its goal in a long flat curve. (p. 157–60)[2]

Though he does not stop to trouble himself with the problem for long, Straus makes a few remarks in the attempt to explain this "remarkable difference." Since the difference is observed at such an early age, he says, it seems to be "the manifestation of a biological, not an acquired, difference" (p. 157). He is somewhat at a loss, however, to specify the source of the difference. Since the feminine style of throwing is observed in young children, it cannot result from the development of the breast. Straus provides further evidence against the breast by pointing out that "it seems certain" that the Amazons, who cut off their right breasts, "threw a ball just like our Betty's, Mary's and Susan's" (p. 158). Having thus dismissed the breast, Straus considers the weaker muscle power of the girl as an explanation of the difference, but concludes that the girl should be expected to compensate for such relative weakness with the added preparation of reaching around and back. Straus explains the difference in style of throwing by referring to a "feminine attitude" in relation to the world and to

space. The difference for him is biologically based, but he denies that it is specifically anatomical. Girls throw in a way different from boys because girls are "feminine."

What is even more amazing than this "explanation" is the fact that a perspective that takes body comportment and movement as definitive for the structure and meaning of human lived experience devotes no more than an incidental page to such a "remarkable difference" between masculine and feminine body comportment and style of movement, for throwing is by no means the only activity in which such a difference can be observed. If there are indeed typically "feminine" styles of body comportment and movement, this should generate for the existential phenomenologist a concern to specify such a differentiation of the modalities of the lived body. Yet Straus is by no means alone in his failure to describe the modalities, meaning, and implications of the difference between "masculine" and "feminine" body comportment and movement.

A virtue of Straus's account of the typical difference of the sexes in throwing is that he does not explain this difference on the basis of physical attributes. Straus is convinced, however, that the early age at which the difference appears shows that it is not an acquired difference, and thus he is forced back onto a mysterious "feminine essence" in order to explain it. The feminist denial that the real differences in behavior and psychology between men and woman can be attributed to some natural and eternal feminine essence is perhaps most thoroughly and systematically expressed by Beauvoir. Every human existence is defined by its *situation*; the particular existence of the female person is no less defined by the historical, cultural, social, and economic limits of her situation. We reduce women's condition simply to unintelligibility if we "explain" it by appeal to some natural and ahistorical feminine essence. In denying such a feminine essence, however, we should not fall into that "nominalism" that denies the real differences in the behavior and experiences of men and women. Even though there is no eternal feminine essence, there is "a common basis which underlies every individual female existence in the present state of education and custom."[3] The situation of women within a given sociohistorical set of circumstances, despite the individual variation in each woman's experience, opportunities, and possibilities, has a unity that can be described and made intelligible. It should be emphasized, however, that this unity is specific to a particular social formation during a particular epoch.

Beauvoir proceeds to give such an account of the situation of women with remarkable depth, clarity, and ingenuity. Yet she also, to a large extent, fails to give a place to the status and orientation of the woman's body as relating to its surroundings in living action. When Beauvoir does talk about the woman's bodily being and her physical relation to her surroundings, she tends to focus on the more evident facts of a woman's physiology. She discusses how women experience the body as a burden, how the hormonal and physiological changes the body undergoes at puberty, during

menstruation and pregnancy, are felt to be fearful and mysterious, and claims that these phenomena weigh down the woman's existence by tying her to nature, immanence, and the requirements of the species at the expense of her own individuality.[4] By largely ignoring the situatedness of the woman's actual bodily movement and orientation to its surroundings and its world, Beauvoir tends to create the impression that it is woman's anatomy and physiology *as such* that at least in part determine her unfree status.[5]

This essay seeks to begin to fill a gap that thus exists both in existential phenomenology and feminist theory. It traces in a provisional way some of the basic modalities of feminine body comportment, manner of moving, and relation in space. It brings intelligibility and significance to certain observable and rather ordinary ways in which women in our society typically comport themselves and move differently from the ways that men do. In accordance with the existentialist concern with the situatedness of human experience, I make no claim to the universality of this typicality of the bodily comportment of women and the phenomenological description based on it. The account developed here claims only to describe the modalities of feminine bodily existence for women situated in contemporary advanced industrial, urban, and commercial society. Elements of the account developed here may or may not apply to the situation of woman in other societies and other epochs, but it is not the concern of this essay to determine to which, if any, other social circumstances this account applies.

The scope of bodily existence and movement with which I am concerned here is also limited. I concentrate primarily on those sorts of bodily activities that relate to the comportment or orientation of the body as a whole, that entail gross movement, or that require the enlistment of strength and the confrontation of the body's capacities and possibilities with the resistance and malleability of things. The kind of movement I am primarily concerned with is movement in which the body aims to accomplish of a definite purpose or task. There are thus many aspects of feminine bodily existence that I leave out of this account. Most notable of these is the body in its sexual being. Another aspect of bodily existence, among others, that I leave unconsidered is structured body movement that does not have a particular aim—for example, dancing. Besides reasons of space, this limitation of subject is based on the conviction, derived primarily from Merleau-Ponty, that it is the ordinary purposive orientation of the body as a whole toward things and its environment that initially defines the relation of a subject to its world. Thus a focus upon ways in which the feminine body frequently or typically conducts itself in such comportment or movement may be particularly revelatory of the structures of feminine existence.[6]

Before entering the analysis, I should clarify what I mean here by "feminine" existence. In accordance with Beauvoir's understanding, I take "femininity" to designate not a mysterious quality or essence that all women have by virtue of their being biologically female. It is, rather, a set

of structures and conditions that delimit the typical *situation* of being a woman in a particular society, as well as the typical way in which this situation is lived by the women themselves. Defined as such, it is not necessary that *any* women be "feminine"—that is, it is not necessary that there be distinctive structures and behavior typical of the situation of women.[7] This understanding of "feminine" existence makes it possible to say that some women escape or transcend the typical situation and definition of women in various degrees and respects. I mention this primarily to indicate that the account offered here of the modalities of feminine bodily existence is not to be falsified by referring to some individual women to whom aspects of the account do not apply, or even to some individual men to whom they do.

The account developed here combines the insights of the theory of the lived body as expressed by Merleau-Ponty and the theory of the situation of women as developed by Beauvoir. I assume that at the most basic descriptive level, Merleau-Ponty's account of the relation of the lived body to its world, as developed in the *Phenomenology of Perception*, applies to any human existence in a general way. At a more specific level, however, there is a particular style of bodily comportment that is typical of feminine existence, and this style consists of particular *modalities* of the structures and conditions of the body's existence in the world.[8]

As a framework for developing these modalities, I rely on Beauvoir's account of woman's existence in patriarchal society as defined by a basic tension between immanence and transcendence.[9] The culture and society in which the female person dwells defines woman as Other, as the inessential correlate to man, as mere object and immanence. Woman is thereby both culturally and socially denied by the subjectivity, autonomy, and creativity that are definitive of being human and that in patriarchal society are accorded the man. At the same time, however, because she is a human existence, the female person necessarily is a subjectivity and transcendence, and she knows herself to be. The female person who enacts the existence of women in patriarchal society must therefore live a contradiction: as human she is a free subject who participates in transcendence, but her situation as a woman denies her that subjectivity and transcendence. My suggestion is that the modalities of feminine bodily comportment, motility, and spatiality exhibit this same tension between transcendence and immanence, between subjectivity and being a mere object.

Section I offers some specific observations about bodily comportment, physical engagement with things, ways of using the body in performing tasks, and bodily self-image, which I find typical of feminine existence. Section II gives a general phenomenological account of the modalities of feminine bodily comportment and motility. Section III develops these modalities further in terms of the spatiality generated by them. Finally, in Section IV, I draw out some of the implications of this account for an understanding of the oppression of women, as well as raise some further

questions about feminine being in the world that require further investigation.

I

The basic difference that Straus observes between the way boys and girls throw is that girls do not bring their whole bodies into the motion as much as the boys do. They do not reach back, twist, move backward, step, and lean forward. Rather, the girls tend to remain relatively immobile except for their arms, and even the arms are not extended as far as they could be. Throwing is not the only movement in which there is a typical difference in the way men and women use their bodies. Reflection on feminine comportment and body movement in other physical activities reveals that these also are frequently characterized, much as in the throwing case, by a failure to make full use of the body's spatial and lateral potentialities.

Even in the most simple body orientations of men and women as they sit, stand, and walk, one can observe a typical difference in body style and extension. Women generally are not as open with their bodies as are men in their gait and stride. Typically, the masculine stride is longer proportional to a man's body than is the feminine stride to a woman's. The man typically swings his arms in a more open and loose fashion than does a woman and typically has more up and down rhythm in his step. Though we now wear pants more than we used to and consequently do not have to restrict our sitting postures because of dress, women still tend to sit with their legs relatively close together and their arms across their bodies. When simply standing or leaning, men tend to keep their feet farther apart than do women, and we also tend more to keep our hands and arms touching or shielding our bodies. A final indicative difference is the way each carries books or parcels; girls and women most often carry books embraced to their chests, while boys and men swing them along their sides.

The approach that people of each sex take to the performance of physical tasks that require force, strength, and muscular coordination is frequently different. There are indeed real physical differences between men and women in the kind and limit of their physical strength. Many of the observed differences between men and women in the performance of tasks requiring coordinated strength, however, are due not so much to brute muscular strength as to the way each sex *uses* the body in approaching tasks. Women often do not perceive themselves as capable of lifting and carrying heavy things, pushing and shoving with significant force, pulling, squeezing, grasping, or twisting with force. When we attempt such tasks, we frequently fail to summon the full possibilities of our muscular coordination, position, poise, and bearing. Women tend not to put their whole bodies into engagement in a physical task with the same ease and naturalness as men. For example, in attempting to lift something, women more often than men fail to plant themselves firmly and make their thighs bear

the greatest proportion of the weight. Instead, we tend to concentrate our effort on those parts of the body most immediately connected to the task—the arms and shoulders—rarely bringing the power of the legs to the task at all. When turning or twisting something, to take another example, we frequently concentrate effort in the hand and wrist, not bringing to the task the power of the shoulder, which is necessary for its efficient performance.[10]

The previously cited throwing example can be extended to a great deal of athletic activity. Now, most men are by no means superior athletes, and their sporting efforts more often display bravado than genuine skill and coordination. The relatively untrained man nevertheless engages in sport generally with more free motion and open reach than does his female counterpart. Not only is there a typical style of throwing like a girl, but there is a more or less typical style of running like a girl, climbing like a girl, swinging like a girl, hitting like a girl. They have in common first that the whole body is not put into fluid and directed motion, but rather, in swinging and hitting, for example, the motion is concentrated in one body part; and second that the woman's motion tends not to reach, extend, lean, stretch, and follow through in the direction of her intention.

For many women as they move in sport, a space surrounds us in imagination that we are not free to move beyond; the space available to our movement is a constricted space. Thus, for example, in softball or volleyball women tend to remain in one place more often than men do, neither jumping to reach nor running to approach the ball. Men more often move out toward a ball in flight and confront it with their own countermotion. Women tend to wait for and then *react* to its approach, rather than going forth to meet it. We frequently respond to the motion of a ball coming toward us as though it were coming *at* us, and our immediate bodily impulse is to flee, duck, or otherwise protect ourselves from its flight. Less often than men, moreover, do women give self-conscious direction and placement to their motion in sport. Rather than aiming at a certain place where we wish to hit a ball, for example, we tend to hit it in a "general" direction.

Women often approach a physical engagement with things with timidity, uncertainty, and hesitancy. Typically, we lack an entire trust in our bodies to carry us to our aims. There is, I suggest, a double hesitation here. On the one hand, we often lack confidence that we have the capacity to do what must be done. Many times I have slowed a hiking party in which the men bounded across a harmless stream while I stood on the other side warily testing my footing on various stones, holding on to overhanging branches. Though the others crossed with ease, I do not believe it is easy for *me*, even though once I take a committed step I am across in a flash. The other side of this tentativeness is, I suggest, a fear of getting hurt, which is greater in women than in men. Our attention is often divided between the aim to be realized in motion and the body that must accomplish it, while at the same time saving itself from harm. We often experience our

bodies as a fragile encumbrance, rather than the media for the enactment of our aims. We feel as though we must have our attention directed upon our bodies to make sure they are doing what we wish them to do, rather than paying attention to what we want to do *through* our bodies.

All the above factors operate to produce in many women a greater or lesser feeling of incapacity, frustration, and self-consciousness. We have more of a tendency than men do to greatly underestimate our bodily capacity.[11] We decide beforehand—usually mistakenly—that the task is beyond us, and thus give it less than our full effort. At such a halfhearted level, of course, we cannot perform the tasks, become frustrated, and fulfill our own prophecy. In entering a task we frequently are self-conscious about appearing awkward and at the same time do not wish to appear too strong. Both worries contribute to our awkwardness and frustration. If we should finally release ourselves from this spiral and really give a physical task our best effort, we are greatly surprised indeed at what our bodies can accomplish. It has been found that women more often than men underestimate the level of achievement they have reached.[12]

None of the observations that have been made thus far about the way women typically move and comport their bodies applies to all women all of the time. Nor do those women who manifest some aspect of this typicality do so in the same degree. There is no inherent, mysterious connection between these sorts of typical comportments and being a female person. Many of them result, as will be developed later, from lack of practice in using the body and performing tasks. Even given these qualifications, one can nevertheless sensibly speak of a general feminine style of body comportment and movement. The next section will develop a specific categorical description of the modalities of the comportment and movement.

II

The three modalities of feminine motility are that feminine movement exhibits an *ambiguous transcendence*, an *inhibited intentionality*, and a *discontinuous unity* with its surroundings. A source of these contradictory modalities is the bodily self-reference of feminine comportment, which derives from the woman's experience of her body as a *thing* at the same time that she experiences it as a capacity.

1. In his *Phenomenology of Perception*,[13] Merleau-Ponty takes as his task the articulation of the primordial structures of existence, which are prior to and the ground of all reflective relation to the world. In asking how there can be a world for a subject, Merleau-Ponty reorients the entire tradition of that questioning by locating subjectivity not in mind or consciousness, but in the *body*. Merleau-Ponty gives to the lived body the ontological status that Sartre, as well as "intellectualist" thinkers before him, attribute to consciousness alone: the status of transcendence as being for itself. It is the body in its orientation toward and action upon and within its surroundings that constitutes the initial meaning-giving act (p. 121, pp.

146–47). The body is the first locus of intentionality, as pure presence to the world and openness upon its possibilities. The most primordial intentional act is the motion of the body orienting itself with respect to and moving within its surroundings. There is a world for a subject just insofar as the body has capacities by which it can approach, grasp, and appropriate its surroundings in the direction of its intentions.

While feminine bodily existence is a transcendence and openness to the world, it is an *ambiguous transcendence,* a transcendence that is at the same time laden with immanence. Now, once we take the locus of subjectivity and transcendence to be the lived body rather than pure consciousness, all transcendence is ambiguous because the body as natural and material is immanence. But it is not the ever-present possibility of any lived body to be passive, to be touched as well as touching, to be grasped as well as grasping, which I am referring to here as the ambiguity of the transcendence of the feminine lived body. The transcendence of the lived body that Merleau-Ponty describes is a transcendence that moves out from the body in its immanence in an open and unbroken directedness upon the world in action. The lived body as transcendence is pure fluid action, the continuous calling-forth of capacities that are applied to the world. Rather than simply beginning in immanence, feminine bodily existence remains in immanence or, better, is *overlaid* with immanence, even as it moves out toward the world in motions of grasping, manipulating, and so on.

In the previous section, I observed that a woman typically refrains from throwing her whole body into a motion, and rather concentrates motion in one part of the body alone, while the rest of the body remains relatively immobile. Only part of the body, that is, moves out toward a task, while the rest remains rooted in immanence. I also observed earlier that a woman frequently does not trust the capacity of her body to engage itself in physical relation to things. Consequently, she often lives her body as a burden, which must be dragged and prodded along and at the same time protected.

2. Merleau-Ponty locates intentionality in motility (pp. 110–12); the possibilities that are opened up in the world depend on the mode and limits of the bodily "I can" (p. 137, p. 148). Feminine existence, however, often does not enter bodily relation to possibilities by its own comportment toward its surroundings in an unambiguous and confident "I can." For example, as noted earlier, women frequently tend to posit a task that would be accomplished relatively easily once attempted as beyond their capacities before they begin it. Typically, the feminine body underuses its real capacity, both as the potentiality of its physical size and strength and as the real skills and coordination that are available to it. Feminine bodily existence is an *inhibited intentionality,* which simultaneously reaches toward a projected end with an "I can" and withholds its full bodily commitment to that end in a self-imposed "I cannot."[14]

An uninhibited intentionality projects the aim to be accomplished and connects the body's motion toward that end in an unbroken directedness

that organizes and unifies the body's activity. The body's capacity and motion structure its surroundings and project meaningful possibilities of movement and action, which in turn call the body's motion forth to enact them: "To understand is to experience the harmony between what we aim at and what is given, between the intention and the performance . . . " (p. 144; see also pp. 101, 131, and 132). Feminine motion often severs this mutually conditioning relation between aim and enactment. In those motions that when properly performed require the coordination and directedness of the whole body upon some definite end, women frequently move in a contradictory way. Their bodies project an aim to be enacted but at the same time stiffen against the performance of the task: In performing a physical task the woman's body does carry her toward the intended aim, often not easily and directly, but rather circuitously, with the wasted motion resulting from the effort of testing and reorientation, which is a frequent consequence of feminine hesitancy.

For any lived body, the world appears as the system of possibilities that are correlative to its intentions (p. 131). For any lived body, moreover, the world also appears to be populated with opacities and resistances correlative to its own limits and frustrations. For any bodily existence, that is, an "I cannot" may appear to set limits to the "I can." To the extent that feminine bodily existence is an inhibited intentionality, however, the same set of possibilities that appears to be correlative to its intentions also appears to be a system of frustrations correlative to its hesitancies. By repressing or withholding its own motile energy, feminine bodily existence frequently projects an "I can" and an "I cannot" with respect to the very same end. When the woman enters a task with inhibited intentionality, she projects the possibilities of that task—thus projects an "I *can*"—but projects them merely as the possibilities of "someone," and not truly *her* possibilities— and thus projects an "I cannot."

3. Merleau-Ponty gives to the body the unifying and synthesizing function that Kant locates in transcendental subjectivity. By projecting an aim toward which it moves, the body brings unity to and unites itself with its surroundings; through the vectors of its projected possibilities it sets things in relation to one another and to itself. The body's movement and orientation organizes the surrounding space as a continous extension of its own being (p. 143). Within the same act in which the body synthesizes its surroundings, moreover, it synthesizes itself. The body synthesis is immediate and primordial. "I do not bring together one by one the parts of my body; this translation and this unification are performed once and for all within me: they are my body itself" (p. 150).

The third modality of feminine bodily existence is that it stands in *discontinuous unity* with both itself and its surroundings. I remarked earlier that in many motions that require the active engagement and coordination of the body as a whole in order to be performed properly, women tend to locate their motion in part of the body only, leaving the rest of the body

relatively immobile. Motion such as this is discontinuous with itself. The part of the body that is transcending toward an aim is in relative disunity from those that remain immobile. The undirected and wasted motion that is often an aspect of feminine engagement in a task also manifests this lack of body unity. The character of the inhibited intentionality whereby feminine motion severs the connection between aim and enactment, between possibility in the world and capacity in the body, itself produces this discontinuous unity.

According to Merleau-Ponty, for the body to exist as a transcendent presence to the world and the immediate enactment of intentions, it cannot exist as an *object* (p. 123). As subject, the body is referred not onto itself, but onto the world's possibilities. "In order that we may be able to move our body towards an object, the object must first exist for it, our body must not belong to the realm of the 'in-itself' " (p. 139). The three contradictory modalities of feminine bodily existence—ambiguous transcendence, inhibited intentionality, and discontinuous unity—have their root, however, in the fact that for feminine existence the body frequently is both subject and object for itself at the same time and in reference to the same act. Feminine bodily existence is frequently not a pure presence to the world because it is referred onto *itself* as well as onto possibilities in the world.[15]

Several of the observations of the previous section illustrate this self-reference. It was observed, for example, that women have a tendency to take up the motion of an object coming *toward* them as coming *at* them. I also observed that women tend to have a latent and sometimes conscious fear of getting hurt, which we bring to a motion. That is, feminine bodily existence is self-referred in that the woman takes herself to be the *object* of the motion rather than its originator. Feminine bodily existence is also self-referred to the extent that a woman is uncertain of her body's capacities and does not feel that its motions are entirely under her control. She must divide her attention between the task to be performed and the body that must be coaxed and manipulated into performing it. Finally, feminine bodily existence is self-referred to the extent that the feminine subject posits her motion as the motion that is *looked at*. In Section IV, we will explore the implications of the basic fact of the woman's social existence as the object of the gaze of another, which is a major source of her bodily self-reference.

In summary, the modalities of feminine bodily existence have their root in the fact that feminine existence experiences the body as a mere thing—a fragile thing, which must be picked up and coaxed into movement, a thing that exists as *looked at and acted upon*. To be sure, any lived body exists as a material thing as well as a transcending subject. For feminine bodily existence, however, the body is often lived as a thing that is other than it, a thing like other things in the world. To the extent that a woman lives her body as a thing, she remains rooted in immanence, is inhibited, and retains a distance from her body as transcending movement and from engagement in the world's possibilities.

III

For Merleau-Ponty there is a distinction between lived space, or phenomenal space, and objective space, the uniform space of geometry and science in which all positions are external to one another and interchangeable. Phenomenal space arises out of motility, and lived relations of space are generated by the capacities of the body's motion and the intentional relations that that motion constitutes. "It is clearly in action that the spatiality of our body is brought into being and an analysis of one's own movement should enable us to arrive at a better understanding" (p. 102, cf. pp. 148, 149, 249). In this account, if there are particular modalities of feminine bodily comportment and motility, it must follow that there are also particular modalities of feminine spatiality. Feminine existence lives space as *enclosed* or confining, as having a *dual* structure, and the woman experiences herself as *positioned* in space.

1. There is a famous study that Erik Erikson performed several years ago in which he asked several male and female preadolescents to construct a scene for an imagined movie out of some toys. He found that girls typically depicted indoor settings, with high walls and enclosures, while boys typically constructed outdoor scenes. He concluded that females tend to emphasize what he calls "inner space," or enclosed space, while males tend to emphasize what he calls "outer space," or a spatial orientation that is open and outwardly directed. Erikson's interpretation of these observations is psychoanalytical: girls depict "inner space" as the projection of the enclosed space of their wombs and vaginas; boys depict "outer space" as a projection of the phallus.[16] I find such an explanation wholly unconvincing. If girls do tend to project an enclosed space and boys to project an open and outwardly directed space, it is far more plausible to regard this as a reflection of the way members of each sex live and move their bodies in space.

In the first section, I observed that women tend not to open their bodies in their everyday movements, but tend to sit, stand, and walk with their limbs close to or closed around them. I also observed that women tend not to reach, stretch, bend, lean, or stride to the full limits of their physical capacities, even when doing so would better accomplish a task or motion. The space, that is, that is *physically* available to the feminine body is frequently of greater radius than the space that she uses and inhabits. Feminine existence appears to posit an existential enclosure between herself and the space surrounding her, in such a way that the space that belongs to her and is available to her grasp and manipulation is constricted and the space beyond is not available to her movement.[17] A further illustration of this confinement of feminine lived space is the observation already noted that in sport, for example, women tend not to move out and meet the motion of a ball, but rather tend to stay in one place and react to the ball's motion only when it has arrived within the space where she is. The timidity,

immobility, and uncertainty that frequently characterize feminine move-ment project a limited space for the feminine "I can."

2. In Merleau-Ponty's account, the body unity of transcending perfor-mance creates an immediate link between the body and the outlying space. "Each instant of the movement embraces its whole space, and particularly the first which, by being active and initiative, institutes the link between a here and a yonder . . . " (p. 140). In feminine existence, however, the projection of an enclosed space severs the continuity between a "here" and a "yonder." In feminine existence there is a *double spatiality*, as the space of the "here" is distinct from the space of the "yonder." A distinction between space that is "yonder" and not linked with my own body possi-bilities and the enclosed space that is "here," which I inhabit with my bodily possibilities, is an expression of the discontinuity between aim and capacity to realize the aim that I have articulated as the meaning of the tentativeness and uncertainty characterizing the inhibited intentionality of feminine motility. The space of the "yonder" is a space in which feminine existence projects possibilities in the sense of understanding that "some-one" could move within it, but not I. Thus the space of the "yonder" exists for feminine existence, but only as that which she is looking into, rather than moving in.

3. The third modality of feminine spatiality is that feminine existence experiences itself as *positioned in* space. For Merleau-Ponty, the body is the original subject that constitutes space; there would be no space without the body (pp. 102, 142). As the origin and subject of spatial relations, the body does not occupy a position coequal and interchangeable with the positions occupied by other things (p. 143, pp. 247–49). Because the body as lived is not an *object*, it cannot be said to exist *in* space as water is *in* the glass (pp. 139–40). "The word 'here' applied to my body does not refer to a determinate position in relation to other positions or to external coor-dinates, but the laying down of the first coordinates, the anchoring of the active body in an object, the situation of the body in the face of its tasks" (p. 100).

Feminine spatiality is contradictory insofar as feminine bodily existence is both spatially constituted and a constituting spatial subject. Insofar as feminine existence lives the body as transcendence and intentionality, the feminine body actively constitutes space and is the original coordinate that unifies the spatial field and projects spatial relations and positions in accord with its intentions. But to the extent that feminine motility is laden with immanence and inhibited, the body's space is lived as constituted. To the extent, that is, that feminine bodily existence is self-referred and thus lives itself as an *object*, the feminine body does exist *in* space. In Section I, I observed that women frequently react to motions, even our own motions, as though we are the object of a motion that issues from an alien intention, rather than taking ourselves as the subject of motion. In its immanence and inhibition, feminine spatial existence is *positioned* by a system of co-ordinates that does not have its origin in her own intentional capacities.

The tendency for the feminine body to remain partly immobile in the performance of a task that requires the movement of the whole body illustrates this characteristic of feminine bodily existence as rooted *in place*. Likewise does the tendency of women to wait for an object to come within their immediate bodily field, rather than move out toward it.

Merleau-Ponty devotes a great deal of attention to arguing that the diverse senses and activities of the lived body are synthetically related in such a way that each stands in a mutually conditioning relation with all the others. In particular, visual perception and motility stand in a relation of reversability; an impairment in the functioning of one, for example, leads to an impairment in the functioning of the other (pp. 133–37). If we assume that reversability of visual perception and motility, the previous account of the modalities of feminine motility and the spatiality that arises from them suggests that visual space will have its own modalities as well.

Numerous psychological studies have reported differences between the sexes in the character of spatial perception. One of the most frequently discussed of these conclusions is that females are more often "field-dependent." That is, it has been claimed that males have a greater capacity for lifting a figure out of its spatial surroundings and viewing relations in space as fluid and interchangeable, whereas females have a greater tendency to regard figures as embedded within and fixed by their surroundings.[18] The above account of feminine motility and spatiality gives some theoretical intelligibility to these findings. If feminine body spatiality is such that the woman experiences herself as rooted and enclosed, on the reversability assumption it would follow that visual space for feminine existence also has its closures of immobility and fixity. The objects in visual space do not stand in a fluid system of potentially alterable and interchangeable relations correlative to the body's various intentions and projected capacities. Rather, they too have their own *places* and are anchored in their immanence.

IV

The modalities of feminine bodily comportment, motility, and spatiality that I have described here are, I claim, common to the existence of women in contemporary society to one degree or another. They have their source, however, in neither anatomy nor physiology, and certainly not in a mysterious feminine essence. Rather, they have their source in the particular *situation* of women as conditioned by their sexist oppression in contemporary society.

· Women in sexist society are physically handicapped. Insofar as we learn to live out our existence in accordance with the definition that patriarchal culture assigns to us, we are physically inhibited, confined, positioned, and objectified. As lived bodies we are not open and unambiguous transcendences that move out to master a world that belongs to us, a world constituted by our own intentions and projections. To be sure, there are

actual women in contemporary society to whom all or part of the above description does not apply. Where these modalities are not manifest in or determinative of the existence of a particular woman, however, they are definitive in a negative mode—as that which she has escaped, through accident or good fortune, or, more often, as that which she has had to overcome.

ᐧ One of the sources of the modalities of feminine bodily existence is too obvious to dwell upon at length. For the most part, girls and women are not given the opportunity to use their full bodily capacities in free and open engagement with the world, nor are they encouraged as much as boys are to develop specific bodily skills.[19] Girls' play is often more sedentary and enclosing than the play of boys. In school and after-school activities girls are not encouraged to engage in sport, in the controlled use of their bodies in achieving well-defined goals. Girls, moreover, get little practice at "tinkering" with things and thus at developing spatial skill. Finally, girls are not often asked to perform tasks demanding physical effort and strength, while as the boys grow older they are asked to do so more and more.[20]

The modalities of feminine bodily existence are not merely privative, however, and thus their source is not merely in lack of practice, though this is certainly an important element. There is a specific positive style of feminine body comportment and movement, which is learned as the girl comes to understand that she is a girl. The young girl acquires many subtle habits of feminine body comportment—walking like a girl, tilting her head like a girl, standing and sitting like a girl, gesturing like a girl, and so on. The girl learns actively to hamper her movements. She is told that she must be careful not to get hurt, not to get dirty, not to tear her clothes, that the things she desires to do are dangerous for her. Thus she develops a bodily timidity that increases with age. In assuming herself to be a girl, she takes herself to be fragile. Studies have found that young children of both sexes categorically assert that girls are more likely to get hurt than boys are,[21] and that girls ought to remain close to home, while boys can roam and explore.[22] The more a girl assumes her status as feminine, the more she takes herself to be fragile and immobile and the more she actively enacts her own body inhibition. When I was about thirteen, I spent hours practicing a "feminine" walk, which was stiff and closed, and rotated from side to side.

Studies that record observations of sex differences in spatial perception, spatial problem-solving, and motor skills have also found that these differences tend to increase with age. While very young children show virtually no differences in motor skills, movement, spatial perception, etc., differences seem to appear in elementary school and increase with adolescence. If these findings are accurate, they would seem to support the conclusion that it is in the process of growing up as a girl that the modalities of feminine bodily comportment, motility, and spatiality make their appearance.[23]

There is, however, a further source of the modalities of feminine bodily existence that is perhaps even more profound than these. At the root of those modalities, I have stated in the previous section, is the fact that the woman lives her body as *object* as well as subject. The source of this is that patriarchal society defines woman as object, as a mere body, and that in sexist society women are in fact frequently regarded by others as objects and mere bodies. An essential part of the situation of being a woman is that of living the ever-present possibility that one will be gazed upon as a mere body, as shape and flesh that presents itself as the potential object of another subject's intentions and manipulations, rather than as a living manifestation of action and intention.[24] The source of this objectified bodily existence is in the attitude of others regarding her, but the woman herself often actively takes up her body as a mere thing. She gazes at it in the mirror, worries about how it looks to others, prunes it, shapes it, molds and decorates it.

This objectified bodily existence accounts for the self-consciousness of the feminine relation to her body and resulting distance she takes from her body. As human, she is a transcendence and subjectivity, and cannot live herself as mere bodily object. Thus, to the degree that she does live herself as mere body, she cannot be in unity with herself, but must take a distance from and exist in discontinuity with her body. The objectifying regard that "keeps her in her place" can also account for the spatial modality of being positioned and for why women frequently tend not to move openly, keeping their limbs closed around themselves. To open her body in free, active, open extension and bold outward-directedness is for a woman to invite objectification.

The threat of being seen is, however, not the only threat of objectification that the woman lives. She also lives the threat of invasion of her body space. The most extreme form of such spatial and bodily invasion is the threat of rape. But we daily are subject to the possibility of bodily invasion in many far more subtle ways as well. It is acceptable, for example, for women to be touched in ways and under circumstances that it is not acceptable for men to be touched, and by persons—i.e., men—whom it is not acceptable for them to touch.[25] I would suggest that the enclosed space that has been described as a modality of feminine spatiality is in part a defense against such invasion. Women tend to project an existential barrier closed around them and discontinuous with the "over there" in order to keep the other at a distance. The woman lives her space as confined and closed around her, at least in part as projecting some small area in which she can exist as a free subject.

This essay is a prolegomenon to the study of aspects of women's experience and situation that have not received the treatment they warrant. I would like to close with some questions that require further thought and research. This essay has concentrated its attention upon the sorts of physical tasks and body orientation that involve the whole body in gross movement. Further investigation into woman's bodily existence would require

looking at activities that do not involve the whole body and finer movement. If we are going to develop an account of the woman's body experience in situation, moreover, we must reflect on the modalities of a woman's experience of her body in its sexual being, as well as upon less task-oriented body activities, such as dancing. Another question that arises is whether the description given here would apply equally well to any sort of physical task. Might the kind of task, and specifically whether it is a task or movement that is sex-typed, have some effect on the modalities of feminine bodily existence? A further question is to what degree we can develop a theoretical account of the connection between the modalities of the bodily existence of women and other aspects of our existence and experience. For example, I have an intuition that the general lack of confidence that we frequently have about our cognitive or leadership abilities is traceable in part to an original doubt of our body's capacity. None of these questions can be dealt with properly, however, without first performing the kind of guided observation and data collection that my reading has concluded, to a large degree, is yet to be performed.

NOTES

This essay was first presented at a meeting of the Mid-West Division of the Society for Women in Philosophy (SWIP) in October 1977. Versions of the essay were subsequently presented at a session sponsored by SWIP at the Western Division meetings of the American Philosophical Association, April 1978; and at the third annual Merleau-Ponty Circle meeting, Duquesne University, September 1978. Many people in discussions at those meetings contributed gratifying and helpful responses. I am particularly grateful to Professors Sandra Bartky, Claudia Card, Margaret Simons, J. Davidson Alexander, and William McBride for their criticisms and suggestions. Final revisions of the essay were completed while I was a fellow in the National Endowment for the Humanities Fellowship in Residence for College Teachers program at the University of Chicago.

1. Erwin W. Straus, "The Upright Posture," *Phenomenological Psychology* (New York: Basic Books, 1966), pp. 137–65. References to particular pages are indicated in the text.

2. Studies continue to be performed that arrive at similar observations. See, for example, Lolas E. Kalverson, Mary Ann Robertson, M. Joanne Safrit, and Thomas W. Roberts, "Effect of Guided Practice on Overhand Throw Ball Velocities of Kindergarten Children," *Research Quarterly* (American Alliance for Health, Physical Education and Recreation) 48 (May 1977); pp. 311–18. The study found that boys achieved significantly greater velocities than girls did.

See also F. J. J. Buytendijk's remarks in *Woman: A Contemporary View* (New York: Newman Press, 1968), pp. 144–45. In raising the example of throwing, Buytendijk is concerned to stress, as am I in this essay, that the important thing to investigate is not the strictly physical phenomenon, but rather the manner in which each sex projects her or his Being-in-the-world through movement.

3. Simone de Beauvoir, *The Second Sex* (New York: Vintage Books, 1974), p. xxxv. See also Buytendijk, p. 175–76.

4. See Beauvoir, *The Second Sex*, chapter 1, "The Data of Biology."

5. Firestone claims that Beauvoir's account served as the basis of her own thesis that the oppression of women is rooted in nature and thus requires the transcendence of nature itself to be overcome. See *The Dialectic of Sex* (New York: Bantam Books, 1970). Beauvoir would claim that Firestone is guilty of desituating woman's situation by pinning a source on nature as such. That Firestone would find inspiration for her thesis in Beauvoir, however, indicates that perhaps de Beauvoir has not steered away from causes in "nature" as much as is desirable.

6. In his discussion of the "dynamics of feminine existence," Buytendijk focuses precisely on those sorts of motions that are aimless. He claims that it is through these kinds of expressive movements—e.g., walking for the sake of walking—and not through action aimed at the accomplishment of particular purposes that the pure image of masculine or feminine existence is manifest (*Woman: A Contemporary View*, p. 278–79). Such an approach, however, contradicts the basic existentialist assumption that Being-in-the-world consists in projecting purposes and goals that structure one's situatedness. While there is certainly something to be learned from reflecting upon feminine movement in noninstrumental activity, given that accomplishing tasks is basic to the structure of human existence, it serves as a better starting point for investigation of feminine motility. As I point out at the end of this essay, a full phenomenology of feminine existence must take account of this noninstrumental movement.

7. It is not impossible, moreover, for men to be "feminine" in at least some respects, according to the above definition.

8. On this level of specificity there also exist particular modalities of masculine motility, inasmuch as there is a particular style of movement more or less typical of men. I will not, however, be concerned with those in this essay.

9. See Beauvoir, *The Second Sex*, chapter 21, "Woman's Situation and Character."

10. It should be noted that this is probably typical only of women in advanced industrial societies, where the model of the bourgeois woman has been extended to most women. It would not apply to those societies, for example, where most people, including women, do heavy physical work. Nor does this particular observation, of course, hold true in our own society for women who do heavy physical work.

11. See A. M. Gross, "Estimated Versus Actual Physical Strength in Three Ethnic Groups," *Child Development* 39 (1968), pp. 283–90. In a test of children at several different ages, at all but the youngest age level, girls rated themselves lower than boys rated themselves on self-estimates of strength, and as the girls grow older, their self-estimates of strength become even lower.

12. See Marguerite A. Cifton and Hope M. Smith, "Comparison of Expressed Self-Concept of Highly Skilled Males and Females Concerning Motor Performance," *Perceptual and Motor Skills* 16 (1963), pp. 199–201. Women consistently underestimated their level of achievement in skills such as running and jumping far more often than men did.

13. Maurice Merleau-Ponty, *The Phenomenology of Perception*, trans., Colin Smith (New York: Humanities Press, 1962). All references to this work are noted in parentheses in the text.

14. Much of the work of Seymour Fisher on various aspects of sex differences in body image correlates suggestively with the phenomenological description developed here. It is difficult to use his conclusions as confirmation of that description, however, because there is something of a speculative aspect to his reasoning. Nevertheless, I shall refer to some of these findings with that qualification in mind.

One of Fisher's findings is that women have a greater anxiety about their legs than men do, and he cites earlier studies with the same results. Fisher interprets such leg anxiety as being anxiety about motility itself, because in body conception

and body image the legs are the body parts most associated with motility. See Fisher, *Body Experience in Fantasy and Behavior* (New York: Appleton-Century Crofts, 1970), p. 537. If his findings and his interpretation are accurate, this tends to correlate with the sort of inhibition and timidity about movement that I am claiming is an aspect of feminine body comportment.

15. Fisher finds that the most striking difference between men and women in their general body image is that women have a significantly higher degree of what he calls "body prominence," awareness of and attention to the body. He cites a number of different studies that have the same results. The explanation Fisher gives for this finding is that women are socialized to pay attention to their bodies, to prune and dress them, and to worry about how they look to others. Fisher, pp. 524–25. See also Fisher, "Sex Differences in Body Perception," *Psychological Monographs* 78 (1964) no. 14.

16. Erik H. Erikson, "Inner and Outer Space: Reflections on Womanhood," *Daedelus* 3 (1964), pp. 582–606. Erikson's interpretation of his findings is also sexist. Having in his opinion discovered a particular significance that "inner space," which he takes to be space *within* the body, holds for girls, he goes on to discuss the womanly "nature" as womb and potential mother, which must be made compatible with anything else the woman does.

17. Another of Fisher's findings is that women experience themselves as having more clearly articulated body *boundaries* than men do. More clearly than men do, they distinguish themselves from their spatial surroundings and take a distance from them. See Fisher, *Body Experience in Fantasy and Behavior*, p. 528.

18. The number of studies with these results is enormous. See Eleanor E. Maccoby and Carol N. Jacklin, *The Psychology of Sex Differences* (Palo Alto, Calif.: Stanford University Press, 1974), pp. 91–98. For a number of years psychologists used the results from tests of spatial ability to generalize about field independence in general, and from that to general "analytic" ability. Thus it was concluded that women have less analytical ability than men do. More recently, however, such generalizations have been seriously called into question. See, for example, Julia A. Sherman, "Problems of Sex Differnces in Space Perception and Aspects of Intellectual Functioning," *Psychological Review* 74 (1967), pp. 290–99. She notes that while women are consistently found to be more field-dependent in spatial tasks than men are, on nonspatial tests measuring field independence, women generally perform as well as men do.

19. Nor are girls provided with example of girls and women being physically active. See Mary E. Duquin, "Differential Sex Role Socialization Toward Amplitude Appropriation," *Research Quarterly* (American Alliance for Health, Physical Education and Recreation) 48 (1977), pp. 188–92. A survey of textbooks for young children revealed that children are thirteen times more likely to see a vigorously active man than a vigorously active woman and three times more likely to see a relatively active man than a relatively active woman.

20. Sherman (see note 18) argues that it is the differential socialization of boys and girls in being encouraged to "tinker," explore, etc., that acounts for the difference between the two in spatial ability.

21. See L. Kolberg, "A Cognitive-Developmental Analysis of Children's Sex-Role Concepts and Attitudes," in E. E. Maccoby, ed., *The Development of Sex Differences* (Palo Alto, Calif.: Stanford University Press, 1966), p. 101.

22. Lenore J. Weitzman, "Sex Role Socialization," in Jo Freeman, ed., *Woman: A Feminist Perspective* (Palo Alto, Calif.: Mayfield Publishing Co., 1975), pp. 111–12.

23. Maccoby and Jacklin, *The Psychology of Sex Differences*, pp. 93–94.

24. The manner in which women are objectified by the gaze of the Other is not the same phenomenon as the objectification by the Other that is a condition of self-consciousness in Sartre's account. See *Being and Nothingness*, trans., Hazel E. Barnes

(New York: Philosophical Library, 1956), part three. While the basic ontological category of being for others is an objectified for itself, the objectification that women are subject to is being regarded as a mere in itself. On the particular dynamic of sexual objectification, see Sandra Bartky, "Psychological Oppression," in Sharon Bishop and Marjories Weinzweig, ed., *Philosophy and Women* (Belmont, Calif.: Wadsworth Publishing Co., 1979), pp. 33–41.

25. See Nancy Henley and Jo Freeman, "The Sexual Politics of Interpersonal Behavior," in Freeman, ed., *Woman: A Feminist Perspective*, pp. 391–401.

Pregnant Embodiment

Subjectivity and Alienation

The library card catalog contains dozens of entries under the heading "pregnancy": clinical treatises detailing signs of morbidity; volumes cataloging studies of fetal development, with elaborate drawings; or popular manuals in which physicians and others give advice on diet and exercise for the pregnant woman. Pregnancy does not belong to the woman herself. It is a state of the developing fetus, for which the woman is a container; or it is an objective, observable process coming under scientific scrutiny; or it becomes objectified by the woman herself as a "condition" in which she must "take care of herself." Except, perhaps, for one insignificant diary, no card appears listing a work that, as Kristeva puts it, is "concerned with the subject, the mother as the site of her proceedings."[1]

We should not be surprised to learn that discourse on pregnancy omits subjectivity, for the specific experience of women has been absent from most of our culture's discourse about human experience and history. This essay considers some of the experiences of pregnancy from the pregnant subject's viewpoint. Through reference to diaries and literature, as well as phenomenological reflection on the pregnant experience, I seek to let women speak in their own voices.

Section I describes some aspects of bodily existence unique to pregnancy. The pregnant subject, I suggest, is decentered, split, or doubled in several ways. She experiences her body as herself and not herself. Its inner movements belong to another being, yet they are not other, because her body boundaries shift and because her bodily self-location is focused on her trunk in addition to her head. This split subject appears in the eroticism of pregnancy, in which the woman can experience an innocent narcissism fed by recollection of her repressed experience of her own mother's body. Pregnant existence entails, finally, a unique temporality of process and growth in which the woman can experience herself as split between past and future.

This description of the lived pregnant body both develops and partially criticizes the phenomenology of bodily existence found in the writings of Straus, Merleau-Ponty, and several other existential phenomenologists. It continues the radical undermining of Cartesianism that these thinkers

inaugurated, but it also challenges their implicit assumptions of a unified subject and sharp distinction between transcendence and immanence. Pregnancy, I argue, reveals a paradigm of bodily experience in which the transparent unity of self dissolves and the body attends positively to itself at the same time that it enacts its projects.

Section II reflects on the encounter of the pregnant subject with the institutions and practices of medicine. I argue that within the present organization of these institutions and practices, women usually find such an encounter alienating in several respects. Medicine's self-identification as the curing profession encourages others as well as the woman to think of her pregnancy as a condition that deviates from normal health. The control over knowledge about the pregnancy and birth process that the physician has through instruments, moreover, devalues the privileged relation she has to the fetus and her pregnant body. The fact that in the contemporary context the obstetrician is usually a man reduces the likelihood of bodily empathy between physician and patient. Within the context of authority and dependence that currently structures the doctor–patient relation, moreover, coupled with the use of instruments and drugs in the birthing process, the pregnant and birthing woman often lacks autonomy within these experiences.

Before proceeding, it is important to note that this essay restricts its analysis to the specific experience of women in technologically sophisticated Western societies. The analysis presupposes that pregnancy can be experienced for its own sake, noticed, and savored. This entails that the pregnancy be chosen by the woman, either as an explicit decision to become pregnant or at least as choosing to be identified with and positively accepting of it. Most women in human history have not chosen their pregnancies in this sense. For the vast majority of women in the world today, and even for many women in this privileged and liberal society, pregnancy is not an experience they choose. So I speak in large measure for an experience that must be instituted and for those pregnant women who have been able to take up their situation as their own.

I

The unique contribution of Straus, along with Merleau-Ponty and certain other existential phenomenologists, to the Western philosophical tradition has consisted in locating consciousness and subjectivity in the body itself. This move to situate subjectivity in the lived body jeopardizes dualistic metaphysics altogether. There remains no basis for preserving the mutual exclusivity of the categories subject and object, inner and outer, I and world. Straus puts it this way:

> The meaning of "mine" is determined in relation to, in contraposition to, the world, the Allon, to which I am nevertheless a party. The meaning of "mine" is not comprehensible in the unmediated antithesis of I and not-I, own and

strange, subject and object, constituting I and constituted world. Everything points to the fact that separateness and union originate in the same ground.[2]

As Sarano has pointed out, however, antidualist philosophers still tend to operate with a dualist language, this time distinguishing two forms of experiencing the body itself, as subject and as object, both transcending freedom and mere facticity.[3] Reflection on the experience of pregnancy, I shall show, provides a radical challenge even to this dualism that is tacitly at work in the philosophers of the body.

To the extent that these existential phenomenologists preserve a distinction between subject and object, they do so at least partly because they assume the subject as a unity. In the *Phenomenology of Perception*, for example, Merleau-Ponty locates the "intentional arc" that unifies experience in the body, rather than in an abstract constituting consciousness. He does not, however, abandon the idea of a unified self as a condition of experience.

> There must be, then, corresponding to this open unity of the world, an open and indefinite unity of subjectivity. Like the world's unity, that of the I is invoked rather than experienced each time I perform an act of perception, each time I reach a self-evident truth, and the universal I is the background against which these effulgent forms stand out: it is through one present thought that I achieve the unity of all my thoughts.[4]

Merleau-Ponty's later work, as well as more recent French philosophy, however, suggests that this transcendental faith in a unified subject as a condition of experience may be little more than ideology.[5] The work of Lacan, Derrida, and Kristeva suggests that the unity of the self is itself a project, a project sometimes successfully enacted by a moving and often contradictory subjectivity. I take Kristeva's remarks about pregnancy as a starting point:

> Pregnancy seems to be experienced as the radical ordeal of the splitting of the subject: redoubling up of the body, separation and coexistence of the self and an other, of nature and consciousness, of physiology and speech.[6]

We can confirm this notion of pregnancy as split subjectivity even outside the psychoanalytic framework that Kristeva uses. Reflection on the experience of pregnancy reveals a body subjectivity that is decentered, myself in the mode of not being myself.

As my pregnancy begins, I experience it as a change in my body; I become different from what I have been. My nipples become reddened and tender; my belly swells into a pear. I feel this elastic around my waist, itching, this round, hard middle replacing the doughy belly with which I still identify. Then I feel a little tickle, a little gurgle in my belly. It is my feeling, my insides, and it feels somewhat like a gas bubble, but it is not;

it is different, in another place, belonging to another, another that is nevertheless my body.

The first movements of the fetus produce this sense of the splitting subject; the fetus's movements are wholly mine, completely within me, conditioning my experience and space. Only I have access to these movements from their origin, as it were. For months only I can witness this life within me, and it is only under my direction of where to put their hands that others can feel these movements. I have a privileged relation to this other life, not unlike that which I have to my dreams and thoughts, which I can tell someone but which cannot be an object for both of us in the same way. Adrienne Rich reports this sense of the movements within me as mine, even though they are another's.

> In early pregnancy, the stirring of the fetus felt like ghostly tremors of my own body, later like the movements of a being imprisoned within me; but both sensations were *my* sensations, contributing to my own sense of physical and psychic space.[7]

Pregnancy challenges the integration of my body experience by rendering fluid the boundary between what is within, myself, and what is outside, separate. I experience my insides as the space of another, yet my own body.

> Nor in pregnancy did I experience the embryo as decisively internal in Freud's terms, but rather, as something inside and of me, yet becoming hourly and daily more separate, on its way to becoming separate from me and of itself. . . .
> Far from existing in the mode of "inner space," women are powerfully and vulnerably attuned both to "inner" and "outer" because for us the two are continuous, not polar.[8]

The birthing process entails the most extreme suspension of the bodily distinction between inner and outer. As the months and weeks progress, increasingly I feel my insides, strained and pressed, and increasingly feel the movement of a body inside me. Through pain and blood and water this inside thing emerges between my legs, for a short while both inside and outside me. Later I look with wonder at my mushy middle and at my child, amazed that this yowling, flailing thing, so completely different from me, was there inside, part of me.

The integrity of my body is undermined in pregnancy not only by this externality of the inside, but also by the fact that the boundaries of my body are themselves in flux. In pregnancy I literally do not have a firm sense of where my body ends and the world begins. My automatic body habits become dislodged; the continuity between my customary body and my body at this moment is broken.[9] In pregnancy my prepregnant body image does not entirely leave my movements and expectations, yet it is

with the pregnant body that I must move. This is another instance of the doubling of the pregnant subject.

I move as if I could squeeze around chairs and through crowds as I could seven months before, only to find my way blocked by my own body sticking out in front of me—but yet not me, since I did not expect it to block my passage. As I lean over in my chair to tie my shoe, I am surprised by the graze of this hard belly on my thigh. I do not anticipate my body touching itself, for my habits retain the old sense of my boundaries. In the ambiguity of bodily touch, I feel myself being touched and touching simultaneously, both on my knee and my belly.[10] The belly is other, since I did not expect it there, but since I feel the touch upon it, it is me.[11]

Existential phenomenologists of the body usually assume a distinction between transcendence and immanence as two modes of bodily being. They assume that insofar as I adopt an active relation to the world, I am not aware of my body for its own sake. In the successful enactment of my aims and projects, my body is a transparent medium.[12] For several of these thinkers, awareness of my body as weighted material, as physical, occurs only or primarily when my instrumental relation to the world breaks down, in fatigue or illness.

> The transformation into the bodily as physical always means discomfort and malaise. The character of husk, which our live bodiness here increasingly assumes, shows itself in its onerousness, bringing heaviness, burden, weight.[13]

Being brought to awareness of my body for its own sake, these thinkers assume, entails estrangement and objectification.

> If, suddenly, I am no longer indifferent to my body, and if I suddenly give my attention to its functions and processes, then my body as a whole is objectified, becomes to me an other, a part of the outside world. And though I may also be able to feel its inner processes, I am myself excluded.[14]

Thus the dichotomy of subject and object appears anew in the conceptualization of the body itself. These thinkers tend to assume that awareness of my body in its weight, massiveness, and balance is always an alienated objectification of my body, in which I am not my body and my body imprisons me. They also tend to assume that such awareness of my body must cut me off from the enactment of my projects; I cannot be attending to the physicality of my body and using it as the means to the accomplishment of my aims.

Certainly there are occasions when I experience my body only as a resistance, only as a painful otherness preventing me from accomplishing my goals. It is inappropriate, however, to tie such a negative meaning to all experience of being brought to awareness of the body in its weight and materiality. Sally Gadow has argued that in addition to experiencing the body as a transparent mediator for our projects or an objectified and al-

ienated resistance or pain, we also at times experience our bodily being in an aesthetic mode. That is, we can become aware of ourselves as body and take an interest in its sensations and limitations for their own sake, experiencing them as a fullness rather than a lack.[15] While Gadow suggests that both illness and aging can be experiences of the body in such an aesthetic mode, pregnancy is most paradigmatic of such experience of being thrown into awareness of one's body. Contrary to the mutually exclusive categorization between transcendence and immanence that underlies some theories, the awareness of my body in its bulk and weight does not impede the accomplishing of my aims.

This belly touching my knee, this extra part of me that gives me a joyful surprise when I move through a tight place, calls me back to the matter of my body even as I move about accomplishing my aims. Pregnant consciousness is animated by a double intentionality: my subjectivity splits between awareness of myself as body and awareness of my aims and projects. To be sure, even in pregnancy there are times when I am so absorbed in my activity that I do not feel myself as body, but when I move or feel the look of another I am likely to be recalled to the thickness of my body.

I walk through the library stacks searching for the *Critique of Dialectical Reason*; I feel the painless pull of false contractions in my back. I put my hand on my belly to notice its hardening, while my eyes continue their scanning. As I sit with friends listening to jazz in a darkened bar, I feel within me the kicking of the fetus, as if it follows the rhythm of the music. In attending to my pregnant body in such circumstances, I do not feel myself alienated from it, as in illness. I merely notice its borders and rumblings with interest, sometimes with pleasure, and this aesthetic interest does not divert me from my business.

This splitting focus both on my body and my projects has its counterpart in the dual location I give to myself on my body. Straus suggests that in everyday instrumental actions of getting about our business, comprehending, observing, willing, and acting, the "I" is located phenomenologically in our head. There are certain activities, however, of which dancing is paradigmatic, where the "I" shifts from the eyes to the region of the trunk. In this orientation that Straus calls "pathic" we experience ourselves in greater sensory continuity with the surroundings.[16]

The pregnant subject experiences herself as located in the eyes and trunk simultaneously, I suggest. She often experiences her ordinary walking, turning, sitting as a kind of dance, movement that not only gets her where she is going, but also in which she glides through space in an immediate openness. She is surprised sometimes that this weighted solidity that she feels herself becoming can still move with ease.

Pregnancy roots me to the earth, makes me conscious of the physicality of my body not as an object, but as the material weight that I am in movement. The notion of the body as a pure medium of my projects is the illusion of a philosophy that has not quite shed the Western philosophical legacy of humanity as spirit.[17] Movement always entails awareness of effort

and the feeling of resistance. In pregnancy this fact of existence never leaves me. I am an actor transcending through each moment to further projects, but the solid inertia and demands of my body call me to my limits not as an obstacle to action, but only as a fleshy relation to the earth.[18] As the months proceed, the most ordinary efforts of human existence, such as sitting, bending, and walking, which I formerly took for granted, become apparent as the projects they themselves are. Getting up, for example, increasingly becomes a task that requires my attention.[19]

In the experience of the pregnant woman, this weight and materiality often produce a sense of power, solidity, and validity. Thus, whereas our society often devalues and trivializes women, regards women as weak and dainty, the pregnant woman can gain a certain sense of self-respect.

> This bulk slows my walking and makes my gestures and my mind more stately. I suppose if I schooled myself to walk massively the rest of my life, I might always have massive thoughts.[20]

There was a time when the pregnant woman stood as a symbol of stately and sexual beauty.[21] While pregnancy remains an object of fascination, our own culture harshly separates pregnancy from sexuality. The dominant culture defines feminine beauty as slim and shapely. The pregnant woman is often not looked upon as sexually active or desirable, even though her own desires and sensitivity may have increased. Her male partner, if she has one, may decline to share in her sexuality, and her physician may advise her to restrict her sexual activity. To the degree that a woman derives a sense of self-worth from looking "sexy" in the manner promoted by dominant cultural images, she may experience her pregnant body as being ugly and alien.

Though the pregnant woman my find herself desexualized by others, at the same time she may find herself with a heightened sense of her own sexuality. Kristeva suggests that the pregnant and birthing woman renews connection to the repressed, preconscious, presymbolic aspect of existence. Instead of being a unified ego, the subject of the paternal symbolic order, the pregnant subject straddles the spheres of language and instinct. In this splitting of the subject, the pregnant woman recollects a primordial sexual continuity with the maternal body, which Kristeva calls "juissance."[22]

The pregnant woman's relation to her body can be an innocent narcissism. As I undress in the morning and evening, I gaze in the mirror for long minutes, without stealth or vanity. I do not appraise myself, ask whether I look good enough for others, but like a child take pleasure in discovering new things in my body. I turn to the side and stroke the taut flesh that protrudes under my breasts.

Perhaps the dominant culture's desexualization of the pregnant body helps make possible such self-love when it happens. The culture's separation of pregnancy and sexuality can liberate her from the sexually objectifying gaze that alienates and instrumentalizes her when in her

nonpregnant state. The leer of sexual objectification regards the woman in pieces, as the possible object of a man's desire and touch.[23] In pregnancy the woman may experience some release from this alienating gaze. The look focusing on her belly is not one of desire, but of recognition. Some may be repelled by her, find her body ridiculous, but the look that follows her in pregnancy does not alienate her, does not instrumentalize her with respect to another's desire. Indeed, in this society, which still often narrows women's possibilities to motherhood, the pregnant woman often finds herself looked at with approval.

> As soon as I was visibly and clearly pregnant, I felt, for the first time in my adolescent and adult life, not-guilty. The atmosphere of approval in which I was bathed—even by strangers in the street, it seemed—was like an aura I carried with me, in which doubts, fears, misgivings, met with absolute denial. This is what women have always done.[24]

In classical art this "aura" surrounding motherhood depicts repose. The dominant culture projects pregnancy as a time of quiet waiting. We refer to the woman as "expecting," as though this new life were flying in from another planet and she sat in her rocking chair by the window, occasionally moving the curtain aside to see whether the ship is coming. The image of uneventful waiting associated with pregnancy reveals clearly how much the discourse of pregnancy leaves out the subjectivity of the woman. From the point of view of others pregnancy is primarily a time of waiting and watching, when nothing happens.

For the pregnant subject, on the other hand, pregnancy has a temporality of movement, growth, and change. The pregnant subject is not simply a splitting in which the two halves lie open and still, but a dialectic. The pregnant woman experiences herself as a source and participant in a creative process. Though she does not plan and direct it, neither does it merely wash over her; rather, she *is* this process, this change. Time stretches out, moments and days take on a depth because she experiences more changes in herself, her body. Each day, each week, she looks at herself for signs of transformation.

> Were I to lose consciousness for a month, I could still tell that an appreciable time had passed by the increased size of the fetus within me. There is a constant sense of growth, of progress, of time, which, while it may be wasted for you personally, is still being used, so that even if you were to do nothing at all during those nine months, something would nevertheless be accomplished and a climax reached.[25]

For others the birth of an infant may be only a beginning, but for the birthing woman it is a conclusion as well. It signals the close of a process she has been undergoing for nine months, the leaving of this unique body she has moved through, always surprising her a bit in its boundary changes

and inner kicks. Especially if this is her first child she experiences the birth as a transition to a new self that she may both desire and fear. She fears a loss of identity, as though on the other side of the birth she herself became a transformed person, such that she would "never be the same again."

Finally her "time" comes, as is commonly said. During labor, however, there is no sense of growth and change, but the cessation of time. There is no intention, no activity, only a will to endure. I only know that I have been lying in this pain, concentrating on staying above it, for a long time because the hands of the clock say so or the sun on the wall has moved to the other side of the room.

> Time is absolutely still. I have been here forever. Time no longer exists. Always, Time holds steady for birth. There is only this rocketing, this labor.[26]

II

Feminist writers often use the concept of alienation to describe female existence in a male dominated society and culture.[27] In this section I argue that the pregnant subject's encounter with obstetrical medicine in the United States often alienates her from her pregnant and birthing experience. Alienation here means the objectification or appropriation by one subject of another subject's body, action, or product of action, such that she or he does not recognize that objectification as having its origins in her or his experience. A subject's experience or action is alienated when it is defined or controlled by a subject who does not share one's assumptions or goals. I will argue that a woman's experience in pregnancy and birthing is often alienated because her condition tends to be defined as a disorder, because medical instruments objectify internal processes in such a way that they devalue a woman's experience of those processes, and because the social relations and instrumentation of the medical setting reduce her control over her experience.

Through most of the history of medicine its theoreticians and practitioners did not include the reproductive processes of women within its domain. Once women's reproductive processes came within the domain of medicine, they were defined as diseases. Indeed, by the mid-nineteenth century, at least in Victorian England and America, being female itself was symptomatic of disease. Medical writers considered women to be inherently weak and psychologically unstable, and the ovaries and uterus to be the cause of a great number of diseases and disorders, both physical and psychological.[28]

Contemporary obstetricians and gynecologists usually take pains to assert that menstruation, pregnancy, childbirth, and menopause are normal body functions that occasionally have a disorder. The legacy that defined pregnancy and other reproductive functions as conditions requiring medical therapy, however, has not been entirely abandoned.

Rothman points out that even medical writers who explicitly deny that

pregnancy is a disease view normal changes associated with pregnancy, such as lowered hemoglobin, water retention, and weight gain, as "symptoms" requiring "treatment" as part of the normal process of prenatal care.[29] Though 75 percent to 88 percent of pregnant women experience some nausea in the early months, some obstetrical textbooks refer to this physiological process as a neurosis that "may indicate resentment, ambivalence and inadequacy in women ill-prepared for motherhood."[30] Obstetrical teaching films entitled *Normal Delivery* depict the use of various drugs and instruments, as well as the use of paracervical block and the performance of episiotomy.[31]

A continued tendency on the part of medicine to treat pregnancy and childbirth as dysfunctional conditions derives first from the way medicine defines its purpose. Though medicine has extended its domain to include many bodily and psychological processes that ought not to be conceptualized as illness or disease—such as child development, sexuality, and aging, as well as women's reproductive functions—medicine continues to define itself as the practice that seeks cure for disease. Pellegrino and Thomasma, for example, define the goal of medicine as "the relief of perceived lived body disruption" and "organic restoration to a former or better state of perceived health or well-being."

> When a patient consults a physician, he or she does so with one specific purpose in mind: to be healed, to be restored and made whole, i.e., to be relieved of some noxious element in physical or emotional life which the patient defines as disease—a distortion of the accustomed perception of what is a satisfactory life.[32]

These are often not the motives that prompt pregnant women to seek the office of the obstetrician. Yet because medicine continues to define itself as the curing profession, it can tend implicitly to conceptualize women's reproductive processes as disease or infirmity.

A second conceptual ground for the tendency within gynecological and obstetrical practice to approach menstruation, pregnancy, and menopause as "conditions" with "symptoms" that require "treatment" lies in the implicit male bias in medicine's conception of health. The dominant model of health assumes that the normal, healthy body is unchanging. Health is associated with stability, equilibrium, a steady state. Only a minority of persons, however, namely adult men who are not yet old, experience their health as a state in which there is no regular or noticeable change in body condition. For them a noticeable change in their bodily state usually does signal a disruption or dysfunction. Regular, noticeable, sometimes extreme change in bodily condition, on the other hand, is an aspect of the normal bodily functioning of adult women. Change is also a central aspect of the bodily existence of healthy children and healthy old people, as well as some of the so-called disabled. Yet medical conceptualization implicitly uses this unchanging adult male body as the standard of all health.

This tendency of medical conceptualization to treat pregnancy as disease can produce alienation for the pregnant woman. She often has a sense of bodily well-being during her pregnancy and often has increased immunity to common diseases such as colds, flu, etc. As we saw in the previous section, moreover, she often has a bodily self-image of strength and solidity. Thus, while her body may signal one set of impressions, her entrance into the definitions of medicine may lead her to the opposite understanding. Even though certain discomforts associated with pregnancy, such as nausea, flatulence, and shortness of breath, can happen in the healthiest of woman, her internalization of various discussions of the fragility of pregnancy may lead her to define such experience as signs of weakness.

Numerous criticisms of the use of instruments, drugs, surgery, and other methods of intervention in obstetrical practice have been voiced in recent years.[33] I do not wish to reiterate them here, nor do I wish to argue that the use of instruments and drugs in pregnancy and childbirth is usually inappropriate or dangerous. The instrumental and intervention orientation that predominates in contemporary obstetrics, however, can contribute to a woman's sense of alienation in at least two ways.

First, the normal procedures of the American hospital birthing setting render the woman considerably more passive than she need be. Most hospitals, for example, do not allow the woman to walk around even during early stages of labor, despite the fact that there is evidence that moving around can lessen pain and speed the birthing process. Routine breaking of the amniotic sack enforces this bed confinement. Women usually labor and deliver in a horizontal or near-horizontal position, reducing the influence of gravity and reducing the woman's ability to push. The use of intravenous equipment, monitors, and pain-relieving drugs all inhibit a woman's capacity to move during labor.

Second, the use of instruments provides a means of objectifying the pregnancy and birth that alienates a woman because it negates or devalues her own experience of those processes. As the previous section described, at a phenomenological level the pregnant woman has a unique knowledge of her body processes and the life of the fetus. She feels the movements of the fetus, the contractions of her uterus, with an immediacy and certainty that no one can share. Recently invented machines tend to devalue this knowledge. The fetal-heart sensor projects the heartbeat of the six-week-old fetus into the room so that all can hear it in the same way. The sonogram is receiving increasing use to follow the course of fetal development. The fetal monitor attached during labor records the intensity and duration of each contraction on white paper; the woman's reports are no longer necessary for charting the progress of her labor. Such instruments transfer some control over the means of observing the pregnancy and birth process from the woman to the medical personnel. The woman's experience of these processes is reduced in value, replaced by more objective means of observation.

Alienation within the context of contemporary obstetrics can be further

produced for the pregnant woman by the fact that the physician attending her is usually a man. Humanistic writers about medicine often suggest that a basic condition of good medical practice is that the physician and patient share the lived-body experience.[34] If the description of the lived-body experience of pregnancy in the previous section is valid, however, pregnancy and childbirth entail a unique body subjectivity that is difficult to empathize with unless one is or has been pregnant. Since the vast majority of obstetricians are men, then, this basic condition of therapeutic practice usually cannot be met in obstetrics. Physicians and pregnant women are thereby distanced in their relationship, perhaps more than others in the doctor–patient relation. The sexual asymmetry between physician and patient also produces a distance because it must be desexualized. Prenatal checkups follow the same procedure as gynecological examinations, requiring an aloof matter-of-factness in order to preclude attaching sexual meaning to them.[35]

There is a final alienation the woman experiences in the medical setting, which drives from the relations of authority and subordination that usually structure the doctor–patient relation in contemporary medical practice. Many writers have noted that medicine has increasingly become an institution with broad social authority on a par with the legal system or even organized religion.[36] The relationship between doctor and patient is usually structured as superior to subordinate. Physicians often project an air of fatherly infallibility and resist having their opinions challenged; the authoritarianism of the doctor–patient relations increases as the social distance between them increases.[37]

This authority that the physician has over any patient is amplified in gynecology and obstetrics by the dynamic of gender hierarchy. In a culture that still generally regards men as being more important than women and gives men authority and power over women in many institutions, the power the doctor has over the knowledge and objectification of her body processes, as well as his power to direct the performance of her office visits and her birthing, are often experienced by her as another form of male power over women.[38]

Philosophers of medicine have pointed out that the concept of health is much less a scientific concept than a normative concept referring to human well-being and the good life.[39] I have argued that there exists a male bias in medicine's concept of health insofar as the healthy body is understood to be the body in a steady state. This argument suggests that medical culture requires a more self-consciously differentiated understanding of health and disease.[40] Contemporary culture has gone to a certain extent in the direction of developing distinct norms of health and disease for the aged, the physically impaired, children, and hormonally active women. Such developments should be encouraged, and medical theorists and practitioners should be vigilant about tendencies to judge physical difference as deviance.

Moreover, to overcome the potentialities for alienation that I have ar-

gued exist in obstetrical practices, as well as other medical practices, medicine must shed its self-definition as primarily concerned with curing. Given that nearly all aspects of human bodily life and change have come within the domain of medical institutions and practices, such a definition is no longer appropriate. There are numerous life states and physical conditions in which a person needs help or care, rather than medical or surgical efforts to alter, repress, or speed a body process. The birthing woman certainly needs help in her own actions, being held, talked to, coached, dabbed with water, and having someone manipulate the emergence of the infant. Children, old people, and the physically impaired often need help and care though they are not diseased. Within current medical and related institutions there exist professionals who perform these caring functions. They are usually women, usually poorly paid, and their activities are usually seen as complementing and subordinate to the direction of activities such as diagnostic tests, drug therapies, and surgical therapies performed by the physicians, usually men. The alienation experienced by the pregnant and birthing woman would probably be lessened if caring were distinguished from curing and took on a practical value that did not subordinate it to curing.

NOTES

1. Julia Kristeva, "Motherhood According to Giovanni Bellini," in *Desire in Language* (New York: Columbia University Press, 1980), p. 237.
2. Erwin Straus, *Psychiatry and Philosophy* (New York: Springer-Verlag, 1969), p. 29.
3. J. Sarano, *The Meaning of the Body*, James H. Farley, trans. (Philadelphia: Westminster Press, 1966), pp. 62–63.
4. Maurice Merleau-Ponty, *The Phenomenology of Perception*, Colin Smith, trans. (New York: Humanities Press, 1962), p. 406.
5. See Rosalind Coward and John Ellis, *Language and Materialism* (London: Routledge and Kegan Paul, 1977).
6. Julia Kristeva, "Women's Time," Jardin and Blake, trans., *Signs*, vol. 7 (1981), p. 31; cf. Kristeva, "Motherhood According to Giovanni Bellini," p. 238.
7. Adrienne Rich, *Of Woman Born* (New York: W. W. Norton, 1976; Bantam paperback edition, p. 47).
8. Rich, pp. 47–48.
9. See Merleau-Ponty, *Phenomenology of Perception*, p. 82.
10. On the ambiguity of touch, see Merleau-Ponty, p. 93; see also Erwin Straus, *Psychiatry and Philosophy*, p. 46.
11. Straus discusses an intentional shift between the body as "other" and as self; see *The Primary World of the Senses* (London: The Free Press, 1963), p. 370.
12. Merleau-Ponty, pp. 138–39.
13. Hans Plugge, "Man and His Body," in Spicker, ed., *The Philosophy of the Body* (Chicago: Quadrangle Books, 1970), p. 298.
14. Straus, *Primary World of the Senses*, p. 245.

15. Sally Gadow, "Body and Self: A Dialectic," *Journal of Medicine and Philosophy*, vol. 5 (1980), pp. 172–85.

16. See Straus, "Forms of Spatiality," in *Phenomenological Psychology* (New York: Basic Books), especially pp. 11–12.

17. Elizabeth V. Spelman, "Woman as Body: Ancient and Contemporary Views," *Feminist Studies*, vol. 8 (1982), pp. 109–23.

18. On the relation of body to ground, see R. M. Griffith, "Anthropology: Man-a-foot," in *Philosophy of the Body*, pp. 273–92; see also Stuart Spicker, "*Terra Firma* and Infirma Species: From Medical Philosophical Anthropology to Philosophy of Medicine," *Journal of Medicine and Philosophy*, Vol. 1 (1976), pp. 104–35.

19. Straus' essay "The Upright Posture" well expresses the centrality of getting up and standing up to being a person; in *Phenomenological Psychology*, pp. 137–65.

20. Ann Lewis, *An Interesting Condition* (Garden City, N.Y.: Doubleday, 1950), p. 83. When I began reading for this essay I was shocked at how few texts I found of women speaking about their pregnancies; this book is a rare gem in that regard.

21. Rich discusses some of the history of views of pregnancy and motherhood; see op. cit., *Of Woman Born*, chapter IV.

22. Kristeva, "Motherhood According to Giovanni Bellini," op. cit., p. 242; Marianne Hirsch makes a useful commentary in "Mothers and Daughters," *Signs*, vol. 7 (1981), pp. 200–22.

23. Sandra Bartky, "On Psychological Oppression," in Bishop and Weinzweig, ed., *Philosophy and Women* (Belmont, Calif.: Wadsworth Publishing Co., 1979), pp. 330–41.

24. Rich, p. 6.

25. Lewis, op. cit., p. 78.

26. Phyllis Chesler, *With Child: A Diary of Motherhood* (New York: Thomas Y. Crowell, 1979), p. 116.

27. Ann Foreman, *Femininity As Alienation* (London: Pluto Press, 1977); Sandra Bartky, "Narcissism, Femininity and Alienation," *Social Theory and Practice*, vol. 8 (1982), pp. 127–43.

28. Barbara Erenreich and Dierdre English, *For Her Own Good* (Garden City, N.Y.: Doubleday, 1978), chapters 2 and 3.

29. Barbara Katz Rothman, "Women, Health and Medicine," in Jo Freeman, ed., *Women: A Feminist Perspective* (Palo Alto, Calif.: Mayfield Publishing Co., 1979), pp. 27–40.

30. Quoted in Gena Corea, *The Hidden Malpractice: How American Medicine Treats Women as Patients and Professionals* (New York: William Morrow, 1977), p. 76.

31. Rothman, op. cit., p. 36.

32. E. D. Pellegrino and D. C. Thomasma, *A Philosophical Basis of Medical Practice* (New York: Oxford University Press, 1981), p. 122; earlier quotes from p. 76 and p. 72, respectively.

33. Suzanne Arms, *Immaculate Deception: A New Look at Women and Childbirth in America* (Boston: Houghton Mifflin, 1975); D. Haire, "The Cultural Warping of Childbirth," *Environmental Child Health*, vol. 19 (1973), pp. 171–91; and Adele Laslie, "Ethical Issues in Childbirth," *Journal of Medicine and Philosophy*, vol. 7 (1982), pp. 179–96.

34. Pellegrino and Thomasma, op. cit., p. 114.

35. J. Emerson, "Behavior in Private Places: Sustaining Definitions of Reality in Gynecological Examinations," in H. Dreitzen, ed., *Recent Sociology*, no. 2 (London: Macmillan, 1970), pp. 74–97.

36. See E. Friedson, *The Profession of Medicine* (New York: Dodd and Mead Co., 1970); Irving K. Zola, "Medicine as an Institution of Social Control," *The Sociological Review*, vol. 2 (1972), pp. 487–504; and Janice Raymond, "Medicine as Patriarchal Religion," *Journal of Medicine and Philosophy*, vol. 7 (1982), pp. 197–216.

37. See G. Ehrenreich and J. Ehrenreich, "Medicine and Social Control," in John Erenreich, ed., *The Cultural Crisis of Modern Medicine* (New York: Monthly Review Press, 1979), pp. 1–28.

38. See B. Kaiser and K. Kaiser, "The Challenge of the Women's Movement to American Gynecology," *American Journal of Obstetrics and Gynecology*, vol. 120 (1974), pp. 652–61.

39. Pellegrino and Thomasma, op. cit, pp. 74–76; see also Tristam Engelhardt, "Human Well-being and Medicine: Some Basic Value Judgments in the Biomedical Sciences," in Engelhardt and Callahan, ed., *Science, Ethics and Medicine* (Hastings-on-Hudson, N.Y.: Ethics and the Life Sciences, 1976), pp. 120–39; and Caroline Whitbeck, "A Theory of Health" in Caplan, Engelhardt, and McCartney, ed., *Concepts of Health and Disease: Interdisciplinary Perspectives* (Reading, Mass.: Addison-Wesley, 1981), pp. 611–26.

40. Arlene Dallery, "Illness and Health: Alternatives to Medicine," in E. Schrag and W. L. McBride, ed., *Phenomenology in a Pluralistic Context: Selected Studies in Phenomenology and Existentialism* (Albany: State University of New York Press, 1983), pp. 167–176.

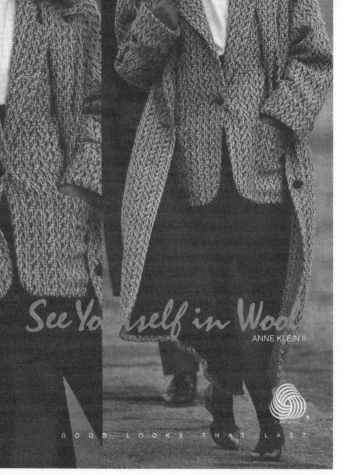

See Yourself in Wool
ANNE KLEIN II

GOOD LOOKS THAT LAST

Women Recovering Our Clothes

"See yourself in wool." Yes, I would like that. I see myself in that wool, heavy, thick, warm, swinging around my legs in rippling caresses. And who might I be? An artist, perhaps, somewhat well established, thinking of my next series. Or maybe I will be a lecturer coming off the airplane, greeted by my colleagues, who will host me at a five-star restaurant. Or perhaps I'm off to meet my new lover, who will greet me face to face and stroke my wool.

But who's this coming up behind me? Bringing me down to his size? Don't look back, I can't look back, his gaze is unidirectional, he sees me but I can't see him. But no—I am seeing myself in wool seeing him see me. Is it that I cannot see myself without seeing myself being seen? So I need him there to unite me and my image of myself? Who does he think I am?

So I am split. I see myself, and I see myself being seen. Might such a split express a woman's relation to clothes, to images of clothes, to images of herself in clothes, whomever she imagines herself to be? Can we separate the panels? I wonder if there's a way we can get him out of the picture.

Matting: Is This a Frame-up?

In her monumental book *Seeing Through Clothes,* Ann Hollander argues that the meaning of clothes is conditioned by pictorial images. Throughout the modern period, Western artists have depicted and sanctified clothing images, associating clothes with kinds of personages and situations. This representation of clothes freezes the conventional into the natural, and people measure women in their clothes in relation to the natural aesthetic created by clothing images.[1]

For most of the modern period, this thesis about the relation of the experience of clothing to images of clothing applied only to those classes able to buy artworks or invited to places where they are displayed. As Ewen and Ewen discuss, however, the mid-nineteenth century witnessed a revolutionary proletarianization of the image with the invention of cheap methods of color printing. By the early twentieth century it would seem that the experience of clothing, especially women's experience of clothing,

is saturated with the experience of images of women in clothing—in advertising drawings and photographs, catalogs, and film.[2]

Hollander cites the historical specificity of twentieth-century women's clothing standards and images conditioned by cinema. The nineteenth century held an image of women's demeanor as statuesque, immobile, hiding or hobbling the limbs. The twentieth century, by contrast, emphasizes the mobility of women in clothes—the exhibition of legs, skirts and pants that do not so much inhibit movement. Images of clothes show women on the move—striding down the street, leaping with excitement, running on the sands, leaning over a desk. If she is standing still, her hair or skirt or scarf flies with the wind. Contemporary images of women's clothes capture a single movement in a narrative whose beginning and end lie outside the frame.[3]

In wearing our clothes, Hollander suggests, we seek to fashion ourselves in the mode of the dominant pictorial aesthetic. In this project the mirror provides us a means of representation. In the mirror we see not the "bare facts," but a clothed image reverberating the dominant magazine and film images of us in our clothes. Contemporary urban life provides countless opportunities for us to see ourselves—in hotel and theater lobbies, in restaurants and powder rooms, in train stations and store windows.[4] I love to walk down a city street when I feel well dressed and to catch sight of my moving image in a store window, trying not to see myself seeing myself. I imagine myself in a movie, freely swinging down the street in happy clothes, on my way. The mirror gives me pictures, and the pictures in magazines and catalogs give me reflections of identities in untold but signified stories. The feminist question is: *Whose* imagination conjures up the pictures and their meanings?

Panel I: Reflections on Snow White's Mirror

Our experience of clothes derives from film in more than a merely associative way, Maureen Turim suggests, but also through producing the implicit narrative imagination of our clothes.

> Films not only expose new fashions to a mass audience, they not only provide the fashion industry with a glittering showcase; because we see those fashions within a narrative context, films also invest fashions with unconscious attachments, connotations. This process, the narration of fashion, means more than the association of a style with a given story or fiction. It is a process that fuses the unconscious effects of film experience with the very lines and colors of clothing designs.[5]

My question is: How shall I describe a woman's pleasure in clothes? If I live my identification with the clothing images through my experience of

film narrative, it may not be too wild to explore our pleasure in clothes through feminist film theory. Following a Lacanian framework, feminist film theorists have developed an account of a female experience of pleasure in the objectified female body within a patriarchal order. The story goes something like this.[6]

Subjectivity is crucially constituted by relations of looking. Through active looking the subject acquires a sense of subject set off against objects. Through looking at an image of himself in the mirror, the subject gains a sense of narcissistic identification with a totalized motor being misrepresented as a unity. In the phallocratic order, however, this subject who takes pleasure in looking at objects other than himself and who takes pleasure in looking at totalized images of himself is a male subject. The phallocratic order splits looking into active and passive moments. The gaze is masculine, and that upon which it gazes is feminine. Women are only lack, the other that shores up the phallic subject, the object that gives power and unified identity to men's looking. If women are to achieve any subjectivity it can only be through adopting this position of the male subject who takes pleasure in the objectification of women.

In film the activity of looking has two aspects—a voyeuristic and a fetishistic—and film positions women's bodies in relation to both sorts of looking. Voyeuristic looking takes a distance from the object of its gaze, from which it is absent and elsewhere. From this distance the object of the gaze cannot return or reciprocate the gaze; the voyeur's look is judgmental, holding power over the guilty object of the gaze by offering punishment or forgiveness. In fetishistic looking, on the other hand, the subject finds his likeness in the object, represented as the unity of the phallus. In film both voyeuristic and fetishistic looking deny the threatening difference of the female, either judging her lacking and guilty or turning her body or parts of her body into an icon in which the subject finds himself, his phallus.

Women also watch films and enjoy them. What, in this account, makes women's pleasure in films possible? Only identification with the male subject. I quote Ann Kaplan:

> Why do we find our objectification and surrender pleasurable? . . . Such pleasure is not surprising if we consider the shape of the girl's Oedipal crisis. . . . The girl is forced to turn away from the illusory unity with the Mother in the prelinguistic realm and has to enter the symbolic world which involves subject and object. Assigned the place of object (lack), she is the recipient of male desire, passively appearing rather than acting. Her sexual pleasure in this position can thus be constructed only around her own objectification. Furthermore, given the male structuring around sadism, the girl may adopt a corresponding masochism. . . . We could say that in locating herself in fantasy in the erotic, the woman places herself as either passive recipient of male desire or, at one remove, as *watching* a woman who is passive recipient of male desires and sexual actions.[7]

I cannot deny that these analyses apply to our experience of clothes, to our experience of images of women in clothes. The voyeuristic gaze is often implicit or explicit in magazine advertising for clothes, and it is easy to find the language of guilt and imperfection attached to the clothed woman. Sandra Bartky describes how women internalize the objectifying gaze of what she calls the "fashion–beauty complex," a gaze that deprecates and evaluates a woman's body.

> I must exist perpetually at a distance from my physical self, fixed at this distance in a permanent posture of disapproval. Thus, insofar as the fashion–beauty complex shapes one of the introjected subjects for whom I exist as object, I sense myself as deficient. Nor am I able to control in any way those images which give rise to the criteria by which those deficiencies appear. . . . All the projections of the fashion–beauty complex have this in common: they are images of *what I am not*.[8]

Good clothes, new clothes, this year's clothes will cover up my flaws, straighten me out, measure me up to the approving eye.

Maureen Turim discusses how within the matrix of film imagery women's clothing fashions fetishize the female body. Through what she calls the "slit aesthetic," clothing cuts play fabric off against bare skin, turning the body or body parts into fetishes. Sweaters cut low in front or back, bathing suits and lingerie cut high on the hip, cutouts in midriff at the waist, skirt slits or short skirts, cutoff pants—all pattern the clothing cut to focus on bare flesh, and frequently the cuts also direct attention to the fetishized neck, breasts, stomach, genitals, thighs, calves, ankles.[9] The slit aesthetic creates the image of the sexy clothed body, an image of phallic female power. We women sometimes respond to this image with desire, the desire to be that sexy woman.

It's all true, I guess; at least I cannot deny it: In clothes I seek to find the approval of the transcending male gaze; in clothing I seek to transform myself into a bewitching object that will capture his desire and identity. When I leaf through magazines and catalogs I take my pleasure from imagining myself perfected and beautiful and sexual for the absent or mirrored male gaze. I take pleasure in these images of female bodies in their clothes because my own gaze occupies the position of the male gaze insofar as I am a subject at all. I will not deny it, but it leaves a hollowness in me. If I simply affirm this, I must admit that for me there is no subjectivity that is not his, that there is no specifically female pleasure I take in clothes.[10]

But I remember the hours that Suzanne and I played with paper dolls, cutting, drawing, coloring, trading their clothes, stacks of their clothes in shoe boxes. Suzanne and I talked about the clothes, and we dressed up the dolls for their activities—going to work or on vacation, visiting each other or going on shopping trips; yes, they went on dates, too, though I don't remember any men paper dolls. I remember playing paper dolls with Suzanne, and I want to be loyal to her.

Panel II: Through the Looking Glass

Luce Irigaray's book *Speculum of the Other Woman*[11] concerns how Western culture expresses a masculine desire and has silenced and repressed a specifically female desire. The masculine discourse that receives expression in Western ontology conceives being in solid objects, self-identical, one and the same thing, to be observed, measured, passed around from hand to hand in the relations of commodity exchange that bind the male social contract. In patriarchal society woman is the supreme object, the possession that complements his subjectivity. In the patriarchal discourse of Western culture, Irigaray suggests, woman serves as the mirror for masculine subjectivity and desire. She reflects back to him his self, as the mother who engendered him or the wife who serves him and gives him his image in a child. The male-gaze theory I have summarized illustrates this function of femininity as the mirror in which man sees himself reflected. The institutions of patriarchy contribute to enhancing male subjectivity by organizing women's desire and action to be identified with his, desiring to make herself into a beautiful object for his gaze, finding her pleasure in his satisfaction.

The subversion of patriarchy, then, according to Irigaray, requires that women speak our desire, not as it has been formed in the interests of men but from and for ourselves. Speaking for ourselves to one another from our own female flesh and imagination, our creation of a different voice can pierce the smug universality of transcendental subjectivity. I am not sure what Irigaray means by our lips speaking together, but for me it means a discovery, recovery, and invention of women's culture. We can mine traditionally female social practices and experiences and find in them specific ways that we as women relate to one another and to ourselves, female-specific intrinsic values. There is no question that there are race, class, and sexuality differences in women's relations to one another, and in this women's culture women most often relate to women of the same race or class identification as themselves. Still, I have often found it easiest to bridge such difference between myself and another woman by talking about elements of women's culture—often clothes.

The project of speaking such women's culture does not deny women's oppression and that structures of femininity support that oppression. But if we have always been agents, we have also expressed our desire and energy in positive symbols and practices. Irigaray suggests that whereas patriarchal masculine desire is obsessed with identifiable objects that can be seen, women's desire is plural, fluid, and interested more in touch than in sight. She links a phallocentric logic of identity with property, the propensity to draw borders, count and measure, and keep hold of one's own; when the goods (women) get together, she suggests, they might speak different relationships. As I recover our clothes, or perhaps cut them out of whole cloth, I shall follow these lines.

Patriarchal fashion folds create a meticulous paradigm of the woman well dressed for the male gaze, then endows with guilt the pleasure we might derive for ourselves in these clothes. Misogynist mythology gloats in its portrayal of women as frivolous body decorators. Well trained to meet the gaze that evaluates us for our finery, for how well we show him off, we then are condemned as sentimental, superficial, duplicitous, because we attend to and sometimes learn to love the glamorous arts.[12] The male gazers paint us gazing at ourselves at our toilet, before the table they call a vanity. In their own image, the male mythmakers can only imagine narcissistic pleasures. Outside this orbit of self-reference, I find three pleasures we take in clothes: touch, bonding, and fantasy.

But for whom do I speak in this "we"? For women. But how can I speak for women? This question expresses a dilemma. Patriarchal domination requires the subversion of its authority by the speaking of a specifically female desire beyond its power to know. But there cannot be a woman's desire; the very project of feminist subversion leads us to the dissolution of such universals. When I speak, then, for whom do I speak? For myself, of course. But this is politics, not autobiography, and I speak from my own experience, which I claim resonates with that of other women. My own experience is particular and limited, and it is possible that it most resonates among white, middle-class, heterosexual professional women in late capitalist society. At least I can claim to speak only for the experience of women like me. I believe that some of the experience I express resonates with that of other women, but that is for them to say. The differences among women do not circumscribe us within exclusive categories, but the only way we can know our similarities and differences is by each of us expressing our particular experience. I offer, then, this expression of women's pleasure in clothes.

TOUCH

Irigaray suggests that masculine desire expresses itself through visual metaphors, that the experience of seeing, gazing, is primary in a masculine aesthetic. Sight is the most distancing of the senses, in which the subject stands separate and against the object, which is other, there. A patriarchal seeing, however, according to Irigaray, separates only in order to know the objects, to master them with the mind's eye and thereby find in the objects the reflection of the subject's brilliance.

Feminine desire, Irigaray suggests, moves through the medium of touch more than sight. Less concerned with identifying things, comparing them, measuring them in their relations to one another, touch immerses the subject in fluid continuity with the object, and for the touching subject the object touched reciprocates the touching, blurring the border between self and other. By touch I do mean that specific sense of skin on matter, fingers on texture. But I also mean an orientation to sensuality as such that includes all senses. Thus we might conceive a mode of vision, for example, that is less a gaze, distanced from and mastering its object, but an immersion in

light and color. Sensing as touching is within, experiencing what touches it as ambiguous, continuous, but nevertheless differentiated.

When I "see" myself in wool it's partly the wool itself that attracts me, its heavy warmth and textured depth. Some of the pleasure of clothes is the pleasure of fabric and the way the fabric hangs and falls around the body. Straight skirts with slits may give thigh for the eye, but the skirt in all its glory drapes in flowing folds that billow when you twirl. History documents the measurement of nobility and grace through fabric. Women have been imprisoned by this history, have been used as mannequins to display the trappings of wealth.

But feminine experience also affords many of us a tactile imagination, the simple pleasure of losing ourselves in cloth. We wander through yard-goods stores, stroke the fabrics hanging off the bolts, pull them out to appraise the patterns, imagine how they might be best formed around the body or the chair or on the windows.

Some of our clothes we love for their own sake, because their fabric and cut and color charm us and relate to our bodies in specific ways—because, I almost want to say, they love us back. Those wool-blend pin-striped elephant-bottom pants that held a crease so well and flopped so happily around my ankles. The green herringbone wool blazer I made with my own hands and after the lining fell apart, I sadly gave it to my sister because the new lining was too small. The wine-red-print full-sleeved smooth rayon blouse, gathered at the shoulders to drape lightly over my chest. Many of our clothes never attain this privileged status of the beloved, perhaps because our motives for having most of them are so extrinsic: to be in style or to give our face the most flattering color, to be cost-effective, or to please others. Some we love with passion or tenderness, though, and we are sad or angry when they become damaged or go out of fashion.

BONDING

The dedication of Diane Keury's marvelous movie *Peppermint Soda*, about two teenage sisters in a Paris lycée, reads: "To my sister, who still hasn't given me back my orange sweater."

Clothes often serve for women in this society as threads in the bonds of sisterhood. Women often establish rapport with one another by re-marking on their clothes, and doing so often introduces a touch of intimacy or lightness into serious or impersonal situations. When we are relaxing with one another, letting down our guard or just chatting, we often talk about clothes: what we like and what we can't stand, how difficult it is to get this size or that fabric, how we feel when we wear certain kinds of clothes or why we don't wear others. We often feel that women will understand the way clothes are important to us and that men will not. Other women will understand the anxieties, and they will understand the subtle clothing aesthetic. We take pleasure in discussing the arts of scarf tying and draping, the rules and choices of mix and match. Women often have stories to tell about their clothes—and even more often about their jew-

elry—that connect these items they wear to other women who once wore them, and we often bond with one another by sharing these stories.

Often we share the clothes themselves. Girls often establish relations of intimacy by exchanging clothes; sisters and roommates raid each other's closets, sometimes unpermitted; daughters' feet clomp around in their mothers' shoes. I love my sweater, and in letting you wear it you wear an aspect of me, but I do not possess it, since you can wear it. Or I go into a fit of rage upon discovering that you have gone out in my favorite blouse, for in doing so you have presumed to take my place. As the clothes flow among us, so do our identities; we do not keep hold of ourselves, but share.

In these relations my clothes are not my *property*, separate things with identifiable value that I might bring to market and thus establish with others relations of commodity exchange that would keep a strict accounting of our transactions. I do not possess my clothes; I live with them. And in relating to other women though our clothes we do not just exchange; we let or do not let each other into our lives.

Women often bond with each other by shopping for clothes. Many a lunch hour is spent with women in twos and threes circulating through Filene's Basement, picking hangers off the racks and together entering the mirror-walled common dressing room. There they chat to one another about their lives and self-images as they try on outfits—the events coming up for which they might want new clothes, their worry about getting a cut that will not emphasize the tummy. Women take care of one another in the dressing room, often knowing when to be critical and discouraging and when to encourage a risky choice or an added expense. Women buy often enough on these expeditions, but often they walk out of the store after an hour of dressing up with no parcels at all; the pleasure was in the choosing, trying, and talking, a mundane shared fantasy.

FANTASY

Women take pleasure in clothes, not just in wearing clothes, but also in looking at clothes and looking at images of women in clothes, because they encourage fantasies of transport and transformation. We experience our clothes, if Hollander is right, in the context of the images of clothes from magazines, film, TV that draw us into situations and personalities that we can play at.

Implicitly feminist critics of media images of women have tended to assimilate all images of women in advertising into the pornographic: that such images position women as the object of a male gaze. Clothing ads are split, however (occasionally visually, as we have seen, which creates a complex and oppressive irony), between positioning women as object and women as subject. Clothing images are not always the authoritative mirror that tells who's the fairest of them all, but the entrance to a wonderland of characters and situations.

Roland Barthes analyzes the rhetoric of fashion magazines to show how

they evoke such fantasy. In using Barthes's ideas to describe women's experience of clothes, I no doubt will tear them from their systematic fabric. Only a man, I think, would have presumed to present *The Fashion System* between two covers.[13] Barthes is a self-conscious theoretician of ideology, aware that no theoretician transcends the ideology he analyzes. At the close of *The Fashion System* he writes:

> There remains a word to be said about the situation of the analyst confronted with, or rather, *within* the systematic universe he has just dealt with; not only because it would be akin to bad faith to consider the analyst as alien to this universe, but also because the semiological project provides the analyst with the formal means to incorporate himself into the system he reconstitutes. (p. 292)

Here is the sensitive theoretician, withdrawing from the authority of the transhistorical gaze precisely in relation to a universe from which he *is* alien, one that speaks a rhetoric not addressed to him. For all his reflexive attention to history and social context, Barthes never remarks on the position of the Fashion analyst as a man.

I don't know that this surprising silence makes his analysis unsatisfactory, or more unsatisfactory than it would otherwise be. Barthes offers wonderfully evocative discussions of the meaning of the rhetoric of fashion magazines that I think express the pleasure of fantasy that clothes can give women. Fashion, he says, offers women a double dream of identity and play—indeed, the invitation to play with identities (pp. 255–56). The fantasies I have as I leaf through the magazine or click the hangers on the rack, or put on the outfit in the dressing room, may be fleeting and multiple possibilities of who I might be, character types I try on, situations in which I place myself imaginatively. I see myself in wool, but in the mode of another (or several others) in transforming possibilities, all without the real-life anxiety of having to decide who I am.

> Yet, in the vision of Fashion, the ludic motif does not involve what might be called the vertigo effect: it multiplies the person wihout any risk of her losing herself, insofar as, for Fashion, clothing is not play but the *sign* of play. (pp. 256–57; cf. pp. 260–61)

This fantasy of multiple and changing identities without the anxiety of losing oneself is possible because Fashion creates unreal identities in utopian places. In our clothing fantasies we are not the voyeuristic gaze before whom the narrative reel unfolds, because the pictures come to us only with the feeling of a narrative, not with narrative itself. Clothing ads, catalogs, music videos, etc., present images of situations, clips of possible narratives, but without any thread and temporality. "The doing involved in Fashion is, as it were, abortive: its subject is torn by a representation of essences at the moment of acting: to display the being of doing, without assuming

its reality" (p. 249; cf. pp. 253, 262, 266). Fashion images are vague, open—
a woman walking on a street, sitting on a patio, leaning on a bed, climbing
up a rock. The variables in the formulae can be filled in with any number
of concrete narrative values, and our pleasure in the fantasy of clothes is
partly imagining ourselves in those possible stories, entering unreality. The
very multiplicity and ambiguity of the fantasy settings evoked by clothes
and by fashion imagery of these clothes contributes to such pleasure.[14]

There is a certain freedom involved in our relation to clothes, an active
subjectivity not represented in the male gaze theory. Here I draw on Sartre
but not his gaze theory. In *The Psychology of Imagination*, Sartre proposes
imaginary consciousness as a modality of freedom.[15] An image is con-
sciousness of an unreal object. In imagining, I am aware of an unreal object
and aware that the object is unreal. The pleasure of imagining derives from
just this unreality, for the unreal object has no facticity, no givenness that
constrains us, no brute physicality that freedom must deal with or face the
consequences. The unreal object has no aspects not presented to me in the
image, no "other side" that transcends my apprehension, as does the per-
ceived object. The image gives the affective dimensions of a person or
situation, what it feels like to be or to see them, without their material
context and consequences. The freedom of the imaginary object lies in the
fact that there is nothing in the object that has not been put there by
imaginary consciousness.

Part of the pleasure of clothes for many of us consists of allowing our-
selves to fantasize with images of women in clothes, and in desiring to
become an image, unreal, to enter an intransitive, playful utopia. There
are ways of looking at oneself in the mirror that do not appraise oneself
before the objectifying gaze, but rather desubstantialize oneself, turn one-
self into a picture, an image, an unreal identity. In such fantasy we do not
seek to be somebody else. Fantasizing is not wishing, hoping, or planning;
it has no future. The clothing image provides the image of situations with-
out any situatedness; there is an infinite before and after; thus the images
are open at both ends to an indefinite multitude of possible transforma-
tions.

One of the privileges of femininity in rationalized instrumental culture
is an aesthetic freedom, the freedom to play with shape and color on the
body, to don various styles and looks, and through them exhibit and imag-
ine unreal possibilities. Women often actively indulge in such theatrical
imagining, which is largely closed to the everyday lives of men or which
they live vicariously through the clothes of women. Such female imagi-
nation has liberating possibilities because it subverts, unsettles the order
of respectable, functional rationality in a world where that rationality sup-
ports domination. The unreal that wells up through imagination always
creates the space for a negation of what is, and thus the possibility of
alternatives.[16]

In the context of patriarchal consumer capitalism, however, such lib-
erating aspects of clothing fantasy are intertwined with oppressing mo-

ments. Perhaps such ambiguity characterizes all mass culture that succeeds in tapping desire. To the degree that feminine fashion fantasy serves as an escape from and complement to bureaucratic scientific rationality for everyone, women's bodies and imaginations are the instruments of a cultural need.

The fantasy of fashion, moreover, often has specifically exploitative and imperialist aspects. Fashion imagery may be drawn indiscriminately from many places and times, and the clothes themselves come from all over the world, usually sewn by very poorly paid women. The fashion fantasies level and dehistoricize these times and places, often contributing to the commodification of an exotic Third World at the same time that they obscure the real imperialism and exploitation that both the fantasies and realities of clothes enact.[17]

It may not be possible to extricate the liberating and valuable in women's experience of clothes from the exploitative and oppressive, but there is reason to try. We can speak of the touch and bonding that move in the shadows, hidden from the light of the phallocentric gaze, and criticize the capitalist imperialist fantasies even as we make up our own.

NOTES

1. Ann Hollander, *Seeing Through Clothes* (New York: Viking Press, 1978).

2. Stuart Ewen and Elizabeth Ewen, *Channels of Desire: Mass Images and the Shaping of American Consciousness* (New York: McGraw-Hill, 1982).

3. Hollander, pp. 345–52.

4. Hollander, pp. 391–416.

5. Maureen Turim, "Fashion Shapes: Film, the Fashion Industry and the Image of Women," *Socialist Review* 71, vol. 13, no. 5 (September–October 1983), p. 86.

6. I derive my account of the male gaze and film from the following authors: Turim, op. cit.; Laura Mulvey, "Visual Pleasure and Narrative Cinema," *Screen*, vol. 16, no. 3 (Autumn 1975); Annette Kuhn, *Women's Pictures: Feminism and Cinema* (London: Routledge and Kegan Paul, 1982), pp. 47–65; and E. Ann Kaplan, *Women and Film: Both Sides of the Camera* (New York: Methuen, 1983), pp. 23–35.

7. Kaplan, p. 26.

8. Sandra Bartky, "Narcissism, Femininity and Alienation," *Social Theory and Practice*, vol. 8, no. 2 (Summer 1982), p. 136.

9. Turim, op. cit., pp. 86–89.

10. Kim Sawchuck, for one, agrees that feminist literature criticizing Fashion is a primary commodifier of women, a major source of the reproduction of women's oppression in patriarchal capitalism; she argues, however, that such accounts are usually too monolothic and one-sided, tending "to fall within the trap of decoding all social relations within patriarchy and capitalism as essentially repressive and homogeneous in its effects" (p. 56). "A Tale of Inscription/Fashion Statements," *Canadian Journal of Political and Social Theory*, vol. XI, no. 1–2 (1987), pp. 51–67.

11. Luce Irigaray, *Speculum of the Other Woman*, Gillian C. Gill, trans. (Ithaca, NY: Cornell University Press, 1985).

12. Sawchuck, p. 58.

13. Roland Barthes, *The Fashion System*, Matthew Ward and Richard Howard, trans. (New York: Hill and Wang, 1983); page references will be given in the text.

14. See Steve Neal, "Sexual Difference in Cinema—Issues of Fantasy, Narrative and the Look," in Robert Young, ed., special issues of *Oxford Literary Review* on "Sexual Difference," vol. 8, nos. 1–2 (1986), pp. 123–32.

15. Jean Paul Sartre, *The Psychology of the Imagination* (New York: Philosophical Library, 1948).

16. Herbert Marcuse, *The Aesthetic Dimension* (Boston: Beacon Press, 1978).

17. Julia Emberly, "The Fashion Apparatus and the Deconstruction of Postmodern Subjectivity," *Canadian Journal of Political and Social Theory*, vol. XI, no. 1–2 (1987), pp. 38–50.

Breasted Experience

The Look and the Feeling

The chest, the house of the heart, is an important center of a person's being. I may locate my consciousness in my head, but my self, my existence as a solid person in the world, starts from my chest, from which I feel myself rise and radiate.[1] At least in Euro-American culture, it is to my chest, not my face, that I point when I signify myself. In Hindu philosophy of the body the chest is not the only center, but it has the integrative power among them.[2]

Structurally, a person's chest can be more or less open, more tight or relaxed, and this often expresses a person as being withdrawn from or open to the world and other people.[3] People who sit and stand straight, chest out, shoulders back, feel ready to meet the world in action, and others judge them as upright, active, open. A person stoop-shouldered, bent, closed around this center appears to be withdrawn, depressed, oppressed, or tired.

If the chest is a center of a person's sense of being in the world and identity, men and women have quite different experiences of being in the world. When a woman places her hand over her heart, it lies on and between her breasts. If her chest is the house of her being, from which radiates her energy to meet the world, her breasts are also entwined with her sense of herself. How could her breasts fail to be an aspect of her identity, since they emerge for her at that time in her life when her sense of her own independent identity is finally formed?[4] For many women, if not all, breasts are an important component of body self-image; a woman may love them or dislike them, but she is rarely neutral.

In this patriarchal culture, focused to the extreme on breasts, a woman, especially in those adolescent years but also through the rest of her life, often feels herself judged and evaluated according to the size and contours of her breasts, and indeed she often is. For her and for others, her breasts are the daily visible and tangible signifier of her womanliness, and her experience is as variable as the size and shape of breasts themselves. A woman's chest, much more than a man's, is *in question* in this society, up for judgment, and whatever the verdict, she has not escaped the condition of being problematic.

In this essay I explore some aspects of the cultural construction of breasts in our male-dominated society and seek a positive women's voice for breasted experience. First I discuss the dominant culture's objectification of breasts. Relying on Irigaray's suggestive ideas about women's sexuality and an alternative metaphysics not constructed around the concept of object, I express an experience of breast movement and sensitivity from the point of view of the female subject. I ask how women's breasts might be experienced in the absence of an objectifying male gaze, and I discuss how breasts are a scandal for patriarchy because they disrupt the border between motherhood and sexuality. Finally, I return to the question of objectification by reflecting on a woman's encounter with the surgeon's knife at her breast.

I. Breasts As Objects

I used to stand before the mirror with two Spalding balls under my shirt, longing to be a grown woman with the big tits of Marilyn Monroe and Elizabeth Taylor. They are called boobs, knockers, knobs; they are toys to be grabbed, squeezed, handled. In the total scheme of the objectification of women, breasts are the primary things.

A fetish is an object that stands in for the phallus—the phallus as the one and only measure and symbol of desire, the representation of sexuality. This culture fetishizes breasts. Breasts are the symbol of feminine sexuality, so the "best" breasts are like the phallus: high, hard, and pointy. Thirty years ago it was de rigueur to encase them in wire, rubber, and elastic armor that lifted them and pointed them straight out. Today fashion has loosened up a bit, but the foundational contours remain; some figures are better than others, and the ideal breasts look like a Barbie's.

We experience our objectification as a function of the look of the other, the male gaze that judges and dominates from afar.[5] We experience our position as established and fixed by a subject who stands afar, who has looked and made his judgment before he ever makes me aware of his admiration or disgust. When a girl blossoms into adolescence and sallies forth, chest out boldly to the world, she experiences herself as being looked at in a different way than before. People, especially boys, notice her breasts or her lack of them; they may stare at her chest and remark on her. If her energy radiates from her chest, she too often finds the rays deflected by the gaze that positions her from outside, evaluating her according to standards that she had no part in establishing and that remain outside her control. She may enjoy the attention and learn to draw the gaze to her bosom with a sense of sexual power. She may loathe and fear the gaze that fixes her in shock or mockery, and she may take pains to hide her chest behind baggy clothes and bowed shoulders. She may for the most part ignore the objectifying gaze, retaining nevertheless edges of ambiguity and uncertainty about her body. The way women respond to the evaluating gaze on their chests is surely as variable as the size and character of the

breasts themselves, but few women in our society escape having to take some attitude toward the potentially objectifying regard of the other on her breasts.

Being does not have to be conceptualized in terms of objects. The ontology of objects is a specifically Western construct that can be traced to the Platonic–Aristotelian doctrines of reason and substance, but has its more recent and continuous relation to modern conceptualization beginning in Cartesian egology.[6]

So what is an object? The correlate and construct of a self-identical subject, outside nature, detached and originary. The subject, outside all objects, fixes the object in its gaze, mastering and knowing it with unambiguous certainty. The object is determinate and definable, with clear boundaries, separated from other objects. It is what it is, does not derive its being from its surrounding context, and does not change its nature from one context to another.[7] The object is passive, inert matter, having no self-moving capacity, its movement all externally and mechanically caused. The object is what can be handled, manipulated, constructed, built up and broken down, with clear accountability of matter gained and lost. The essential properties of the object are thus all quantities: extension, location, velocity, weight.

Practically, the object is property. The object is what is had, owned, with clear boundaries of right. Objects are precisely countable, so that owners can keep accounts of their property. They attain their full weight as commodities, objects for exchange on the market, in a circulation of power where precise accounting of equivalents and contract is the source and locus of power.[8]

Breasts are the most visible sign of a woman's femininity, the signal of her sexuality. In phallocentric culture sexuality is oriented to the man and modeled on male desire. Capitalist, patriarchal American media-dominated culture objectifies breasts before a distancing gaze that freezes and masters. The fetishized breasts are valued as objects, things; they must be solid, easy to handle. Subject to the logic of phallocratic domination of nature, their value, her value as a sexual being, appears in their measurement. Is she a B-cup or a C-cup? Even when sleek athletic fashions were current, breasts were often still prominent. And today the news is that the big bosom is back.[9]

What matters is the look of them, how they measure up before the normalizing gaze. There is one perfect shape and proportion for breasts: round, sitting high on the chest, large but not bulbous, with the look of firmness. The norm is contradictory, of course. If breasts are large, their weight will tend to pull them down; if they are large and round, they will tend to be floppy rather than firm. In its image of the solid object this norm suppresses the fleshy materiality of breasts, this least muscular, softest body part.[10] Magazines construct and parade these perfect breasts. They present tricks for how to acquire and maintain our own—through rigorous

exercise or $50 creams (neither of which generally produces the desired effect), or tricks of what to wear and how to stand so as to appear to have them.

Like most norms of femininity, the normalized breast hardly describes an "average" around which real women's breasts cluster. It is an ideal that only very few women's bodies even approximate; given the power of the dominant media, however, the norm is ubiquitous, and most of us internalize it to some degree, making our self-abnegation almost inevitable.[11] Even those women whose breasts do approximate the ideal can do so only for a short period in their lives. It is a pubescent norm from which most women deviate increasingly with each passing year. Whatever her age, if she has given birth her breasts sag away from the ideal; perhaps they have lost some of their prepartum fullness and roundness, and her nipples protrude. Whether a woman is a mother or not, gravity does its work, quickly defining a woman's body as old because it is no longer adolescent. The truly old woman's body thereby moves beyond the pale. Flat, wrinkled, greatly sagging, the old woman's breasts signify for the ageist dominant culture a woman no longer useful for sex or reproduction, a woman used up. Yet there is nothing natural about such a decline in value. Some other cultures venerate the woman with wrinkled, sagging breasts; they are signs of much mothering and the wisdom of experience. From their point of view an obsession with firm, high breasts would be considered to express a desire to be immature.[12]

II. Woman-centered Meaning

However alienated male-dominated culture makes us from our bodies, however much it gives us instruments of self-hatred and oppression, still our bodies are ourselves. We move and act in this flesh and these sinews, and live our pleasures and pains in our bodies. If we love ourselves at all, we love our bodies. And many women identify their breasts as themselves, living their embodied experience at some distance from the hard norms of the magazine gaze. However much the patriarchy may wish us to, we do not live our breasts only as the objects of male desire, but as our own, the sproutings of a specifically female desire.

But phallocentric culture tends not to think of a woman's breasts as hers. Woman is a natural territory; her breasts belong to others—her husband, her lover, her baby. It's hard to imagine a woman's breasts as her own, from her own point of view, to imagine their *value* apart from measurement and exchange. I do not pretend to discover a woman-centered breast experience. My conceptualization of a woman-centered experience of breasts is a construction, an imagining, that I will locate in the theme of a desubstantialization. If we move from the male gaze in which woman is the Other, the object, solid and definite, to imagine the woman's point of view, the breasted body becomes blurry, mushy, indefinite, multiple,

and without clear identity. The project of giving voice to a specifically female desire is an important one for feminism, I think, but it does not exist, somewhere underlying phallocentric desire as a pure and authentic female core. It must be made up, and its making is itself a political strategy.

A metaphysic generated from feminine desire, Luce Irigaray suggests, might conceptualize being as fluid rather than as solid substances, or things. Fluids, unlike objects, have no defininte borders; they are unstable, which does not mean they are without pattern. Fluids surge and move, and a metaphysic that thinks being as fluid would tend to privilege the living, moving, pulsing over the inert dead matter of the Cartesian world view.[13] This is, simply, a process metaphysics, in which movement and energy is ontologically prior to thingness and the nature of things takes its being from the organic context in which they are embedded.

I know that I am not making a popular move when I appeal to a metaphysics of fluids in constructing a woman-centered experiential voice. Irigaray's idea that women are specially linked to the aqueous is the subject of much ridicule, which sometimes makes me wonder whether there is a fear going on even among feminists, a fear of the loss of "something to hold on to." As far as I am concerned, it is not at all a matter of making a claim about women's biology or bodies, for conceptualized in a radically different way, men's bodies are at least as fluid as women's. The point is that a metaphysics of self-identical objects has clear ties to the domination of nature in which the domination of women has been implicated because culture has projected onto us identification with the abject body. It makes a difference how we think about beings in the world, and we can make choices about it that seem to have political implications. A process metaphysics, a metaphysics of fluids, where the being of any location depends on its surrounding and where we cannot delineate clearly what is inside and outside, is a better way to think about the world from an ecological point of view. Inasmuch as women's oppression derives to a significant degree from literal and figurative objectification, I am suggesting, subverting the metaphysics of objects can also be liberating for women.

An epistemology spoken from a feminine subjectivity might privilege touch rather than sight.[14] Unlike the gazer, the toucher cannot be at a distance from what she knows in touch. While active, touch is simultaneously passive. The gazer can see without being seen, and as Foucault has pointed out, this possibility is a major source of modern disciplinary powers. But the toucher cannot touch the happenings she knows without also being touched by them. The act of touching is also necessarily an experience of being touched; touching cannot happen without a touching back, and thus there can be no clear opposition between subject and object, because the two positions constantly turn into each other. With touch as the model of experience of the world, moroever, dividing the world into objects with definite borders makes much less sense. Touch differentiates— indeed, takes pleasure in—the subtlest difference of texture or softness,

but inasmuch as the things touched also touch each other, the borders are not firm. Without a place outside the world to stand, touching also steps down from the clouds of universalism; a knowledge that is in touch with things knows them in their concreteness, and not merely as the instances of general laws imagined by a mathematical mind.

From the position of the female subject, what matters most about her breasts is their feeling and sensitivity rather than how they look. The size or age of her breasts does not matter for the sensitivity of her nipples, which often seem to have a will of their own, popping out at the smallest touch, change of temperature, or embarrassment. For many women breasts are a multiple and fluid zone of deep pleasure quite independent of intercourse, though sometimes not independent of orgasm. For a phallic sexuality this is a scandal. A woman does not always experience the feeling of her breasts positively; if they are large she often feels them pulling uncomfortably on her neck and back. Her breasts are also a feeling of bodily change. She often experiences literal growing pains as her body moves from girl to woman. When she becomes pregnant, she often knows this first through changes in the feeling of her breasts, and many women have breast sensitivity associated with menstruation. When she is lactating, she feels the pull of milk letting down, which may be activated by a touch, or a cry, or even a thought.

Breasts stand as a primary badge of sexual specificity, the irreducibility of sexual difference to a common measure. Yet phallocentric sexuality tries to orient the sexual around its one and only sexual object. Active sexuality is the erect penis, which rises in its potency and penetrates the passive female receptacle. Intercourse is the true sex act, and nonphallic pleasures are either deviant or preparatory. Touching and kissing the breasts is "foreplay," a pleasant prelude after which the couple goes on to the real Thing. But in her own experience of sexuality there is a scandal: she can derive the deepest pleasure from these dark points on her chest, a pleasure maybe greater than he can provide in intercourse. Phallocentric heterosexist norms try to construct female sexuality as simply a complement to male sexuality, its mirror, or the hole—lack that he fills. But her pleasure is different, a pleasure he can only imagine. To the degree that he can experience anything like it, it's only a faint copy of female potency. Imagine constructing the model of sexual power in breasts rather than penises. Men's nipples would have to be constructed as puny copies, just as men have constructed women's clitorides as puny copies of the penis. Of course this all presumes constructing sexuality by a common measure. Phallocentered construction of sexuality denies and represses the sensitivity of breasts.

> For what male "organ" will be set forth in derision like the clitoris?—that penis too tiny for comparison to entail anything but total devaluation, complete decathexization. Of course, there are the breasts. But they are to be classed among the secondary, or so-called secondary, characteristics. Which no doubt justifies

the fact that there is so little questioning of the effects of breast atrophy in the male. Wrongly, of course.[15]

Both gay men and lesbians often defy this niggardly attitude toward nipple sexuality. Gay men often explore the erotic possibilities of one another's breasts, and lesbians often derive a particular pleasure from the mutual touching of breasts.

The breasts, for many women, are places of independent pleasure. Deconstructing the hierarchical privilege of heterosexual complementarity, giving equal value to feelings of the breast diffuses the identity of sex. Our sex is not one but, as Irigaray says, plural and heterogeneous; we have sex organs all over our bodies, in many places, and perhaps none is privileged. We experience eroticism as flowing, multiple, unlocatable, not identical or in the same place.[16]

The brassiere functions partly as a barrier to touch. Without it, every movement can produce a stroking of cloth across her nipples, which she may find pleasurable or distracting, as the case may be. But if the chest is a center of a person's being-in-the-world, her mode of being surely differs depending on whether her chest is open to touch, moving in the world, or confined and bordered.

Without a bra, a woman's breasts are also deobjectified, desubstantialized. Without a bra, most women's breasts do not have the high, hard, pointy look that phallic culture posits as the norm. They droop and sag and gather their bulk at the bottom. Without a bra, the fluid being of breasts is more apparent. They are not objects with one definite shape, but radically change their shape with body position and movements. Hand over the head, lying on one's back or side, bending over in front—all produce very different breast shapes. Many women's breasts are much more like a fluid than a solid; in movement, they sway, jiggle, bounce, ripple even when the movement is small.

Women never gathered in a ritual of bra burning, but the image stuck. We did, though, shed the bra—hundreds of thousands, millions of us. I was no feminist when, young and impetuous, I shoved the bras back in the drawer and dared to step outside with nothing on my chest but a shirt. It was an ambiguous time in 1969. I had a wondrous sense of freedom and a little bit of defiance. I never threw the bras away; they were there to be worn on occasions when propriety and delicacy required them. Why is burning the bra the ultimate image of the radical subversion of the male-dominated order?[17] Because unbound breasts show their fluid and changing shape; they do not remain the firm and stable objects that phallocratic fetishism desires. Because unbound breasts make a mockery of the ideal of a "perfect" breast. The bra normalizes the breasts, lifting and curving the breasts to approximate the one and only breast ideal.

But most scandalous of all, without a bra, the nipples show. Nipples are indecent. Cleavage is good—the more, the better—and we can wear

bikinis that barely cover the breasts, but the nipples must be carefully obscured. Even go-go dancers wear pasties. Nipples are no-nos, for they show the breasts to be active and independent zones of sensitivity and eroticism.

What would a positive experience of ourselves as breasted be in the absence of the male gaze? There are times and places where women in American society can experience hints of such an experience. In lesbian-dominated women's spaces where women can be confident that the male gaze will not invade, I have found a unique experience of women's bodies. In such women's spaces women frequently walk around, do their chores, sit around and chat naked from the waist up. Such a context deobjectifies the breasts. A woman not used to such a womanspace might at first stare, treating the breasts as objects. But the everydayness, the constant engagement of this bare-breasted body in activity dereifies them. But they do not thereby recede, as they might when clothed. On the contrary, women's breasts are *interesting*. In a woman space with many women walking around bare-breasted, the variability and individuality of breasts becomes salient. I would like to say that in a womanspace, without the male gaze, a woman's breasts become almost like part of her face. Like her nose or her mouth, a woman's breasts are distinctive, one sign by which one might recognize her. Like her mouth or her eyes, their aspect changes with her movement and her mood; the movement of her breasts is part of the expressiveness of her body.

III. Motherhood and Sexuality

The woman is young and timeless, clothed in blue, a scarf over her head, which is bowed over the child at her breast, discreetly exposed by her hand that draws aside her covering, and the baby's hand rests on the round flesh. This is the Christian image of peace and wholeness, the perfect circle of generation.[18] With hundreds of variations, from Florentine frescoes to the cover of dozens of books at B. Dalton's, this is a primary image of power, female power. To be purity and goodness itself, the origin of life, the source to which the living man owes his substance—this is an awesome power. For centuries identification with that power has bonded women to the patriarchal order, and while today its seductive hold on us is loosening, it still provides women a unique position with which to identify.[19]

But it is bought at the cost of sexuality. The Madonna must be a virgin mother. The logic of identity that constructs being as objects also constructs categories whose borders are clear and exclusive: essence/accident, mind/body, good/bad. The logic of such oppositions includes everything, and they exclude one another by defining the other as excluded by their oneness or essence. In Western logic woman is the seat of such oppositional categorization, for patriarchal logic defines an exclusive border between motherhood and sexuality. The virgin or the whore, the pure or the impure,

the nurturer or the seducer is either asexual mother or sexualized beauty, but one precludes the other.

Thus psychoanalysis, for example, regards motherhood as a substitute for sexuality. The woman desires a child as her stand-in for the penis, as her way of appropriating the forbidden father. Happily, her desires are passive, and she devotes herself completely to giving. Helene Deutch, for example, identifies normal motherhood with feminine masochism; the true woman is one who gets pleasure from self-sacrifice, the abnegation of pleasure.[20]

Barbara Sichtermann discusses this separation of motherhood and sexuality:

> Basically, women were only admitted to the realm of sexuality as guests to be dispatched off towards their "true" vocation as agents of reproduction. And reproduction was something which happened outside the realm of pleasure, it was God's curse on Eve. Women have to cover the longest part of the road to reproduction with their bodies and yet in this way they became beings existing outside sexuality, outside the delights of orgiastic release, they became asexual mothers, the bearers of unborn children and the bearers of suffering. Breast-feeding too was of course part of this tamed, pleasureless, domesticated world of "maternal duties."[21]

Patriarchy depends on this border between motherhood and sexuality. In our lives and desires it keeps women divided from ourselves, in having to identify with one or another image of womanly power—the nurturing, competent, selfless mother, always sacrificing, the soul of goodness; or the fiery, voluptuous vamp with the power of attraction, leading victims down the road of pleasure, sin, and danger. Why does patriarchy need this division between motherhood and sexuality? This is perhaps one of the most overdetermined dichotomies in our culture; accordingly, I have several answers to this question.

In the terms in which Kristeva puts it,[22] for both sexes entrance into the symbolic requires repressing the original jouissance of attachment to the mother's body. A baby's body is saturated with feeling, which it experiences as undifferentiated from the caretaking body it touches; repeated pains break the connection, but its pleasure is global and multiple. Eroticism must be made compatible with civilization, submission to the law, and thus adult experience of sexuality must repress memory of this infantile jouissance. Adult meanings of eroticism thus must be divorced from mothers. Even though for both genders, sexual desire and pleasure are informed by presymbolic jouissance, this must be repressed in the particular cultural configuration that emphasizes rationality as unity, identity, thematic reference.

The dichotomy of motherhood and sexuality, I said, maps onto a dichotomy of good/bad, pure/impure. These dichotomies play in with the

repression of the body itself. One kind of attachment, love, is "good" because it is entirely defleshed, spiritual. Mother love and the love of the child for the mother represent the perfection of love—eroticism entirely sublimated. Fleshy eroticism, on the other hand, goes on the other side of the border, where lies the despised body, bad, impure. The separation of motherhood and sexuality thus instantiates the culture's denial of the body and the consignment of fleshy desires to fearful temptation.

The incest taboo also accounts for the separation, as even classical Freudianism suggests. Such patriarchal propriety in women's bodies may be unconsciously motivated by a desire to gain control over himself by mastering the mother. But sexual desire for the mother must be repressed in order to prepare the man for separation from femininity and entrace into the male bond through which women are exchanged. As Dinnerstein suggests, repression of desire for the mother is also necessary to defend his masculinity against the vulnerability and mortality of the human condition.[23]

Now to some explanations more directly related to the interests of patriarchy. By separating motherhood and sexuality men/husbands do not have to perceive themselves as sharing female sexuality with their children. The oedipal triangle has three nodes, and there are issues for the father as well as the child. The Law of the Father establishes ownership of female sexuality. The satisfactions of masculinity are in having her to minister to his ego, the complement to his desire; he has private ownership of her affections.[24] Her function either as the phallic object or the mirror to his desire cannot be maintained if her mother love is the same as her sex love. They need to be projected onto different people or thought of as different kinds of relationships.

The separation between motherhood and sexuality within a woman's own existence seems to ensure her dependence on the man for pleasure. If motherhood is sexual, the mother and child can be a circuit of pleasure for the mother, then the man may lose her allegiance and attachment. So she must repress her eroticism with her child, and with it her own particular return to her repressed experience of jouissance, and maintain a specific connection with the man. If she experiences motherhood as sexual, she may find him dispensable. This shows another reason for repressing a connection between motherhood and sexuality in women. A woman's infantile eroticism in relation to her mother must be broken in order to awaken in her a heterosexual desire. Lesbian mothering may be the ultimate affront to patriarchy, for it involves a double displacement of an erotic relation of a woman to a man.

Without the separation of motherhood and sexuality, finally, there can be no image of a love that is all give and no take. I take this as perhaps the most important point. The ideal mother defines herself as giver and feeder, takes her existence and sense of purpose entirely from giving. Such a mother–giver establishes a foundation for the self-absorbed ego, the subject of modern philosophy, which many feminists have uncovered as being

happily male.[25] Thus motherhood must be separated from her sexuality, her desire. She cannot have sexual desire in her mothering because this is a need, a want, and she cannot be perfectly giving if she is wanting or selfish.

In all these ways, then, patriarchy is founded on the border between motherhood and sexuality. Woman is both, essentially—the repository of the body, the flesh that he desires, owns and masters, tames and controls; and the nurturing source of his life and ego. Both are necessary functions, bolstering male ego, which cannot be served if they are together, hence the border, their reification into the hierarchical opposition of good/bad, pure/impure. The separation often splits mothers; it is in our bodies that the sacrifice that creates and sustains patriarchy is reenacted repeatedly.[26] Freedom for women involves dissolving this separation.

The border between motherhood and sexuality is lived out in the way women experience their breasts and in the cultural marking of breasts. To be understood as sexual, the feeding function of the breasts must be suppressed, and when the breasts are nursing they are desexualized. A great many women in this culture that fetishizes breasts are reluctant to breast-feed because they perceive that they will lose their sexuality. They believe that nursing will alter their breasts and make them ugly and undesirable. They fear that their men will find their milky breasts unattractive or will be jealous of the babies who take their bodies. Some women who decide to breast-feed report that they themselves are uninterested in sex during that period or that they cease to think of their breasts as sexual and to take sexual pleasure in their breasts while they are nursing.[27]

Breasts are a scandal because they shatter the border between motherhood and sexuality. Nipples are taboo because they are quite literally, physically, functionally *undecidable* in the split between motherhood and sexuality. One of the most subversive things feminism can do is affirm this undecidability of motherhood and sexuality.

When I began nursing I sat stiff in a chair, holding the baby in the crook of my arm, discreetly lifting my shirt and draping it over my breast. This was mother work, and I was efficient and gentle, and watched the time. After some weeks, drowsy during the morning feeding, I went to bed with my baby. I felt that I had crossed a forbidden river as I moved toward the bed, stretched her legs out alongside my reclining torso, me lying on my side like a cat or a mare while my baby suckled. This was pleasure, not work. I lay there as she made love to me, snuggling her legs up to my stomach, her hand stroking my breast, my chest. She lay between me and my lover, and she and I were a couple. From then on I looked forward with happy pleasure to our early-morning intercourse, she sucking at my hard fullness, relieving and warming me, while her father slept.

I do not mean to romanticize motherhood, to suggest by means of a perverted feminist reversal that through motherhood, women achieve their access to the divine or the moral. Nor would I deny that there are dangers in the eroticization of mothering—dangers to children, in particular, that

derive from the facts of power more than sexuality. Mothers must not abuse their power, but this has always been so. Certainly I do not wish to suggest that all women should be mothers; there is much that would be trying about mothering even under ideal circumstances, and certainly there is much about it in our society that is oppressive. But in the experience of many women we may find some means for challenging patriarchal divisions that seek to repress and silence those experiences.

Some feminist discourse criticizes the sexual objectification of women and proposes that feminists dissociate women from the fetishized female body and promote instead an image of women as representing caring, nurturing, soothing values. American cultural feminism exhibits this move: women will retreat from, reject patriarchal definitions of sexuality and project motherly images of strength, wisdom, and nurturance as feminist virtues, or even redefine the erotic as like mother love.[28] Much French feminism is also in danger of a mere revaluation that retains this dichotomy between motherhood and sexuality, rather than exploding patriarchal definitions of motherhood.[29]

A more radical move would be to shatter the border between motherhood and sexuality. What can this mean? Most concretely, it means pointing to and celebrating breast-feeding as a sexual interaction for both the mother and the infant.[30] It means letting women speak in public about the pleasure that many report they derive from their babies and about the fact that weaning is often a loss for them.[31] But there is a more general meaning to shattering the border, which applies even to mothers who do not breast-feed and even to women who are not mothers. Crashing the border means affirming that women, all women can "have it all." It means creating and affirming a kind of love in which a woman does not have to choose between pursuing her own selfish, insatiable desire and giving pleasure and sustenance to another close to her, a nurturance that gives and also takes for itself. Whether they are mothers or not, women today are still too often cast in the nurturant role, whatever their occupation or location. This nurturant position is that of the self-sacrificing listener and stroker, the one who turns toward the wounded, needful ego that uses her as mirror and enclosing womb, giving nothing to her, and she of course is polite enough not to ask. As feminists we should affirm the value of nurturing; an ethic of caring does indeed hold promise for a more human justice, and political values guided by such an ethic would change the character of the public for the better. But we must also insist that nurturers need, that love is partly selfish, and that a woman deserves her own irreducible pleasures.

IV. The Knife at the Breast

Patriarchal culture, I have said, constructs breasts as objects, the correlate of the objectifying male gaze. What matters most is how breasts look and measure, their conformity with a norm, the impossible aesthetic of round,

large, and high on the chest. These objectifying constructions are clearly manifest in surgical medicine's angle on the breast.

Plastic surgeons cut into breasts more than into any other body part. In 1986 alone women reportedly had a total of 159,300 enlargements, lifts, or reductions; 93,500 of these were enlargements.[32] Breast surgery is not something to be taken lightly. For one thing, it is expensive. An augmentation operation may cost anywhere from $3,000 to $6,000. One writer suggests that breast enlargement has become another sign of Yuppie success in the consumer culture, where what you can buy is a major measure of your worth.[33] Like other operations, moreover, breast enlargements and reductions can cause considerable pain and bruising, and sometimes require special drains and incisions; often the healing process takes many months.[34] In many cases sensitivity in the breasts may be temporarily or permanently reduced.

Popular culture much touts the possibilities of the plastic body.[35] You can have the body you choose, ads and magazine articles suggest; you don't have to be stuck with your given body. But these messages do not give us a choice of the variety of real possible bodies. No, the idea that we can have the body we choose is that we can choose to take the body we have—with its particular lumps, folds, bone structure, and round spots— and make it over into the one and only good body, the slender but voluptuous glamour body that haunts the look, the scene, the pictures viewed. So cosmetic surgery, once the hidden instrument of assimilation or youthfulness, now is openly discussed by doctors, patients, and celebrities. There is little choice of what body to value; the normalized body is reinforced by the transformative possibilities of medical technology. Why wouldn't a woman "choose" perfect breasts when the opportunity is there?

Though this operation sometimes results in some temporary or permanent loss of feeling and sometimes leaves prominent scars, breast reduction appears to carry fewer risks than augmentation does. Some women with very large breasts experience back or neck pain, and some women even risk debilitating damage to their posture and bone structure from very large breasts. Breast-reduction surgery is much less commonly performed than is augmentation. As a feminist, I am less uncomfortable with reduction than with augmentation because it appears that most women who have reductions do so for the sake of comfort or because there are medical indications that they risk back damage. I find augmentation more questionable in its implications.

A phallocentric construction of breasts, I suggested earlier, privileges the look, their shape and size and "normalcy." From a woman's point of view, their feeling, sensitivity, and erogenous possibilities are more important—factors unrelated to their size or the way they look. Breast augmentation has as its purpose only looks: to enhance a woman's presentation on stage or in magazine photos, to make her look more normal or sexy, to better fill out the look of her clothes. Few people are fooled by the feel of

an enlarged breast—it is firmer and harder than one made only of flesh. As for the woman's own feeling, the healing time can be long and painful, and in a few women the pain is never quite gone. And while she may look sexier, she may lose some sexual sensitivity in her breasts as a result of the surgery.

I also said that phallocentric culture objectifies the breasts. Breast augmentation often actually makes women's breasts more like objects. They take on that stability and firmness implicit in the Barbie ideal; some women report that it becomes painful for them to lie on their stomachs because the mass of their breasts pushes into their flesh. Others report reluctance to lie on their backs on the beach because their breasts do not flop with the pull of gravity, the way other women's do.[36] In as many as one-third of cases, the tissue around the implant becomes literally rock-hard, causing unwelcome shape and pain, and usually requiring its removal or replacement. Implants filled with saltwater can deflate, while those filled with silicone may slowly leak their contents into the body. Medical journals have published reports of such postsurgical possibilities as future immune-system problems and toxic-shock syndrome. Since very little research has been done on these questions, no risks are confirmed. As more and more women opt for breast surgery, more research must be done. Perhaps the most disturbing risk that may be associated with breast surgery is cancer. Some physicians worry that breast implants can make it more difficult to discover a tumor early, whether by hand or through a mammogram.[37] A study by Dow Corning Corp. found that breast implants caused cancer in some laboratory rats.[38]

In this society that fetishizes breasts more than any other part of a woman's body, and also because a woman's breasts are bound up in some ways with her sense of herself, a woman with small breasts often suffers embarrassment, humiliation, or a sense of inadequacy. She often hears subtle or not-so-subtle comments on her flat chest, especially in her adolescence. Especially when the popular magazines they read offer them the ease of the plastic body, it is little wonder that many women seek augmentation.[39] For some women, moreover, bigger breasts are a condition of career success. Many women models and entertainers undergo augmentation operations, if not as a condition of employment, still at the suggestion of employers.[40]

Given the frequency of breast-augmentation surgery, I believe that much of it must be frivolous and unnecessary, like diamonds or furs. But my criticism is not of women who elect augmentation surgery. Their decisions may be rational responses to the particular constraints of their lives, their emotional needs, the social pressures they are under, and so on. The extent to which it can be said, however, that women are exercising choice when they elect augmentation, however, is questionable. Phallocentric norms do not value a variety of breast forms, but rather elevate a standard; women are presented culturally with no choice but to regard our given breasts as inferior, puny, deflated, floppy. While most plastic surgeons do present

the facts about possible risks and consequences of the surgery, many women nevertheless report surprise at the pain, the length of healing, their lack of feeling, how comparatively little their breasts have been enlarged. Thus it is not clear how well informed many of them really are. For the most part, augmentation surgery seems to fall within the great category of disciplinary practices in which women feel that they must engage in order to achieve and maintain femininity.[41] Like dieting and much exercise, surgery can be understood as a self-punishment necessary to bring her body into line.

Cancer is the other occasion for a knife at the breast. Here, in the center of my being, in these pleasurable orbs in which so much value is invested—theirs and mine—can lurk the dark home of malignancy. Until recently the undisputed normal therapy for breast cancer was a mastectomy—removal of the breast, often together with lymph nodes and pectoral muscles. Research recently has suggested that removal of the cancerous lump, together with intensive chemotherapy, is as effective in many cases.[42] But a great many women diagnosed with breast cancer still lose a breast through surgery.

There is little doubt that in many cases of breast cancer, mastectomy is either the only or the best therapy. Still, many medical professionals seem not to be sensitive to the deep identity issues that many women face with breast loss. More research and education must be done to provide alternative therapies so that mastectomy will be a last resort, and more genuinely supportive services should be provided for women who still must undergo breast loss.

A number of studies have documented that many women suffer serious emotional distress with breast loss, sometimes for years. This distress is often not detected by health professionals, let alone treated.[43] That breast loss is a trauma should come as no surprise. As I have said, for many, if not most, women, breasts are an important aspect of identity. While their feelings about their breasts often have been multiple and ambivalent, nevertheless they are a central element in their bodily self-image. Phenomenologically, the chest is a center of a person's being in the world and the way she presents herself in the world, so breasts cannot fail to be an aspect of her bodily habitus. For many women, breasts are a source of sexual pleasure or bodily pride. Many women emotionally locate important episodes in their life history—such as coming to adulthood or having children—in their breasts.

My reading about women's experiences with mastectomy leads me to think that frequently, the integration of breasts with a woman's self is seriously denied in the events of mastectomy. In conformity with Western medicine's tendency to objectify the body and to treat the body as a conglomerate of fixable or replaceable parts, a woman's breast is considered to be detachable, dispensable. A lack of sensitivity to how important a woman's breast is to her identity probably accounts for the fact that for so long, radical mastectomy was the only accepted therapy for breast cancer.[44]

People often seem to take the attitude toward breast loss that after all, breasts are really not functional, only decorative. They doll you up, make you beautiful and sexy, but you don't need them in the same way you do legs or hands. If the woman is middle-aged or old, her breasts may be perceived as being even more dispensable, since she will have no more children and her sexuality is usually denied. The woman who expresses feelings of rage or depression at the idea and actuality of breast loss is often made to feel that she is unacceptably vain. She is encouraged to become detached and to "take it like a man." To the degree that people sympathize with the emotional trauma of breast loss, it is most often from a male-identified point of view. They assume that a woman's major emotional problem is in relation to her husband or male lover, that she worries how he will love her body; and the popular literature about breast loss is full of stories of the selfless and magnanimous men who stand by their women, insisting that they love her and not her breasts.

That she in an important sense *is* her breasts is denied, and thus she is not allowed to be public and honest in her fear and grief. Then, when she has lost her breast, the culture's message is clear and unambiguous: She must adjust by *learning to hide* her deformity. Above all, she must return to daily life looking and behaving as though nothing has happened. She replaces her breast with a prosthesis, which finally achieves the objectified attributes of the phallicized breast: it is firm, does not jiggle, points just right (except when it slips), and usually has no nipple. Or today, women can opt for the ultimate in breast objectification: surgical reconstruction. Fulfilling the dream of replaceable parts, for a fee and through additional pain, a woman can be "as good as new." Or so the hope is held out to her, even though many women find themselves surprised and disappointed by how little a reconstructed breast looks and feels like the lost breast.[45]

Whether she wears a prosthesis or a surgically constructed artificial breast, she certainly cannot feel the same. Both objects serve to hide and deny her loss of feeling and sensitivity, both sexual and also the simple daily feeling of being in the world with these breasts. Prosthesis and reconstruction give primacy to the look, to the visual constitution of a woman's body. Her trauma is constructed not as the severance of her self and her loss of feeling, but as her becoming visually deformed, repulsive to look at. She must protect others from viewing her deformity and herself from the gaze of repulsion. So of course most women will wear a prosthesis and cannot be criticized for doing so.

Audre Lorde points out a crucial consequence of this culture's enslavement to a woman's looking "normal" after breast loss. Besides making it difficult or impossible for a woman to come to terms with her new body, it also makes it difficult or impossible for one-breasted women to identify one another. It renders a woman's experience completely invisible not only to those who do not wish to think about cancer and breast loss, but also to those who have experienced them. Given the frightening frequency of

breast cancer among women in American society, this primacy of the nor-
malizing look completely silences and isolates a huge number of women.

> Prosthesis offers the empty comfort of "Nobody will know the difference." But
> it is that very difference which I wish to affirm, because I have lived it, and
> survived it, and wish to share that strength with other women. If we are to
> translate the silence surrounding breast cancer into language and action against
> this scourge, then the first step is that women with mastectomies must become
> visible to each other. For silence and invisibility go hand in hand with pow-
> erlessness. By accepting the mask of prosthesis, one-breasted women proclaim
> ourselves as insufficients dependent upon pretense. We reinforce our own iso-
> lation and invisibility from each other, as well as the false complacency of a
> society which would rather not face the results of its own insanities.[46]

The opportunity thus does not offer itself to her to transform her body
identity into a one-breasted woman, an Amazon. In a differently con-
structed culture, she might reconstitute her body identity and learn to love
herself with one breast. Women's body histories are fluid and changing; it
would be possible for her to form a new and positive body identity. She
adjusted to being breasted when she was a teenager; if she had children,
she adjusted to radical changes in her body form when she was pregnant.
Only among lesbians is there an effort to affirm in public the possibility
of a positive one-breasted woman, and even in such woman-centered com-
munities the success is often ambiguous.

NOTES

I am grateful to Sandra Bartky, Lucy Candib, Drew Leder, and Francine
Rainone for helpful comments on an earlier version of this paper. Thanks
to Nancy Irons for research help.

Considering the vast explosion of women's-studies literature in the past
two decades, there is an amazing absence of writing about women's ex-
perience of breasts, and some of what little there is does not arise from
feminist sensibility. One wants to explain why it is that feminists have not
written about breasts, even when there is a great deal of writing about
sexuality, mothering, the body, and medical interactions with women's
bodies. Why this silence about breasts, especially when if you tell women
you are writing about women's breasted experience, they begin to pour
out stories of their feelings about their breasts? Women are interested in
talking about their breasted bodies and interested in listening to one an-
other. But we almost never do it in conversation, let alone in writing.

In the darkness of my despair about women's own breast censorship,
I uncovered a gold mine: Daphna Ayalah and Isaac Weinstock, *Breasts:
Women Speak About Their Breasts and Their Lives* (Summit Books, Simon and
Schuster, 1979). This is a collection of photographs of the breasts, with
accompanying experiential accounts, of fifty women. Ayalah and Wein-

stock asked all the women the same set of questions about growing up, sexuality, aging, birthing and nursing, and so on. Thus while each woman's stories are her own and in her own words, they can be compared. The authors were careful to interview different kinds of women: old, young, and middle-aged; women of color as well as white women; women who have and have not had children; lesbians as well as straight women; models; call girls; etc. This is an extraordinary book, and many of the generalizations I make about women's experience in this paper are derived from my reading of it.

NOTES

1. Erwin Straus locates the self as consciousness phenomenologically in the head, but mentions the chest or trunk as an important location of the self in movement and a sense of immediate affective experience of the self in the world; see "The Forms of Spatiality," in *Phenomenological Psychology* (New York: Basic Books, 1966), pp. 22–27. Seymour Fischer finds heart awareness an important variable in body consciousness; see *Body Experience in Fantasy and Behavior* (New York: Appleton-Century Crofts, 1970), e.g., chapter 27.

2. See Barbara Ann Brenna, *Hands of Light* (New York: Bantam Books, 1987), pp. 132–35.

3. One of the women interviewed by Ayalah and Weinstock relies on the ideas of yoga to suggest that her sense of herself and her relation to her breasts influenced her entire being in the world as either tight or relaxed in the chest. See Daphna Ayalah and Isaac Weinstock, *Breasts: Women Speak About Their Breasts and Their Lives* (Summit Books, Simon and Schuster, 1979).

4. Many of the women interviewed by Ayalah and Weinstock trace significant aspects of their adult personalities to their adolescent experiences of breast development.

5. See Sandra Bartky, "On Psychological Oppression," in Sharon Bishop and Marjorie Weinzweig, eds., *Philosophy and Women* (Belmont, Calif.: Wadsworth Publishing Co., 1979), pp. 33–41; and E. Ann Kaplan, "Is the Gaze Male?" in *Women and Film: Both Sides of the Camera* (New York: Methuen, 1983), pp. 23–35.

6. Martin Heidegger, *What is a Thing?*, W. B. Barton and Vera Deutsch, trans. (Chicago: Henry Regnery Co., 1967).

7. Carolyn Merchant takes "context independence" to be one of the defining characteristics of the materialist mechanical view of nature, which triumphed over an organic view of nature in the seventeenth century. See *The Death of Nature* (Berkeley: University of California Press, 1980), chapter 9.

8. I am thinking of Irigaray's attention to the property and commodity basis of objecthood; "Women on the Market," in *This Sex Which is Not One* (Ithaca, N.Y.: Cornell University Press, 1985), pp. 170–91.

9. "Forget Hemlines: The Bosomy Look Is Big Fashion News," *Wall Street Journal* (2 December 1988), p. 1, A9; Jeremy Weir Alderson, "Breast Frenzy," *Self* (December 1988), pp. 83–89.

10. Susan Bordo suggests that achievement society takes Western culture's denial of the body and fleshiness to extremes, projecting norms of tightness and hardness for all bodies. This is the particular contemporary cultural meaning of the demand for slenderness in both men and women, but especially in women. Bordo does not

mention breasts specifically in this discussion, but clearly this analysis helps us understand why media norms of breasts make this impossible demand for a "firm" breast. See Bordo, "Reading the Slender Body," in Mary Jacobus, Evelyn Fox Keller, and Sally Shuttleworth, ed. *Body/Politics: Women and the Discourses of Science* (New York: Routledge Chapman and Hall, 1989), pp. 83–112.

11. See Sandra Bartky, "Foucault, Femininity and the Modernization of Patriarchal Power," in Irene Diamond and Lee Quinby, ed., *Feminism and Foucault: Reflections on Resistance* (Boston: Northeastern University Press, 1988).

12. Comment of Fran, in Ayalah and Weinstock, p. 136.

13. Irigaray, "The Mechanics of Fluids," in *This Sex Which Is Not One*, Catherine Porter, trans. (Ithaca, N.Y.: Cornell University Press, 1985). Compare Jeffner Allen, "An Introduction to Patriarchal Existentialism," in Allen and Young, ed., *The Thinking Muse: Feminism and Modern French Philosophy* (Bloomington: Indiana University Press, 1989), especially pp. 81–83; and "The Naming of Difference: Truth and Female Friendship," in *Lesbian Philosophy: Explorations* (Palo Alto, Calif.: Institute of Lesbian Studies), especially pp. 104–6.

14. The ontology of the later Merleau-Ponty is the closest there is to an epistemology based on touch. See "The Intertwining—The Chiasm," in *The Visible and the Invisible*, Alphonso Lingis, trans. (Evanston, Ill.: Northwestern University Press, 1968); Irigaray comments on this text in *Ethique de la Difference Sexuelle* (Paris: Editions de Minuit, 1984), pp. 143–72.

15. Irigaray, *Speculum of the Other Woman* (Ithaca, N.Y.: Cornell University Press, 1985), pp. 22–23.

16. "This Sex Which Is Not One," in the volume of the same title, pp. 23–33.

17. Susan Brownmiller suggests that women going braless evoke shock and anger because men implicitly think that they own breasts and that only they should remove bras. See *Femininity* (New York: Linden Press, Simon and Schuster, 1984), p. 45.

18. For an interesting discussion of the meaning of this image in the Renaissance, see Margaret R. Miles, "The Virgin's One Bare Breast: Female Nudity and Religious Meaning in Tuscan Early Renaissance Culture," in Susan Rubin Suleiman, ed., *The Female Body in Western Culture* (Cambridge, Mass.: Harvard University Press, 1985), pp. 193–208.

19. Kristeva, "Sabat Mater" in Suleiman, ed., op cit; see also Susan Rubin Suleiman, "Writing and Motherhood," Garner, Kahane and Sprengnether, ed., *The (M)other Tongue: Essays in Feminist Psychoanalytical Interpretation* (Ithaca, N.Y.: Cornell University Press, 1985), pp. 352–77.

20. Deutch, *Psychology of Women*, vol. II, cited in Suleiman, op. cit., p. 356.

21. Barbara Sichtermann, "The Lost Eroticism of the Breasts," in *Femininity: The Politics of the Personal* (Minneapolis: University of Minnesota Press), p. 57.

22. See, for example, Kristeva, "The Father, Love, and Banishment," in *Desire in Language* (New York: Columbia University Press, 1980), pp. 148–58.

23. Dorothy Dinnerstein, *The Mermaid and the Minotaur* (New York: Harper and Row, 1977), chapter 6.

24. Carole Pateman makes a forceful and scholarly argument that modern patriarchal ideology implicitly supports a view of men as owning women through the marriage contract and the prostitution contract. See *The Sexual Contract* (Stanford, Calif.: Stanford University Press, 1988), chapters 5–7.

25. See Naomi Schemen, "Individualism and the Objects of Psychology," and Jane Flax, "Political Philosophy and the Patriarchal Unconscious: A Psychoanalytic Perspective on Epistemology and Metaphysics," both in Sandra Harding and Merrill B. Hintikka, ed., *Discovering Reality: Feminist Perspectives on Epistemology, Metaphysics, Methodology and Philosophy of Science* (Dordrecht, the Netherlands: D. Reidal Publishing Co., 1983).

26. Ann Ferguson discusses a "double consciousness" created in mothers by the

enactment of this split between motherhood and sexuality in their lives; see "On Conceiving Motherhood and Sexuality: A Feminist Materialist Approach," in Joyce Trebilcot, ed., *Mothering: Essays in Feminist Theory* (Totowa, N.J.: Rowman and Allenheld, 1983), especially pp. 162–65. Kristeva talks about women as essentially sacrificed in the male social contract. See, for example, "Women's Time," op. cit.

27. Women's attitudes toward breast-feeding and its relation or lack of it to sexuality are, of course, extremely variable. Teenage mothers, for example, have a great deal more difficulty than do older mothers with the idea of breast-feeding, probably because they are more insecure about their sexuality. See Lorie Yoos, "Developmental Issues and the Choice of Feeding Method of Adolescent Mothers," *Journal of Obstetrical and Gynecological Nursing* (January–February 1985), pp. 68–72. Ayalah and Weinstock interview many mothers specifically about their attitudes toward and experiences in breast-feeding. The reactions are quite variable, from women who report the experience of breast-feeding as being nearly religious to women who say they could not consider doing it because they thought it was too disgusting.

28. In the feminist sexuality debate, some sexual libertarians accuse those with whom they debate of holding a kind of desexualized, spiritualized, or nurturant eroticism. See Ann Ferguson, *Blood at the Root* (London: Pandora Press, 1989), chapter 7, for an important discussion of the way out of this debate. I do not here wish to take sides in this debate, which I hope is more or less over. The debate certainly reveals, however, the strength of a good/bad opposition around eroticism as it plays out in our culture. Ferguson suggests that the debate sets up an opposition between pleasure and love, which is an unhelpful polarity.

29. See Donma Stanton, "Difference on Trial: A Critique of the Maternal Metaphor in Cixous, Irigaray, and Kristeva," in Allen and Young, ed., *The Thinking Muse.*

30. This is the main point of Sichtermann's article, cited in note 21.

31. See Harriet H. Myers and Paul S. Siegel, "Motivation to Breastfeed: A Fit to the Opponent-Process Theory?" *Journal of Personality and Social Psychology*, vol. 49, no. 1 (July 1985), pp. 188–93.

32. Jeremy Weir Alderson, "Breast Obsessed," *Self* (December 1988); also "Whose Breasts Are They, Anyway?" *Mademoiselle* (August 1987), p. 70.

33. Alderson, op. cit.

34. Ayalah and Weinstock report on a woman who had breast-reduction surgery, and the operation caused pain, bruising, and for a while no feeling in the breasts (see p. 52). Another woman gives an excruciating account of her experience with breast enlargement and its pain and loss of feeling (pp. 110–11).

35. Susan Bordo argues persuasively that twentieth-century advanced capitalist consumer culture has gone beyond the Cartesian mechanistic metaphysics and its correlate mechanical understanding of the body, to a view of the body as plastic, moldable, completely transformable and controllable, according to a variety of possibilities. See "Material Girl: Postmodern Culture, Gender and the Body," unpublished manuscript, Le Moyne College, May 1989.

36. See Lennart Ohlsen, et al., "Augmentation Mammoplasty: The Surgical and Psychological Effects of the Operation and Prediction of the Result," *Annals of Plastic Surgery*, vol. 13, no. 4 (October 1984), pp. 280–98, for reports of these sorts of complaints.

37. Alderson, op. cit.

38. *Wall Street Journal,* op. cit.

39. One study reports that 57 percent of women seeking augmentation surgery were influenced by popular magazines in their views of breasts, compared with only 15 percent of those in a control group. See Lennart Ohlsen, et al., op. cit.

40. Ayala and Weinstock interview several women who had augmentation surgery because of their jobs.

41. See Bartky, op. cit., "Foucault and Femininity," and Bordo, op. cit., "Slender Body."

42. Boston Women's Health Collective, *Our Bodies, Ourselves* (New York: Simon and Schuster, 1976; second edition, 1983).

43. See Taylor, Lichtman, Wood, Bluming, Dosik, and Liebowitz, "Illness-Related and Treatment-Related Factors in Psychological Adjustment to Breast Cancer," *Cancer,* vol. 55, no. 10 (May 1985), pp. 2506–13; Collette Ray, Janet Grover, H. V. Cert, and Tom Misniewski, "Nurses' Perceptions of Early Breast Cancer, and Their Psychological Implications, and of the Role of Health Professionals in Providing Support," *International Journal of Nursing Studies,* vol. 21, no. 2 (1981), pp. 101–11.

44. See Rose Kushner, *Breast Cancer: A Personal History and Investigative Report* (New York: Harcourt Brace Jovanovich, 1975), pp. 302–10. Kushner also suggests that the prevalence of mastectomy may derive from the predominance of men over female medicine.

45. See Karen Berger and John Bostwick, *A Woman's Decision* (New York: C. V. Mosby Co., 1984); the authors are advocates of breast reconstruction, but they report that some women are disappointed that their new breasts do not look like the old ones.

46. Audre Lorde, *The Cancer Journals* (Trumansburg, N.Y.: The Crossing Press, 1980), p. 61.

Index

IRIS MARION YOUNG, Associate Professor of Public and International Affairs at the University of Pittsburgh, is author of *Justice and the Politics of Difference* and coeditor, with Jeffner Allen, of *The Thinking Muse: Feminism and Modern French Philosophy.*

Athena Theodore, The Professional
woman, Cambridge: Schenkman
Publish Co 1971

Anne Statham, Laurel Richardson
& Judith Cook — Gender &
Univ Teaching - A Negotiated
Difference, Albany: State
Univ of NY 1991